Cubism
and its histories

DAVID COTTINGTON

Manchester University Press

Manchester and New York

distributed exclusively in the USA by Palgrave

The right of David Cottington to be identified as the author of this work has been
asserted by him in accordance with the Copyright, Designs and Patents Act 1988.

Published by Manchester University Press
Oxford Road, Manchester M13 9NR, UK
and Room 400, 175 Fifth Avenue, New York, NY 10010, USA
www.manchesteruniversitypress.co.uk

Distributed exclusively in the USA by
Palgrave, 175 Fifth Avenue, New York,
NY 10010, USA

Distributed exclusively in Canada by
UBC Press, University of British Columbia, 2029 West Mall,
Vancouver, BC, Canada V6T 1Z2

British Library Cataloguing-in-Publication Data
A catalogue record for this book is available from the British Library

Library of Congress Cataloging-in-Publication Data applied for

ISBN 0 7190 5003 0 *hardback*
 0 7190 5004 9 *paperback*

First published 2004

12 11 10 09 08 07 06 05 04 10 9 8 7 6 5 4 3 2 1

Typeset by
D R Bungay Associates, Burghfield, Berks

Printed in Great Britain
by the Alden Press, Oxford

For Linsey, Andy and Joe

Contents

Illustrations

Colour plates

Black-and-white figures

Every effort has been made to obtain permission to reproduce copyright material in
this book. If any proper acknowledgement has not been made, copyright-holders
are invited to contact the publisher.

Preface

The title and the contents page of this book deserve some explanation. 'Cubism', after all, is a term whose elasticity of reference in the near-century since its emergence has been considerable. In the past few years alone its history has been represented, at one extreme, as the creation solely of Picasso over a five year period, at the other, as that of more than twenty artists in Paris – to take account only of its city of origin – over more than twenty years.[1] A constant, through these and the many interpretive positions in between, has been the assessment of cubism as fundamental to modernist art, as the keystone of the arch that it threw across the century after Manet; but, again, the terms of this assessment have varied widely (in ways that correlate with these representations of it). Almost as constant has been an assumed autonomy on the part of cubism, however defined, *vis-à-vis* factors that lay outside the studio – but this is now increasingly challenged, on a variety of grounds. The consequence is, presently, a degree of confusion as to just what cubism was, how and why it happened in Paris when it did, and according to whom. A primary purpose of this book is therefore to offer a history of cubism that takes into account not only what the style and the movement signified at the time of their emergence – and why – but the ways in which (and the principal writings through which) their subsequent significance for modernism has been constructed; that is, to bring cubism's historiography into its history.

This is not to propose a comprehensive survey. Any attempt at one, on a level of analysis adequate to cubism's complexity, would now be futile as well as foolhardy: in the generation and more since John Golding's *History and Analysis*[2] the subject and its historiography have become far too big, and a pretention to comprehensiveness is now too questionable. What follows is therefore a selective account: cubism lasted longer, and encompassed the work of more artists, than I here give consideration to, and the omissions in both respects should be recognised. So, too, I hope, will the reasons for such omissions.

As to the first: it is true that a complete account of the trajectory of cubism, as a style of painting (and sculpture) in active and continuous practice and elaboration, and as a movement with continuous cultural valency or partisan appeal, would take the discussion through to the end of the 1920s; it is true also that consideration only of its pre-First World War history risks losing sight of the constitutive role of wartime and post-war cubism for the subsequent evolution of modernism. Yet,

reciprocally, to take that trajectory itself as the primary conceptual frame – to take the '-ism' as a given – is to assume a degree of internal coherence, even autonomy, for cubism as a style and a movement that is in no sense justified *a priori*; indeed it would be to beg the very questions that need to be addressed if a historical under-standing of it in both respects is to be reached.

The guiding principle of my account of cubism's emergence and elaboration is that of the *heteronomy* of this history – as a style and a movement constructed across, and shaped by, the particular discourses that gave meaning to the experi-ence of modernity in Paris in the early twentieth century. That discursive space, those discursive formations and their intersections or contestations, were specific to the conjuncture of their *avant-guerre* decade, I would argue – inseparable, ulti-mately, from each other and from the available meanings that cubism held in that moment. Thus to bracket this history of cubism within that decade is not simply to tell the story yet again in an old way; rather, it is to prioritise *conjuncture* over *trajec-tory* (to put it schematically) as the more appropriate frame of analysis. And to choose 1905 and 1914 as its limits is to not only re-emphasise the primacy, over any subsequent moment in that trajectory, of the events, artistic practices and their products that made cubism, however defined, in those years, but to hold on to the significance of these limit dates as framing an identifiable conjuncture. For all of the problems of treating August 1914 as an epochal 'break' (since the discursive conti-nuities that ran through from pre- to post-war France have become increasingly evident to historians of this period in recent years), it remains the case that it was a break in more ways than it was not, and in ways that affected cubism fundamen-tally. Perhaps the most crucial of these was the calamitous consequence of the out-break of war for the mood of excitement over modernity that had expressed itself, in the immediate pre-war years, in some cubists' very public engagement with themes of 'modernolatry' and 'simultaneity' (to borrow those apposite terms from their futurist rivals). Their shared pictorial experimentation had brought together an enthusiasm for that engagement and a determination to critique the conventions of its representation that were fatally sapped by the experience of the war's brutali-ties, and by the mobilisation and dispersal of many of cubism's leading participants.

I have argued elsewhere for such a conjunctural reading of cubism in avant-guerre Paris – in sum, that the avant-garde field within which it was fashioned was itself consolidated between the collapse of the political coalition of the centre and left (the Bloc des Gauches) in 1905, and the *Union sacrée* that rallied the discordant nation and took it into war in 1914, and that cubism was both a product of, and con-tributory to, this conflicted moment.[3] The book recapitulates that argument, but seeks also to map more fully the different 'wings' of the pre-1914 cubist movement (*gallery* and *salon* cubism) and their relation to each other, as well as to trace the construction, on the foundations provided by the balance of forces which this rela-tionship had established by that date, of what subsequently became the dominant model of its stylistic interpretation and art-historical assessment. It is thus not only contraints of space that have governed some of the omissions of certain works of

art, individuals, stages of development and media from the account, though they
have played their part: I have aimed throughout to identify the salient features of
cubism's terrain and of its historiographical architecture.

Thus, for example: insofar as it was within the medium and associated studio
practices of painting that the aesthetics and devices of cubism were first elaborated,
and since it has been in relation to pictorial concepts and innovations that its signif-
icance has subsequently been assessed – but also because to have extended the
scope of this study beyond painting would have lengthened it unfeasibly – I give no
consideration here to the work of sculptors associated with the movement, much as
I would have liked to. Of the few who were major contributors to its history
(Duchamp-Villon, Laurens, Lipchitz, Archipenko and Zadkine chief among
them) only the first of them produced work prior to August 1914 that related more
than peripherally to cubist concerns, and to give Duchamp-Villon his due on his
own terms would have taken me too far from those concerns into different (if over-
lapping, and also fascinating) fields of discourse. Similarly, the *Cubist House* project
must be recognised as integral to cubism's agenda, and a manifestation of its some-
times contradictory response to the discursive pressures of the moment, and yet
the issues it raises about the relation between modernism and decoration open into
both broader fields, and a later conjuncture, than this book can encompass other
than in passing. I have been equally selective in tracing the lineage of cubism's art
history, focusing more closely on post-1945 and Anglo-American writings than on
the earlier, predominantly French, contributions to this historiography, in recogni-
tion both of the generally more immediate relevance of the more recent writing for
contemporary approaches to cubism, and of its significance for the construction of
the critical modernist paradigm.

The bipartite structure of the book is, I hope, self-explanatory, but should not be
taken to indicate an assumption that 'discourses' and 'readings' are on some funda-
mental level separable and autonomous. Both are, of course, social and ideological
constructions – not only this, but interdependent to a considerable degree; and
while I distinguish, for analytical purposes, the discourses I outline as constitutive
of the 'cubist conjuncture' from those readings that have been made of its cultural
product, it would be disingenuous to propose a putatively objective history of
cubism against which selected interpretations are then measured. Instead, the his-
tory itself should be seen as produced through and between readings – for which
the evidence and justification are, I trust, clearly presented, and that are at times (at
points of particular salience in the 'narrative' of cubism, when significant interpre-
tations that have been offered are in conflict) explicitly juxtaposed. I hope that the
ways in which cubism's histories have been written will thereby have been made
more transparent.

Acknowledgements

In the researching, writing and producing of this book I have incurred too many debts to too many people ever to acquit myself of them all adequately, but there are some to whom particular thanks are due here. In Paris, Pascal Rousseau, Lisa Werner and Colette Giraudon generously shared both their own research and their responses to my ideas on numerous enjoyable occasions. In the USA Nancy Troy, Natasha Staller, Beth Gersh-Nesic and Jeffrey Weiss gave their greatly valued support over the long haul that the project turned out to be, while Mark Antliff provided information and commentary that clarified my thinking on key points of detail. In England the readiness of Paul Overy, Tag Gronberg and Brandon Taylor to respond to repeated versions of particular arguments has been much appreciated, and in Prague Vojtech Lahoda's kindness in furnishing me with the results of his research on Vincenc Kramár was crucial for my account of that collector-historian of cubism. In Falmouth, my MA students over the past five years have both nourished and endured my enthusiasm for cubism and its conjuncture. To all of them I am extremely grateful; needless to say, such shortcomings as this book displays despite their help are entirely my own.

It is safe to say that *Cubism and its histories* would not have appeared without the unflagging support of several people at Manchester University Press: Vanessa Graham who, while an editor there, first suggested the project to me; Alison Welsby, who took it up as her successor and whose continued commitment as the book grew in both scope and size I have much appreciated; and Jonathan Bevan, whose diligence ensured that deadlines and protocols were kept in sight. I have also benefitted from the kindness of many collectors and museum staff who have gone out of their way to help me track down and obtain photographs and permissions, in particular Mme Anne Lesage of RMN, and Mme Jeanne-Yvette Sudour of the Musée Picasso, both in Paris. These items were funded by grants from The British Academy and Falmouth College of Arts' Research Awards Fund, to both of which I am most grateful.

Above all, though, I am indebted to Linsey Cottington for her unstinting encouragement for this project, and Andy and Joe for putting up with endless bedtime stories about the adventures of the cubists. Without them I would never have started this book, let alone finished it.

PART I

DISCOURSES

1

Cubism, the avant-garde and the liberal Republic

For some years, under the pretext of renewing art, of modernising its procedures, of creating new forms and presenting new formulas, certain exploiters of the public's credulity have indulged in the most insane hyperbolae of extravagances and eccentricities.

I would not dream of contesting their unfortunate right to do so, but I cannot accept that our Fine Arts administration should countenance these jokes in bad taste and should graciously hand over our national palaces for manifestations that risk compromising our marvellous artistic patrimony. (Jules-Louis Breton[1])

I do not in the least wish ... to offer a defence of the principles of the cubist movement! In whose name would I present such a defence? I am not a painter ... What I do defend is the principle of the freedom of artistic experimentation ... My dear friend, when a picture seems bad to you, you have the incontestable right not to look at it, to go and look at others. But one doesn't call the police! (Marcel Sembat[2])

With that exchange of views, cubism in 1912 entered the parliamentary arena in France. In the Chamber of Deputies early that December, deputies Breton and Sembat – both socialists – were the leading protagonists in a debate whose occasion was the recent Salon d'Automne held at the Grand Palais, and in particular the inclusion in it of works by cubist painters. At issue – as their remarks indicate – was the relation between art and the State: specifically, whether the Government should allow the Salon d'Automne to make use of a state building, and thus appear to countenance whatever art its jury should accept for exhibition. The exchange was brief; the Chamber soon moved on to weightier matters and cubism's single moment of parliamentary notoriety was quickly over. But why did it occur at all? Why should Deputy Breton have wished, in his colleague Sembat's words, to 'call the police' over the cubists' paintings? There were, after all, only four works in the fine art section of that year's Salon d'Automne by members of the group which had made its public debut at the Salon des Indépendants eighteen months earlier. Henri Le Fauconnier stole the limelight with a huge picture, over 3 metres wide, entitled *Mountaineers Attacked by Bears* (plate XII), while Albert Gleizes showed *Man on the Balcony*, Jean Metzinger his *Dancer in a Café* (plate XVI), and Fernand Léger *Woman in Blue*. If to the average salon visitor these paintings, which I discuss

in later chapters, probably looked decidely odd – indeed were all but illegible – at least they were not pornographic or, on the face of it, morally offensive in some other way; there was anyway, by 1912, a fairly established convention that each year's Salon d'Automne would provide the public with a few pictures worthy of ridicule, and the newspaper cartoonists with targets for their ribald wit.[3] Yet the debate in the Chamber came as the climax of the campaign against their inclusion that Breton and others had been waging in the press for the previous two months. Launched soon after the opening of the Salon d'Automne by an open letter to the fine arts minister, published in *Le Matin*, from a Paris city councillor, the campaign gathered adherents from across the critical (and political) spectrum. Their contributions, as they echoed, endorsed and elaborated each other's sentiments, throw into relief for the modern reader a set of interrelated preoccupations and anxieties which reveal, as I show, some of the meanings that avant-garde art had in the public discourse of the pre-war Republic.

At the moment of this debate, cubism was at the height both of its public notoriety and of its trajectory as a movement. As cubism, and the stylistic commonalities that marked it out, diversified through the work of increasing numbers of adherents in the months that followed, and as its originators began to go their separate ways, its collective momentum began to dissipate. By the autumn of 1913, the critic Roger Allard could note the lack of an identifiable group style, and declare the dismemberment of 'the cubist empire' to be 'a *fait accompli*'.[4] The outbreak of war both confirmed this dismemberment, as military duties claimed some of cubism's key players, and ushered in a decade of consolidation, and contestation, of its achievement. In the autumn of 1912, however, that momentum seemed unstoppable.

It had been generated within two distinct, and for a time almost completely separate, artistic environments: one, the relatively closed and self-contained milieu of the *bande à Picasso*, the Montmartre-based circle of poets and collectors centred, from around 1907–8, on the studios of Picasso and Braque, and on the little private gallery of dealer Kahnweiler; the other, the circle of writers and painters that developed out of the Abbaye de Créteil venture of 1906–7,[5] was centred from 1909–10 on the studio of Le Fauconnier on the left bank, and was orientated towards the public fora of the Salon des Indépendants and the Salon d'Automne. Cubism was the first art grouping to be thus divided between different market sectors. If the *gallery* cubism of Picasso and Braque, with Kahnweiler's astute assistance, furnished the movement with a reputation for an obscurantism and hermeticism that were soon seen to be among its chief characteristics, it was the *salon* cubism of Le Fauconnier, Gleizes, Metzinger, Léger and Robert Delaunay that secured its public profile. For this was launched, at the 1911 Indépendants, following a carefully planned promotional manoeuvre that secured Le Fauconnier's election to the chair of the Commission de Placement; charged with arranging the hanging of the exhibition, he packed it with members of his circle. The Commission placed the works of those five artists in a prominent position, hanging them together in room

41. Even the painters themselves, however, were unprepared for the public and critical uproar that this grouping of paintings provoked. Gleizes later recalled the opening day of the exhibition:

> It was a marvellous Parisian spring day, sunny and warm. I passed through the first group of rooms, in which there were few people. But the further I went the denser became the crowd ... our room was packed, people were shouting, laughing, complaining, protesting in all manner of ways ... We couldn't understand it. The whole afternoon it was like this. Room 41 never emptied[...]
>
> Overnight we had become famous. Unknown, or nearly, the day before, our names were bandied everywhere, not only in Paris but in the provinces and abroad [6]

Eighteen months later, not only were the artists who had launched salon cubism with such *éclat* once again at the centre of scandal,[7] but their group project, the *Cubist House*, was the object of almost equal attention at that year's Salon d'Automne. Comprising three furnished interiors and part of a full-scale façade – the collective work of eighteen members of the cubist circle – it was literally unmissable by the salon's visitors since it provided the entrance to the decorative arts' section, and two weeks after the Salon opened Roger Allard wryly observed that it had already received more insults than a cubist painting.[8] Only ten days after that opening came a further, and comprehensive, demonstration of the movement's potency. The Salon de la Section d'or (Salon of the Golden Section) was timed to rival the Salon d'Automne; it was, if far smaller, nevertheless impressively big for a group exhibition: at the galerie de la Boétie, over thirty artists showed around 200 paintings and sculptures, displaying thereby not only the range of work that the movement encompassed but also the number of its adherents.[9] To accompany and support the exhibition a collection of critical essays was published: *La Section d'or*, presented as the first issue of a proposed periodical (subsequent issues never materialised), contained contributions from no fewer than nineteen writers. Its editor, Guillaume Apollinaire, and two other critics also propounded the aesthetic of cubism in a series of lectures at the gallery. Finally, that autumn also saw the publication of cubism's unofficial manifesto *Du 'Cubisme'*, written by two of the most prominent members of the salon 'wing' of the movement, Gleizes and Metzinger.[10] The product of discussions held at the informal weekly gatherings, at the house of the three Duchamp brothers in suburban Puteaux, that since the autumn of 1911 had become its intellectual and organisational focus, the 6,000-word pamphlet was a comprehensive, programmatic and combative statement of the cubist aesthetic, as understood by these two self-appointed spokespersons, and immediately became a reference work on contemporary art for commentators across Europe.

Such promotional and critical activity as thus underpinned the ascendancy of cubism in 1912 may seem after nearly a century of similar practices to be an inescapable, even integral, aspect of avant-garde art-making. At the time, however, it was not yet so; not only were the apparatus of modern art criticism and the conventions of promotional hyperbole newly established, but so was the avant-garde

itself. How it came to be so, and with what consequences for art practice – and cubism in particular – are questions in need of consideration.

Cubism in the avant-garde

The term 'avant-garde' is ubiquitous in writing and discussion about modern art, yet equally imprecise in its reference. Persistent ambiguities in usage and conception have contributed both to the impoverishment of our understanding of the history of the avant-garde as a formation and to a misunderstanding of the relation of avant-gardism to modernism. Not only have modern art historians tended to confuse *our* idea of the early twentieth-century avant-garde with that which the producers, critics and audiences of art in the pre-1914 decade took it to be, and assumed that this was, simply, those artists who made works that are today seen as belonging to the modernist canon (and who in so doing defined themselves as avant-garde); there has been a failure to distinguish avant-gardism from the specific character of social and cultural alienation that preceded the emergence of the avant-garde formation. To an extent this is understandable. After all, through the second half of the nineteenth century there occurred a progressive disengagement of artists from the established institutional frameworks of art education, professional practice and exhibition, and their replacement by alternatives – as regards the last of them, the narrative that runs from Courbet's pavilion at the 1855 Exposition universelle, through the impressionist exhibitions of the 1870s and 1880s, to the activities of dealers such as Durand-Ruel and Vollard is a now familiar one. As an accompaniment to those changes, a profounder alienation from the mainstream was experienced by some artists, an alienation of the kind identified by Linda Nochlin, in a keynote article of 1968, as 'central to our concept of avant-gardism', one that was 'psychic, social, ontological'. For artists such as Manet and writers such as Flaubert and Baudelaire, she argued, 'their very existence as members of the bourgeoisie was problematic, isolating them not merely from existing social and artistic institutions but creating deeply felt internal dichotomies as well'.[11] There are, however, two problems with this definition. The first is that while alienation was certainly a cardinal component of avant-garde consciousness, the two were not the same. The second is that it takes no account of the fundamentally collective character of avant-gardism – that is, of its emergence (and that of the avant-garde as a formation) as a function of social developments which affected whole groups of artists rather than individuals.

There were several levels to these developments. One has been described by the French sociologist Christophe Charle, in his analyses of the intellectuals and other 'elites' of the early Third Republic, as a double paradox. The republican regime held out the promise of an open society governed by meritocratic values, but in fact remained a class society the upper echelons of which remained closed to those without the appropriate credentials. At the same time, the reforms in higher education, including art education, of the late 1870s and 1880s, and the growing cultural

reputation of Paris gave the literary and artistic professions greater social esteem; yet channels of advancement within them were choked – indeed chances of making a living at all were crushed – by the surfeit of aspirant writers and painters that these developments produced. To 'live as a bourgeois and think as a demi-god', which was Flaubert's declared aspiration, still required – as Charle notes – the means of a bourgeois; as a compensation for the frustrations of their lack of access to those means, and as security against their consequent marginalisation, increasing numbers of such aspirants were by the turn of the century reaching for the collective identities of 'intellectual' and 'avant-garde'.[12]

A second level was that of the emergent private gallery sector of the art market in the late nineteenth century, within which, as Martha Ward notes, certain developments were crucial for the construction of an avant-garde. The establishment of Georges Petit's lavish gallery with its explicit appeal to aristocratic taste was 'especially welcomed in the midst of the economic depression and the republican reforms of the arts', and its attractions enticed Monet and Renoir away from Durand-Ruel in 1886.[13] As impressionism thus moved up the market, and its allure became increasingly select – a development that Ward terms its 'privatisation' – the neo-impressionist circle came together around the painters Pissarro, Seurat and Signac in an opposition to it that was at once aesthetic and political, their paintings inscribed with their leftist sympathies. As Ward argues, their adoption of the prefix 'neo-' (coined by the sympathetic critic Félix Fénéon) amounted to a 'disruptive strategy of simultaneously historicising, superseding, and reviving impressionism'.[14] Underpinning this avant-gardist gesture there developed, crucially, an infrastructure of little reviews – a product of the liberalisation of the press laws in 1881 – and associated exhibition spaces. The Société des Artistes indépendants was founded, with Signac as its president, in 1884, establishing an annual juryless salon; many little reviews showed their artistic allegiances by holding art exhibitions on their premises. Equally significantly, writers associated with those reviews extended their literary activities to encompass the exhibitions. 'They took on the dealer–critic system by promoting an art supposedly outside of it', notes Ward, 'in a language that defied its manners of judgement and creations of value.'[15]

Such were the factors, operating at once on macro- and micro-economic and societal levels, that determined the emergence of an identifiable population of non- (even anti-) academic artists in late nineteenth-century Paris and engendered avant-gardist aspirations within its membership. The consolidation of that population into the counter-cultural formation of the avant-garde, and of those aspirations into both a sense of collective identity and a set of strategies for self-promotion, amounted in effect to the creation of what sociologist Pierre Bourdieu has termed a 'field' of cultural production, a notion that usefully seizes the dynamic and structuring character of the relationships within this avant-garde.[16] It was this complex development that provided the formative professional context for the generation of artists – the cubists among them – which followed that of the neo-impressionists. Direct experience of its various aspects began early for

this generation. Of the thousands of young men and women who descended on Paris around 1900 with hopes of pursuing a successful artistic career many found their way not to the Ecole des Beaux-Arts (which had traditionally provided the gateway to one) but to the private academies, the *académies libres* or *académies payantes* which had initially given supplementary tuition to students they prepared for the Ecole but were beginning to supersede that overcrowded and increasingly moribund institution. The oldest of them was the Académie Julian, founded in 1868, though by 1900 it was rivalled by the Académie Colarossi and the Académie de la Grande Chaumière, and within a decade by others, including the Carrière, the Palette, the Ranson, the Moderne, the Russe and the Wassilief.[17] Together they provided the institutional base for a growing body of art students; attendance at such academies thus helped to distinguish this emergent alternative population from the academic mainstream. So too did the tuition their students received: although very varied in terms of quality and commitment – to judge from the memoirs of some of their alumni – this tuition was provided for the most part by artists who, while established, were situated towards the aesthetically radical end of the professional spectrum: for example, the former *nabis* Bonnard, Sérusier and Denis who taught at the Ranson or the Moderne's Guérin. At the beginning of 1912 such access to innovative aesthetics was increased when cubist Le Fauconnier replaced society painter J.-E. Blanche as professor at La Palette, and was joined on the teaching staff by Metzinger. Not only was this a testimony to the widening influence of cubism in Paris that I have already noted, but it had a significant effect, as we shall see in chapter 5, on the dissemination of cubist precepts across the European avant-garde network.[18] For the most part the private academies were located in Montparnasse; this *quartier*, though not yet the social and cultural attraction it became just prior to the First World War, was already well frequented by artists and writers – drawn by, among other things, the Tuesday evenings held by the literary review *Vers et Prose* from 1905 at the Closérie des Lilas brasserie and the popular Bal Bullier dancehall opposite. But half of Montparnasse – the 6th *arrondissement*, north of the boulevard Montparnasse – was also comfortably bourgeois, the home of journalists, politicians, established writers and artists who taught at the Ecole. The private academies shared that character: their fees, at around FF1.50 per hour, were beyond the reach of many, and their students were predominantly young French or foreign artists from middle-class backgrounds.

Many of those students were women; for, quite apart from its surfeit of applicants, the Ecole des Beaux-Arts did not accept women until 1897 (and its *ateliers*, where the leading academic artists taught, not until 1900), and the private academies were thus the only route to a professional fine art career available to them, providing access to study from the nude model (though at twice the fee that male students were charged) and instruction by established artists. Among those who benefited from such facilities were Sonia Terk (later Delaunay) at La Palette, Marevna at the Julian, Alice Halicka and Juliette Roche (later Gleizes) at the Ranson.[19] The benefits were, however, mixed – in the first place, because aspirant

women art students were until 1900 distinguished at the first hurdle from their
male co-aspirants, prevented from acquiring the training and, more importantly,
the cachet and connections that the Ecole alone provided at the outset of a bour-
geois artistic career. Although some women were determined enough to combat
this handicap by founding their own professional society, the Union des femmes
peintres et sculpteurs, in 1881, they fought a losing battle against the dominant cul-
tural discourse, which constructed a separate category for '*l'art féminin*', whose
qualities – such as sensuousness, delicacy and intimacy – were those thought
proper to contemporary femininity.[20] Beneath a critical rhetoric which, larding this
category with superlatives, pretended that there was equality in such difference
between the aesthetic aptitudes of men and women, there ran a note of condescen-
sion that sometimes, as in critic Octave Uzanne's book *The Modern Parisienne*
(1910), surfaced as sour contempt: 'Women authors, painters and musicians have
multiplied during the last twenty years in bourgeois circles, and even in the *demi
monde*', he noted.

> In painting especially they do not meet with the violent opposition they endured in
> former times. One may even say that they are too much in favour, too much encour-
> aged by the pride and ambition of their families, for they threaten to become a veri-
> table plague, a fearful confusion, and a terrifying stream of mediocrity.[21]

It is true that for the generation of middle-class young women who enrolled at
the private academies in the first decade of the twentieth century the spaces of fem-
ininity were changing. Their social and professional independence from patriar-
chal (and in particular domestic) constraints were greater than before, and with
them the opportunities to make and exhibit uncompromisingly unacademic paint-
ings alongside those of their male colleagues; the private academies were instru-
mental in this development (figure 1.1).[22] But there was a second aspect to the
mixed benefits that they afforded: if they gave access to the emerging community of
the avant-garde, this was defined in terms that were incompatible with the contem-
porary construction of femininity. Uzanne, again, made this crystal clear: 'the
unknown paintress fighting for fame', he argued,

> is irritable, restless, egotistical, and art, of which she talks too much, 'her art' as she
> calls it, has ended by stripping from her all her feminine graces, her coquetry, her
> childishness, her amorous nonchalance, all that is exquisite in women ... she is preoc-
> cupied only with her canvases, her sketches, her future exhibitions, with frames to
> find, measures to take to obtain the best place on the wall, press notices to prepare;
> she is a dreadful bore ... forgetting her sex and its innate qualities, she has evolved into
> a frightful androgyne.[23]

Ironically, the masculinity – indeed, the virility – of the avant-garde artist was
being increasingly emphasised in that first decade of the century, at least partly in
response to the perceived threat posed by this influx of women to male artistic iden-
tity. In a now famous article of thirty years ago Carol Duncan showed how pervasive,

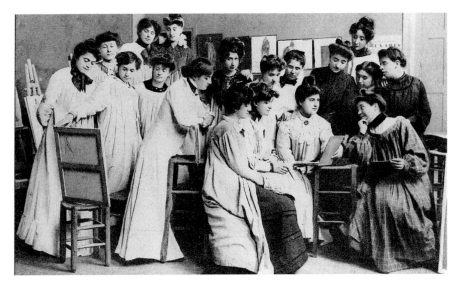

1.1 A class of women students at the Académie Humbert in 1904

1.2 The 'cité d'artistes' of La Ruche, c.1910

in the early twentieth-century European avant-garde formation, was the trope of 'the earthy but poetic male, whose life is organised around his instinctual needs', and whose art 'depicts and glorifies what is unique in the life of th[is] artist – his studio, his vanguard friends, his special perceptions of nature, the streets he walked, the cafés he frequented'.[24] Paradigmatic for this – for reasons I explore – was Picasso, whose *papiers-collés* of 1912–14 in particular are pungently evocative of just this world, their word–image play of puns and dirty jokes wittily inscribing its laddish exclusivity (figure 7.1). Linking this trope of the virile avant-gardist with a broader crisis of masculinity, Duncan argued that such art represented the fantasies and fears of middle-class men in a changing urban world, struggling against the strictures of bourgeois life. Others have since developed her argument, noting the paradox of male artists laying claim to modernity through the adoption of not just anti-bourgeois but of regressive social relations of sexuality, and marking their distinction from an earlier dandified (and for them dangerously feminised) artistic identity by embracing what they saw as a 'primitive' masculinity.[25]

Also in Montparnasse – but in social terms 'across the tracks' from the private academies – in the 14th and 15th *arrondissements* south of the boulevard Montparnasse, a less affluent and then still partly rural area at the edge of the city, was another element of the emergent population of the avant-garde: the collection of *cités d'artistes*, ramshackle buildings full of low-rent rooms and studios housing scores of penniless artists, many of them immigrants from Eastern Europe and Russia. The most celebrated of these buildings was La Ruche, a peculiar circular building that still stands, made of remnants from the 1900 Exposition universelle, and home for a while to Léger, Archipenko, Chagall, Soutine and others (figure 1.2). Almost exclusively male, this community (others included those of the Cité du Maine, Cité Boulard – made with remnants from a previous exposition, that of 1889—and Cité Falguière) lived close to destitution in studios costing FF50–150 a year.[26] If a social (and to an extent gender) division existed between the glamourless poverty of these *cités* and the genteel student milieu of the academies, there was also an aesthetic divide between the ex-*nabi* decorative aesthetic purveyed by many teachers at the latter (until the arrival of Le Fauconnier and Metzinger at La Palette) and the predilection for East-European styles and cultural models that characterised the former. This burgeoning alternative population was thus by no means homogeneous.

It was also dispersed, since other of its components, equally distinguishable in both social and aesthetic terms, were across Paris in Montmartre. A world away not just from Montparnasse but even from the districts of Paris that nestled at the foot of its steep slopes, 'La Butte', as it was known by its familiars, was still a village at the turn of the century (figure 1.3). Housing a social mix of smallholders and market gardeners, workers from the factories of the northern suburbs, shop-workers from the nearby Dufayel department store, anarchists and villains, it provided fertile ground for the creation of a myth of a bohemia of which it was the capital (until that myth brought about its suffocation, by 1914, under the weight of

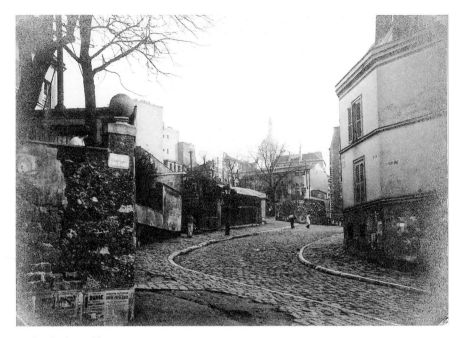

1.3 Rue Ravignan, Montmartre, c.1910

tourism), and cheap living for an artistic colony – once again exclusively male, for
that bohemia was a fiercely patriarchal construction – comprised chiefly of two
groups.[27] The older of these was that of the *humoristes*, among them Willette and
Steinlen, artists and illustrators who frequented the cabarets that clung to its slopes
– the most famous of which was the Chat Noir, opened in 1881—and worked with
the satirical press, associated with them, that flourished in the wake of the liberali-
sation of the press laws in that year.[28] The younger was the milieu of artists centred
on the Bateau-Lavoir studios and, within these, on the activities of Picasso; it
included several young artists drawn like him to Paris from Spain around the time
of the 1900 exposition, as well as such poets as Salmon, Jacob and Apollinaire.
Between these two groups there was little social contact, and marked differences in
aesthetic allegiance; but they were distinguished still more from the artistic main-
stream, both by the social and cultural marginality of Montmartre, and by the mar-
ginality of their relation to that mainstream's marketplace.

For market forces were also working to consolidate the field of the avant-garde,
both in the public forum of the annual salons and in the private spaces of the galleries,
as the rising pressure of the numbers of exhibitors in both sectors put a premium on
strategies of self-promotion. In the days of state monopoly, the mid-nineteenth-cen-
tury salon had averaged 3,000 exhibits; by 1914, now the Salon des Artistes français,
it was averaging 5,500, and had been joined by those of the Indépendants (estab-
lished in 1884), the Nationale (1890) and the Automne (1903); already by 1911 the
Salon des Indépendants and the Salon d'Automne, now cardinal points of reference

for the growing population of the avant-garde, were between them exhibiting nearly 9,000 works of art each year, while between 1896 and 1910 the number of exhibitors at the Indépendants rose from around 150 to over 1,000.[29] As the critic Louis Vauxcelles observed in 1911, with art production on this scale (his estimate was 17,000 salon exhibits a year), the market was saturated; only a tiny proportion of works were bought by *amateurs*, and not many more by the State.[30]

The promotional strategies pursued by artists faced by this surfeit of numbers can be divided into two types. The first to be elaborated was the attempt to obtain greater visibility for their works. One means to this was participation in the smaller exhibitions of new work that preceded the salons and acted as curtain-raisers for them. Since the early years of the Republic the government-fostered diversification of exhibition venues had encouraged the development of exhibitions in socially exclusive private clubs, or *cercles*, that were the Parisian equivalent of London's gentlemen's clubs; the exhibitions of two of these, the Union artistique and the Cercle artistique et littéraire –known familiarly as 'L'Epatant' and 'Le Volney', respectively – were major social events, patronised by financiers as well as leading artists. By 1900 these were being joined by other societies, the number of which mushroomed over the next decade: between them, these *salonnets*, as they were christened by Vauxcelles, showed 10,000 works a year by 1911.[31] Until the cubists' 1912 initiative of the Salon de la Section d'or, however, their creation responded to commercial and social, rather than aesthetic, requirements, and they exhibited little stylistic coherence; they were also often dominated by older and established artists wanting to distinguish themselves from the *hoi polloi*. Members of the latter began instead to pursue a different organisational tactic: exhibition as a group within the salon. In 1905, Matisse and a group of friends, including Derain and Vlaminck, managed to secure a prominent location for the exhibition of their works at the Salon d'Automne, through the friendly offices of the chair of the Commission de Placement, Georges Desvallières. The result was the gratifyingly loud critical response that launched fauvism on the Parisian public.[32] It was a tactic adopted and developed by the cubists some years later with equal success, as I have noted.

A second strategy was intervention in the critical debate that was by now a permanent feature of the contemporary art market. Since its initial flowering, following the liberalisation of the press laws in the early 1880s, the literary and artistic culture of the *petites revues* had steadily expanded, partly because of the surfeit of numbers in the writing market and the inability of the majority to find employment in the established press. Young writers (and, in their wake, young artists) made their initial reputation in these small magazines; over 185 such revues circulated in the period 1900–14, the majority of them founded after 1910.[33] Among the consequences were an aesthetic debate of extraordinary complexity and range, and the proliferation of avant-gardist '-isms'. As Gleizes later recalled, these 'would soon multiply according to the will of artists seeking more to attract attention to themselves than to realise serious works'.[34]

Even as self-styled avant-garde artists elaborated such promotional strategies (which served to underwrite their emerging collective consciousness), the centre of gravity of the art market was shifting from the public arena of the salons to the more private spaces of the multiplying commercial galleries. This shift was gradual – the two sectors had co-existed for generations, and the salons would continue to be significant well into the twentieth century – but there were decisive changes in the decade prior to the First World War that were crucial in consolidating the distinctiveness, and in determining the structure, of the avant-garde formation, and the place of cubism within it. Conventionally, the Paris art market had functioned, like much business in late nineteenth-century France, according to principles of entrepreneurial prudence and 'live and let live'. The leading dealers operated a benevolent oligopoly, tolerating yet also 'farming' a hierarchy of smaller and less capitalised galleries. This practice left spaces open, on both the demand and the supply side, for risk-takers. Into the former stepped a small number of collectors willing to speculate – if modestly – on the work of unorthodox and unacademic unknowns. Among such collectors were the fourteen *amateurs* who joined together in 1904 to form the Société de la Peau de l'Ours (Skin of the Bear Society), with the express purpose of amassing over ten years, at an annual cost of FF250 each, a collection of 'important works by young painters or those just establishing some notoriety', and selling it at a profit at the end of this period.[35] The group's name, taken from a La Fontaine fable in which two hunters sell a bearskin to a furrier before even trying – and, when they did, failing – to catch the bear indicates both its speculative motives and its members' awareness (indeed, enjoyment) of the risks involved. This was a new kind of collector, to whom the Peau de l'Ours' organiser and principal buyer, André Level, gave the name *dénicheur*, or 'winkler-out of bargains',[36] for whom the pleasure afforded by the exercise of their discernment and independence of judgement in discovering such 'important works by young painters' was equal to that of the aesthetic contemplation of the prize.[37] Drawn in their search for such art towards the mythical bohemia for which Montmartre then stood, the patronage of the *dénicheurs* gave valuable support to La Butte's network of penurious small galleries and bric-à-brac shops, which constituted the front line of infrastructural support for its avant-garde community. Correspondingly disregarding of the unknowns of Montparnasse – habitués of both the academies and the *cités d'artistes* alike – as lacking such bohemian allure, they thus acted, unwittingly, to reinforce existing (or emerging) subdivisions within the avant-garde population at large. They also served to reinforce gender imbalances, for few of these *dénicheurs* were interested in purchasing work by women artists (not least because their purchases from the avant-garde enabled them to share vicariously in the heroic identity of the latter): thus of the fifty-four artists represented in the Peau de l'Ours' collection at its auction in 1914, only one was female.[38]

The activities of the *dénicheurs* also made apparent to one aspiring art dealer the opportunities that lay open to those willing to take risks on the supply side. Daniel-Henry Kahnweiler, a reluctant apprentice stockbroker from Stuttgart, in

1907 persuaded his family to give him FF25,000 and a year to prove his abilities as a Paris picture dealer instead. Thus short of time but better capitalised by far than most small galleries, he put both to shrewd use, renting a tiny gallery space in the rue Vignon near the place de la Madeleine, a fashionable location on the edge of the *quartier* where the leading dealers were gathered, and quickly putting together a stock of relatively inexpensive pictures that was at the leading edge of their tastes.[39] After thus securing his short-term survival he pursued a more independent strategy that was based on an acute reading (perhaps helped by his stockbroker training) of the dynamics of the market, steadily narrowing the range of purchases to focus on the work of a few artists he judged to be of particular promise and who were still available: in particular Picasso, whose reputation within avant-garde milieux was huge but whose recent *Demoiselles d'Avignon* (plate I) had scared away erstwhile patrons; but also Braque, Derain and Vlaminck, all of whom had begun with fauvism, newly fathomed by the market, yet were sailing into uncharted waters. He bought directly from the artists, introducing the innovation of 'exclusivity', that is, an agreement to take every picture the artist produced, at set prices according to size. This was a device unheard of until then in the cautious world of the Paris market; 'paintings must circulate, change their milieux', Vollard explained to Vlaminck – as he acquiesced, ironically enough, in the artist's selling to Kahnweiler, in 1907, some of the first pictures the novice dealer obtained.[40] Kahnweiler accompanied this selectivity with an exhibition policy that combined inaccessibility in Paris – requiring his artists to refrain from showing anywhere else, salons included – with an acceptance of every possible opportunity of foreign exposure. By means of such entrepreneurship he also accumulated a small but loyal clientele of *dénicheurs*, for (what he later termed) the 'aristocratic' reputation which he thus cultivated for his artists appealed to them unostentatiously in such a way that were able to enjoy the exercise of their discernment in patronising such a select, but internationally recognised, stable of artists.[41]

By such initiatives Kahnweiler helped to shape the emergent avant-garde. Firstly, because, in providing such support for painting that was at the leading edge not only of modernist experimentation but of speculation in a bullish market, he raised the profile of his artists – and that of experimentation in general – both in Paris and, perhaps even more influentially, across Europe.[42] And, secondly, because his aggressive championing of this small stable of artists sharpened distinctions and rivalries between coteries within that avant-garde, and helped to precipitate that elaboration, by artists without dealers, of a range of strategies of competitive self-promotion of which Roger Allard showed himself already weary in 1913:

> With the aid of newspaper articles, knowingly organised exhibitions, with contradictory conferences, polemics, manifestos, proclamations, prospectuses and other futurist publicity, a painter or a group of painters is launched. In Boston or Kiev or Copenhagen, this hubbub creates an illusion and foreigners send in some orders.[43]

The two wings of cubism

Cubism was produced across this market and the fragmented avant-garde it sup-
ported and shaped – the first modernist movement to encompass such distinct and
almost mutually exclusive spaces within these. This fact was of fundamental
importance for its stylistic evolution (and also, as I show later, for its role in the sub-
sequent history of modernist painting). For the point, and the manner, of the
artists' orientation to the art market influenced every aspect of their work: the
making, the showing, the viewing – and thus the available meanings – of their
paintings and sculptures, prints and designs.[44] The circumstance which had
brought the salon cubists together in the first place (the recognition on their part of
shared aesthetic concerns, evident in the pictures they each showed at the 1910
Salon d'Automne) itself encouraged the shared exploration of the stylistic qualities
that these works had in common, and thus their enhancement in the paintings that
followed.[45] Orientation to the salon led also to a shared predilection for pictures of
large (indeed, progressively larger) scale, ambitious subject matter and – ironically
– a methodical, even academic, mode of production that replaced their earlier prac-
tices of rapid execution and loose handling, sanctified by the impressionist para-
digm. Reciprocally, the market orientation of the gallery cubists took their painting
and practice in the opposite direction. In the period prior to Kahnweiler's 1909
decision to underwrite Picasso's entire output, the artist had become accustomed
to progressing from one substantial project to another, following precisely that
rhythm of working imposed by salon showing. Although he remained aloof from
participating in the salons, the sequence of major paintings – including the
Demoiselles d'Avignon (plate I) and the *Three Women* (figure 2.6) – that resulted
from this manner of working were nevertheless public in their address, declarations
of his avant-gardist ambition. Braque, though he had earlier worked within the
impressionist paradigm, painting loosely worked fauvist pictures, adopted a similar
rhythm of working in response to Picasso (if not to the same degree), answering the
Demoiselles with his biggest and most considered works to date, *Large Nude* and
Woman (figure 2.3). Kahnweiler's shift to comprehensive patronage in early 1909
was accompanied by an abrupt change in their rhythm of working – signalled, in
Picasso's case, by his abandoning in mid-project of a major multi-figure composi-
tion, *Carnival at the Bistro*, for which he had already made several sketches, and its
reconfiguration as an – albeit monumental – still-life (figures 2.10 and 2.11). From
that moment, he painted no more figure groups, and no more large works, until the
Woman in a Chemise project of 1913.[46] No longer addressed to the avant-garde pop-
ulation at large, and their avant-gardism underwritten by Kahnweiler's commer-
cial support, the painting of Picasso and Braque from mid-1909 had as its putative
audience the small circle of their associates and patrons: the dealer and his half-
dozen clients, the poets of the *bande à Picasso*; above all, each other. Their subse-
quent recollections of this period are illuminating: both Braque's description of it
as 'like two climbers roped together on a mountain' and Picasso's pithier 'Braque

was my wife' raise a corner of the curtain on an extraordinarily close working rela-
tionship, which lasted for over three years.[47] There was a corresponding change in
the implicit mode of address of this work, as these paintings on a smaller scale, their
subjects predominantly still-lifes and single figures, became increasingly private in
orientation, their handling stylistically dense, each painting a fresh point of entry to
an exploration that extended in an open series from work to work; eliptical and
often playful in their intertextuality, these were accessible only to initiates (plates V
and VI).

This private character of gallery cubism stood in sharp contrast to that of the
salon group, but it did not by any means remove it from the avant-garde arena.
Kahnweiler knew very well that his policy of aloofness only increased critical
interest: 'I'm afraid that the mystery with which Picasso surrounds himself only
serves his legend', declared Vauxcelles in frustration in 1912. 'Let him hold an
exhibition, simple as that, and then we'll judge it.'[48] Kahnweiler knew too that in an
increasingly dealer-centred market, picture sales were more important than pub-
licity for securing a painter's reputation. For those without dealers, however, pub-
licity in that market was crucial, and from the first moment of their coming
together as a group the salon cubists turned to writing, both to promote and explain
their paintings and to raise their avant-gardist profile. The Italian poet Marinetti
had shown the way in February 1909, publishing his manifesto of futurism on the
front page, no less, of the conservative Parisian daily *Le Figaro*; less spectacularly
but no less ambitiously, Le Fauconnier and Metzinger addressed the insider audi-
ence of the avant-garde the following year with articles that laid out, with impres-
sive obscurity, the principles of their painting.[49] Le Fauconnier accompanied this
activity with an astuteness as to the benefits of showing his work across Europe that
was rivalled only by Kahnweiler's; as a result, within months he was recognised as
the theoretician, and by tacit consent the leader, of salon cubism.[50]

If Marinetti's initiative showed the way ahead for publicity-seeking artists, it
was, as Jeffrey Weiss observes, as part of the wider developments taking place in the
presentation of art, as well as in merchandising in general.[51] Critic Camille
Mauclair's essay 'The prejudice of novelty in modern art', though published two
months after the futurist manifesto, was probably written earlier, and points an
accusing finger at a widespread phenomenon: a restlessness for novelty that
resulted in stylistic extravagance; it was a 'fatal mania', he argued, and had brought
about a 'crisis' in all the arts. The blame lay with the press and the mentality of the
public, and with the artists themselves.[52] Weiss notes that this connection with con-
temporary developments in the press, particularly in the field of advertising, was
not lost on others; citing several critics who condemned, with varying degrees of
severity, the influence of such developments, he concludes that 'the very concept of
new or original art bore an uncomfortable resemblance to appeals for consumer
approval'.[53] For consumers and consumerism were indeed increasingly salient fea-
tures of both the economic and the urban landscape of modern Paris, as they were
elsewhere.

The spectacular city

To be in Paris at the turn of the century was to stand at the centre of the maelstrom of modernity. The city was at the height of its reputation as the capital of Western culture, and that year 50 million people came from all over the world to sample the spectacle that symbolised it – the Exposition universelle. They came to a city only just emerging from a half-century of urban renewal by which it had been radically transformed. Baron Haussmann's programme for the modernisation of Paris, which had punched broad boulevards through the impenetrable slums of its central *quartiers*, making the heart of the city more governable, more sanitary and more amenable to commercial and residential colonisation by the bourgeoisie, had continued long after his fall from office in 1870 as prefect of the Seine, and the physical upheaval of endless demolition and construction that it entailed had been the everyday experience of two generations of Parisians (figure 1.4).[54] For those generations' middle-class members, the new boulevards were increasingly lined with diversions on which to spend their rising incomes. Department-store shopping was by 1900 an established leisure pastime: the opening of new premises for the pioneering *grand magasin* Au Bon Marché in 1869 had been quickly followed by new emporia for the Magasins du Louvre in 1877 and Printemps in 1881. The

1.4 Construction of the avenue de l'Opéra, *c.*1877

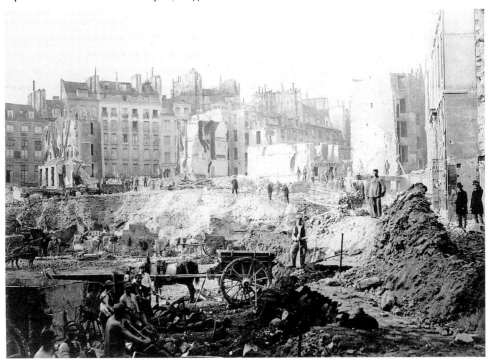

pre-1914 decade saw the development of this large-scale retailing into a mass-market system defined not only by its number of customers but by the range of goods on offer. As Michael Miller argues, this was 'a new commercial concept, designed to accommodate (and induce) a society that, more and more, would seek its identity in the variety of goods it consumed'.[55] Further big stores opened (La Samaritaine in 1903) and existing ones both expanded (the Bon Marché's annexe opened in 1912) and widened their range of merchandise after 1900 from traditional dry goods into a huge variety of commodities.[56]

This growth in retailing was accompanied – indeed, made possible – after 1900 by the rapid expansion in the techniques, and the volume, of merchandising. As Rosalind Williams observes, it was 'the sheer emphasis' on this aspect of commerce that distinguished the Exposition universelle of 1900 from its predecessors, a new conjunction 'between imaginative desires and material ones, between dreams and commerce'.[57] Three years later, France's first advertising trade magazine, *La Publicité*, was founded; by 1912, advertising billboards – colloquially known as '*les barre-la-vue*' – had so proliferated in Paris and the surrounding countryside that angry demands were made in the press and in Parliament to ban free-standing signs (figure 1.5).[58] Yet the press had itself become one of the primary vehicles for the spread of advertising. In a development that had its origins in the mid-nineteenth century, when Emile de Girardin halved the price of his *La Presse* and relied on selling advertising space to make up the difference, dependence on this source of revenue had changed the look, the content and the character of newspapers. By 1914 the French penny-press had the largest circulation in the world, selling 4.5 million papers daily in Paris alone; as circulation grew, so did the number of pages in which to accommodate the adverts: from four to six, then to eight and sometimes more.[59]

As Adam Gopnik and Kirk Varnedoe suggest, for a young foreigner like Picasso, this particularly Parisian penny-press culture must have been fascinating; 'the local newsstand was a fountainhead of urban modernity, the focal point of a new kind of massive daily disgorgement of information and persuasion run together, in fast-changing styles of type, layout and political and commercial appeal' (figure 1.6).[60] From the autumn of 1912 – following the lead of Braque, who first included *papier-collé* in his arsenal of

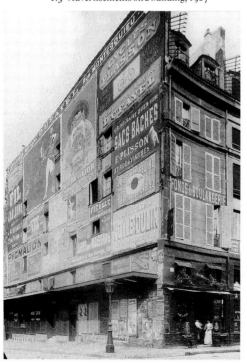

1.5 Advertisements on a building, 1907

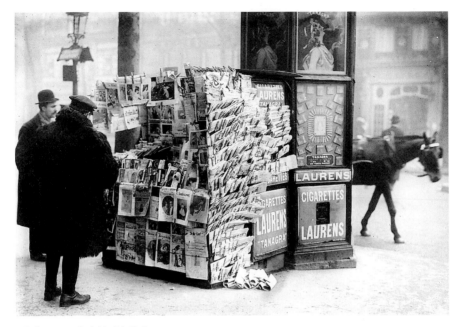

1.6 A news vendor's kiosk in Paris, c.1900

pictorial techniques (*Fruit Dish and Glass*; see p. 128), but characteristically adapting
it by adding newspaper to the repertoire – Picasso revelled in the possibilities this
offered of referencing modern city life in all its variety, juxtaposing news stories with
advertisements, reports of political crises with those of domestic dramas, in a witty
and often ribald play of words and images (see p. 200). Yet these little collages were
also private affairs, cut-and-paste pictograms scaffolded by cubist armatures so con-
densed and economical that – it is worth reminding ourselves, since they have
become familiar – they were in 1912 decipherable only by the initiates of the *bande à
Picasso*. Others in and around the salon cubist movement displayed a comparable
enthusiasm for the new typographical environment of the billboard and the penny-
press, but had more public ambitions for the pictures they constructed from its ele-
ments. Robert Delaunay's huge painting *Third Representation: The Cardiff Team*, of
the winter of 1912–13 (see p. 118), included billboards along with rugby players, an
aeroplane and the giant ferris wheel from the 1900 exposition, not only as emblems of
modernity but as elements in a visual vocabulary that he hoped would modernise
pictorial language. His choice of the unjuried Salon des Indépendants for its first
exhibition signalled a determination to reassert painting's public role, to challenge
the domination exerted by newsprint, newsreel and commercial imagery over the
terms in which everyday life was represented. During the following year his wife and
artistic partner Sonia took this effort a stage further, applying the vocabulary of jux-
taposed complementary colours, elaborated in their paintings of the previous year, to
the design of posters for familiar products such as the aperitif Dubonnet and Pirelli

tyres – acknowledging the opportunities that advertising presented to modernist art by collapsing the distinction between them (figure 4.12).[61]

There was a demotic, even populist, element in the embrace of the modern visual vernacular by such avant-garde artists. Robert Delaunay was quite explicit about it: 'As for our work I think the public has made an effort to get used to it', he wrote to Kandinsky in 1912. 'It can only do so slowly because it is stuck in its old habits. On the other hand there is a lot for the artist still to do ... The primitive stiffness of the system is still a stumbling-block for the public in the way of its enjoyment.'[62] If for his part Picasso had no such ambitions, still he delighted in the burgeoning popular culture of Paris, and appropriated for his own use, in ways that I explore in detail later, not only its materials (such as newspapers) but its formulae, tropes and styles. Thus, for example, the music-hall revue, a genre of entertainment that was hugely popular in the pre-1914 decade, offering, in a series of fast-paced short sketches and songs, a satirical commentary on current events great and small. As Jeffrey Weiss argues, this entertainment

> furnishes virtually a complete agenda of the motifs and devices in cubist collage, especially in the oeuvre of Picasso. As a model, it comprises the entire jumble of pasted subjects in any given picture, rather than requiring us to acknowledge some and ignore others. The vocabulary of the revue is the vocabulary of collage, a period lexicon of technical language specific to both: the *actualité*; the pun, the allusion and the *à peu près*; the *sous-entendu* and *entente*; irony, satire and *grivoiserie*; newspaper, advertising and song.[63]

It would be a mistake, however, to interpret such engagement with popular culture as evidence of an unproblematical identification on the part of these artists with that culture or its audiences. For that would be to ignore the significance of this engagement with the popular as an avant-gardist gesture – that is, as a means by which avant-garde artists could mark their distinction from dominant culture. Sociologist Pierre Bourdieu has described this stratagem:

> Intellectuals and artists have a special predilection for the most risky but also most profitable strategies of distinction, those which consist in asserting the power, which is peculiarly theirs, to constitute insignificant objects as works of art or, more subtly, to give aesthetic redefinition to objects already defined as art, but in another mode, by other classes or class fractions (e.g., kitsch). In this case, it is the manner of consuming which creates the object of consumption, and a second-degree delight which transforms the 'vulgar' artifacts abandoned to common consumption ... into distinguished and distinctive works of culture.[64]

There were certainly plenty of opportunities to indulge in such 'second-degree delight', for the popular entertainment industry was growing as fast as was that of retail. As the reputation of Paris as the entertainment capital of Europe reached its zenith, receipts of its theatres and *spectacles*, which had nearly doubled between the 1870s and the 1890s, doubled again by 1911 and increased yet more sharply by

1913.[65] One cultural commentator noted in 1902 that there were more than 300 café-concerts, music-halls and other such venues in the city, presenting between them (among other things) around 15,000 new songs a year.[66] If many of these places attracted a mixed class of clientèle, it seems to have been those which catered to the lower end of the social spectrum that experienced the more dynamic growth. The music-hall, with its rapid sequence of varied acts – acrobatics, juggling, magic, comedy, songs and satire – was cheaper, less demanding and less inhibited than the theatre and the café-concert, and it attracted predominantly (though not exclusively) working-class audiences; by 1901, according to one observer, it had 'definitively' replaced these other forms of entertainment, which were too wedded to convention.[67] The growth of the cinema, available to the public from the mid-1890s, was the quickest of all: from five permanent venues in Paris in 1900 (as opposed to temporary screens erected in billiard halls and the like), the number rose to 200 by 1913 and 260 by 1914.[68] Its audience was, until the First World War, emphatically from the lower end of the social spectrum. This was in part because of its ease of access: at prices ranging per session from FF2 to 30 centimes it was the cheapest form of commercial entertainment in the city, and as its programme consisted of numerous unrelated short films its auditoria could be entered and left at any time, with little requirement for attention to codes of dress or conduct. It was in part a result of inheritance: like music-hall, cinema owed much to the fairground and the circus in its partiality to magic acts and slapstick comedy, and prior to 1914 many fairground sideshows showed films.[69] The *bande à Picasso* took a conspicuous delight, as innumerable chroniclers of its history have testified, in patronising the cinema; one member, Maurice Raynal, wrote a regular column on cinema for Apollinaire's magazine *Les Soirées de Paris* that was laced with an ironic enjoyment of the unintentional errors and banalities of those early films, and that advertised the group's cultivation of a taste for films about Fantômas, the pulp thriller arch-criminal. This, together with Juan Gris's appropriation of the cult hero Fantômas in a painting of 1915, represents, among other things, a prime example of the strategy of distinction that Bourdieu describes.[70]

This strategy was, moreover, a function of a social dynamic that tended to distance the bourgeoisie, and the avant-garde formation as part of it, from the working class in the pre-1914 decade. For the experience of Parisian modernity was not homogeneous but fragmented, and specific to social position. If Baron Haussmann's modernisation of the city had enhanced its spectacular qualities, it had simultaneously worsened life for many people. Less visible than the city-centre redevelopments, but no less of an upheaval, was the displacement from its historic *quartiers* and customs of an urban workforce that was being steadily proletarianised by the pressures of consumerism – by the mechanisation of production and de-skilling in many trades as the department stores drove prices down. Former artisans were pushed out to the mushrooming suburbs, dominated by automobiles and machine-tool factories, to live lives that encroached hardly at all on the city wherein they had grown up. Within the city too, many of those employed to produce the

new consumer goods were being forced into the outer *quartiers*, their paths rarely crossing those of the purchasers of these goods, and their impoverishment growing in stark contrast to the rising income of the latter.[71]

Class and culture

As the urban working class began to experience an ever sharper deterioration in its quality of life, the socialist and anarchist movements grew rapidly, developing their organisational bases outside and, in the case of socialism, within the parliamentary system. When nationalist agitation at the height of the Dreyfus Affair in 1898–99 endangered the Republic itself, the Socialist Party in the Chamber of Deputies joined the radicals to form the Bloc des Gauches, supporting premier Waldeck-Rousseau's Government – the socialist Deputy Millerand even joining the cabinet – and, from 1903, that of his successor, Combes. But the experience of participation in government quickly disillusioned many socialists: Millerand was soon co-opted by a regime that had little real interest in changing the social status quo. The 'official philosophy' of the dominant political grouping of the pre-war period, the Radical Party, which underpinned the policies of its successive governments in the fifteen years prior to 1914, was the doctrine known as 'solidarism'.[72] First presented as a coherent political position in Léon Bourgeois's book *De la solidarité* (1896), it guided the efforts of these governments to steer a middle road between the claims of capital and labour, and to replace conditions of exploitation and class conflict with those of collaboration and association – not to offer an alternative to capitalist social relations, but to accommodate French social and entrepreneurial customs to the expansionary demands of capitalist modernisation, to moderate but not negate the latter in the recognition that, if unchecked, they would provoke a challenge to the social order. Socialism was thus the main enemy; to defeat it, members of the working class had to be brought into the Republic as full citizens by encouraging not only their ownership of property and their access to its social and cultural benefits but their recognition of the responsibilities attendant on these.

The Bloc des Gauches thus had, at least for the radical politicians who led it, a tacit as well as an overt agenda. Its overt purpose was, as noted, to defend the Republic against the nationalist Right; implicitly however, it was also a defence against the threat posed by the Left, an instrument for the integration of the working class with the dominant social order. As such, the Bloc des Gauches had an important extra-parliamentary dimension in the broad effort of incorporation of working-class men and women within the liberal Republic, by means of what have been termed 'parapolitical' organisations: profit-sharing and worker-shareholding schemes, company unions, workers' housing cooperatives, the garden city movement, adult education institutions. From the turn of the century such organisations mushroomed: the Société française des habitations à bon marché, the Musée social, the Société d'éducation sociale, the *universités populaires*, the Société de l'Art pour Tous, to name only a few.[73]

Such associations recruited their activists from across the spectrum of middle-class occupations: business and professional people, as well as intellectuals and artists, participated in this broad-based initiative of cultural paternalism. Among the latter were members of the cubist movement, both artists and their critic friends. Painter Albert Gleizes and poet Alexandre Mercereau came early into the field, as founder-members in 1905 of an adult education institute for young apprentices; in the years following others in the circles from which cubism emerged followed their lead, giving regular lectures on modern art and literature at the Université populaire du Faubourg Saint Antoine in the heart of the furniture-making quarter of Paris.[74] The participation of artists and writers in the extra-par-liamentary initiatives of the Bloc des Gauches found its clearest expression, however, in *l'art social* movement, which sought the cultural integration of the working class through the provision of wider access to an appreciation of the joys of art and the cultural heritage of France. Its main instrument was the promotion of the decorative, or applied, arts – the encouragement both of a wider awareness (and indeed use) of them, and of popular, traditional craft practices. As art social's leading spokesperson, the respected art administrator and critic Roger Marx declared:

> When an art is intimately joined to a society's collective life, only the designation *art social* is appropriate for it. The prerogative of its inventions cannot be limited to a single class, for it belongs all without distinction of rank or fortune; it is the art of the hearth and the garden city, of the castle and the school, of the precious jewel and of peasant embroidery; it is also the art of the soil, the race and the nation.[75]

The populism of Marx's argument is evident – as, too, is the Barrésian inflexion of the final phrase. Less evident to present readers is the self-consciously solidarist politics that it signals; for Marx's emphasis here on the values of rural craft tradi-tion, an emphasis that he repeated elsewhere at this time,[76] represented at the level of cultural politics the efforts made by the Radical Party to bring about a rap-prochement between peasants and urban workers, and between provincial tradi-tions and capitalist modernisation, by courting rural industries and communities.[77] Also less evident, perhaps, is the even-handedness of Marx's statement as regards gender – its indexing of women as well as men in its celebration of traditionally feminine decorative arts, such as embroidery, and of the 'hearth' as the traditional space of those arts. Such references, however, had clear, if complex, associations in 1909. For *l'art social* sought also to buttress the domestic role of women in French society, at a time of increasing unrest among women over the social and legal con-straints on them.

Across the Western world, from the late nineteenth century, growing numbers of middle-class women were laying claim to the opportunities for educational and pro-fessional advancement that liberal capitalism had opened up, and industrial expan-sion was drawing working-class women into employment outside of the home. The modest increase in their independence that resulted both fuelled demands for legal,

political and social equality with men that were loudly voiced by the burgeoning feminist movement, and created alarm among men of all classes at the consequences for the patriarchal order of the emergence of the 'new woman'.[78] In France that alarm was given an added dimension by the nation's declining birthrate, which led to what can only be called hysterical calls by men for measures to reinforce women's domestic–procreative role.[79] Among the responses, as Debora Silverman observes, was a broad-based campaign in the 1890s, led by the Union centrale des arts décoratifs, to encourage the revival of traditionally female domestic craft practices, and thereby to co-opt for the existing order, in a way that paralleled attempts at the cultural integration of the working class, those aspects of French feminism which acknowledged separate spheres of activity for men and women.[80]

The previous decade's insistence on the feminine character of decorative art was replaced soon after the turn of the century, however, by the even-handedness that characterises Marx's definition. The reason for that shift was primarily economic: France's decorative arts industries, once the envy of Europe, were perceived to be in a crisis too acute to be left solely to women – indeed it had been exacerbated, it was felt by many skilled craftsmen, by the threats posed to their own employment and wage rates by competition from lower paid women, who could be taken on to work with the machines that were replacing their skills.[81] Now French decorative arts were being displaced from their international pre-eminence by those of other nations, primarily Germany's. An exhibition of furniture and domestic interiors by designers from Munich at the 1910 Salon d'Automne in Paris revealed, it was agreed, how far behind their competitors French producers had slipped, and it gave an extra urgency to an anxious, and widening, contemporary debate on the reasons why.[82] A call for artists to take up the decorative arts for the sake of the nation was answered by many, including André Mare, a member in 1912 of the salon cubist milieu, who in that year originated and directed the Cubist House project.

If the efforts of the activists of *l'art social* were thus successful at the economic level, they were, however, far less so at the social level, for hardly had the campaign been launched to bring the working class into the cultural fold through the decorative arts than the political landscape changed radically in 1905–6 – so radically, indeed, that those years have been seen as a watershed in French political life – bringing to an end not only the Bloc des Gauches but most of the multifarious initiatives of cultural paternalism it had fostered.[83] The change was the result principally of two developments. The first was the crisis brought about by the German kaiser's visit to Morocco in March 1905, a gesture which represented a challenge to French rule of its protectorate and for a time threatened the outbreak of war between the two nations. Historians have dated from this moment the expansion of French nationalism beyond the confines of the political right, and the beginnings of its evolution into a pervasive mood of patriotism that gripped most of the nation.[84] The second was the adoption of the principle of autonomous political action on the part of the French Left, represented by the decision of the socialist movement to

join the anarchists in ceasing to participate in goverment, and by the adoption on the part of both movements of a policy of overt anti-militarism (and of tacit anti-nationalism).[85] These moves placed the politically organised working class beyond the pale of the solidarist settlement, and as the radicals absorbed (and broadened) the nationalism with which the Republic had been threatened from the Right, defence of the existing order against socialism became the overt, rather than tacit, agenda of a governmental coalition whose centre of gravity drifted steadily further to the Right in the years prior to 1914.

Politics and the avant-garde

Working-class autonomism found its most concrete expression in strike action to improve, or to resist deterioration in, working conditions; the years following the end of the Bloc des Gauches saw a sharp rise in the number of strikes and of those participating in them. The rise was especially sharp in Paris and its suburbs, where in 1906 a quarter of all strikes occurred, and on 1 May of that year the skilled artisans of many of the city's decorative arts' industries joined unskilled workers from the suburban factories to lead a nationwide campaign for an eight-hour working day. As Madeleine Rebérioux notes, the consequence was not only the enactment less than three months later of a law that made obligatory a weekly rest day– one of the few pieces of social legislation of the pre-1914 decade – but, more generally, alarm on the part of the bourgeoisie at the possibility of social conflict.[86] As the tide of nationalism rose, fear of revolution was fuelled also by the anti-nationalism of the Left, and xenophobia was joined by deep hostility to 'the enemy within': those people, whether as individuals or as members of social groups, who did not – or appeared not to – wear their nationalism on their sleeve were objects of suspicion, often hostility, sometimes contempt.

Hence the abuse heaped on the cubists and assorted foreigners who exhibited in the Grand Palais in the autumn of 1912. Never mind that (for reasons to be explored) all those cubists who showed their work in the annual salons were French – indeed, that in their paintings of that year some of them sought to articulate the very nationalism that was informing such energetic condemnation of them; in the feverish mood of the moment, aesthetic experimentation as such was suspect, for it threatened to undermine the very foundations of French cultural identity. Hence, too, the extraordinary violence, and the revealing rhetoric, of that abuse. For Deputy Breton, calling in aid the contemporary discourse of psychiatry, the cubists' paintings were 'monstruous', 'insane', 'horrific', 'infantile' and 'primitive'. Critic Georges Lecomte similarly condemned the paintings as 'repugnant deformations' and the work of 'impotent dilettantes', but reached also for the language of xenophobia in dismissing their 'ignorant barbarities'. City Councillor Lampué, who opened the campaign, was more specific in this respect, dismissing Salon d'Automne President Frantz Jourdain contemptuously (and mistakenly) as 'Belgian' – and also comparing the cubists to anarchist outlaws.[87]

This last flourish was a telling one, for it made plain the conflation of aesthetic and political counter-discourses that was at the heart of bourgeois hostility to avant-garde art. It was not new: a year earlier, in the wake of a second diplomatic crisis over Morocco, as international and inter-class tensions came close to breaking point, conservative critic Gabriel Mourey had reviewed the previous Salon d'Automne in identical terms:

> The cubists play a role in art today analogous ... to that sustained so effectively in the political and social arena by the apostles of antimilitarism and organised sabotage; and just as it is evident that the preachings of Hervé have contributed strongly to the renaissance of patriotic sentiment that we are now witnessing, so doubtless the excesses of the anarchists and saboteurs of French painting will contribute to reviving, in artists and amateurs worthy of the name, the taste for true art and true beauty.[88]

In general terms, of course, the conflating of aesthetic and political subversion was not new in 1911 either; since Courbet in the mid-nineteenth century if not earlier, radical art and radical politics had been regular bedfellows, or were regarded as such, and Mourey's own generation had witnessed, in the 1890s, the close relationship between the emergent artistic and literary avant-gardes and anarchist agitation.[89] What was new in 1911 was the perceived autonomy – indeed isolation – of the artistic avant-garde and the revolutionary syndicalist movement as formations: for the years since the collapse of the Bloc des Gauches had seen not only the withdrawal of the politically organised working class behind the stockade of syndicalism, but that consolidation of the filiations between the cenacles and coteries of un- or anti-academic artists that I have traced, a process that turned this loose scattering of disenfranchised cultural producers first into an identifiable and self-conscious population and then into a *field* of artistic production. It was, indeed, at this moment that the term 'avant-garde' first began to be applied to, and claimed by, certain groups of artists, both as a declaration of cultural identity and as a promotional device in an increasingly crowded art marketplace.[90] This apparent secession from the cultural mainstream carried also the implication of opposition to the liberal Republic itself, and it is understandable that in the crisis of 1911–12 observers such as Mourey and Lampué should take as much for granted.

They were, however, mistaken. The collapse of the Bloc des Gauches, precipitated in part by the disaffection of syndicalists and socialists, in turn produced within many artists and writers of this avant-garde population a disillusionment with the project of class collaboration, and their replacement of this with an exclusively aesthetic militancy – of which the consolidation of an avant-garde formation was a partial result. This development was registered by, *inter alia*, the growing momentum of neo-symbolism within the coteries of the Parisian literary avant-garde at that time, and the ascendant reputations of two heroes of that movement: the poet Stéphane Mallarmé, who had died a decade earlier, and the philosopher Mécislas Golberg, who died in 1907, just as the pace of aestheticist withdrawal was quickening. The

spread of neo-symbolism has been well charted: centred on two little reviews, *Vers et Prose* (founded in 1905), which quickly gained an importance in the avant-garde milieux surpassed only by that of the *Nouvelle Revue française* (hereafter, *NRF*) after 1909; and *La Phalange* (founded in 1906), whose editor, Jean Royère, was a self-declared *mallarmiste*. Neo-symbolism included among its affiliates André Salmon, Guillaume Apollinaire and the *fantaisiste* group of poets which they unofficially led. The work of this group, as *belle époque* chronicler André Billy recalled, was 'opposed to all serious, social [or] humanitarian tendencies' in contemporary poetry.[91] The aestheticism of Mallarmé himself, far from being indifferent to such concerns, had been closely aligned with the revolutionary ambitions of 1890s anarchism, but in the post-Bloc des Gauches conjuncture anarchism was in no position to broker the increasingly distant relations between political activists and the aestheticist avant-garde; for the majority of the latter, *mallarmisme* represented a position of art for art's sake, and Mallarmé's poetry was defended for its freedom from contamination by vulgar politics rather than its subversiveness. This trajectory of aestheticist with-drawal was epitomised in the brief career of Mécislas Golberg. Born of wealthy Polish Jews, Golberg came to Paris in the 1890s to study medicine, but instead threw himself into the anarchist movement, founding a little review that spoke for the unemployed; but after a brush with the law in 1898 he turned instead to aesthetics, elaborating a highly personal yet paradigmatic fusion of Nietzschean individualism, Hegelian idealism and neo-platonic mysticism. His major work, the posthumously published *La Morales des lignes* (1908), presented aesthetics as the means to the dis-covery of the harmony that existed in the world; a quietist justification of the social status quo, it was widely read and admired in neo-symbolist circles.[92]

Instances such as these testify, then, to the gulf that opened up in the post-Bloc des Gauches decade between the aestheticist militants of the artistic avant-garde and the politically organised working class. Unlike *fin-de-siècle* aestheticism, which was in close sympathy with anarchism, this avant-gardism was distanced from the socialism and revolutionary syndicalism that had replaced anarchism as the main motors of working-class political activism. For the artists who declared it, avant-gardism no longer complemented that activism, but was, on the contrary, a com-pensation for their dislocation from it. Yet it must be remembered that the avant-garde formation was not monolithic: not a single community, nor possessed of a single ideology, nor even – although identifiably distinct from the cultural mainstream – by definition opposed to the bourgeois values which that mainstream represented. It was, instead a cultural population – progressively, a field – of com-plex character, divided within itself by multiple filiations, fractured – like French (and in particular Parisian) society at large – by the pressures and tensions of a nationalism whose momentum was gathering rapidly with each passing year of the new century. Just how those forces were manifested within that cultural field – articulated with and through cubism – is a subject for the next chapter.

2

Languages of classicism

Classicism, law and order

'In literature, in politics, young people have a passion for order', noted the artist, critic and ardent right-wing Catholic Maurice Denis in 1909.[1] His matter-of-fact coupling of such ostensibly distinct fields of activity is a reflection of the extent to which the discourse of nationalism was then setting the terms of much cultural debate – for as Raoul Girardet observed, with the failure of the anti-Dreyfusards to upset the republican political order much of their energy was transferred principally to the effort of elaborating and disseminating what for some of them was a coherent doctrine, for others an ethic and an aesthetic.[2] Ironically, in the ensuing decade, these together had an indirect influence on public attitudes that was as broad as that of their previous direct political agitation had been restricted. The doctrine was largely the work of Charles Maurras. A Provençal by birth, he had been formed by the classicism of the Mediterranean litoral to which his province belonged, and by the emphatic regionalism of the Félibrige movement that dominated its cultural politics in the late nineteenth century; to these he added an adherence to both the positivism of Comte and Le Play's authoritarian vision of a hierarchical, organic society.[3] The intellectual system he fashioned was an amalgam of these elements. Its centrepiece was a commitment to the restoration of the monarchy: only with the clearly ordered society which this would ensure could France be saved from the destructive effects of republican democracy and its associated individualism. 'Once you have postulated a will to preserve our nation of France, everything follows, can be deduced ineluctably', he argued. 'If you have resolved to be a patriot, you are obliged to be a royalist ... Reason requires it.'[4] And reason was the cardinal quality, for Maurras: the safeguard against the anarchy of the passions, whose political product was the disastrous Revolution, and the foundation of the achievements of the seventeenth century, of Louis Quatorze and classicism. Only by returning to the principles of order and respect for tradition could France rediscover the qualities that had made this the greatest epoch of its history.

Such a doctrine was necessarily sharply exclusionary, in both political and cultural terms. While the force and authority of Maurras's argument enabled Action française to assume the leadership of the anti-republican Right, and to command the enthusiastic allegiance of a significant minority of Parisian writers, artists and

students – launched in 1905, by 1908 the Ligue d'Action française dominated the
Latin quarter[5] – its overt anti-republicanism and sectarian demeanour alienated
many more, both within these milieux and across the country. Less doctrinaire, and
more inclusive, were the ethics and the aesthetics of the post-Dreyfus nationalism
fashioned by Maurice Barrès. Born and brought up in Lorraine, one of the two
eastern provinces of France annexed by Germany in 1871, Barrès was acutely
responsive to the implications of territorial integrity and inheritance; partly in con-
sequence, he placed less value than did Maurras on the purity of France's cultural
lineage and more on the unity, within the concept of the nation, of its disparate
regions and traditions. Having in his earlier career as a novelist and essayist cele-
brated an untrammeled individualism – his first trilogy of novels, published
between 1888 and 1891, was grouped under the title of *Le Culte du Moi* – the expe-
rience of the Dreyfus Affair replaced this with a profound collectivism, as he
became aware of the extent to which the individual was formed and defined by
society and by history, and with a desire to see reconciliation between the warring
factions into which that affair had split the nation. 'Society' was the French nation,
its shared customs, territory and communities; 'history' was the succession of its
generations through the centuries, the continuity of *la terre et les morts* – 'the land
and the dead'. 'As long as I live', he declared in a lecture of 1899,

> neither my ancestors nor my benefactors will have turned to dust. And I am confident
> that I will be watched over, when I can no longer protect myself, by some of those
> whom I awaken ... Thus I have my fixed points, my markers in the past and in pos-
> terity. If I connect them, I obtain one of the principal lineages of French classicism.
> How can I not be ready to make any sacrifice to protect this classicism that forms my
> very backbone?[6]

There were limits, however, to the inclusiveness of Barrès's nationalism, for the
principle of filiation by descent grounded it on supposed racial distinctions and
entailed the refusal of French identity to Jews, Protestants and naturalised for-
eigners. His vision was thus less benign than the slogan *la terre et les morts* suggests,
and this, when translated as 'blood and soil', indicates clearly the close relation it
bore to the Nazism and fascism of later decades.[7] Yet the breadth of its appeal in pre-
1914 France was real, for here was a fusion of ethics and aesthetics that offered not a
logic of nationalism but a poetics.[8] In Barrès' understanding of it, 'nationalism'

> is more than merely politics: it is a discipline, a reasoned method to bind us to all that is
> truly eternal, all that must develop in continued fashion in our country. Nationalism is
> a form of classicism; it is in every field the incarnation of French continuity.[9]

In a conservative, still substantially rural, country such as France was in 1900, such
a profound traditionalism met with widespread support among communities with
anxieties about the pace of industrialisation and its consequences for time-hon-
oured ways of living. Barrès's ideas, moreover, had a strong populist tenor: critical
of the rationalism on which Maurras founded his system – critical indeed of such

systematic thought – he insisted that attachment to tradition was a matter of emo-
tion, intuition and instinct rather than of logic, and he accused intellectuals in gen-
eral, 'all these aristocrats of thought', of being 'in revolt against their own
unconscious', out of touch with the real world of feelings. Against them he coun-
terposed the 'sure instinct' of the 'humble people', the masses.[10] As historian Zeev
Sternhell notes, for Barrès 'popular judgement was based upon an unreflective
spontaneity originating in the unconscious, uncorrupted by long meditations on
obscure abstractions'; the *petit peuple* thus stood for him as the authentic guarantor
of the identity of France.[11]

There were flavours both of Maurrasian anti-republicanism and of Barrésian
xenophobia in the campaign against the cubists in 1912 – which is ironic, since at that
very moment the cubist painter Albert Gleizes was voicing overtly nationalist senti-
ments in defence of his art in a series of newspaper articles and interviews.[12] But such
reactionary attitudes did not encompass the whole spectrum of nationalisms in that
avant-guerre decade. For the discourse of modern French identity had a complexity
that was the product of more than 100 years of post-revolutionary history, for most of
which time nationalism had been a standard of the political left, although all sides in
the social conflicts of the nineteenth century had called in aid the language and
mythology of nationhood. At the centre of all of these debates were the perceived
racial distinctions between Gauls and Franks, and between celtic and Roman inheri-
tances, and, as Eugen Weber observes, the 'race war metaphor' into which these dis-
tinctions were distilled could be enlisted to a variety of ends:

> It continued to be used because it could justify the continuation of a revolution that
> its enemies wanted to hobble, or the national integration with which revolutionaries
> triumphant, calling themselves republicans, eventually did hobble it, or eventually
> the counterrevolution of those who wanted to transform a degraded society and
> revivify it with integrations and exclusions of their own.[13]

Moreover, while it is true that certain of its key emphases – on racial continuity, on
qualities of intuition and faith as against the cold rationality of the latin tradition –
indicate the close relation between this gallic nationalism and that of Barrès (who
was moreover sympathetic to it),[14] there were also others that aligned it with the
doctrine of 'solidarism'. As Weber notes:

> *Solidarité* and *association* were key words of the 1848 left … The Radical party of
> Bourgeois, Eugène Pelletan, and Georges Clemenceau was a direct heir of this 1848
> tradition … The revolution, whether in 1789 or in 1848, had not been made to estab-
> lish some unimaginable dictatorship of the proletariat, but to open access to power to
> the Commons – synonym of Gaulish masses …[15]

As tensions rose in the avant-guerre decade, internationally between France and
Germany, domestically between republicans and their opponents, this card of 'race
war' thus came to be played across the ideological spectrum, in the cultural arena as
much as the political, and – as regards the former – in the academic mainstream as

readily as in the neglected or oppositional spaces on or beyond its margins. Thus, while leading art historians sought to recover the aesthetic (as well as the ethical) values of a gallic (and in origin celtic) culture that had been destroyed by the 'invasion' of the Italian Renaissance,[16] within the emergent field of the avant-garde influential spokespersons were interpreting classicism itself as celtic in origin and popular in character. One such was Adrien Mithouard, whose varied activities as poet, essayist, publisher and politician gave him a strategic position in literary milieux. As expounded by him in a series of treatises and in his magazine *L'Occident*, French classicism combined two fundamental qualities: a sense of realism, which accepted the action of time on things and 'which passionately holds works up to the world', and a sense of harmony and stability, 'which contains them within the outline of its forms'.[17] Epitomised both by the cathedrals of the Ile-de-France and by the art of Poussin, this was a classicism that was able to comprehend celtic as well as latin culture ('the modern world has become Breton, and is proud of it', Mithouard claimed in 1904[18]), the symbolist poets as well as the parnassians, Delacroix as well as Ingres.

As Michel Décaudin concluded from his survey of literary coteries, the possibilities of 'a national literature, a renaissance of classicism' were 'passionately debated everywhere' between 1908 and 1911 – but, he added, ' they were often mixed with political options that modified at once their meaning and their resonance'.[19] The noisy neo-classicist polemicising of the literati of Action française in their *Revue critique des idées et des livres*, and their supporters (such as the painter and former *nabi* Emile Bernard, in his magazine *La Rénovation esthétique*) was countered by André Gide's *NRF*, founded in 1909 with the aim of applying Mithouard's Barrésian criteria in the contemporary field. As such it embraced a wide range of new art and writing, expounding a 'modern classicism' that maintained an equilibrium between order and vitality, and criticising the Maurrasian doctrine for stifling the latter in its demands for purity. From its opening issue Gide clashed with Maurrasian J. M. Bernard over the latter's condemnation of the poetry of Mallarmé as sterile and elitist, arguing in support of its aestheticism that no theory ever served to make a work of art any more than it did to destroy one, and that the beauty of those poems was their own best defence. Gide's eloquence was influential, and gave currency to a *mallarmisme* that, though it reduced and distorted the complexity of the poet's work, appealed to many in the milieux of the avant-garde – the *bande à Picasso* included. Yet at the same time the *NRF* was drawn by such disputes towards the political right, and the issues of its first two years display a consensus around Catholic, nationalist and even anti-semitic attitudes; so marked, indeed, was its patriotic ardour that its recent historian 'wonders if it was being mischievous about it'.[20]

It was this position, also, to which the classicism of Maurice Denis approximated. A close friend of Gide, his adherence to classical values had been secured by a visit with the latter to Rome in 1898, and tempered by his friendship with Mithouard. An article for *L'Occident* in 1904, deploring the neglect of a fifteenth-century fresco in a Breton church which he saw as equal to the work of artists of the

Italian Renaissance, adumbrates an accommodation between Maurrassian and Barrésian emphases that he would develop over the next few years; paralleling Mithouard's equal emphasis on realism and harmony, he theorised a relationship between the realism of the native cultural tradition and the equilibrium of classical culture, assigning almost as much value to the naivety and awkwardness of what he saw as 'primitive' art as he did to the refinement of that of Rome.[21] For all his public support for Maurras's politics, his aesthetics were closer to those of Barrès: in a review of the 1905 Salon d'Automne he criticised the work of Matisse – the paintings for which critic Vauxcelles coined the term 'fauve', in his review of the same salon – for being overly rational. The artist should 'give up the effort to make a completely new art with reason alone', he declared; 'he should put more trust in sensibility, in instinct, and accept, without too many scruples, much of the experience of the past. A recourse to tradition is our best safeguard against the vertigo of reasoning and the excess of theories.'[22] These remarks seem directed at least as much against neo-classicism as against Matisse's art, and he emphasised his distance from the former four years later. 'What makes a renaissance', he declared in the 1909 article referred to earlier, 'is less the perfection of the models one chooses than the strength and the unity of purpose of a vigorous generation.'[23]

Braque and Picasso: Cézanne and primitivism 1907–8

The *enquête* on 'present tendencies in the plastic arts' that Charles Morice conducted in the spring and summer of 1905, in the pages of the *Mercure de France*, attracted more replies than most, in a decade in which such soundings of opinion were the common currency of intellectual exchange between the literary and artistic coteries of Paris. Fifty-six correspondents answered his questions on the significance of impressionism, the role of nature in art, the possibility of new directions and the importance for present painting of, respectively, Gauguin, Whistler, Fantin-Latour and Cézanne.[24] The consensus was in favour of the last-named of these, and Paul Sérusier's remarks summarised the arguments of many: 'If a tradition is to be born in our time, it is from Cézanne that it will come', he declared, 'not a new art, but a resurrection of purity, solidity, *classicism*, in all the arts.'[25] The inclusive classicism of Sérusier's friend and former co-*nabi* Denis, and his interpretation of Cézanne in its terms, theorised a way out of fauvism, in the years that followed, for a number of its former practitioners who came to share this dissatisfaction with the impressionist paradigm of loose brushwork and lack of pictorial structure. Among them was Braque, whose concerns even as a fauve were with the use of colour contrasts not for decorative effect, as in Matisse's paintings of 1905–6, but for the creation of volume and the illusion of sculptural relief. Over the course of a year, beginning in the autumn of 1907, he revisited Cézanne's old haunts around L'Estaque, near Marseilles, and the paintings he had made of them, recapitulating in a series of some two dozen landscapes not only Cézanne's abandoning of impressionist style – and the shift that this implied from

a mode of painting grounded in perception towards one centred on conception –
but his turn from impressionism's celebration of the dynamism of the modern
city towards the classical motifs of the Mediterranean coast.[26] What is clear from
these paintings, however, is that, like Cézanne, his pictorial concerns were not
entirely subsumable within the classical paradigm: taking his cue from the subtle
inconsistencies of perspective and passage-brushed spatial elisions by means of
which Cézanne often accommodated the demands of motif and medium, Braque
progressively exaggerated these to the point of paradox, subverting the residual
classical rationality of the paintings' geometries and low-relief space with dynamic
planar and spatial discontinuities and elisions. By August 1908, however, he
appears to have learnt, from this *rodage* with Cézanne, how the classical formula
could be used to anchor and order the radical disruption of pictorial illusionism
that was increasingly capturing his imagination, and also how the rectilinearity of
classical composition could itself disrupt that illusionism, by functioning as a sign
for the picture surface, referencing the materiality of the latter both by the flat-
tening effect of its scaffolding and by its echoing of the framing edge. As yet, in
Houses at L'Estaque (figure 2.1), this possibility was only hinted at; the emphatic

2.1 Georges Braque,
Houses at L'Estaque,
1908

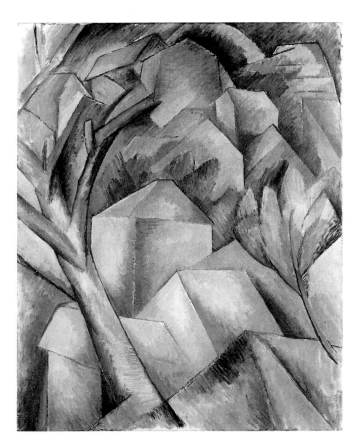

cube of the central house more than holds its own against such indexing. But Braque had come a long way in a year.

Equally profound, however, were the consequences of another close encounter, this time with the *Demoiselles d'Avignon* (plate I). Braque saw Picasso's painting for the first time on what was probably his first visit to the latter's Bateau-Lavoir studio, in the company of Apollinaire, in late November 1907;[27] 'it is as if someone had drunk kerosene to spit fire', it appears, was his initial comment.[28] At the opposite aesthetic pole from classicism, the *Demoiselles* drew on the alterities of African and Iberian figurative conventions to image a 'masculinist dystopia', a claustrophobic confrontation with five flattened and distorted naked whores that condensed, as economically as did Freud's characterisation of women as 'the dark continent', the double ambivalence – both fear and fascination – shared by many European men at that moment, including members of the Parisian artistic avant-garde formation.[29] As yet incompletely assimilated into the French – or indeed European – colonial framework, Africa was then the object of hectic inter-imperialist rivalry, and tales of depravity and of outlandish customs among the populations of Dahomey or the Congo Basin, brought back by those engaged in their subjugation in the name of France (or Belgium, or England) served both to reinforce a stereotype of black peoples as savages – and thus to justify their subjugation – and to heighten the European male's fascination with their alterity.[30] This ambivalence was inscribed most deeply in the *Demoiselles*' two most radically distorted figures, depicted with features, or wearing masks, resembling those that around the turn of the century were finding their way to the markets or into the ethnographic museums of European cities in the wake of colonisation.[31] If the relation of these two figures to their 'European' neighbours in the *Demoiselles* suggested to Picasso, as it has to most of the painting's historians, a narrative of regression, of 'contained eroticism lapsing into raw animality',[32] it is an animality to which the artist seems to have been compulsively attracted, devoting his attention almost exclusively in the following eighteen months to a series of refigurings of these Africanised women – and in them, building on the extraordinary dislocations of form, spatial illusion and perspective that they above all the other figures in the *Demoiselles* manifest. For his part, Braque needed little reflection to understand the significance – in formal terms at least – of Picasso's wilful distortions of figures and ambient space: within days he was working on a multi-figure composition of his own, which transcribed these features – but not the disturbing Africanness – of the *Demoiselles* into the terms of his own concerns. The resulting painting, *Woman*, exhibited at the Indépendants the following March, is lost, but a related drawing (figure 2.2) was reproduced in Gelett Burgess's now celebrated 1910 article, rediscovered by Edward Fry in the mid-1960s, 'The wild men of Paris'.[33] It shows three women (or possibly a single figure in three different positions) staring out at the viewer from a space so confined and so completely occupied by their interlocked limbs that the illusion of low-relief sculpture is paramount. This work seems to have been quickly followed by another big figure picture, the *Large Nude* of April

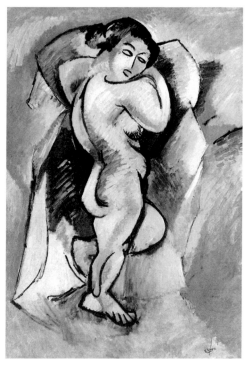

2.2 Georges Braque, *Three Nudes*, 1908 **2.3** Georges Braque, *Large Nude*, 1908

1908 (figure 2.3). Less successful than the drawing in accommodating the radical flatness and figural dislocations of the *Demoiselles*, the painting appears tentative, its startling combination of views of the figure's front and back juxtaposed unconvincingly with the more or less conventional space in which she is set; unable as yet to reconcile his explorations of Cézanne with Picasso's challenging innovations, Braque's adaptation of the former's device of *passage* to mediate this juxtaposition serves only to underline its awkwardness.

Despite such hesitancy, Braque's encounter with Picasso's art at this particular moment was thus felicitous: as he wrestled with the formal implications of the *Demoiselles*, he found on the one hand that they showed the way beyond Cézanne to a radically self-referential kind of painting that could place the conventions of pictorial illusionism at the centre, as it were, of the picture, and on the other hand that Cézanne's method and the aesthetic of classicism together provided a sheet-anchor, of a more than merely aesthetic kind, against an iconoclasm on Picasso's part that was dizzying in its exuberance. The encounter was felicitous for Picasso, too: for in picking up so promptly the gauntlet he had thrown down with his remarkable painting, and in doing so with just those Cézannist means, Braque presented Picasso with the challenge of a reinterpreted classicism, provocatively modernised and problematised. Picasso's immediate interest, however, was in a further engagement

with 'Africanness' and what it signified for him. The configurations of the African artifacts he had encountered in a now notorious visit to the Trocadéro ethnographic museum (now the Musée de l'Homme) in Paris, in June or July 1907, provided the artist with the basis of an expressionist syntax that he was to explore over the next few months.[34] The *Demoiselles* was followed immediately by *Nude with Drapery* (figure 2.4): its deployment of scarifications and planar modelling, suggestive of African sculpture, amounted to a further 'estrangement' of the already strange second-to-left *demoiselle*, and could be seen as a trenchant riposte to Matisse's *Blue Nude* (figure 2.5) whose own alterity pales – the pun seems appropriate – by comparison almost into cuteness. But steadily, after the first shock of the Trocadéro and his absorption of this, Picasso's interests turned towards the technical ramifications of these Africanist devices and, principally through the agency of Braque, once again to Cézanne, in a series of works in which the fear and loathing inscribed in the *Demoiselles* was re-articulated in formal terms. It would be several years before such raw and challenging sexuality as that painting displays would surge to a similar voltage in Picasso's painting, but the dispersal of its charge was not immediate: over a period of a year from the winter of 1907–8 this series, common to which was the theme of a group of female nude figures, was the vehicle for what was, in effect, the sublimation of his sexual anxieties into progressively more exclusively aesthetic dramas. The decisive step, as Leo Steinberg showed in a trenchant analysis, was taken in the *Three Women* of late 1908, in which Picasso replaced the Africanist motifs of the first version of this picture with its present surface of muted greens and terracottas, arranged through relations of complementary and contiguous hues into a pattern of mostly triangular planes (figure 2.6). Yet, as Steinberg observes, in both the compacted, airless arrangement of its figures with their shared contours and pleated flesh, and the primordial gloom of its mood, it is distinctly un-Cézannesque. Steinberg's explanation for this inconsistency is that a complete accommodation to the latter's 'way of immersing all perceived data in the systematic unity of the painting … blotting out differences of shape, density, texture',[35] as for instance in his late 'Bathers' paintings, was not characteristic of Picasso, 'whose possessive sight grapples the things it sees, and whose selfhood demands complementary selves in responsive embodiment'. Hence, Steinberg suggests, 'his need to resist that in Cézanne which contravened his own ego, unless he could make something of the conflict induced'[36] – namely, articulate through it his ambivalence towards women. For try to exorcise them though he may have done in the *Demoiselles*, the demons of female sexuality continued to plague him, and the close identity which it declared between his masculine and artistic selves continued to be the central term of much of his painting of 1908.

There were other motivations besides these, however, for Picasso's re-engagement with Cézanne in the autumn of 1908. The paintings Braque had brought back from L'Estaque (figure 2.1) and had shown in Kahnweiler's gallery in November gained him notoriety, and he was widely regarded as the creator of a new style – a development that would have spurred Picasso's rivalry, just as the

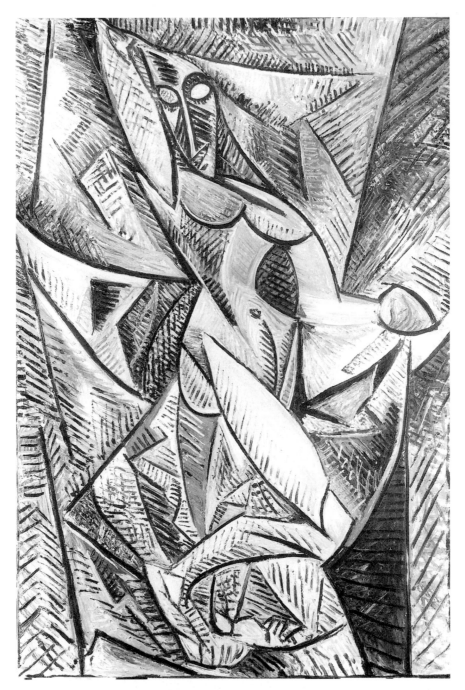

2.4 Pablo Picasso, *Nude with Drapery*, 1907

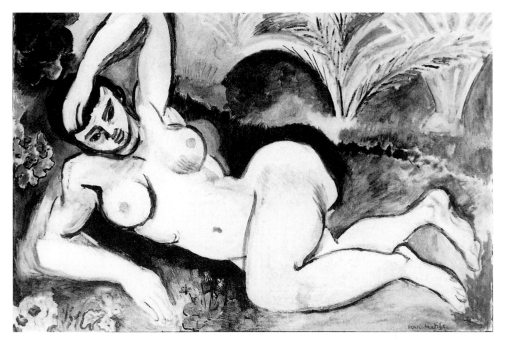

2.5 Henri Matisse, *Blue Nude (Souvenir of Biskra)*, 1907

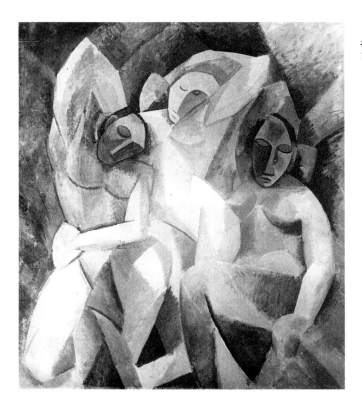

2.6 Pablo Picasso,
Three Women, 1908

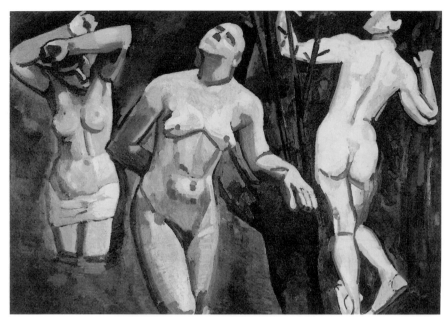

2.7 André Derain,
Bathers, 1907

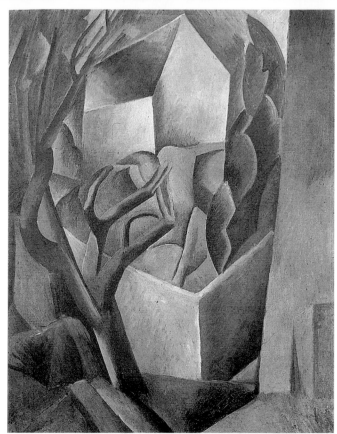

2.8 Pablo Picasso,
Cottage and Trees, 1908

critical attention given to the ambitious nudes of Matisse and Derain at the 1907 Indépendants (figures 2.5 and 2.7) had provoked the radicalism of the *Demoiselles*.[37] More importantly, these paintings suggested a way forward. It was not the order and stability of Braque's new manner that interested him; a comparison of his own paintings from La Rue-des-Bois that same summer, with their borrowing of Henri Rousseau's sharp, surface-hugging, linear style and volumetric simplifications, clearly shows Picasso's concern, on the contrary, to maximise their dynamic effect (figures 2.8 and 2.9).[38] Rather, it was the subtle emphasis on a rectilinear scaffolding or lattice that Braque extrapolated from Cézanne's method, and whose indexing both of the materiality of a picture and of the classical tradition offered the possibility of symbolising in formal and stylistic terms that psychic conflict which the theme of *Three Women* addressed.

In the project that followed, this increased investment by Picasso in style as the carrier of meaning was itself symbolised – both in the project as a whole, as it developed, and in the finished picture in which it resulted. *Carnival at the Bistro* was a large figure composition begun in late 1908 and transformed over the course of that

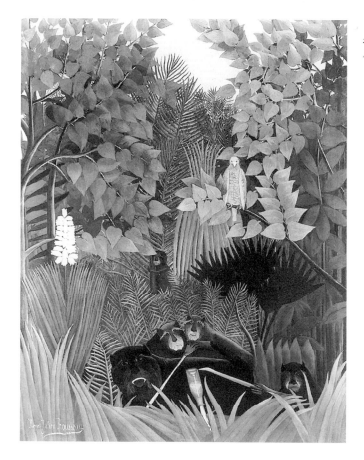

2.9 Henri Rousseau, *Merry Jesters*, 1906

winter, as Christian Geelhaar was the first to observe, into the still-life *Bread and Fruitdish on a Table* (figures 2.10 and 2.11).[39] As William Rubin subsequently showed, what began as a commemoration in *commedia dell'arte* costume of the recent Bateau-Lavoir banquet in honour of Henri Rousseau ended as a homage to the twin presiding genii of Picasso's art, Rousseau and Cézanne, in which each part of the still-life is depicted in a corresponding style: the fruitbowl on the left with Rousseauesque hand-made precision, the loaves and table-top at the right with Cézannesque *passage* and *non-finito*, and the central section representing Picasso's attempted reconciliation of the two.[40] This transmutation marks the artist's tacit acknowledgement of the sublimation of his sexual anxieties into a preoccupation with formal and technical issues;[41] as such, it marked also his abandoning of projects of grouped figure compositions until after 1914.

There was another dimension, however, to the transition that *Bread and Fruitdish* marked, for, as I noted earlier, that was the moment at which Kahnweiler undertook to purchase every work produced by Picasso and Braque. The move was both brave

2.10 Pablo Picasso, *Study for 'Carnival at the Bistro'*, 1909

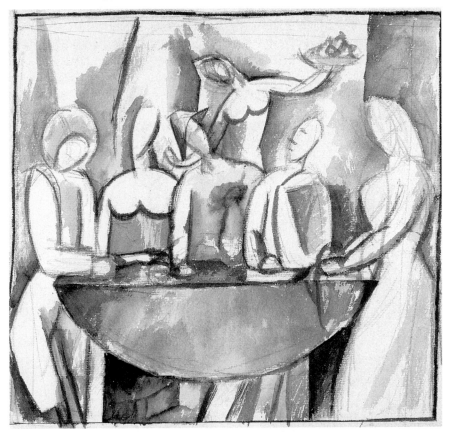

and astute: brave because the two painters were clearly sailing into waters for which neither current avant-garde practices nor the market which supported them had provided charts; but astute because at the beginning of 1909 there were signs, for those who could read them, that the market was now bullish enough for some of its players to invest in such adventurers. Picasso in particular was finding patrons: Gertrude Stein, already a fairly regular client, bought eight of his major works from 1908, and would acquire another six during the year that followed; she was, moreover, joined at this moment by other *dénicheurs* – the Russian merchant Sergei Shchukin, the industrialist Frank Haviland, and Roger Dutilleul, a Frenchman of private means, all joined Kahnweiler's small circle of clients in the year from late 1908.[42] Perhaps most decisively for the dealer, his rival Vollard, who had, out of cautiousness or prudence (he could afford both by 1907) stopped buying Picassos when he saw the *Demoiselles*, returned to the fold;[43] his purchase of the *Bread and Fruitdish* in the spring of 1909 must have clinched Kahnweiler's decision to go for broke.

The consequence of this development for Picasso in particular was not only that his entire output was now financially underwritten but, as I have argued elsewhere,

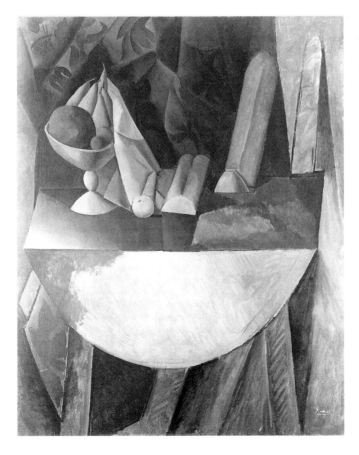

2.11 Pablo Picasso, *Bread and Fruitdish on a Table*, 1909

that the art practice from which it emerged altered fundamentally.[44] No longer painting for the putative audience of the avant-garde at large, investing time and ambition in a sequence of major pictorial projects, but for that of the small sub-cultural grouping that began to recognise itself at this moment, he adopted a radically different way of working, approaching each fresh canvas as a new point of departure in his on-going engagement with Braque's reworking of Cézanne and his own assimilation of the lessons of Rousseau. For Braque, too, although he had already returned to such a way of working after rising to the challenge of the *Demoiselles* with his own major nude composition, this coming together of a close circle of initiates was not only conducive to single-minded formal experimentation but encouraged him to tighten his grip on the tiger's tail of Picasso's iconoclasm. Although not yet in that daily contact which would soon shape both their working habits and their pictures, each painter was now for the other his primary viewer within this little audience of aficionados. Summering in different locations that year – Picasso in the hill village of Horta da Ebro in northern Spain, Braque at La Roche-Guyon, one of Cézanne's haunts, a picturesque town on the Seine fifty miles down-river from Paris – they each produced a series of works whose similarities are striking, and yet whose differences are telling. In a sequence of five paintings of the emblematically French château that perched on an escarpment above the river at La Roche-Guyon, Braque developed the classical armature of his L'Estaque pictures of the previous year into a diagonal lattice, accentuating its linear geometries with the use of Cézanne's habitual pattern of diamond-shaped brushstrokes (figure 2.12). Together with a further reduction of his already limited palette to tonal variations of two colours, a bottle green and a greyish-yellow ochre, this enabled him both to heighten the ambiguities of the relationships between solid volumes and adjacent spaces – sometimes even freeing shading from its ostensible illusionistic function of modelling form, to signify itself as a device (as in the upper centre of *Castle at La Roche-Guyon*) – and to enhance the suggestion of an overall low-relief space. At the same time, in Spain, in a parallel series of landscapes, Picasso was elaborating the terms of his resistance to the Cézannesque classicism that these paintings thus referenced. As in their paintings of a year earlier, his *Houses on the Hill, Horta da Ebro* (plate II), shares with Braque's paintings of the castle a gamut of stylistic features: a palette limited to greens, greys and ochres, diamond facetting, a plurality of viewpoints. But in place of the latter's careful balancing act, Picasso here characteristically exaggerated the interpenetration of volumes and spaces, and the equivocation between solidity and transparency, sharpening their ambiguities into contradictions, and uncoupling the devices of perspective and *chiaroscuro* from their illusionistic function with an abruptness and completeness that subverts any possibility of spatial coherence. Yet the effect of this uncoupling is not mere incoherence, but instead an estrangement of these devices comparable with that achieved in the Africanist paintings of 1907, though now without expressionistic affect. For Picasso this marked at once a means of resisting the harmonising, unifying tendencies of Cézanne's painting, and a deepening interest in the linguistic character of

pictorial representation, the consequences of which for the future direction of his painterly explorations, it will be seen, were to be profound.

For his part, Braque must have found in these Horta paintings, which he would have seen on his return to Paris that autumn, both an acknowledgement of and a provocation to his own developing concerns. His response was not immediate, however; in the still-life *Mandora* (figure 2.13), of around the turn of the year, his interest was clearly in giving greater emphasis to the diagonal lattice that was adumbrated at La Roche-Guyon, and in capitalising on the ways in which such a formal conceit signified a picture's surface even as it conjured from it an image of depth. Here the grid of diamond facets, fused yet distinguished by deft touches of passage and chiaroscuro, extends almost fully across that surface, pulverising its subject to reconfigure it in terms of its own regularity and flatness. More brutal in its disruption of discrete forms than any Cézanne, the effect of the unity that its pattern imposes on the visual field is, however, to return to the sheer opticality of the latter's late watercolours, yet without the painstaking point-by-point anchorage of these in the perceived particularities of their motif; the result is a lack of tension between the two, and a hint of stylisation. Braque was perhaps aware of this, for in *Violin and Pitcher* (plate III), painted early in the new year, he took a leaf from Picasso's Horta lexicon, disrupting the uniformity of the grid with repeated juxtapositions of viewpoints, and contradictions between transparency and opacity

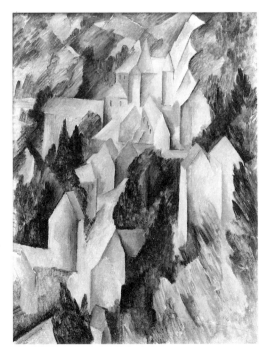

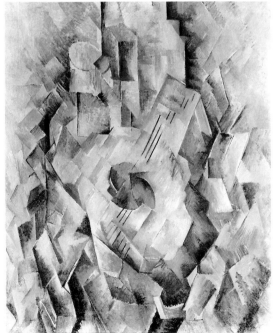

2.12 Georges Braque, *Castle at La Roche-Guyon*, 1909

2.13 Georges Braque, *Mandora*, 1909–10

– surpassing the latter, indeed, in the bravura quality of the brushwork in some of these. And he went further: the witty *trompe-l'oeil* nail at the top of the work has the effect of throwing the other painted illusions into relief, of establishing a mimetic absolute, as it were, against which the representational relativities of the other devices are measured, from the legibility of the folded corner of sheetmusic and the violin scroll to the near-indecipherability of what seems to be a piano – and which in turn, of course, reveal the conventionality of mimesis itself.

If Braque was readier to align himself with the dominant emphases, both aesthetic and extra-aesthetic, of the classicist discourse, its appeal for Picasso, too, was reinforced by the exhibition at the 1909 Salon d'Automne of twenty-five figure paintings by Corot; less well-known than his landscapes, these came as a revelation to both artists, their gravity and austerity, and their play of volumes and spaces against plain studio backgrounds, matching not only the cultural mood of the moment, but also the different – though close, and converging – pictorial concerns of Picasso and Braque. *Girl with a Mandolin (Fanny Tellier)* of the spring of 1910 reworks Corot's accommodations of sculptural volume and painterly flatness through Picasso's own emerging radical syntax of angular facets, abrupt changes of viewpoint and spatial ambiguities (figures 2.14 and 2.15). Its sobriety, stasis and

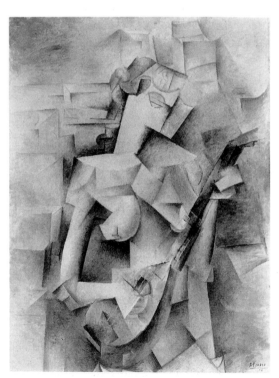

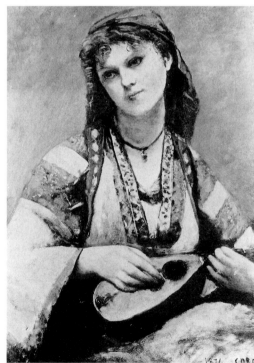

2.14 Pablo Picasso, *Girl with a Mandolin*
(Fanny Tellier), 1910

2.15 Camille Corot, *Gypsy Girl with Mandolin*
(Christine Nilsson), 1874

simple volumes are a re-affirmation of classical values, but they also provide the foundation for a scaffolding of lines and planes that is more rigorously rectilinear and subtly reductive than ever. In semiotic terms, the motifs of the eyes, instrument, hair and breast of the figure are both more clearly iconic (and more clearly distinguished) than were many of the details of the Horta landscapes, and yet the juxtaposition of the ellipticality common to them all with the rectangularity of the grid suggests the beginnings of a system of symbolic signs grounded in this simple difference. Once again, the conceptual rigour of the classical formula provided the springboard for a significant advance; the next step, which Picasso was to take that summer, would be crucial.

Shadows and silent objects: gallery cubism from Cadaqués to Céret

Among the several interpretations offered by the historians of cubism of the pictures that Picasso and Braque made in 1910 and 1911 – the years of some of the most hermetic and yet haunting images to come out of their brief and extraordinary partnership – almost all have agreed on one thing: that those painted by Picasso at Cadaqués, on the Costa Brava, in the summer of 1910 mark a watershed. Beyond this, however, there is wide disagreement – over what this moment represented, how it came about, and with what consequences, although the first account of it, given by Picasso's former dealer Kahnweiler in *Der Weg zum Kubismus* (written in 1915, published in 1920) provides the starting-point for the majority. The work at Cadaqués 'was the decisive advance which set cubism free from the language previously used by painting', Kahnweiler declared; Picasso 'had pierced the closed form. A new tool had been forged for the achievement of the new purpose.'[45] Following him, modernist art historians have seen this work primarily in formalist terms, as a breakthrough to a kind of painting, on the part of Braque as well as of Picasso, that led to a progressively more radical and reflexive accommodation of illusionistic depth with picture surface, of figure with ground, and of perception with conception, and brought their art to the brink of abstraction. From Alfred Barr in 1936 to William Rubin more than fifty years later this has been presented as a narrative of unswerving two-handed formal experimentation and successive achievement, a linear development in which the years 1910–11 saw in Braque's and Picasso's paintings the culmination of 'analytic' cubism and the beginnings of its evolution into 'synthetic' cubism – terms that Barr borrowed from Kahnweiler but crucially redefined.[46] Subsequently, Yve-Alain Bois has reworked this narrative in semiotic terms, while accepting its interpretive paradigm – discarding the analytic–synthetic metaphor and placing greater stress on the rupture between phases of cubism, but retaining its chronological framework.[47]

Since the early 1970s, however, interpretations have also been offered that call the Barr–Kahnweiler paradigm into question. Leo Steinberg adumbrated, in a series of influential articles through that decade to which I have referred above, an understanding of gallery cubism prior to 1912 that not only privileged Picasso

clearly over Braque but pointed to a psychological dimension to his experimenta-
tion, a continuation of the cathexis of *Demoiselles* in a play of affect that charged his
painting of those years with more than solely formal significance.[48] Alongside
Steinberg Rosalind Krauss first sketched in 1971 and, over the next two decades,
elaborated an interpretation of Picasso's cubism that built on the former's insights
into the role of the viewer in this play of affect. Developing from what she recog-
nised as Steinberg's phenomenological premises, Krauss interprets that cubism as
registering a 'withdrawal of the tactile and carnal from the field of the visual', the
logic of which Picasso acknowledged but which he experienced as a profound loss.
Reading the fragmentation and spatial ambiguities of *Fanny Tellier*, in these terms,
as ambivalence, Krauss thus offsets the unremitting optimism of the received nar-
rative with a poignant note of regret, even of tragedy.[49] Most recently, T. J. Clark
has complemented, if also contested, the tenor of Krauss's interpretation with a
powerfully revisionist interpretation of his own that (perhaps mischievously, cer-
tainly tellingly) draws on Kahnweiler's account – but only to turn it upside down.
Taking his cue from the dealer's remark that 'little satisfied', Picasso returned from
Cadaqués 'to Paris in the autumn with his unfinished works',[50] Clark challenges the
reductive logic of the still-dominant formalism with an assessment of Picasso's pic-
tures of 1910–12 as 'painting at the end of its tether'; he insists on their 'deep, wild,
irredeemable obscurity' and reads their strange new language as a 'counterfeit' of a
new description of the world, an imagining of how this would look that was yet also
'a thriving on that imagining', 'fiercely unwilling' to surrender imitation to the
arbitrariness of the sign.[51]

I leave to a later chapter any fuller assessment of these competing interpretive
models and claims about this most hermetic phase of gallery cubism, returning
here to the point on which they are agreed. Certainly the contrast is striking
between *Girl with a Mandolin (Fanny Tellier)* (figure 2.14), one of the last pictures
on which Picasso was working before leaving for Cadaqués in June 1910, and a
painting of the same subject, *Woman with a Mandolin* (plate IV), made during that
summer visit. In place of the legibility, indeed the evident charms, of the figure of
Mlle Tellier, the Cadaqués' female is all but indecipherable, her volumes flattened
into a radically non-mimetic configuration of angular planes, some tilted into
depth by a play of arbitrarily directed light and shade, their contours opened to the
surrounding pictorial field, their surfaces shimmering between opacity and trans-
parency. In semiotic terms, the shift from iconic to symbolic signs is clear: Bois
suggests that Cadaqués marks a further stage in Picasso's search for a 'unitary
system of notation' organised around the repeated devices of grid, 'sickle' shapes
(elaborated from, among other sources, *Fanny Tellier*'s ellipses) and shading; he
might have added transparency for, as Clark notes, it is this quality, above all, of the
Cadaqués' paintings that distinguishes them from their predecessors.[52] And yet
there are elements of resemblance, and, more than mere residues of iconicity, they
provide information crucial to the deciphering of the figure: most legibly, the belly
of the mandolin, sensually and suggestively illuminated (bottom centre), but also, if

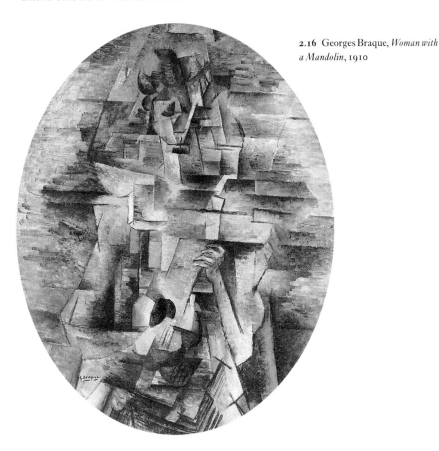

2.16 Georges Braque, *Woman with a Mandolin*, 1910

more schematically, the tilt of the head and neck characteristic of Picasso's previous female instrumentalists.[53] With these as guides, other components of the subject can be located, albeit less precisely: shoulders, one or more elbows, the general configuration of this half-length figure. Overall, then, *Woman with a Mandolin* does not instance an abandoning of iconicity so much as a testing of what Bois has termed its elasticity – a stretching of this, as it were, to its limit.[54] Clearly – and here again, most are agreed – that limit was reached at Cadaqués; Picasso could go no further in that direction without risking complete indecipherability, and an unwished-for appearance of 'abstraction'.

For Braque, who had remained in Paris over the summer but probably visited Picasso in Cadaqués in late August en route to a three-month stay in L'Estaque,[55] that risk appears to have loomed large, although not immediately. His work since *Violin and Pitcher*, such as *Woman with a Mandolin* (figure 2.16) of that spring, the first of several oval pictures that the two made in those years, had anticipated certain of the qualities of the paintings he saw there, notably the elaboration of a grid of tilted planes opened to their surrounding field, and his inclination (which Rubin and others have noted) to work a painting away from the motif in the direction of

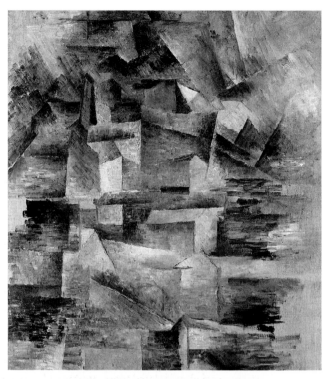

2.17 Georges Braque,
*Rio Tinto Factories at
L'Estaque*, 1910

2.18 Georges Braque,
Bottle and Fishes, 1910

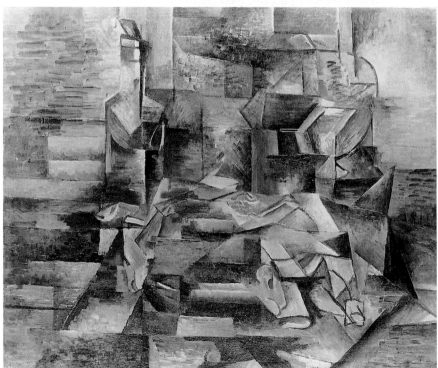

abstractness predisposed him to absorb readily Picasso's radical simplifications.[56] *Female Figure*, painted in L'Estaque that autumn, now lost,[57] and a number of small drawings of about the same time, are comparable with the *Woman with a Mandolin* in their reductiveness, while his *Rio Tinto Factories at L'Estaque* (figure 2.17) accommodates the regular lattice of rectangular notations that Picasso was working up in some Cadaqués' landscapes into a shimmering kaleidoscopic pattern of roofs and walls against the hillside.[58] But always these appropriations and reworkings are more legible, and still anchored to traditional French pictorial values – those of Corot and Cézanne; and his response to even this slippage towards indecipher-ability was, for the moment, to reconsider, to retrace his steps, in his painting through the rest of 1910, back to the more coherent space of his still-lifes of the pre-vious autumn and to a greater reliance on recognisable motifs (figure 2.18)

Picasso too inclined, in the pictures he painted on his return to Paris that autumn, to a greater reliance once more on iconic signs. Whether this was out of the 'dissatis-faction' that Kahnweiler reported accompanying his departure from Cadaqués and hence, as Clark suggests, in the belief that whatever 'success' the lean and reductive style of his summer work represented, it was of the wrong kind, 'cubism near freezing point'; or whether, on the contrary, as Bois argues, he grasped the opportu-nity which that style now offered to separate cubism's illusionist devices and their organising grid from any mimetic purpose, allowing the necessary minimum of information to be carried by isolated hieroglyphic signs, is open to debate.[59] At times in these paintings of late 1910, as in the celebrated *Portrait of Daniel-Henry Kahnweiler* (figure 2.19), iconic details, drawn with a cartoonist's acuity from observed traits of their subject, function wittily as foils to a now-dominant grid that is detached yet more completely from any precise descriptive function; at others – as in the portraits of Uhde (figure 2.20) and Vollard, begun before but completed after Cadaqués – the juxtaposition of these two orders of signification results in an image the awkwardness of which, as Clark observes, borders on kitsch.[60]

Perhaps, however, that cartoonist's acuity is the point here. In a seminal article of twenty years ago Adam Gopnik pointed to the close relationship that Picasso's notebooks of 1905–7 reveal between his enjoyment of the graphic insights of carica-ture and his explorations of the formal characteristics of Congolese and Ivory Coast masks.[61] He observed that in his portrait paintings over the three years beginning with that of Gertrude Stein in 1906 the artist brought these two graphic idioms together with the Western portrait tradition, into a dialogue between 'high' and 'low' art: 'The antimimetic strategies of likeness embedded in the caricature could be integrated into Picasso's finished portraits only after they had been reimagined as primitivism', Gopnik suggested.[62] 'What Picasso has done is to invent a kind of creole, a language that assimilates an alien vocabulary to a familiar syntax'; it was through this primitivism that he accomplished 'the move from low to high, the vic-tory of the notebook over the easel'.[63] It was in the portraits of 1910, however, and especially the post-Cadaqués picture of Kahnweiler that, Gopnik argues, the two traditional strategies of the caricature and the Leonardesque portrait were fused.

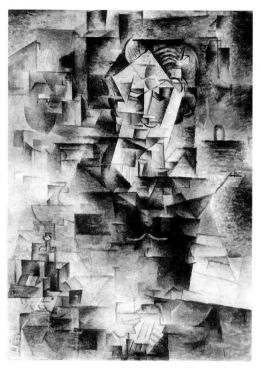

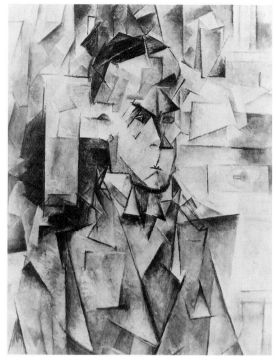

2.19 Pablo Picasso, *Portrait of Daniel-Henry Kahnweiler*, 1910

2.20 Pablo Picasso, *Portrait of Wilhelm Uhde*, 1910

'Instead of a simple substitute of low for high, instead of the simple importation of an exotic vocabulary, we find a complex but systematic exchange of dialects.'[64] What made this possible was Picasso's realisation: 'Caricature is in embryo what the cubist syntax brought to maturity: a working representational code that comments on the way representational codes work.'[65] Perhaps this was the crucial recognition after Cadaqués; whether or not the recent decision of his cartoonist compatriot and Bateau-Lavoir neighbour Juan Gris to take up painting was contributory to it, the availability of caricature as a model of a graphic system that combined reflection on the way the mind works in its representation of the visible world with sharp (and subversive) analysis of its particulars may have underwritten Picasso's return from the brink of abstraction.[66]

However this re-engagement with resemblance and its interspersing of iconic and symbolic signs is interpreted, the dialectic between them – and, on a broader canvas, that similar dialectic between the artistic personalities and predilections of the two painters – gave rise over the following year to pictures of unprecedented depth and richness. Within the self-sufficient little milieu of cognoscenti now gathered around their work, they elaborated their private painterly lexicon in an open series of dense, difficult and intertextual paintings. As Rubin observes, Braque's

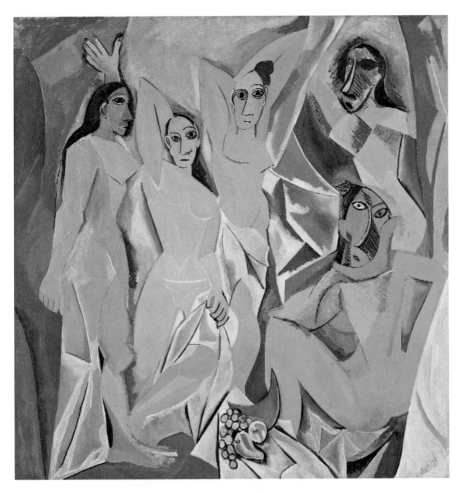

I Pablo Picasso,
Les Demoiselles d'Avignon,
1907

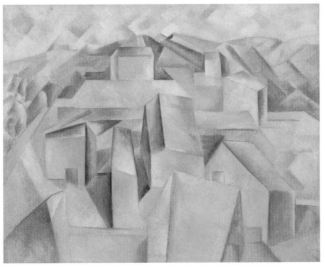

II Pablo Picasso, *Houses
on the Hill, Horta da Ebro*,
1909

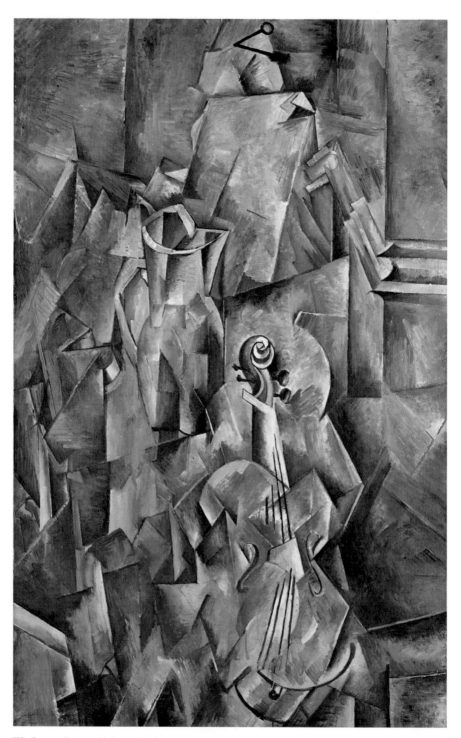

III Georges Braque, *Violin and Pitcher*, 1909–10

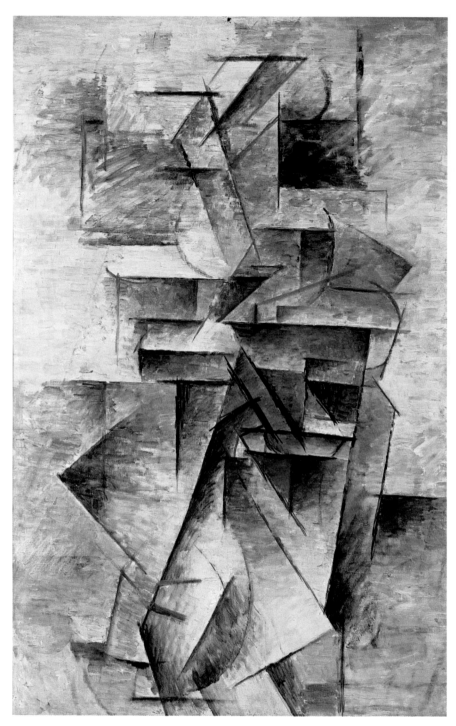

IV Pablo Picasso, *Woman with a Mandolin*, 1910

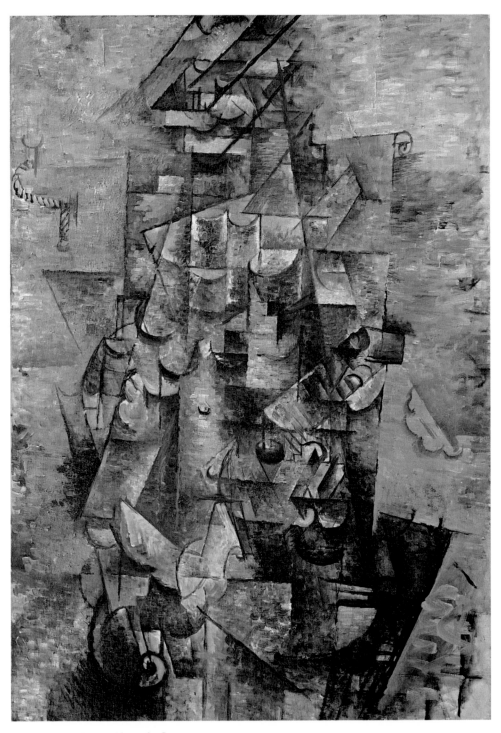

V Georges Braque, *Man with a Guitar*, 1911

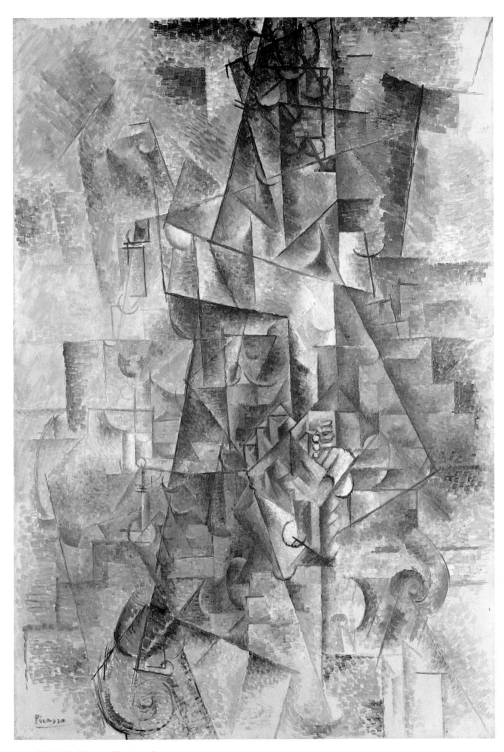

VI Pablo Picasso, *The Accordionist*, 1911

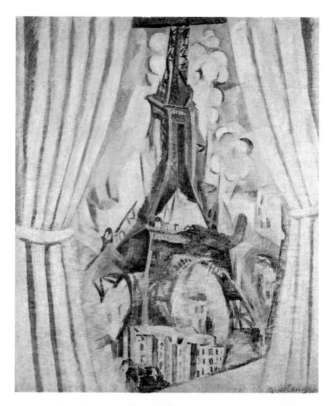

VII Robert Delaunay,
Eiffel Tower with Curtains,
1910–11

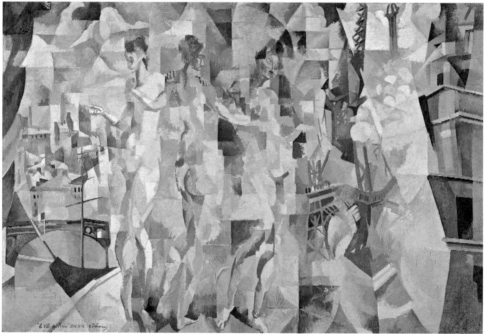

VIII Robert Delaunay, *The City of Paris*, 1912

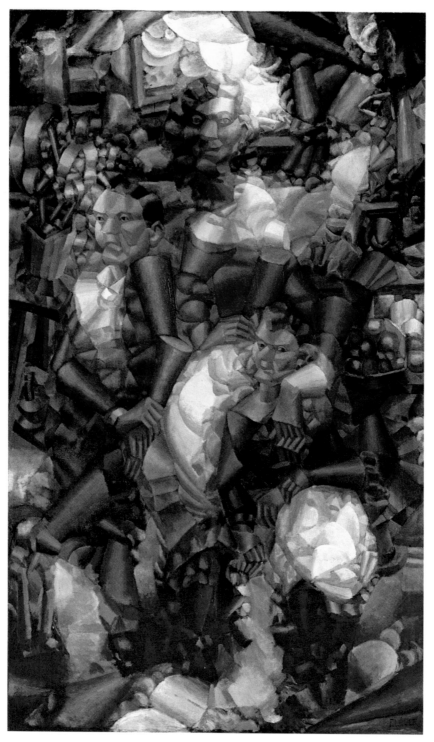

IX Fernand Léger, *Study for Three Portraits*, 1911

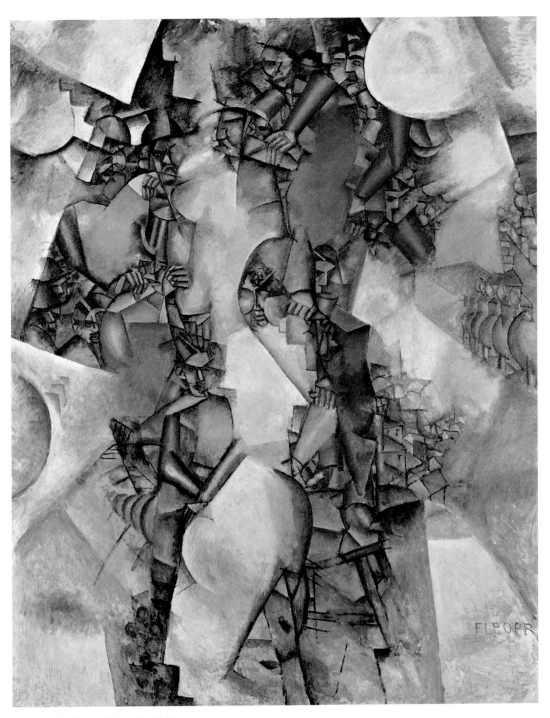

X Fernand Léger, *The Wedding*, 1911–12

'painterly gift', his insistence on dissolving distinctions between figure and ground and his attachment to pictorial order interacted, over the months of their closest partnership, with Picasso's anarchic iconoclasm and his 'commitment to the morphological and conceptual definition of his subjects',[67] and within the horizon of those qualities they found in the configuration of the grid or lattice they had jointly evolved both generative possibilities that they could explore and constraints that they could challenge. Together these allowed the two to express, in Clark's words, 'an immense, unstoppable relish at putting the means of illusionism through their paces',[68] and to produce pictures so uncannily similar that they acquired a kind of anonymity. The poet Mallarmé, celebrating the 'incantatory power' of words, had pointed the way towards this state, envisaging his own authorial self-effacement as these took the initiative, 'mobilised by the collision of their inequalities, kindling reciprocal reflections like the flashes of fire between precious stones'.[69] But such self-effacement seems uncharacteristic, especially of Picasso – for whom the display of his creative individualism was, as the *Demoiselles* project indicates, of fundamental importance – and it is a measure of the profound significance which this close collaboration with Braque held for him that he should have allowed its imperatives to push that individualism, however temporarily, into second place.

Perhaps the high point, and the closest moment, of their partnership was the series of paintings the two artists made while summering together in Céret, in the south of France, in 1911. Among them were Braque's *Man with a Guitar* (plate V) and Picasso's *Accordionist* (plate VI). Although there are differences between these two pictures – for example, Braque's greater commitment to a unified low-relief space and his thicker, more painterly, facture, as against Picasso's enjoyment of abrupt spatial discontinuities and his deftly fashioned play of overlapping transparent planes – the similarities are equally significant. Each approaches the severity of Picasso's Cadaqués' paintings by means of a reduction of representational means to a minimum of signs, both painters moving further away from iconicity than in any of their work of the year since that visit, in the creation of a lexicon of graphic marks and painterly motifs (symbolic signs) the representational meaning of which is primarily dependent on relations of difference and position within the picture as a whole: in each case, the play of diagonals and triangles against a rectilinear grid. Yet both artists rely, critically, on isolated iconic details (a loop of curtain rope, the fretboard of a guitar, the bellows of an accordion) as clues, or cues, to the reading of their paintings. The juxtaposition of perspective schemas which had been effectively deployed in generating the 'grids' in their paintings of 1909–10 serves in both works to reveal the conventional character of pictorial perspective itself, giving each painter greater freedom to position these details without regard to the demands of illusionistic coherence. Thus in both paintings, the spiral shapes (lower left and right), denoting two upholstered chair-arm scrolls, each pictured from a different angle, are enough, in combination with their positioning, to suggest the chair in which the musician sits, and also function as units in a system of differences between circles and straight lines in which the former stand variously for sleeve

cuffs, collars, eyelids, soundholes, and so on. Yet in each painting there is a surfeit of illusionistic space; Picasso in particular plays with the devices of illusionism with a bravura that is at times astonishing, creating, in the centre of the picture especially, such a complex interplay of transparencies, viewpoints and possible vistas that the result, in another of Clark's apposite phrases, is a 'deep, wild, irredeemable obscurity'.[70] Thus sparkling with reciprocal reflections in the spirit of Mallarmé, *The Accordionist* teeters provocatively on the brink of incoherence. How Picasso and Braque would avoid tipping over it is explored in a later chapter.

Classicism and Bergsonism: the emergence of salon cubism

In another part of the forest of the avant-garde, other artists were immersing themselves, like Picasso and Braque, in the winter of 1909–10 in the art of the classical tradition, but with different interests and goals. Albert Gleizes and Henri Le Fauconnier met in the milieu that emerged from the Abbaye de Créteil venture;[71] its members, mostly poets, included Alexandre Mercereau and Roger Allard, both of whom were beginning also to write art criticism, and Jules Romains. Their aesthetic interests met in a celebration of everyday life and human community that contrasted clearly with the aestheticism of the neo-symbolist movement whose ascendancy was noted earlier; rejecting the introspective aesthetic of the latter, they took as cardinal literary reference points the lyric optimism of the American poet Walt Whitman, whose *Leaves of Grass* was published in translation in 1909, and the humanism of Emile Verhaeren, whose *Les Villes tentaculaires* (1895) and *Les Forces tumultueuses* (1902) registered the social consequences of urban growth and industrialisation in his native Flanders. Such a twin allegiance, underpinned by a profound attachment to Bergsonian vitalism, gave scope for wide differences of emphasis within the group between rural and urban models of community. Although they rejected the imagery and language of symbolism, they shared an interest in its technical innovations, in particular that of *vers libre*, which allowed more flexibility in the structure of a poem than had the fixed formula of the traditional alexandrine measure.

Within this circle Gleizes and Le Fauconnier were prompted, by the classicist revival and associated retrospectives, to an equivalent exploration of the 'science of structures' that they believed the artists of the Renaissance to have possessed, and which the neo-classicists David and Ingres were thought to have inherited. 'How many conversations we had about these great ancestors', Gleizes later recalled. 'How often we strove to discover the genesis of their works! How many diagrams we tried to elaborate to penetrate these!'[72] Le Fauconnier took the lead in this. He had recently returned from Brittany where he had been living for two years; a landscape of 1910, *L'Ile Bréhat* (figure 2.21), the product of a summer visit to old haunts, reveals his debt to Cézanne in its tentative use of *passage* in the foreground and middleground, and of the latter's signature diamond-pattern brushwork. But the *repoussoir* trees and geometric ordering of the composition make clear that this was a Cézanne viewed through the lens of classicism. Tentative though its combination of

2.21 Henri Le
Fauconnier, *L'Ile
Bréhat*, 1910

values and references was, such painting caught the eye of more than one spectator.
The collector Shchukin bought a companion landscape from that Breton summer, at
the 1910 Salon d'Automne, to hang in his Moscow mansion, perhaps alongside his
Picassos; the young critic Roger Allard noted his entries, as I have mentioned, in his
review of the same salon; and the painter Jean Metzinger discussed his work along-
side that of Picasso, Braque and Delaunay in an article of the same month. All three
were probably drawn to the artist by more than the contemporaneity, such as it was,
of his style, however. For, as I have noted, Le Fauconnier was also an astute avant-
gardist, and quick to see the advantages of networking between the milieux of
Europe's proliferating avant-garde population; already by September 1910 he was in
close enough contact with Kandinsky's Neue Kunstlervereinigung (NKV) in
Munich to be invited to exhibit in its annual salon, and to write a statement for its cat-
alogue. What he produced was a dense and jargon-ridden text that purported to
explain the laws of art in mathematical terms; despite, or because of, its obscuran-
tism, it must have circulated among and impressed his friends in Paris, for both
Allard and Metzinger echoed its phrases in their own writings.[73] The former, looking

for a way beyond both the aesthetic of impressionism and the sterility of the neo-classical reaction to this, found in Le Fauconnier's theorising, and in the paintings that he, Gleizes and Metzinger had exhibited that autumn, the signposts he needed. 'A beautiful picture is nothing other than a true equilibrium, an equivalence of weights and a true harmony of numbers', Allard declared. Dismissing the 'arid formulae' of neo-classicism, he called for 'an expansion of tradition towards the classicism of the future'. Metzinger, for his part – after opening his article with the rhetorical question 'Is there any of the most modern works in painting and sculpture that does not secretly obey the Greek rhythm?' – noted that 'Le Fauconnier situates his ideal, inaccessible above all to those who speak endlessly of order and of style, in a vast equilibrium of numbers'.[74]

Significantly, both Allard and Metzinger interpreted the classicist emphases that they thus perceived and welcomed in terms that contemporary readers would have understood as explicitly Bergsonian, given the wide currency of the philosopher's ideas at that moment. The painter was the more tentative, observing of Braque that 'whether he paints a face or a fruit, the total image radiates in time (*la durée*): the painting is no longer a dead portion of space', without elaborating on the implications of this temporality.[75] Allard went further, however: not only was there a similar gesture towards Bergsonism in his suggestion that the work of Le Fauconnier and his friends presented 'the essential elements, in all their pictorial plenitude, of a synthesis situated in time',[76] but in his next article he developed this suggestion into a fully-fledged fusion of these seemingly incompatible notions, Bergsonian dynamism and classical stasis. He did so at one remove from contemporary art practice, in an assessment of the painting of Poussin whose pretext was a recent acquisition by the Louvre of a picture by that artist. It was the balance that Poussin achieved in pictures such as the *Arcadian Shepherds* between the dynamism implied by the frozen gestures of its figures and the stasis of its composition, Allard argued, which gave such paintings a *living* beauty, one that must be intuited rather than analysed. 'Thus to love the living work for the vital forces that are in it, is to understand and possess nature, since by an act of genius a human thought has known how to contain it whole.'[77] In this emphasis not only on time but on movement, vitality and intuition, Allard at once claimed Poussin unmistakably for Bergsonism, since those particular concepts, between them, were the very essence of his philosophy as popularly understood, and tacitly harnessed the authority of both to the innovations, as he interpreted them, of the future salon cubists – underscoring the cognitive role of such a classicist aesthetic with the implication that it takes artistic genius of this character to know nature fully.

With this argument, Allard sought to appropriate the values of France's *grand siècle* iself, so beloved of the neo-classicists of Action française, both to the more inclusive, intuitive classicism of Barrès – for as I have noted, it was with Barrésian traditionalism that Bergson's ideas were seen at the time to be most closely aligned – and to this current in contemporary painting. In so doing he built a bridge between the incipient modernism of the emergent salon cubist group and the

conservative nationalism which that traditionalism represented, extending the hegemony of the latter into a milieu that had until then been indifferent to overtly political argument, and offering the former the means to relate their painterly preoccupations to their awakening response to the nationalist call to order. Allard was not alone in making this emphasis; as Mark Antliff has shown, other writers such as Joseph Billiet and Tancrède de Visan were also at pains to fashion a Bergsonist understanding of, on the one hand, the classical tradition, on the other, the engagement of the post-Abbaye poets with themes from everyday life.[78] But his essays did much both to consolidate the emerging authority of Le Fauconnier, in particular, among the artists of his circle, and to foster their Bergsonist inclinations. It was because of this authority that the latter's work on the painting *Abundance* (figure 2.22) was followed so closely, as Gleizes later recalled, by Léger, Robert and Sonia Delaunay, Metzinger and himself, as well as most of their poet friends, through the winter of 1910–11; and it was because of the currency of such ideas within their milieu that the painting came to stand as a manifesto of pictorial Bergsonism – and to be exhibited across the length and breadth of Europe, in the years prior to the First World War, as a landmark in the development of cubism.[79]

That *Abundance* of all paintings should have had such a status seems, now, hard to understand, so academic in its theme, so awkward in its handling and unadventurous in its style does it appear to modern eyes.[80] But in 1911 it had several levels of resonance. This female nude, her womb at the very centre of the composition, her male child canonised by a tree-trunk halo, surrounded by emblems of nature's fecundity and regenerative inevitability, symbolised not only Bergson's *élan vital* but also a mythical, pre-lapsarian world of rural plenty, its future secured by her reproductive role, its traditional hierarchies safeguarded by the castle in the background; at a time when industrial and urban modernisation, anti-clericalism, feminism and a decline in the birthrate were creating widespread anxiety for the future of France, such a celebration of motherhood and apple pie was beguiling for nationalists. For post-symbolist avant-gardists in search of non-mimetic means to the expression of ideas and emotions, such as non-naturalistic colour, or irregular verse rhythms, or the symbolic geometries that, according to neo-platonic tradition, encoded mystical truths, the geometries of Le Fauconnier's picture and the numerological jargon with which his 1910 treatise was laced must have been equally suggestive. In its repeated contrasts of curves and angles, and its heavily painted volumes conveying an idea of abundance, the painting offered a visual equivalent to the 'rhythmic constant' and the 'lyric intuition' with which the poets of his circle such as Vildrac and Duhamel, and critics such as de Visan, were preoccupied.[81] And in its relatively even fragmentation of the visual field into painterly diamond facets, *Abundance* referenced both the techniques of Cézanne and the picture surface, paralleling the work of Braque and Picasso with a *gaucherie* that, from the perspective of Denis's appreciation of the art of French 'primitives', would itself have had a positive value.

By their own later accounts, two of the future salon cubist group were stimulated by the example of *Abundance* to adapt its innovations for their own use, in

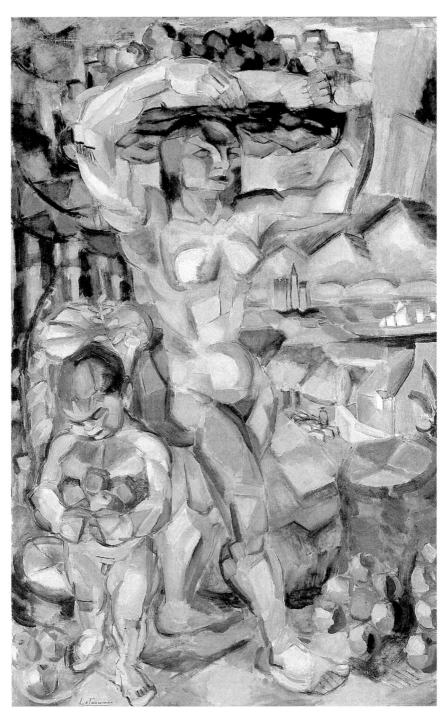

2.22 Henri Le Fauconnier, *Abundance*, 1910–11

paintings which they exhibited, the following spring, alongside it in room 41 of the Indépendants. Gleizes described in his *Souvenirs* how, as a result not only of his exploration with Le Fauconnier of the secrets of the Renaissance artists but of his growing familiarity with his friend's painting, he had by 1910 turned from impressionist views of the Ile-de-France to other landscapes, as well as portraits of friends and relatives, that were characterised by strong geometries, simple and sharply modelled volumes and sober colouring.[82] One of his two major entries in room 41 has been lost, but in the other, *Woman with Phlox* (figure 2.23), Gleizes sought – following *Abundance* – to maximise the dynamism of the play of volumes between the figure, the furniture and the ambient interior space. The painting goes further than Le Fauconnier's, however, in calling attention through its spatial ambiguities to the devices by which these are created, to the point at times of incoherence. Yet in thematic terms the painting seems less ambitious. *Woman with Phlox* can be interpreted both as symbolising a harmony between humanity and nature that the dense play of volumes serves, as in *Abundance*, to underscore, and also as an anxious celebration of the domestic role of women – both of which ideas would have been consonant with the preoccupations of some of the salon cubists' circle; but other interpretations have been offered, and there is no direct evidence for any of them.[83]

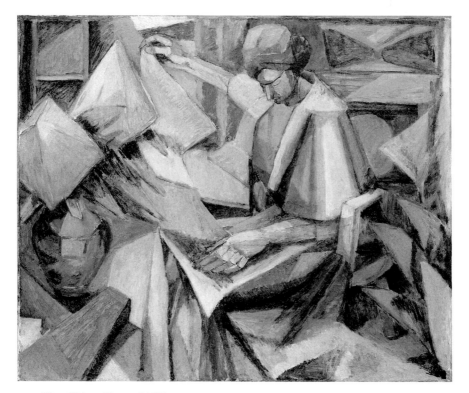

2.23 Albert Gleizes, *Woman with Phlox*, 1910–11

The same can be said of Léger's main entry for room 41, *Nudes in the Forest* (figure 2.24). Apparently just a radical reworking of the traditional pastoral theme of *alfresco* nude female figures, this painting was begun in 1909, and left incomplete until Léger returned to it after observing the progress of *Abundance*. The 'battle of volumes' that he later described it as being certainly summarises its chief characteristic: like Le Fauconnier's work, it is both monumental and dynamic, its trio of nudes seemingly carved out of their woodland setting, facetted into sharply juxtaposed planes and volumes by a patterning presumably derived from the dappling of *sous-bois* light and shade; it is clear, however, that Léger was uninterested in Le Fauconnier's message of rural harmony. This battle of volumes seeks, if anything, to contest that myth with a counter-pastoral image of nature's energy that was strikingly independent. A declaration of Léger's combative avant-gardism, it perhaps drew on the excitement of poet and painter friends, such as Jules Romains and Robert Delaunay, with the dynamism of modern urban life, and anticipates his own celebration, in a lecture of a few years later, of the visual contrasts of the modern landscape – a celebration to which I return in the next chapter.

2.24 Fernand Léger, *Nudes in the Forest*, 1910–11

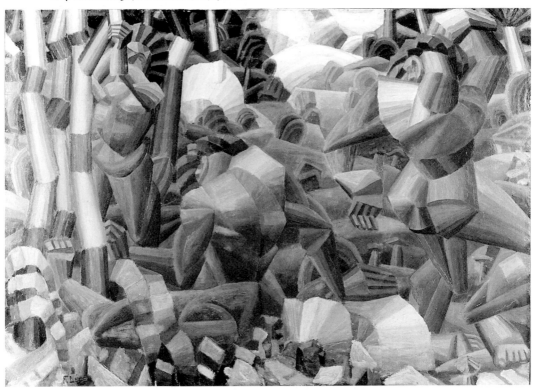

Metzinger and Gleizes 1910–11: between two cubisms

The formal qualities that were common to these paintings shown together in room 41 – an appearance of physical density achieved by the firm modelling, in sober even-hued colours, of fragmented, geometric forms distributed evenly across the visual field, and imbricated with their ambient space to present (with varying degrees of emphasis) an illusion of low relief – were close enough to those that, as I have said, characterised the paintings of Picasso and Braque two or three years earlier to have led generations of art historians to assume that the former were simply derivative of the latter. The origins, implications and consequences of this assumption I discuss later, but it needs to be said at this point that it is largely erroneous. The Parisian avant-garde formation, as I have indicated, was not monolithic: its social topography, the differences of market orientation between salon and gallery cubism, the relative lack of overlap between the patrons and supporters of each (the preference of the *dénicheurs* for buying from dealers and studios in Montmartre rather than from the salons, for instance, has been noted), the differences in the aesthetic preoccupations, and responses to the nationalist call to order, of the two groups of artists and their milieux – these factors make such a reading of derivative qualities out of pictorial chronology alone highly questionable. As Daniel Robbins has shown, the circumstantial evidence suggests that each camp's awareness of the existence of the other emerged probably mutually, accompanied by (at the very least) mutual wariness, during the winter of 1910–11 at the earliest, and possibly not until the public fuss over room 41; he suggests that the salon cubists did not meet Picasso personally, and Gleizes and Le Fauconnier did not set eyes on gallery cubism, until after the Salon d'Automne of that year.[84] Before then, those formal devices that were to become the chief hallmarks of the cubist style – the juxtaposition of different viewpoints and the dissolving or disruption of contours between figure and ground – were not used by most of the future salon cubists (although they came to be during the following year); nor, reciprocally, did either Braque or Picasso seek to make a pictorial statement on an elevated, epic theme such as that represented by *Abundance*. There was one exception to this mutual incomprehension, however: for Jean Metzinger had a foot in both camps, and it is perhaps his painting from 1910 above all that has done most to justify the assumptions of derivativeness, if at some unreasonable cost to his own artistic reputation.

Metzinger was in some ways a prototypical avant-gardist: intellectually acute, eager for novelty, culturally elitist and ambitious. Gravitating to the Montmartre artistic community on his arrival in Paris from Nantes in 1902, he was soon exhibiting neo-impressionist paintings in Berthe Weill's gallery. But as the dealer later recalled with amusement, he changed his painting style frequently at that time, and by 1908 had arrived at a *nabi*-esque *cloisonnisme* and a post-synthetist decorative aesthetic that he explained to Gelett Burgess late that year – his inclusion in the latter's 'Wild men of Paris' article in which both were illustrated probably owing more to his developed skills of self-promotion, however, than to his place in

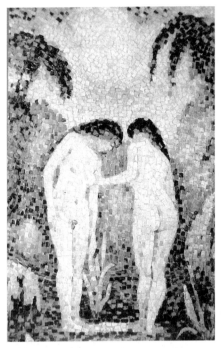

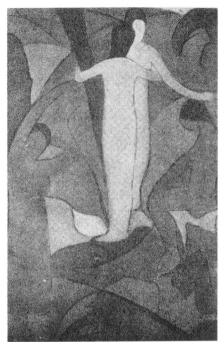

2.25 Jean Metzinger, *Two Nudes in a Garden, c.*1906 **2.26** Jean Metzinger, *Bathers, c.*1908

the Montmartre milieu[85] (figures 2.25 and 2.26). Keenly responsive to new ideas and ascendant reputations, he was soon friendly with the poet Max Jacob and in 1907 met Apollinaire, whose portrait he painted in 1909, and Picasso. He began to write poetry, publishing in little reviews some verses in a neo-symbolist vein, beneath whose exotic imagery ran two concerns that would surface in the critical and theoretical essays he wrote from 1910: a belief in the cultural and moral superiority of artistic creativity; and a fascination with number and geometry that went back to his schooldays.[86] By 1910 he was familiar enough with the Bateau-Lavoir and/or Kahnweiler's gallery to be able to reproduce with remarkable completeness and fluency the style of Picasso's very latest painting, exhibiting at the Salon d'Automne of that year a *Nude* that bears a close resemblance to the latter's recently finished *Portrait of Wilhelm Uhde* (figures 2.27 and 2.20). From the poor black-and-white reproduction that is the only record of his painting, now lost, it appears that Metzinger captured much of the look of Picasso's picture even down to the details of the facial features and exploded cranium of the figure, although some of the diagonals and related devices that surround it seem, if not merely decorative, to relate more to Picasso's Horta landscapes than to his current work. It is an accomplished pastiche; but since it bears little relation to anything in his previous work, it is hard to see it as anything other than a wholesale plagiarism, or to see Metzinger's motives for painting – and so promptly exhibiting – it as other than avant-gardist

opportunism. He followed this work with another figure composition, *Two Nudes* (figure 2.28), which he showed in room 41,[87] and which seems (again from a reproduction – this painting, too, is lost) ironically to represent a step back, both in terms of Picasso's development – towards the latter's nude studies of a year earlier such as *Fanny Tellier* (figure 2.14) – and in the stylised facetting with which it articulates the mannerist elongation of the figures.

By the autumn of 1910, Metzinger was strategically positioned within the emerging cubist movement. Over the summer he had met, through his friend Robert Delaunay (they had known each other since 1905), the other painters with whom he was to exhibit in room 41, and his entries at the Salon d'Automne had impressed them as much in their audacity as in their indication of shared formal concerns.[88] In November he published his 'Note sur la peinture', perhaps grasping thereby the opportunity provided by his familiarity – at the time, unique among his new circle of friends – with the work of Picasso and Braque, to assume the leadership of the soon-to-be salon cubist group.[89] But the article was more than just an avant-gardist gesture, for, as it clearly shows, Metzinger knew what he was talking about. Paradoxically, given the lack of originality of his painting at that point, it presented the first informed and theoretically sophisticated explanation of the range of painting within the nascent movement, presenting a coherent and

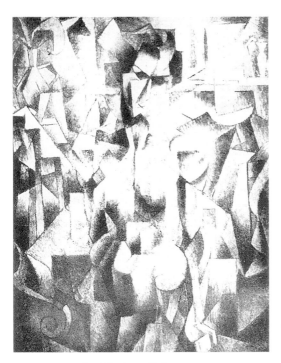

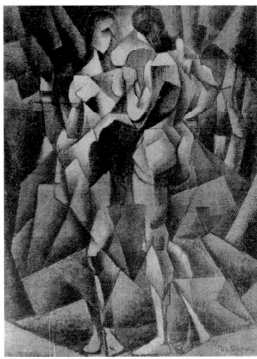

2.27 Jean Metzinger, *Nude*, 1910 2.28 Jean Metzinger, *Two Nudes*, 1910–11

nuanced interpretation of the work of both its wings that no other commentator could yet match. He explained Robert Delaunay's paroxysmic paintings of the Eiffel Tower[90] as pictorial equivalents to the contemporary experience of urban modernity, but, responding perhaps to the discursive force of the classicist revival, and distancing himself from the 'perceptual' paradigm that had governed his own earlier neo-impressionist work, and on which he saw Delaunay's painting as still being based, he preferred the balance between intelligence and sensuality, and the resulting grandeur, that Le Fauconnier's painting achieved. Discussing gallery cubism in the Bergsonian terms that Allard in the same month would apply to the work of the emergent salon group, he remarked (as already noted) on Braque's 'clever mixing of the successive and simultaneous', such that 'the total image radiates in time', noting in Picasso's painting the 'free [and] mobile perspective' that it established, from which, he observed, 'that ingenious mathematician Princet has deduced an entire geometry'.[91]

Such Bergsonian and mathematical inferences had little to do with gallery cubism as I have described it above, even though Metzinger did acknowledge Braque's fashioning of 'new formal signs'. As several of cubism's more recent historians have agreed, neither the temporal reconstitution of dissected objects that he inferred from them nor the mathematics he associated with them were proposed or inscribed in these paintings of Picasso and Braque, whose frequent juxtaposition of perspective views of their motifs had more to do with an insistence on their materiality and an engagement with the complexities of the representation of this, as I have suggested, than with the idealism that underlies Metzinger's interpretation.[92] Nevertheless his inferences were significant, for the first of them offered a coherent and provocative rationale for its innovations, and one consistent with the contemporary intellectual currents I have already charted, while the second referenced a preoccupation that would emerge over the next eighteen months, as I show in the next chapter, as the main common point of reference of the different discourses that the cubist movement was beginning to comprehend. Both, moreover, were means of theorising the paradigm shift from a perceptual to a conceptual painting that Metzinger recognised as fundamental to the two wings of this movement: 'Cézanne showed us forms living in the reality of light, Picasso brings us a material account of their real life in the mind', he declared.[93] Ironically, while he insisted on the break which this represented from classicism – asserting that the artists he discussed 'are too enlightened to believe in the stability of any system, even were it to be called classic art'[94] – his own painting of the following year became more and more overtly classicist, replacing his pastiches of Picasso with cubistic cover versions of eighteeth-century formulae. *Tea-Time* (*Le Goûter*, also known as *Woman with Teaspoon*), exhibited at the 1911 Salon d'Automne (figure 2.29), is as stylistically programmatic as it is distant from the qualities of gallery cubism. Yet the painting was possibly didactic in intention, as well as decorative: a demonstration exercise, as Christopher Green suggests, in the distinction between idea and sensation. The word *goûter* means also 'to taste', and in Metzinger's picture the suggestion of activated senses

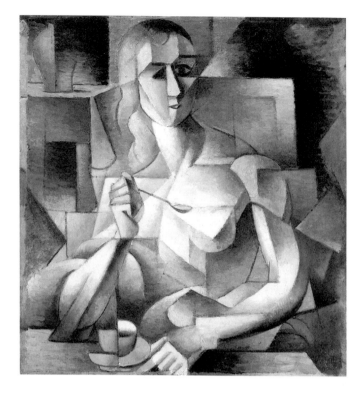

2.29 Jean Metzinger, *Tea-Time* (*Le Goûter*), 1911

(touch, vision, above all taste) is acute. Yet the woman's sensations are known, not felt, by the viewer, and the difference between the two is emphasised both by the diagrammatic juxtaposition of the cup in section and three-quarter views, and the geometric rationalisation of her torso.[95] This didacticism, and the painting's programmatic adoption of the concertina-folded brow motif from Picasso's Horta figure works of 1909, were matched by Metzinger's further codification of gallery cubism in an article he wrote at this time. Published in the daily *Paris-Journal* as a reply on behalf of the salon cubists to a critique of them that had appeared some months earlier, '"Cubisme" et tradition' developed the Bergsonian emphasis on 'mobile perspective' that he had made the cornerstone of Picasso's cubism the previous year, to explain the ideas of his co-exhibitors of room 41: 'They have allowed themselves to turn around the object so as to give, under the control of intellect, a concrete representation of it made of several successive aspects. The painting possessed space, see now that it also reigns in time.'[96]

If such an interpretation took Metzinger away from the real concerns of the painters on whose work it had initially been based, it did provide a means to assimilate, and adapt to the different concerns of salon cubism, some of the most provocative radicalisms of gallery cubism of a year earlier. Pedalling thus backwards in mid-1911 from these, he met Gleizes going forward. The latter had followed his *Woman with Phlox* (figure 2.23) of the start of the year, then his largest work to date,

with a still larger painting, *In the Kitchen* (figure 2.30), whose image of domestic and rural tranquillity and of the nurturing role of woman both clarified the apparent theme of the earlier picture and transposed the elevated allegory of *Abundance* into the minor key of genre. With its awkwardly assertive rounded and angular volumes set in a conventional space, and its monochrome brown colouring, it reprised, similarly, both the expressive means of those paintings and their *gaucheries*. Over that summer, however, as he later recalled, Gleizes found himself often in the company of Metzinger, and the two developed a close working relationship. *Landscape, Meudon* (figure 2.31) recalled the almost daily journey he made to the latter's summer retreat in this village, then on the edge of the south-western suburbs of Paris – the scene depicted is identifiable as the view down-river, west towards the setting sun, with Meudon on the left bank of the Seine and Boulogne-Billancourt on the right. In 1911 the latter area was the site of rapid industrialisation, of the mushrooming factories of car-makers Renault; yet Gleizes represented it in clearly pastoral terms, unmistakably Claudian in reference.[97] Its busy planar geometry, reminiscent of Metzinger's contemporary landscape, replaces his former assertion of dense and fruitful volumes with a kaleidoscope of *aperçus*, equivalences of shape and shifts of perspective – a dynamic interplay of forms and spaces that is expressive of the *élan vital* of nature rather than of the momentum of automobile technology. Together, these qualities implied a message that set the cultural values of the rural past against those of urban modernity.

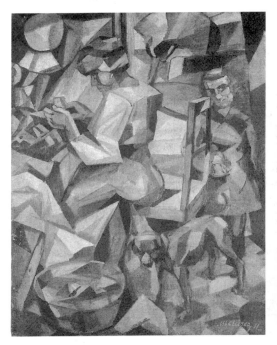

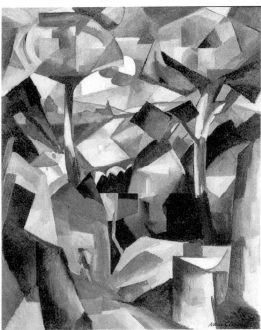

2.30 Albert Gleizes, *In the Kitchen*, 1911 **2.31** Albert Gleizes, *Landscape, Meudon*, 1911

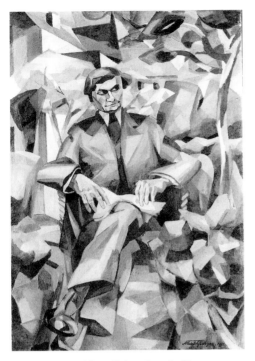

2.32 Albert Gleizes, *Portrait of Jacques Nayral*, 1911

If in stylistic terms this painting marked a change of tack for Gleizes, an appropriation of Metzinger's hand-me-down *picassisme*,[98] the new portfolio of formal devices that he thereby acquired served to enrich his means of representation of an idea that remained consistent with the theme of *Abundance* and the prevailing ideology of the circle centred on it. Attracted by the painterly brio of these modified elements of gallery cubism, which must have seemed a significant advance, in technical terms, from the model provided by Le Fauconnier, he pushed this quality of dynamism further in his next painting, a portrait of his friend and future brother-in-law Jacques Nayral seated in the painter's garden (figure 2.32). Developing from the Meudon landscape's more dynamic passages, as well as, perhaps, from Léger's extraordinary *Nudes in the Forest*, he sought to grasp the 'permanent reality', as he later put it, of his sitter in – and yet also beneath – the equivalences that he established between

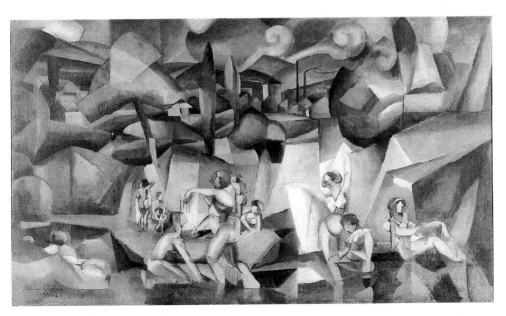

2.33 Albert Gleizes, *The Bathers*, 1912

details of figure and surrounding environment, and which animated the picture surface.[99] The effort was contradictory, however, for the two pictorial logics of fragmentation and structure cancelled each other, and the result was the very 'impressionism of form' for which, ironically, Gleizes condemned the work of Picasso and Braque, in an article written at that time.[100] Perhaps he was arguing with himself as well as fundamentally misreading gallery cubism here, for in his next major picture, *The Bathers* (figure 2.33), shown at the 1912 Indépendants, he returned to the sobriety and relative formal simplicity of the Meudon and earlier paintings. This was a far more successful work, in both technical and thematic terms an accommodation of the interests he had shared with Le Fauconnier to those of the other salon cubists. Acknowledging perhaps the enthusiasm of some of these cubists for the dynamic quality of modern urban and industrial life – examined in chapter 3 – *The Bathers* shows a harmonious and balanced landscape in which emblems of that modernity (factory chimneys and smoke) are interleaved with the surrounding countryside, folded into the rhythms of what is otherwise a thoroughly classical pastoral vision. The devices appropriated from Metzinger are fused with his earlier stress on volumes and deployed, succinctly if somewhat programmatically, to signify at once the qualities of modernity and the primitive – the two held together symbolically, perhaps, by the Bergsonian classicism of the bathers, the arcs of their movements frozen like those of Poussin's *Arcadian Shepherds* as described by Allard.

Cubism and the classicist critique

Few critics outside the *bande à Picasso* and the post-Abbaye circle appreciated the affiliations with the classicist revival inscribed by the developments I have traced in this chapter. Indeed, the hostility towards cubist painting of most writers and artists whose allegiance was to the Maurrassian wing of that revival is a reminder both of the fragmented character of the formation of the literary and artistic avant-garde and of its heteronomy – its dependence on, and articulation of, broader discursive forces. Among the most implacable, and yet most reflective, of such hostile critics was Jacques Rivière, a member from 1909 of the group of writers around Gide's *NRF*, who discussed cubism in general terms and at some length in an article published in March 1912. Starting from a shared hostility to impressionism, which he condemned for its fascination with the passing moment and its fetishising of individual sensibility, Rivière argued, from a neo-Kantian position of which he was then perhaps among the most conspicuous of occupants in the Parisian literary avant-garde, that the task of painting was to 'represent objects as they are, that is, other than as we see them'.[101] From this position of apparent concurrence with their privileging of conception over perception he proposed, first, to 'provide the cubists with a little more freedom and assurance by furnishing them with the underlying reasons for what they are doing',[102] and he applauded in particular their innovations of combined perspective views and inconsistent lighting, arguing that

such devices were necessary for the presentation of an image of an object which was truthful and informative, and which avoided the accidents of its appearance from a single viewpoint. But Rivière's second, and principal, aim was, as he put it, to show 'how badly the cubists have misunderstood cubism',[103] and he ridiculed them for misusing these devices to the point of absurdity, for rejecting the compositional order and hierarchy that they permitted and the clarity of volumes that they served to enhance. In place of order, clarity and truth the cubists produced anarchy, 'that mad cacophony that makes us laugh'. In sum,

> they seem to be parodying themselves ... They suppress the volume of an object because they do not wish to omit any of its elements. They suppress the respective integrity of objects in the picture because they wish to keep them intact. They suppress the depth that serves to distinguish them because they wish to represent its solidity.[104]

And he concluded, with savage derision: 'There is in cubism an extremely interesting and important idea. But there are certainly none more anxious than the cubists to find out what it is.'[105]

What Rivière then laid out by way of an alternative to the mistakes, as he saw them, of the cubists was his own proposed means to the articulation of that idea: a meticulously detailed set of procedures for the representation of the object world that took account of its depth and illumination without employing the deceptions of perspective or fugitive lighting. Instead of the latter, the painter will 'distinguish the different views of an object, yet display these with equal illumination, by means of lightly-drawn arrises that will tilt them away from each other like the slopes of a roof, articulating the solidity that they possessed in nature, retaining their oblique and angular inter-relationships'. The arrises were to be defined with a pattern of light and shade distributed as the need arises, rather than as if from a single direction.[106] Rather than submit an object to the distortions of perspective, the painter will present it 'as we see it when we see it well',[107] depicting the depth and space between them 'as if this were a material thing. Thus, from all the arrises soft planes of shadow will lead off towards the more distant objects.'[108] These proposed formulae are at once ingenious and unusually thought-through for a critic, and one moreover who had no close acquaintance with studio practices, and it is tempting not only to read them in terms of the 1909–10 work of Picasso and Braque, whose low-relief, close-valued, interleavings of plane and space Rivière seems precisely to be describing, but beyond that to conceive of this critic as unique among cubism's first audience in understanding at once the reflexivity of the representational system that Picasso in particular was fashioning and the stubborn materialism that guided him.[109]

To do so would be a mistake, however, for several reasons. First, because although the critic did single out an artist as exemplifying his proposals, it was neither Picasso nor Braque, but André Lhote, 'whose recent works', he noted in closing his essay, 'seem to me to mark, with an admirable simplicity, the decisive

2.34 André Lhote,
Bacchante, 1912

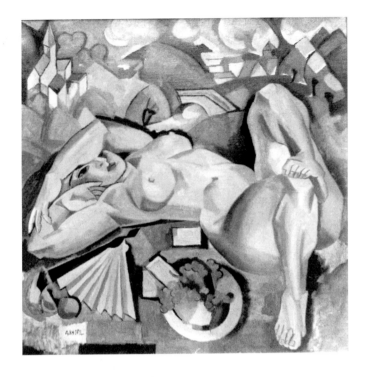

future of the new painting'.[110] A friend of long standing and fellow-member of the *NRF* circle, Lhote had in 1909–12 fashioned a style of painting that amalgamated elements of Cézanne's innovations with the more decorative devices of salon cubism into a superficial, easy-viewing, 'modern classicism' that epitomised the accommodations favoured, as I have noted, by the *NRF*. Rivière had written about his work in 1910 in terms that, as well as assimilating Lhote to his own preferred classical tradition, had anticipated the proposed formulae of his 1912 essay, and reciprocally, the artist seems to have taken up his suggestions (figure 2.34).[111] It is hardly likely that a critic who in 1912 could see such an artist as the great hope of modern painting, and his work as exemplifying his own proposed procedures, would have grasped the point of Picasso's innovations; less likely still that he would be in a position to 'glimpse … [this] peculiar new version of the old modernist saw about truth to the world in painting depending on truth to what painting consists of'.[112] Rivière in 1912 was no modernist, old or new; his interest in the formulae that he detailed in his essay was not that of a painter, and there was nothing in his education or his activities as an *homme de lettres* that might have given him any comprehension of, let alone empathy with, the 'base kind of materialism' that guided Picasso's brush.[113] His concern, rather, was for the truth of objects, which – as a neo-Kantian – he understood to be conceptual, and for a painting that represented it. Rivière's argument was cogent and coherent, but this coherence, for lack of which he so mercilessly castigated the cubists, was won at the expense of any

understanding of the formal ambiguities and equivocations that made their work so
fruitful; the result was a reductive interpretation that betrayed disdain for, rather
than empathy with, painters and their *métier*.

If Rivière's critique identified thus sharply the points of difference between
cubism and the 'modern classicism' of the *NRF* circle, however, Lhote's appropria-
tion of certain of its stylistic formulae illustrated how its innovations could be assim-
ilated in ways that separated the reflexive from the ordered qualities of cubism, and
made of its interrogations of illusionism a set of decorative devices that appealed
unmistakably to traditional French values and genres – and this assimilation itself
shows how permeable were the borders of the avant-garde formation, how its het-
eronomy lay not only in its fragmented character but also in the recuperability, for
the mainstream, of its most iconoclastic gestures. As the appeal both of avant-
gardism and of the nationalist call to order grew in the avant-guerre, numerous
artists found in French medieval and popular art the means to answer both: qualities,
at once formal and symbolic, that provided a substitute for the perceived primitivism
of African art and which reaffirmed, rather than ruptured, their links with national
cultural traditions. Some of them, Derain for one, drew on such sources to produce

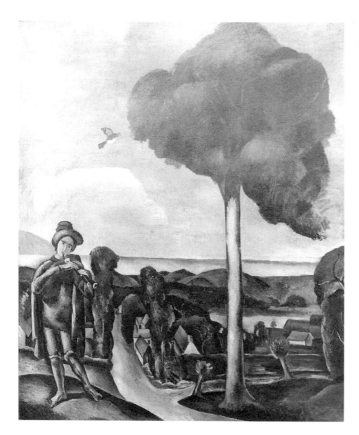

2.35 André Derain,
The Bagpiper, 1911

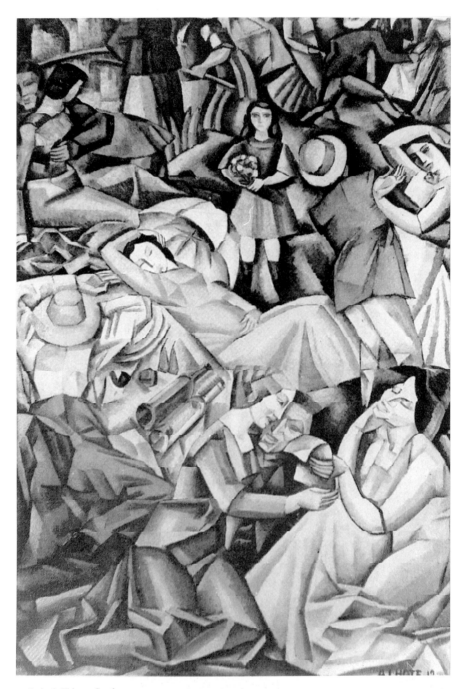

2.36 André Lhote, *Sunday*, 1911–12

works of originality and authority like *The Bagpiper* of 1911 (figure 2.35), whose lyri-
cism and melancholy recall, as modern commentators have noted, the paintings of
Henri Rousseau and, through them, the French *imagier* tradition.[114] Others, such as
Lhote (whose encounter with the romanesque frescoes of Saint-Savin in 1910 was as
decisive for him as had been the sight of a fresco in a Breton church six years earlier
for Denis) succeeded only in pastiching both sources, in paintings such as *Sunday*
(figure 2.36), shown at the 1912 Indépendants, whose confected populism set a
precedent for much of his subsequent work. Somewhere in between the two Roger
de la Fresnaye combined an attachment to the rigours of classicism with painterly
skills and a sharp eye for the decorative potential of cubism's post-1911 hallmark
devices, producing in the immediate pre-war years paintings such as *The Conquest of
the Air* of 1912–13 (figure 2.37) whose balance of French classicism, nationalist senti-
ment and cubist simultanism is finely judged.[115] Yet in certain passages, such as the
vignettes of roofscapes, this work could stand as an illustration of the procedures that
Rivière had advocated the previous year as a corrective to the cubists' mistakes;
which goes to show how diverse were the languages of classicism with which cubism
engaged prior to 1914.

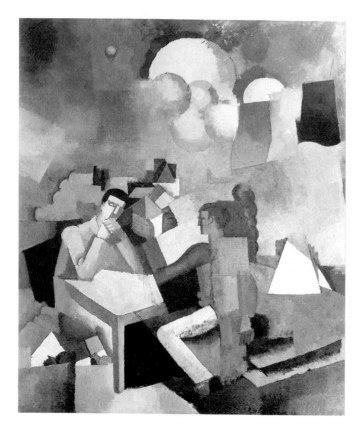

2.37 Roger de la
Fresnaye, *The Conquest
of the Air*, 1912–13

Changing perspectives:
modernolatry and simultaneity

Robert Delaunay: populism and modernity

The *éclat* of cubism's public launch at the 1911 Salon des Indépendants and the perceivable stylistic similarities between the paintings of the occupants of room 41 obscured only partially the fact that both as a movement and as a group style it was an unstable constellation of aesthetic interests and painterly practices. Even at this moment of its début, the differences between the sombre pastoral nudes and domestic interiors of Gleizes, Le Fauconnier, Léger and Metzinger and the vibrant cityscapes of Robert Delaunay did not escape the critics who were shepherding them together. Roger Allard in particular found in the latter paintings evidence of an affiliation to impressionism and a complicity with the ideas of the futurists, both of which he disapproved of, and contrasted Delaunay unfavourably in this with the 'more considered' work of Le Fauconnier.[1] The observation, if not the judgement, was characteristically acute, for Delaunay's three salon entries (probably one from his *Eiffel Tower* series and two on the theme of *The City* – see plate VII and figure 3.1[2]) did indeed represent an awkward – and, as will be seen, interim – amalgam of impressionist colourism and futurist dynamism. But this was not the whole story, for the urban iconography and dislocated perspectives of these paintings registered other affiliations too. While the formal experimentation and avant-gardist iconoclasm of his co-exhibitors brought Delaunay and his wife and artistic partner Sonia into the nascent cubist movement, these earlier allegiances were soon to take them out of it again. This temporary intersection of interests was to have lasting consequences, however, for all parties to it.

Robert Delaunay's artistic education had been unconventional even for a generation for which the emergent formation of the avant-garde was establishing a range of alternatives to the once mandatory training of the Ecole des Beaux-Arts. Unlike other members of the cubist movement, almost all of whom had studied, even if in some cases only briefly, at one or other of the private academies whose avant-guerre heyday I discussed in chapter 1, he acquired the skills of his craft on his own terms, by apprenticing himself, first, for two years, to a firm of theatrical decorators in the working-class quarter of Belleville, and subsequently, if less formally, to the

innovative styles of painting that were annually displayed at the Salon d'Automne and the Indépendants. Both experiences were of lasting aesthetic significance: the former, as we shall see, in giving him the confidence to paint on a large scale, and to work quickly, developing his formal ideas directly on the canvas as he did so; the latter in providing him with a close acquaintance with the late neo-impressionism of Signac and his associates, as well as the fauvism of Matisse, Derain and their friends which was then at the leading edge of avant-gardist innovation.

There was more than aesthetic significance in these apprenticeships, however. Joining the Ronsin studio, if it was Delaunay's own initiative, was an early gesture of independence from the social as well as the artistic circles and conventions customary for a young man of the upper bourgeoisie.[3] Even if not his own idea, the experience entrenched a sense of alienation from his own class, and from the qualities of intellectualism and taste by which he felt it was represented in the avant-garde, and fostered a corresponding populist sympathy towards working-class culture and values. Both of these attitudes Delaunay declared repeatedly in the next decade:

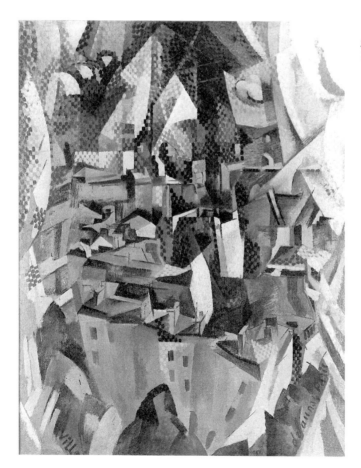

3.1 Robert Delaunay, *The City No. 2*, 1911

'there is a team coming together now', he wrote to the German painter Franz Marc in early 1913, 'which is overturning intellectualism and taste. *Métier* has a big role to play now.'[4] And in an essay of six months later they were coupled with an explicit rejection of the intellectualism of his erstwhile comrades of room 41: 'the world is not our representation recreated by reasoning (cubism), the world is our *métier*'.[5]

The implicit populism of this stress on *métier* was nourished by Delaunay's friendship with the painter Henri Rousseau, and his profound admiration of the latter's work. The two had met in 1906 and, despite the generations that separated them, became very close; as he later indicated, Delaunay was attracted to the old painter by those very qualities that were made fun of by many of the young artists and writers from the milieux of the avant-garde who frequented Rousseau's *soirées*: his guileless self-belief, and in his pictures a wide-eyed enthusiasm for the modern world which for his young friend showed the way towards a painterly language adequate to its representation. In the year following his friend's death, in September 1910, Delaunay drafted, but never completed, a book on his art; the notes that survive, some of which were published after his own death, both indicate what Rousseau's painting meant to him and suggest what he took from it into his own work. This was, above all, a particular combination of traditionalism and modernity. Repeatedly Delaunay's notes celebrate an artistic culture in France outside of, and ignored by, academy and avant-garde alike, and champion Rousseau as representative of it –

> the very type of those painters one meets in the suburbs, in the countryside and small towns, the unaffected and direct expression of artisans, fairground and barbershop painters, amateurs, milkmen etc. Of all this painting, which has its direct root in the fertile ideas of the people, Rousseau was the genius, the precious flower.[6]

Issuing 'from the depths of the people', this art was 'as completely misunderstood in revolutionary as in academic art circles'.[7]

But if he identified with the alienation of his late friend, Delaunay recognised also the huge, yet hard-won, achievements of Cézanne; together they represented, he argued, the 'two tendencies of our epoch':

> Rousseau, the people, always sure of himself, with all that certainty of his race, full of it from the first moment to the last ... Cézanne, the bourgeois, the first mould-breaker, the first saboteur. Two forms, completely distinct, of this heroic epoch of modern painting. Two primitives of this great movement.[8]

As I have said, these twin enthusiasms were shared, at that same moment, by Picasso, whose own homage to the *douanier* and the 'master of Aix' found pictorial expression in the *Bread and Fruitdish on a Table* (figure 2.11). But there were crucial differences between their respective engagement with this inheritance. Picasso found in Rousseau's idiosyncratic, surface-hugging, linear style and its volumetric simplifications a means both to avoid the traps of contemporary painterly formulae and his own extraordinary facility, and to negotiate the

opportunities presented by a re-invigorated classicism and Braque's reworking of this through Cézanne. A consequence of Delaunay's unorthodox artistic education and his friendship with Rousseau, by contrast, was that his engagement with the contemporary classicist revival was much less direct, and was routed through his attachment to that marginalised, popular tradition that the *douanier* represented for him. Moreover, Rousseau's traditionalism was for Delaunay inseparable from his modernity: as he wrote to Marc in the spring of 1913, his old friend's work 'rejoins tradition through its vision, through movement, which is what is modern in him'.[9] Indeed, the example of the *douanier*'s enthusiasm for the emblems of modernity – his readiness to include the Eiffel Tower, aeroplanes, airships and rugby players in his urban iconography – was instrumental in shaping his young friend's artistic development.

By 1909 Delaunay had assimilated some of the lessons of what most excited him in the late work of Cézanne, a posthumous retrospective of whose paintings at the Salon d'Automne in 1907 was a revelation not only for him but also for several other future participants in the cubist adventure. Unlike Braque, Picasso, Gleizes or Metzinger, however, Delaunay's neo-impressionist-informed interest in colour led him first not to the conceptual simplifications and exaggerations of the *Cottage and Trees* (figure 2.8) but to perceptual concerns. As he wrote later: 'Cézanne's watercolours announced cubism. Their coloured, or rather luminous, plans destroyed the object.'[10] Prompted perhaps by the exhibition of these late watercolours at galerie Bernheim-Jeune in May 1909, he began that month a series of paintings of an aisle of the church of Saint-Séverin in the Latin Quarter that explored the visual sensation of deep space, and the role of colour and mobile perspective in its representation (figure 3.2).[11]

There was perhaps more in Delaunay's choice of subject for these paintings, though, than his interest in perception alone. As Pascal Rousseau and others have noted, the gothic was a key term of reference in the burgeoning debate over the cultural identity of France, standing for many of its participants as emblematic of qualities that were fundamental to that identity – whether these were understood as primitive or classical, all were agreed on their importance.[12] Delaunay's unorthodox artistic education, it seems, had left him outside of this debate, but his strong attachment to artisanal cultures, and those traditions of which Rousseau was the 'precious flower' was certainly congruent with, and surely drew on, the populist aspects of Barrésian discourse, by then hegemonic, that I have noted, and he may well have thought of Saint-Séverin and the gothic in such terms. It is likely, however, that he was also influenced in this choice (and in that of the spire of Notre-Dame for the subject of another series of paintings in that same year) by the availability of postcards of both motifs, and by their presentation of aerial perspectives on the city. For such new views were a staple genre of postcards in that avant-guerre, a product of the contemporary enthusiasm for the emblems and experiences of modernity for which the futurists coined the term *modernolatrià*. Delaunay was an inveterate collector of such postcards, many of which survive in

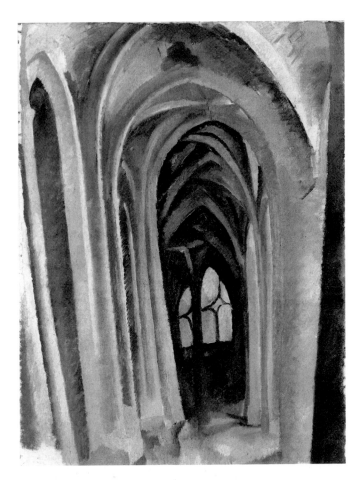

3.2 Robert Delaunay,
Saint-Séverin No. 2,
1909

the archives of his and Sonia Delaunay's papers in Paris, and he often used them as
starting-points for his compositions.

It is one such card, indeed, that marks the moment of a radical development of
his aesthetic and perceptual interests, and one in which the modernity, rather than
the traditionalism, of the art of his friend Rousseau was instrumental. In
September 1909 Delaunay painted one of the first of his many images of the Eiffel
Tower, *The Airship and the Eiffel Tower* (figure 3.3). Based on a postcard view of
the dirigeable *République* circling the Tower that same month (it was destroyed on
25 September in a crash), the little picture was also indebted to the example of
Rousseau. For the latter had amended a recent painting of his own, *View from the
Sèvres Bridge*, to mark the event, placing in the empty sky a balloon, the bi-plane
of the Wright brothers and the *Republique*, and it was probably in response to this
gesture of modernolatry that Delaunay – who already owned Rousseau's
Landscape with the Airship 'La Patrie' of 1907 – painted his own version of the
same event.[13] It borrows from the *douanier* in stylistic terms also, adding to its

Cézannesque tonality and brushwork a Rousseauesque linearity and simplification of volumes. The year 1909 was also, of course, that of Louis Blériot's celebrated first aerial crossing of the English Channel, an event whose preparation and achievement that July had been followed with universal enthusiasm. The French press declared 1909 'aviation year',[14] but in fact aviation mania rose steadily in France with every subsequent year that passed until the war, and the papers carried almost daily stories about new exploits and articles about the scientific, sporting and, increasingly, military potential of aeroplanes. Yet Delaunay pursued this enthusiasm further than most,[15] and Rousseau's example in 1909 was the provocation to an engagement on his part, both with the motifs and aerodynamics of aviation and with what it stood for in terms of modern experience, that was aesthetic as well as popular.

While the *douanier* provided the painterly precedent and the cultural legitimation for Delaunay's transcription of his populism into a modern key, however, it was supported by other factors, chief of which was the spreading influence, among

3.3 Robert Delaunay, *The Airship and the Eiffel Tower*, 1909

the circles into which he found himself drawn from 1909, of the ideas of the poet Jules Romains and of the Italian futurists. Romains's poem *La Vie unanime*, published by the Abbaye Press in 1908 to wide acclaim, celebrated the innumerable collectivities (of, among others, workplace, neighbourhood, class and custom) that both structured social life in the metropolis and dissolved the individuality of each of its inhabitants – subsuming all of which was the urban agglomeration itself: 'I am like a grain of sugar in your mouth, glutton city', he wrote.[16] Critical response to the poem yielded a term, *unanimism*, for its principles; *La Vie* and the works with which Romains followed it over the next two years won the poet a modest celebrity. Drawn to the post-Abbaye milieu in 1909–10 partly through his friendship with some of its habitués, in particular Fernand Léger and Alexandre Mercereau, Delaunay found much in unanimism that overlapped with his emerging interest in the visual experience of modernity. At the same time, he and his new associates found both support and provocation for their ideas, as well as a direct challenge to their avant-gardist self-esteem, from a source outside of Paris. Filippo Marinetti bought space on the front page of *Le Figaro* in February 1909 to publish his 'Founding manifesto of futurism' which hymned 'the multicoloured, polyphonic tides of revolution in modern capitals', and it was followed just over a year later by the 'Technical manifesto of futurist painting' in which the leading futurist painters spelt out how artists should seek to represent this urban and industrial modernity: 'The gesture which we would reproduce on canvas shall no longer be a fixed *moment* in universal dynamism. It shall simply be the *dynamic sensation* itself', they declared. 'The construction of pictures has hitherto been foolishly traditional. Painters have shown us the objects and the people placed before us. We shall henceforward put the spectator in the centre of the picture.'[17] Although as yet unsupported by any evidence of pictorial achievement in this direction, the outspoken modernolatry and innovative self-publicity of these Italians gave them an instant avant-gardist reputation in the Parisian artistic press that was impossible for the nascent salon cubist milieu to ignore – and there was talk, throughout 1911, of an exhibition of futurist paintings at Bernheim-Jeune that November.[18]

The futurists' engagement with perceptual experience was clearly congruent with Delaunay's concerns in the *Saint-Séverin* series, while their modernolatry chimed with the enthusiasms of several members of the post-Abbaye circle. It was in this context, and perhaps in response to these stimuli, that he embarked on an exploration of the theme of urban modernity and its visual experiences, to which the *Airship and Tower* was the prelude. This exploration took the form of two series of paintings that he worked on concurrently, one of the Tower itself and the other of a view across the city's rooftops towards its distant silhouette on the Paris skyline. It was a subject clearly emblematic of modernity in the popular imagination and, as a defining feature of Paris shared by – and simultaneously visible to – all of its inhabitants, provided a focus for that collective metropolitan identity celebrated by Romains. But the Tower in both representations also afforded Delaunay the means to develop his perceptual and painterly concerns: its colossal height, the

startling juxtapositions of perspective as it loomed over buildings or closed a street vista were extrapolations on a grand scale of the sensations that the 'Saint-Séverin' series had addressed. The *Eiffel Tower* now in Karlsruhe (figure 3.4), painted probably in May 1910 in Nantua, near Lyon, where he and Sonia spent that summer (and thus worked up from sketches, postcards and memory) was among the first products of this set of interests, and its compositional framework with the two halves of the Tower, viewed from below and from above at once, collapsing into each other like the result of an earthquake,[19] served as the template for the major Tower paintings of the next year, in each of which Delaunay progressively enhanced the dynamism – both 'modernolatrous' and perceptual – of his subject. The first of these was probably the *Tower with Curtains* of 1910–11 (plate VII) that he showed in room 41 at the 1911 Indépendants, where its conceit of curtains framing the view caught the imagination, as we have seen, of critic Roger Allard.

The device of the curtains also proved fruitful for the series of *City* paintings (based on a postcard view – figure 3.5 – taken from the top of the Arc de Triomphe towards the Tower) on which Delaunay was concurrently working, and indicates the interactive relation between the two compositional schemes. From the beginning of 1911, curtains like those in the room 41 *Tower* posited once again the view

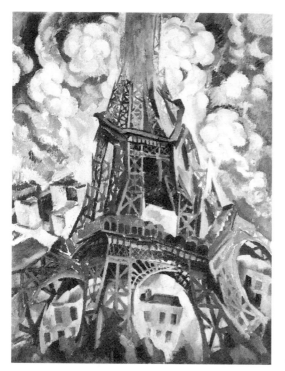

3.4 Robert Delaunay, *Eiffel Tower*, 1910

3.5 Postcard showing view from Arc de Triomphe towards Eiffel Tower, *c.*1910

from a domestic interior out across the city (figures 3.1 and 3.6). This suggestion was reinforced by the introduction of a neo-impressionist pattern of little squares that hangs, in the Guggenheim work, across the entire scene like a screen of lace. But this screen serves also, in that painting, to fragment the components of the middle distance; superimposed on a rectilinear grid that seems to be derived only partly from the motif and is shot through by shafts of sunlight like those of the *Tower with Curtains* – only now geometricised into angular facets – its effect is to tie the illusion of deep space back onto the surface and to enhance the reflexive quality of the latter.

In his handling of the upper half of the picture especially, Delaunay thus came close to gallery cubism, in particular to the appearance of the works that Picasso and Braque brought back from their previous summer's work in Cadaqués and L'Estaque, respectively (figure 2.17). His aesthetic interests still fundamentally distinguished Delaunay's work from gallery cubism at this time; specifically, his engagement with questions of perception and colour science, and his exploration – for which the picture–window conceit was to be central – of non-mimetic ways of representing on canvas the perceptual experiences characteristic of urban

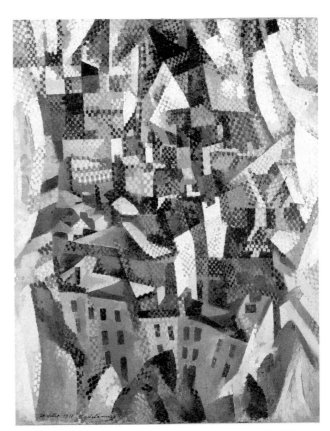

3.6 Robert Delaunay, *The City*, 1911

modernity, stood in clear contrast to the conceptual and linguistic orientation of Picasso and Braque's contemporary work. Indeed, his re-adoption of a pointillist *facture* was probably provoked in part, as his perceptual interests were confirmed, by the re-publication that year of Signac's *D'Eugène Delacroix au néo-impression-nisme*. Yet the grisaille colouration of its patterning in *The City* surely owes as much to its deployment by Picasso and Braque as it does to Signac's precepts – a deployment which, as T. J. Clark observes, mocks the pretensions of those pre-cepts to scientific truth and insists on the artifice of neo-impressionist technique by rendering it in, of all things, black (or brown) and white.[20] In the next, and final, painting of the series, *Window on the City No. 3* (figure 3.7) of December 1911, he pursued yet further the implications of the rectilinear grid that characterised their current explorations, consolidating it into a clear checkerboard configuration, counterpointing it with a second – diagonal – grid of pointillist squares, and extending both to cover the picture's entire surface.

This foregrounding of neo-impressionist technique seems to have posed prob-lems, however. The shift to a 'landscape' format canvas loosened the equation of picture with window, reducing the interplay with deep space of the preceding

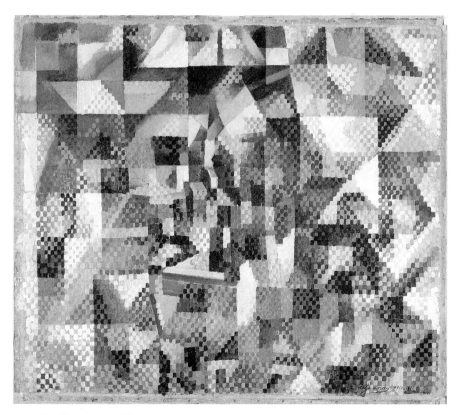

3.7 Robert Delaunay, *Window on the City No. 3*, 1911

works to a small central diamond-shaped area. At the same time, the kaleidoscope of checkered squares and triangles that surrounds this only partly references the framing curtains; elsewhere, anchored neither to perceived particulars of the motif nor to a spatial orchestration of colour (the relationships of which remain largely tonal, and dominated by a play of black and white), it comes dangerously close, for Delaunay, to ornamental abstraction – paralleling in this the stylisation that, I suggested, characterised Braque's *Mandora* (figure 2.13) of a year earlier. Perhaps he recognised as much, for after this painting he dispensed with neo-impressionist brushwork, relying instead solely on the scaffolding of the cubist grid for the *Windows* series of works through which he pursued, over the course of 1912, his experiments in the constructive potential of colour.

Gallery cubism had its effect, too, on the *Tower* series. In responding to the challenge of the futurists, Delaunay worked to maximise the dynamic sensations that this subject represented: bringing the putative viewer out from the safety of a domestic interior into the maelstrom of the city by substituting *repoussoir* buildings for the framing curtains of the previous *Tower*, changing the proportions of his canvas to stress the Tower's dizzying height, collapsing summit into base with ever greater abruptness (figure 3.8).[21] The effect of these changes was also, however, to lessen both the reflexivity that the picture–window conceit introduced and the interplay between surface and depth it afforded; in the terms set by gallery cubism, these were

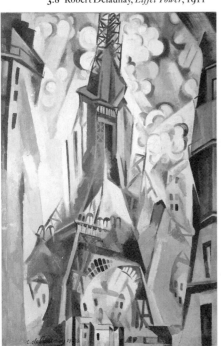

3.8 Robert Delaunay, *Eiffel Tower*, 1911

serious losses. His response, in a cluster of works painted at the end of 1911, was to alter radically the configuration of the Tower so that both base and summit were viewed as if from above, montaged together and flattened against an arabesque pattern derived from an aerial photograph of the Champ de Mars (figures 3.9, 3.10). The result was a compositional formula that exchanged a representation of the dynamism of urban experience anchored in *perception* for one grounded in *conception*; as such, and for all the modernolatry of its subject, this was a tilt towards the aesthetics of a cubism that his friend Metzinger was active in promulgating.

As with the contemporary *Window on the City No.3* (figure 3.7), then, Delaunay's exploration and accommodation of the innovations of gallery cubism had led him, by the end of the year, to a certain equivocation. It was perhaps fortuitous that at that moment he was able to mount a retrospective exhibition of his work to date: in February 1912 he shared the galerie Barbazanges with Marie Laurencin, showing

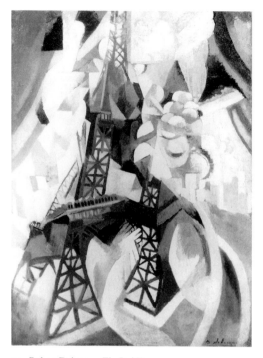

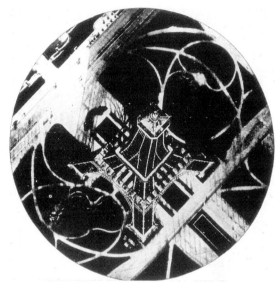

3.10 Aerial photograph from top of the Eiffel Tower, 1909

3.9 Robert Delaunay, *The Red Tower*, 1911

forty-six works, some of them assiduously borrowed from collectors across Europe, the ensemble of which must have given him a unique chance to take stock. The result was immediate and impressive: the monumental *City of Paris* (plate VIII), painted in less than a month, in time for inclusion in the 1912 Indépendants, at once a resume of his preoccupations and allegiances of the previous two years and, as will be seen, a stepping-stone to his emerging interests.

Simultaneity (1): everywhere at once

Mention of Metzinger should serve to remind us that Delaunay was not alone in his negotiations with gallery cubism on the one hand and futurist ideas on the other. Although he seems to have been more comfortable working in isolation than in close companionship with other painters, including his wife Sonia,[22] 1911 was a year of heady collective experimentation and rivalry within the salon cubist milieu, for all of whose members, though in a variety of ways, the ideas of the Italians and the paintings at Kahnweiler's gallery provided both challenge and inspiration. It was probably during the weeks that surrounded their debut in room 41, I have suggested, that its participants first became directly acquainted with the cubist paintings that were hung unobtrusively in Kahnweiler's tiny gallery in the rue Vignon, as they were drawn, with the encouragement of Allard and Apollinaire, both towards a deeper

understanding of the common ground between themselves and to recognition of the avant-gardist advantages of building upon it. Léger later recalled that

> if Apollinaire and Max Jacob hadn't come to see us, we wouldn't even have known what was going on in Montmartre. They told us to go to Kahnweiler's, and there, with old Delaunay, we saw what the cubists were doing. And Delaunay, surprised by the sight of their grey canvases, exclaimed 'But they paint with spiders' webs, these guys!' That helped to lighten the mood a bit.[23]

Delaunay's remark suggests that what they saw were the post-Cadaqués and pre-Céret paintings of Picasso and Braque, and this is supported by other evidence.[24] Although there was thus little opportunity (and, as I argued earlier, little incentive) for any of them except Metzinger, who already had a foot in both camps, to adapt in their own work the devices they saw in these pictures of the spring of 1911, most of the features that were the hallmarks of this phase of gallery cubism – the arbitrary distribution of light and shade, the juxtaposition of radically disparate viewpoints, the fragmentation and elision of forms and their surrounding spaces, and the reduction of signifiers to a spare and nearly abstract geometric scaffolding – did find their way, over the following year, into salon cubist painterly practice. But they were refracted, in the process, through the specific interests of each of its adherents, and altered in fundamental ways as a result. For these interests were multiplying through 1911, as the salon cubist circle widened. At the 1911 Salon d'Automne the principals of room 41 not only reprised their spring *succès de scandale* – their works were once more grouped together, again to the disgust of journalist critics and the hilarity of the salon public – but also amplified it, with new adherents showing work alongside theirs, and another exhibition that followed hard on the heels of the Automne's.[25]

The concerns of Léger in particular were closest to those of Delaunay, of all those in this now wider circle, and yet also distinct from them. Léger spent the summer following the group's debut at his family home in Normandy, returning with a painting for the Salon d'Automne, the monumental *Study for Three Portraits* (plate IX) that was at once a development of his own *Nudes in the Forest* (figure 2.24) and an acknowledgement of the paradigms set by other cubists. What this development yielded, however, was an impressionism of form in which an exaggeration of the density of volumes and their dissolution by light worked to cancel each other out; more critically, perhaps, it substituted a rhythmic and harmonious integration of forms for the counter-pastoral dynamism of the *Nudes*. On reflection (and his return to the city) Léger seems to have preferred the latter, for in his painting from that autumn he changed tack, following Delaunay (whose near-neighbour he now was) in engaging with the challenges and promises presented by gallery cubism and futurist modernolatry. A series of small works of late 1911 based on the view across the Paris skyline from his new rooftop studio was the vehicle for an exploration of the dynamic character of city vision; the motif was identical to that of Delaunay's *City* paintings, only with Notre Dame replacing the Eiffel Tower as the distant focus and plumes of

chimney-smoke the shafts of light (figure 3.11). But where the latter had adopted
gallery cubism's fragmentation, repetition and elision of solids and spaces as a means
of dissolving forms, Léger developed the possibilities of contrasts between them, to
produce a battle no longer only of volumes but now of curves, angles, lines and
planes, and fashioned the device of mobile perspective into a means of montaging
radically disparate views onto a pictorial surface whose reflexivity was grounded not,
as with the picture–window conceit of the *City* paintings, in perception, but – like
the recent explorations of Picasso and Braque – in conception; that is, in an acknowl-
edgement of the conventional character of pictorial representation.

 Such devices and concerns, it must be emphasised, were the talk of the studios in
the salon cubist milieu in late 1911; prompted not only by technical enthusiasms but
also by avant-gardist rivalries that were both interpersonal and international, and by
the growing notoriety of the movement, each man from room 41 was quick to appro-
priate and adapt, and to take a distinctive position on, the latest pictorial innovations.
The impending exhibition of the futurists sharpened the salon cubists' sense of that
distinctiveness. Although as yet an unknown quantity in pictorial terms (with the
possible exception of the work of Severini[26]), the ideas in their manifestos were so
congruent with those circulating in the post-Abbaye milieu, their promotion of
them so full of swagger, that their Parisian debut was keenly anticipated. 'The simul-
taneousness of states of mind in the work of art: that is the intoxicating aim of our art',

3.11 Fernand Léger, *Smoke Over the Rooftops*, 1911

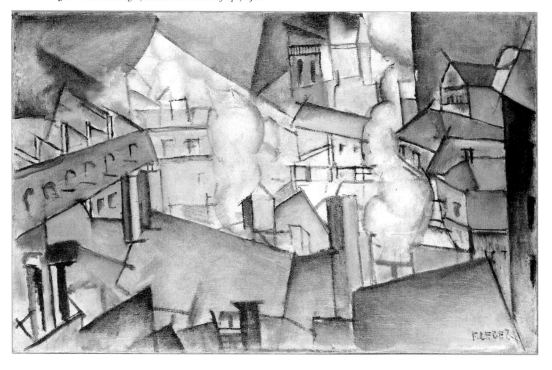

they declared in 'The exhibitors to the public', the Preface to their Bernheim-Jeune catalogue. 'In order to make the spectator live in the centre of the picture ... the picture must be the synthesis of *what one remembers* and of *what one sees*'.[27] There was much here that both coincided with the aesthetic concerns of the salon cubists and corresponded fairly closely with certain of their painterly devices – and given the increasingly international (and increasingly rapid) character of avant-garde networking, it is not easy to determine the provenance of these ideas. Boccioni elaborated many of those summarised in 'The exhibitors to the public' in a lecture in Milan in May 1911, but the visit that he and the other futurist painters paid in October 1911 to Paris, where they reconnoitred the studios of Gleizes, Metzinger, Le Fauconnier and others (apparently at the behest of Severini who, alone of the signatories to their 'Technical manifesto', had first-hand acquaintance with cubist paintings) was itself an occasion for discovering what both gallery and salon cubists were up to.[28] If the engagement of Delaunay and Léger with the representation of urban dynamism was in part a response to that manifesto, for his part Boccioni appears to have returned to Milan from his tour of Paris studios full of what he had seen in them; his *Simultaneous Visions* (figure 3.12), painted later that year, borrows from Delaunay's *City No. 2* and *City* (figures 3.1 and 3.6) its plunging, vertiginous, foreground perspective, and his reworked *States of Mind* triptych seems equally indebted, in its use of stencilled lettering and rectilinear scaffolding, to the example of Braque and Picasso (figure 3.14). In the last analysis, such borrowings have to be seen as more than mere plagiarism, in either direction: they registered, rather, a convergence of interests in exploring new means of visual representation of a modernity that was yet subject to different interpretations. This convergence was at once attested to and characterised by the ubiquity, but also the multiplicity of meanings, acquired by the buzzword 'simultaneity' from the end of 1911.

It is generally agreed that the Italian artists were the first to make the term a *mot du jour* in avant-garde discussions, in the manifesto of late 1911 here quoted from,[29] but those discussions were themselves shaped by that popular discourse of 'modernolatry' already noted, and in particular by those aspects of it for which the radical changes in spatio-temporal experience consequent on new technologies of travel and communications were central. The Exposition universelle of 1900 had featured several spectacles, most of them mechanised variations of the diorama, that celebrated such experience in their simulation of intra- and inter-continental travel (such as *Tour of the World* and the *Panorama of the Trans-Siberian*) or of balloon flights over Paris (such as Grimoin-Sanson's *Cinéorama-Balloon*). 'The realism of these attractions', notes Vanessa Schwartz, 'derived from both the subject they represented and the technology that put passengers in the middle of things and simulated motion'[30] – and the subsequent decade saw a rapid and widespread diffusion of such experiences through, on the one hand, a proliferation of cinematic, photographic and literary representations of them, and on the other the burgeoning of aviation technology and associated aviation mania. It was this popular appetite for the experience of what they termed 'simultaneity' that the futurists

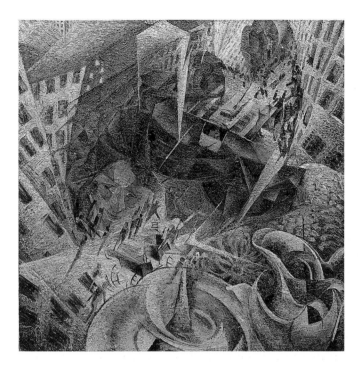

3.12 Umberto
Boccioni, *Simultaneous
Visions*, 1911

both exploited in their avant-gardist hyperbole and sought to articulate in their
painting by 'making the spectator live in the centre of the picture', and it was the
apposite quality of their term that gave it such ubiquity.

They were not alone in this initiative, however. 'Simultaneity' bore a resem-
blance to Jules Romains's guiding concept of *unanimism* – although his celebration
of the collectivities of the modern metropolis contrasted with their still funda-
mentally individualist modernolatry[31] – and his aesthetic provided an organising
formula for the articulation of the experiences of urban modernity; in the literary
and artistic avant-gardes of Paris, unanimism was followed over the next few
years, as will be seen later in this chapter, by several other related '-isms' that
hymned the new beauties of modern cities and the 'intense life' of their crowds.[32] I
have suggested that Léger's *Nudes in the Forest* drew on Romains's example in its
bold (but somewhat incoherent) counter-pastoral dynamism (while his *Smoke
Over the Roofs* series looked to that of Delaunay's cityscapes); his next work
brought those concerns together into a resolved and impressive pictorial state-
ment. Again adapting Delaunay's window motif, *The Smokers* (figure 3.13), of the
winter of 1911–12, presents in the foreground two half-length figures facing the
viewer and positioned on a balcony; in the background behind them, framed by
balustrade and curtains, and fragmented like the Paris roofscapes of his previous
paintings by billowing smoke – here, from their pipes – a view of a field, trees,
houses and other buildings. Significantly, this is neither an urban nor a rural land-
scape, but that point at the edge of town where the two meet: a characteristically

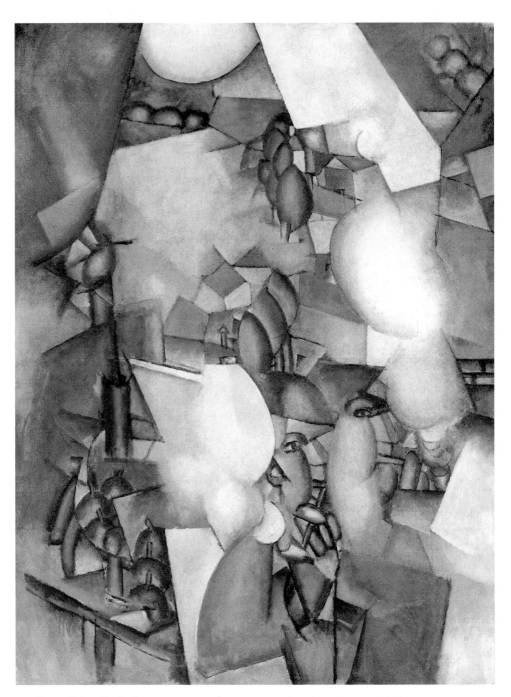

3.13 Fernand Léger, *The Smokers*, 1911–12

abrupt boundary at a time of rapid urban sprawl, and one that Léger appears to take both as a metonym for modernity and as a site of the dynamic visual contrasts for which he was finding expression in his painting. The smokers, mediating between the viewer and the scene behind them, seem to be agents of this urban dynamic, the puffs of their pipe-smoke animating the surface pattern and marshalling its encircling upward movement.[33]

Close as Léger's enthusiasms were to those of the futurists at the end of 1911, there were significant differences: *Smokers* displays none of the Italians' interest in, or means of, representing either states of mind or movement. But within weeks his thinking seems to have changed, for his major entry to the Indépendants the following spring, *The Wedding* (plate X), appropriated and developed both.[34] Although similar to its predecessor in its use of smoky volumes and sharp formal contrasts, this huge painting used these devices to very different effect – not to animate an observable prospect, but to frame, fragment and articulate on several levels an image built from remembered visual perceptions. This is an image of a wedding as a unanimist event, an instance of one of those collectivities, Romains's little deities, that direct the lives of modern men and women. As such it parallels closely Boccioni's triptych *States of Mind*, and Léger's deployment of veils and shards of smoke resembles especially the second version of that work's central painting *The Farewells* (figure 3.14), whose swirling vapours suggest both the steamy locomotive

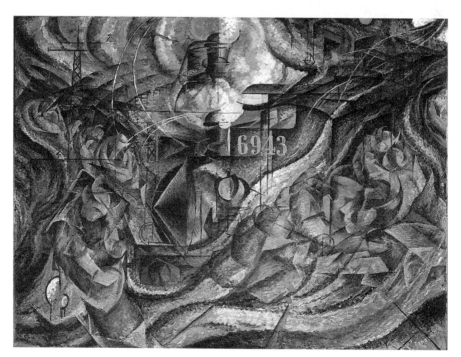

3.14 Umberto Boccioni, *States of Mind I: The Farewells*, 1911–12

and the emotive ambience – except that *The Wedding*'s vapours have no perceptual origin; like the mists of memory, they sweep the scene into a spiralling motion that, for this viewer, seems to anticipate the dizzy-spin device of Hollywood film 'flash-backs'. In formal terms, the picture draws together Léger's explorations and inno-vations of the previous several months, from the *Study* to *The Smokers*, joining the implicitly Bergsonian splintered forms and flickering movement of the former with the dynamic contrast of lines and planes, volumes and hues, that characterised the latter – but its opening out towards the concerns of the futurists registered the cur-rency of these, and the gathering momentum of the discourse of simultaneity, within the milieu of salon cubism.

Others within the circle that gathered at the weekly meetings in Puteaux also responded, though in fairly complex and sometimes ambivalent ways, to the futurists' polemic, refracting the concept of simultaneity and its connotations through their existing concerns. On an avant-gardist level, Gleizes and Metzinger in particular felt it incumbent on the group to meet the challenge of the Italians – although, as Duchamp later noted, the group was 'far from homogeneous', these two painters sought, in the words of another of its members, Ribemont-Dessaignes, 'to establish a kind of legislation of the cubist movement', going so far as to insist on Duchamp's removal from the 1912 Indépendants of his painting *Nude Descending a Staircase No. 2* (see p. 159), lest its plainly cinematographic depiction of that descent seem too obvious, and too public, an acknowledgement of the force of futurist example.[35] It was probably also during this winter of 1911–12 that they began to write *Du 'Cubisme'*, the 6,000 word statement of cubist principles and critique of its rivals (futurism, unnamed but clearly identifiable, among them) which they published the following autumn as cubism's self-appointed spokespersons. Metzinger had already sought over the previous eigh-teen months to codify the pictorial innovations he discerned in the paintings of both wings of the movement around the concept of a 'mobile perspective', a Bergsonian interpretation of cubism's juxtaposed viewpoints; in *Du 'Cubisme'*, with Gleizes, he reprised this idea, implicitly contrasting this sense of simul-taneity – 'the fact of moving around an object to seize it from several successive appearances, which, fused into a single image, reconstitute it in time' – with that of the futurists – 'And those who mistake the bustle of the street for plastic dynamism will eventually appreciate the differences.'[36]

For Metzinger, these differences were not so much due to the Bergsonian tenor of his idea of dynamism (that, at least, cubism shared with futurism), as to the role it allocated to intellect, and in particular to geometry. The cubists 'have allowed themselves to move around an object so as to give, under the control of intellect, a concrete representation of it made of several successive aspects', he had written a year earlier;[37] almost certainly on his initiative, *Du 'Cubisme'* related their explo-rations to non-Euclidean geometry and to Riemann's theorems.[38] Number had held, indeed, a permanent fascination for him: 'It is Number that separates sounds from silence, light from shadow, form from void. Michelangelo and Bach seemed

like divine calculists to me.'[39] 'It was this science that gave me a taste for the arts', he later recalled, writing of his studies as a schoolboy in Nantes: 'Already I sensed that mathematics alone enables a work to last. Whether it is the result of patient study or a vivid intuition, it alone is able to reduce to the strict unity of a mass, a fresco or a [sculptural] bust our pathetic diversities.'[40] This fascination with number was instrumental in placing Metzinger at the centre of the cubist movement for a time in 1912. Gleizes, for his part, followed up *Du 'Cubisme'* with a series of statements, on his own behalf, that were increasingly coloured by nationalism and xenophobia.[41] Yet his painting over the same period displayed a more nuanced response to current debates in the Puteaux milieu. If *Bathers* (figure 2.33), which he showed in the 1912 Indépendants, held industrial modernity and classical pastoral in a careful balance that still owed much to the example of Le Fauconnier's painting, as I noted in the previous chapter, the work that followed amplified that accommodation between embracing the present and attachment to the past with formal means that belonged to the vocabulary of simultaneity. *Passy* (*The Bridges of Paris*) (figure 3.15), first shown at the Société Normande exhibition in June and probably painted that spring, resembles Léger's *Wedding* and Delaunay's *City of Paris* – but is more radical than either – in its discontinuities of forms and vistas, montaged together like cut-and-pasted postcards into abrupt vertical juxtapositions that are surely indebted also to Picasso and Braque's paintings from Céret of the previous summer

3.15 Albert Gleizes, *Passy (The Bridges of Paris)*, 1912

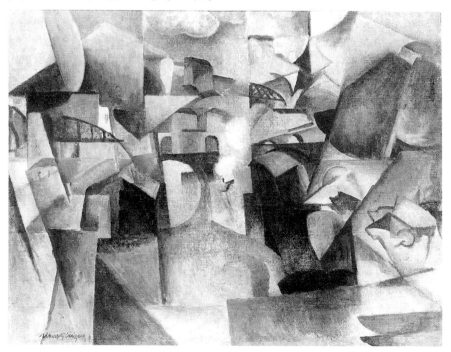

(see figure 3.16). Ignoring the reflexive qualities and implications of all of these works, however, Gleizes focused on the thematic potential of such discontinuities, presenting a composite image which imbricates views of steel swing-bridges and stone arches as metonyms of old and new Paris. For all its apparent radicalism, the organising perspective of *Passy* remains that of a conventional landscape, while the sobriety of its colour and composition are tacitly classical in reference. Gleizes thus repeated in this work the message of the *Bathers*, reaching an accommodation with the enthusiasms of his fellow cubists in the representation of a diachronic, rather than synchronic, simultaneity, a reassertion of temporal continuity and of Bergsonian *durée* in a nationalist key.[42]

Having thus arrived at what was an effective, if eclectic, synthesis of potentially conflicting approaches to modernity and the deployment of the pictorial conceits of cubism in its representation, Gleizes worked over the next year both to enrich it and to make it his own. Two ambitious and complex paintings, the centrepieces of successive autumn showings, were the principal result. *Harvest Threshing* (plate XI), first shown in the Salon de la Section d'or of October 1912,[43] was a huge picture, at over 2.5 by 3.5 metres dwarfing the other exhibits. It was less fragmented spatially than *Passy*, but also less legible, its fundamentally conventional spatial recession and unity of focus on the group of harvesters overlaid with a busy compositional geometry that has affinities with the contemporary work of Metzinger. Allard would remark somewhat disparagingly of the latter's recent pictures a year later that they were more complicated but not more complex than his previous work;[44] the same might be said, too, of Gleizes's painting, except that the organising trapezoidal schema of *Harvest Threshing* has a more than decorative effect. For it ties the sweeping rhythms of the harvesters and of the background trees and hills into a pictorial order that in 1912 had associations of tradition and continuity in both aesthetic and social terms, referencing (and hymning) the timeless inevitability of the harvest as constitutive of community at the level both of *le pays* and, by implication, the race and the nation as well.

Gleizes's substitution of a linear scaffolding for the cut-and-paste montage of *Passy* can, moreover, be seen in technical terms as a step towards a systematic approach to, and accommodation with, the reflexive possibilities of gallery cubist painting, that he eventually formalised in the 1920s.[45] The diagonal sides of its central tilting trapezoid adumbrate his use of a device that Braque and Picasso had already made familiar (plate IV) although, as Daniel Robbins first noted, Gleizes's use of it to mediate between a picture's framing rectangle and the often deep space of his landscape motifs differed from its deployment in the shallow spaces of their paintings. As such it was a register of the steady ascendancy that gallery cubism was gaining, as will be seen, within the Puteaux circle.[46] Yet his major paintings of 1913 held to a typically salon cubist engagement with simultaneity – indeed *The Football Players*, shown in the Indépendants that opened in mid-March 1913, had an enthusiasm for modern and popular subject matter shared by Robert Delaunay, whose *Third Representation: The Cardiff Team* (see p. 118) was in the same exhibition. If

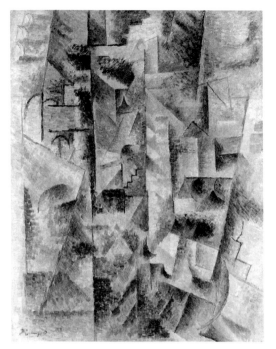

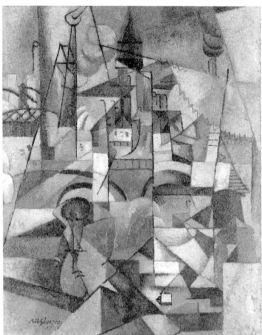

3.16 Pablo Picasso, *Landscape at Céret*, 1911 3.17 Albert Gleizes, *The City and the River*, 1913

his next salon 'machine', *The City and the River* (figure 3.17), his principal entry at
the 1913 Salon d'Automne, was less wholeheartedly modern in its subject, it was
nevertheless an upbeat, dynamic representation of the modern industrial city.[47]
Combining the montage of vignettes of his motif that *Passy* introduced with the
linear scaffolding of *Harvest Threshing*, with paired diagonals configuring once
again an implied tilting plane that both indexes the picture surface and orchestrates
the disparate elements of its montage, this was a development in formal terms. Yet,
as in those paintings, such elements fall into place in a conventional perspective
whose coherent spatial recession, punctuated midway by the bridge pier, is closed
by the church and its spire – and it is these pre-industrial features that, with
the river, command the scene into which the emblems of modernity (iron bridge,
factory, stevedore) are set. Once again, the simultaneity is dynamic – vital –
but diachronic, the old and the new bound together in a harmony grounded in
tradition.

Where Gleizes thus found a (fragile) harmony, Le Fauconnier found himself in
1911–12 in a dilemma. His painting after *Abundance* was shaped by the twin vectors
of avant-gardist ambition and nostalgic, tacitly anti-modern, ruralism which that
keynote picture registered, and in the eighteen months that followed the group's
debut in room 41 he made a series of increasingly complex yet ponderous salon pic-
tures whose dense facture and obscure imagery betrayed the development of the

tension between these two motivations into a contradiction. It was just as the futurists paid their first visit to Paris that he began work on *The Huntsman* (figure 3.18), a painting even bigger than *Abundance*. Exhibited at the Indépendants the following spring and intended clearly as a sequel, it incorporated not only the two principal figures from that painting but also the striking innovation – and one which he seems to have been the first of the salon cubists to adopt – of isolated vignettes (a railway bridge, a church, a villagescape) inserted within the scene with no attempt at their spatial reconciliation with it. An example of simultaneity as the futurists understood it, that of 'states of mind' that pre-dated (and probably influenced) Léger's use of them, these montaged images suggested remembered elements of the scene depicted. *The Huntsman* appears, however, to stand for the very opposite of futurism, apparently offering an equation between its principal figure (a self-portrait) and the modern world of violence and metal, in which that violence is mediated by the artist who discovers the visual language appropriate for its expression. If this inference is correct, and if these grandiose ideas were indeed Le Fauconnier's, they indicate a deepening of the painter's attachment to traditionalism, and of his pessimism in the face of modernisation.

3.18 Henri Le
Fauconnier, *The
Huntsman*, 1911–12

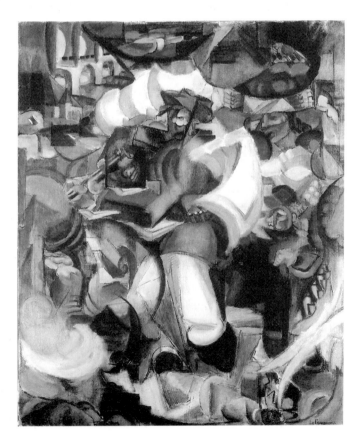

On one level the pessimism was perhaps justified in late 1911 and early 1912, for the prospect of imminent war with Germany had been brought closer than ever by the second Moroccan crisis, of July 1911, and its repercussions. To suggest that *The Huntsman* was in any sense a direct response to diplomatic tensions would be absurd, collapsing into a crude binary relation of political 'cause' and artistic 'effect' the complex cultural movement within which Le Fauconnier's art practice was formed; yet the crisis, in both heightening alarm at the prospect of war and giving further motivation to the projects of national self-definition surveyed earlier, could only have exacerbated the tensions between traditionalism and modernism, nationalism and avant-gardism, that *Abundance* had inscribed. Those tensions were etched more clearly still in his next work, the huge *Mountaineers Attacked by Bears* (plate XII) that he showed at the 1912 Salon d'Automne – the exhibition, it will be remembered, that provoked the public row and parliamentary debate over the 'scandal' of cubism with which this book opened. Indeed Le Fauconnier's picture was at the epicentre of that small storm, and featured, it seems, in a Gaumont cinema newsreel, perhaps because of its vast scale (at 2.4 by 3 metres it was a salon 'machine' of the time-honoured kind),[48] but perhaps also because of its equally colossal illegibility and its idiosyncratic subject. Again, the theme appears to be the relationship between humanity and nature: an alfresco meal enjoyed by the eponymous mountaineers being interrupted by marauding bears. Again, the scene is dislocated and narrative elements incorporated in the manner of *The Huntsman* – some borrowed from the latter, others – notably a telegraph pole with conductors (upper left) – new, but with less success because the paint handling is insufficiently nuanced, and the composition too cluttered, for anything but isolated details to be deciphered. Given this repeated juxtaposition, though, of new technology and traditional community, it is possible to infer a general theme: that the dislocation by modern civilisation of centuries-old ways of living goes against nature, and risks provoking from it a violent reaction. In late 1912 such a message would have been powerfully amplified by the organicist discourse of Barrésian anti-rationalism. It is possible, too, that Le Fauconnier meant, further, to implicate the pictorial dynamism and dislocations of salon cubism and futurism in this provocation, since this was the last of his paintings to make use of such stylistic devices, and his last salon 'machine'. Its singular yet fascinating failure to harness the avant-garde stylistics of his cubism to his deepening hostility towards the urban experience and the social implications of modernity marked, effectively, the end of his contribution to the cubist movement.[49]

If Le Fauconnier's position became steadily marginalised by the progressive centring of salon cubist avant-gardism around 'simultaneity', that of the women artists of this milieu, it must be stressed, was deeply problematised. I noted earlier that women in pursuit of an artistic career within the avant-garde formation faced, on the one hand, educational and market-related obstacles, on the other, the constraints of a masculinist construction of avant-gardism. The experiences of three such women who were part of the milieux of salon and/or gallery cubism offer

instances of how they fared against those impediments. The bleakest was that of Maroussia Rabannikoff: partner and wife of Le Fauconnier, this young woman from a middle-class Russian family abandoned her studies at the Sorbonne in 1906 in favour of painting, exhibiting at the Indépendants of 1910 and in room 41 the following year, alongside Le Fauconnier and the other salon cubist debutants. She was noticed at the first of these by Apollinaire, who compared her work with that of her partner in their common 'striv[ing] for expression and power, somewhat to the detriment of beauty'.[50] Yet from the moment of salon cubism's emergence, 'Maroussia' became invisible to the critics, and she was never mentioned again in their columns; no works by her survive, and all that is known of her is her marriage to Le Fauconnier in Russia in 1912, her certification as insane in 1920, and her death in 1927.[51]

If Maroussia's artistic (and perhaps personal) identity was effaced by the avant-gardism of her partner, that of Sonia Delaunay was only circumscribed by that of hers, but in revealing ways. Like the former, a young woman from a middle-class Russian family, but unlike her, already pursuing an artistic education when she came to Paris in 1905, Sonia Terk abandoned painting soon after meeting Robert Delaunay, in 1909, despite having already begun to make a reputation with a solo exhibition in a private gallery that year, turning instead for three years to decorative arts media such as embroidery, quilting and bookbinding. Although this move was determined in part by her pregnancy and early motherhood, Robert's fierce competitiveness was also probably a factor: 'From the day we started living together', she later recalled, 'I played second fiddle', and while Sonia returned to painting in 1913, she never exhibited her paintings alone again until after Robert's death.[52] Though her artistic partnership with the latter was close and productive, it was one whose driving force was his avant-gardist ambitions and the strategies he pursued to achieve them. Ironically it was when the couple's straitened financial circumstances forced them, in 1916–17, to look to commercial outlets and patrons that Sonia's position in the partnership changed, her design interests and decorative art experience enabling her to adapt far more readily than Robert to the requirements of the market.

Like Sonia Delaunay, Marie Laurencin made accommodation for the avant-gardism of her male artist friends. As Apollinaire's companion she was a member of the *bande à Picasso* from 1907, and as close to the fountainhead of gallery cubism as any painter; moreover, she was included (probably at Apollinaire's behest) in the room 41 grouping. As such she was uniquely positioned both to understand the range of innovations being pursued in the two milieux and to contribute to their furtherance. Instead she deferred to her colleagues' ambitions – not, like Sonia, by abandoning painting, however, but by accepting the mantle of *peintre féminin*, indeed exaggerating the attributes of a constructed femininity in personal as well as aesthetic terms. There were two aspects to this deferential self-positioning. There was an overt declaration of inadequacy on her part: 'If I did not become a cubist painter', she wrote in later life, 'it is because I never could. I was not capable of it –

but I am passionate about their researches'; and she declared, more generally: 'If I feel so far removed from painters it is because they are men ... Their discussions, their researches, their genius have always astonished me ... the genius of men intimidates me.'[53]

This modesty was not just a matter of retrospective rationalisation, for in 1912 her lack of self-confidence almost led her to abandon plans to join Robert Delaunay in a prestigious private gallery exhibition. She wrote to the latter shortly before this opened, in February of that year: 'Someone has just come to arrange an exhibition with you at Barbazanges, but my dear friend, what poor things I shall be able to send – For you and for me, that's irksome ... It worries me greatly, and for the single reason that I doubt the quality of what I will show.'[54] Such lack of confidence was accompanied by an embrace of the conventional attributes of femininity that she emphasised almost the point of parody: 'I feel perfectly at ease with everything feminine. When I was little I used to love silk threads, I used to steal pearls and coloured cottonreels; I would hide them and look at them when I was alone. I always wanted to have lots of children so that I could comb their hair and put ribbons in it.'[55] Laurencin's art met with a correspondingly gallant response from contemporary critics, André Salmon hailing her as one of the two major figures of *l'art féminin* and the Muse of cubism, and praising the grace and fantasy of her seductive compositions.[56]

The experiences of these three artists show how women were either effaced or displaced by the masculinism of the avant-garde and the terms in which it defined the modernist project. But, as Rita Felski observes, modernism is only one aspect of women's modernity, and it is reductive to assume that their articulation of the latter can be subsumed within the formally self-conscious, experimental and anti-mimetic modes of representation that have been taken as characteristic of the former. Moreover, as Peter Wollen has argued, the modernism bequeathed by that avant-garde – and canonised by generations of modernist art historians – was a teleological construct whose monolithic character has obscured the complexity of its pre-1914 actuality, and the plurality of its possible futures in that avant-guerre. The problem in the end, suggests Wollen, is how to find ways to deconstruct the monolith, and rediscover the complexity; part of the solution must be to acknowledge the alternative traditions, genres and discourses within and outside of avant-garde practices that informed the art of women who were thus displaced.[57] The examples of Laurencin and Delaunay point to such alternatives: the embrace by the former of the masquerade of femininity, and the engagement of the latter with the requirements – and the opportunities – of the fashion industry, enabled each of them to articulate, if in different ways, significant aspects of women's experience of modernity.

Simultaneity (2): differences and disputes

Until the arrival of the futurists in Paris in late 1911, Robert Delaunay laid no claim to the notion of *simultaneity* to describe his painting. Although perhaps prompted by the Italians' rhetoric, his engagement with the themes of city roofscape and

Eiffel Tower as metonyms of modern Paris had more in common, as I have noted, with Romains's celebration of the collective consciousness to which it gave rise than with the futurists' still fundamentally individualist modernolatry, and, as Pascal Rousseau notes, he shared with the poet also a populist attachment to a particular kind of metonym: those 'object-spectacles' such as the Tower (and the ferris wheel nearby) bequeathed by the exposition of 1889, the Arc de Triomphe and aeroplanes, that were at once objects of the modern gaze and vantage-points from which its panoramic extension of the urban field of vision could be experienced.[58] It would seem, indeed, that the futurists' declaration of primacy in the introduction of the term both coincided with Delaunay's first explorations, in the *Window on the City No. 3*, of a radically different understanding of the meaning and potential of simultaneity in painting, and provoked him to a sharp critique of their work and ideas. In that painting of December 1911 he introduced a system of colour relations, central to which was that of the simultaneous contrast of complementary colours; after pausing to summarise his work of the previous two years in the huge painting *The City of Paris*, rapidly painted in early 1912,[59] he developed the insights he had acquired from this exploration of the interaction of colours in the months that followed, in an open series of paintings – more than twenty between April and December 1912 alone – with the common (core) title of *Windows*, that can be seen as the major turning-point of his art, and a clear departure from the concerns of salon cubism. Alongside his painting he read voraciously in colour science during these months, following up his earlier immersion in neo-impressionism and his reacquaintance in 1911 with Signac's treatise by studying the theories of Chevreul, Rood and others.

His researches – as well as the mounting pressures of avant-gardism – resulted in an essay, his first attempt (other than the uncompleted project of the memoir of Henri Rousseau) at setting down on paper his ideas on aesthetics , and the start of an intermittent but lifelong effort to place his ideas in the public domain.[60] Written in the summer of 1912, at a time, significantly, when the terms in which cubism should be understood were being energetically contested in print by some of the painters themselves and their writer associates, and when Delaunay was anxious to differentiate himself and his new work from cubism, his essay 'La Lumière' was a brief but complex and coded statement. It distinguished firmly between his art, grounded in visual perception and built with dynamic colour relations that he termed 'simultanéité rythmique', and an art based on a conceptual geometric attachment to objects, in a set of aphoristic declarations that obliquely but (within its primary intended readership of the avant-garde) recognisably referred both to cubism and to futurism. And it gestured towards abstraction, declaring light to be the sole reality and the ordering of colour in dynamic, harmonious relationships (which he called 'simultanéité') to be its expressive vehicle.[61]

In a note on his painting written late the following year, at a moment when he felt it had become important to straighten the record of contemporary artistic achievements, Delaunay returned to the distinction between his interpretation of

'simultanéité' and that of the futurists. This time his explanation was direct and uncoded: *his* was

> an art of simultaneous contrasts, of *forms of colour* ... *line is limitation. Colour gives depth* (not perspective, *not successive*, but *simultaneous*) *both its form and its movement.* The simultaneous vision of the futurists has a completely different meaning ... Successive and mechanical dynamism in their painting, just as their manifesto makes plain. It is a mechanical, and not a living, movement.[62]

This elaboration, not only of an alternative understanding of simultaneity to that of the futurists, but of an approach to painting whose grounding in visual perception contrasted clearly with the increasingly conceptual basis of cubism, was momentous for Delaunay, and a huge leap forward in his pictorial thinking. Avant-gardist rivalry was only one of several factors that, together, may have provoked it. Others include the close friendship that Robert and Sonia developed in the winter of 1911–12 with Apollinaire, who was himself then beginning to sense the momentum of a move towards abstraction building up in experimental painting across Europe; his declaration in February 1912 that in painting 'the subject now has little or no importance', and his prediction that 'the new painters will provide their admirers with artistic sensations due exclusively to the harmony of lights and shades' was greatly indebted to discussions with Delaunay, but also reflected an awareness of the contemporary work of others.[63] The example of Kandinsky was probably also a spur: the Russian painter had three 'abstract' pictures in the 1912 Indépendants, and his essay *Concerning the Spiritual in Art* had recently been translated by Sonia and her friend Elisabeth Epstein.[64] Although Kandinsky's mystical and metaphysical predilections would have been of no interest to Robert, his explorations of colour relationships would certainly have struck a chord. Together with the interest shown in his work by Paul Klee, who met the Delaunays during a fortnight's stay in France the following April,[65] these factors would have underwritten his interest in the colour theories that he was then studying, and in the application of the lessons he learned from them in the paintings on which he was embarking, in which colour was to play a primary role.

It has been suggested, indeed, that Robert's exchange of ideas with Klee in April was the direct impetus for this new departure.[66] Begun in Paris, the *Windows* series was completed in Paris by the end of the year. From internal – stylistic – evidence it appears that the first of them took up where the *Window on the City No. 3* had left off.[67] Replacing its neo-impressionist mosaic with a pattern of flat, atmospheric facets orchestrated around relations of complementary and contiguous colours, the composition remains anchored to the Eiffel Tower silhouetted (if, this time, in two juxtaposed views) against a blue sky – a thematic constant that functioned through the first dozen or so paintings in the series both iconically to marshal their suggestions of mobile perspective and montaged viewpoints into coherent and conventional spatial recession, and optically to orchestrate the increasingly subtle contrasts between complementaries, and between 'slow' and 'fast' colours (plate XIII).

In later *Windows* pictures, though, Delaunay progressively dispensed with this anchor as he explored the possibility of a painting increasingly freed from iconicity and able, solely by means of the 'simultaneity' of colour relations, to express the dynamism of the modern world. As Picasso and Braque had discovered over the previous two years, in a parallel but quite distinct process of exploration of the elasticity of iconic signs, this was a matter of trial and error, and Delaunay found himself using new iconic details even as he dispensed with old ones, despite condemning, in articles written at the same time, art that depended on the representation of objects as 'literary'.[68] Clearly the summer and autumn of 1912 formed a moment of intense reflection and experimentation for him, as he sought to comprehend and integrate, in his painting, ideas and techniques deriving both from his reading and from his increasingly wide network of like-minded artists – and, at the same time, to push forward towards abstraction along a path that his lifelong attachment to the perceptual bases of painting had, in the circumstances of this intellectual ferment, suddenly opened up, and to distinguish himself, in aesthetic and in avant-gardist terms, from the cubist movement as he did so.[69] Underpinning many of these ideas (as Spate, Rousseau and others have noted) was a commitment to a Bergsonist understanding of the world that, as I have argued, was widely shared – indeed by this time it set the terms of the dominant discourse of modernity within the Parisian literary and artistic avant-gardes – yet which each competing '-ism' also interpreted to its own advantage and the reciprocal disadvantage of its rivals.[70] Thus, for Delaunay, condemning alike the cinematographic depiction of movement on the part of the futurists and the geometry of the cubists as 'mechanical' in contrast to the implicitly Bergsonian vitality of his dynamic harmony of uneven colour relationships.

It will be evident that the different uses of the term 'simultaneity' traced in this chapter had a common grounding in a Bergsonism thus flexibly and at times pragmatically interpreted. And it was perhaps inevitable that the mounting pressures of avant-gardist rivalry and self-promotional hyperbole should erupt in a quarrel over its provenance that drew in most of the artists and writers whose contributions to its dissemination I have discussed, as well as several others. The quarrel began slowly, with Delaunay responding to the momentum of futurist publicity that had been gathering since the Italian painters' Parisian debut in early 1912, by including 'simultaneity' in the titles of the *Windows* paintings he sent to an exhibition of his work in Berlin in February 1913. He was supported by Apollinaire, who had been staying with the Delaunays for some weeks during a time of personal upheaval at the end of 1912 and, acquainted for the first time at close hand with their paintings and ideas, was sufficiently impressed to write a glowing review of Robert's entries to the 1913 Indépendants, declaring:

> Here is orphism ... Delaunay is one of the most gifted and most audacious artists of his generation. His dramatisation of coloured volumes, his sudden breaks in perspective, and his irradiation of planes have influenced a great many of his friends ... This is simultaneity.[71]

Like a bull to a red rag, Boccioni responded immediately with a furious article in *Lacerba* entitled 'The futurists plagiarised in France', and over the following several months an energetic exchange of views and accusations was pursued by the three of them, but also by others, across the pages of *Der Sturm*, *Les Soirées de Paris*, *L'Intransigeant* and *Lacerba*.[72]

Before this quarrel had run its course, however, it opened on another front as well. In September 1913 a prospectus was widely distributed in the press announcing the publication of *Prose on the Trans-Siberian and of Little Jehanne of France*, a 'synchromous representation' jointly authored by poet Blaise Cendrars and artist Sonia Delaunay.[73] Cendrars had met the Delaunays at Apollinaire's new apartment late in 1912, and Sonia in particular found in his newly published long poem *Easter in New York*, with its abrupt juxtapositions of old religion and new city pleasures, echoes both of her favourite poet, Rimbaud, and of the contrasts with which she and Robert were experimenting, and the two agreed to work together on 'the first simultaneous book' that would integrate poetry and painting. *Prose on the Trans-Siberian* (plate XIV) was the result, a concertina-folded 'simultaneous text painting'[74] 2 metres long with Cendrars's poem (in ten typefaces in almost as many colours) running down the right side and, down the left, Sonia's syncopated rhythm of arcs, angles and vibrant colours running in counterpoint and complement to it. As Bergman observes, there is no indication in the work itself that Sonia sought to integrate her design or its colours symbolically or specifically with any part of the poem, except at the end where both terminate in an image of the Eiffel Tower and the Great Wheel.[75] Nor is the specific basis of their claim that the work was 'the first simultaneous book' clearly apparent, although it does display simultaneous contrasts of colours, analogous contrasts of poetic images, and these visual and verbal elements engage the reader simultaneously. It is probable that the term's valency in avant-gardist discourse was as significant as these associations of the term for Sonia and Cendrars – yet these several dimensions of its meaning together signal the reasons for that valency as succinctly, and yet as comprehensively, as any product of the avant-guerre.

Certainly their use of the slogan in the prospectus hit a nerve, for just like Boccioni six months earlier, the poet and founder–editor of *Poème et Drame* Henri-Martin Barzun leapt to protest (in his case anonymously) in October, even before the publication of the *Prose*, citing his prior coinage of the term in May of that year, in a manifesto-essay that took up an entire issue of his magazine.[76] Attacking Apollinaire's poetry as well as the Delaunay–Cendrars production, in a tract that named neither but which pointed to them as clearly as its anonymity referenced him, it too sparked a furious exchange of letters (by, among others, André Salmon and Paul Fort, as well as Barzun, Cendrars and Apollinaire) in the pages of *Paris-Journal* that ran intermittently through to the July of the following year.[77] This, however, might be said – to borrow Marx's celebrated phrase – to have been the 'farce' to the 'tragedy' of Boccioni's quarrel, since Barzun's self-aggrandising claims were even more full of bombast than were those of the futurists, and even

less securely underwritten by his poetical works, the simultaneity of which con-
sisted in the juxtaposition of different chants for several voices, all to be spoken at
once and thus producing an incomprehensible cacophony. As several participants
in the correspondence pointed out, if it wasn't nonsense, it already had a name,
that of 'opera'! 'Barzun I denounce you, false prophet, false poet', declared
Cendrars in an open letter to the increasingly beleaguered claimant – a *mot juste*
that seems to have become the most memorable utterance of the quarrel, and poor
Barzun's epitaph. Yet if this episode reveals the farcical side to the avant-gardism
of that moment, it also offers the historian an insight into the currency of 'simul-
taneity' in that avant-guerre; and if Barzun's protest, like that of Boccioni, served
in the end only to blur beyond utility the connotations of this buzzword, it can
remind present readers of what was at stake, for cubists and their competitors
alike, in its appropriation.

4

'High' and 'low'

Metzinger's modernity

For Jean Metzinger, modernity and the representation of it were more complex than the speed, simultaneity and cinematography of the futurist 'take' on them suggested. Alone of the original five salon cubists he had shown no interest, either before their debut in room 41 or since, in addressing the epic character of the new century, be it in a ruralist–vitalist or urban simultanist vein, and although he gravitated in 1910 towards the circle then dominated by Le Fauconnier he was as little inclined to follow the latter's pictorial precepts as he was to pay much attention to the challenge of the Italians. Instead, as I have shown, after his initial apprenticeship to neo-impressionism he was drawn by acquaintances within the community of Montmartre and his own aesthetic predilections to the Mallarmist hermeticism of Bateau-Lavoir cubism, whose stylistic hallmarks he diligently, if superficially, appropriated in his paintings of 1910 and 1911. By the time of the last of these – *Tea-Time* (*Le Goûter*) (figure 2.29) – Metzinger was, however, beginning to establish his own artistic voice. Not only was this painting more unequivocally classical in its pedigree (and recognised as such by critics who instantly dubbed it 'La Joconde cubiste'[1]) than any of its now relatively distant sources in Picasso's oeuvre, but in its clear if tacit juxtaposition, remarked on by Green and others, of sensation and idea – taste and geometry – it exemplified the interpretation of innovations from both wings of the cubist movement that Metzinger was offering in his essays of the time, as well as the paradigm shift from a perceptual to a conceptual painting that he recognised as now common to them.

Ironically, if it was the emphasis on geometry that most succinctly represented both this shift and Metzinger's own predilections (his lifelong attachment to the cerebral pleasures of mathematical order and proportion have already been noted), as well as furnishing the common denominator of the Puteaux discussions and ensuring Metzinger's pivotal role in them,[2] it was *taste* that increasingly characterised his paintings from the start of 1912 until the war – taste, that is, understood not as one of the five senses but as a quality of discernment and independent judgement. While *Tea-Time* denoted the first, it also connoted, for those who were in a position to read it, the second. This was a quality that, in *Du 'Cubisme'*, the pamphlet he co-authored with Gleizes during the course of 1912, Metzinger made

much of as a means of sorting the sheep from the goats within the expanding menagerie of the artistic avant-garde: of distinguishing, in particular, the cubism of painters such as themselves, 'who move freely in the highest planes', from that of the movement's mediocre camp followers. For taste was a register of creativity: 'Any painter of healthy sensitivity and sufficient intelligence can provide us with well-painted pictures', they declared, 'but only he can awaken beauty who is designated by Taste.'[3] Suffused with Nietzschean archness, *Du 'Cubisme'* is full of assertions such as these, their undisguised elitism serving to underscore the clear separation its authors wished to establish between their art and popular culture: 'Let the artist deepen his mission more than he broadens it. Let the forms which he discerns and the symbols in which he incorporates their qualities be sufficiently remote from the imagination of the crowd to prevent the truth which they convey from assuming a general character.'[4] Another intended separation was that between painting and decorative art: 'Many consider that decorative preoccupations must govern the spirit of the new painters. Undoubtedly they are ignorant of the most obvious signs which make decorative work the antithesis of the picture.'[5]

Perhaps their insistence betrayed a certain anxiety as to the attractions, and also the spread, of both commercial popular culture and the decorative arts movement. For among the particular ironies of such assertions are, firstly, that the pictures Metzinger painted during the months in which *Du 'Cubisme'* was drafted display, often with panache, decorative qualities and a sense of taste more characteristic of the fashion industry than of either salon cubism's simultanism or the ascetic obscurantism of gallery cubism – and in so doing articulate a distinct and at times captivating response to the experience of modernity – and, secondly, that at the time of the pamphlet's publication, one of them was decorating a wall in a suite of furnished interiors (the so-called *Cubist House*) whose design represented the most ambitious collective venture of the cubist movement to that date.

The emergence of these qualities in Metzinger's work was not a result of any sudden conversion. His *Two Nudes* (figure 2.28) of room 41, painted at the time of his most assiduous imitation of the stylistic conceits of gallery cubism, have the languorous grace and elongated proportions reminiscent more of Primaticcio than of Picasso, and the busy fragmentation of their forms seems (from the grainy black-and-white photo which is all that remains of the painting) to be motivated more by decorative interests than by the reflexive and linguistic concerns of the latter. After the clarity and measure of the demonstration-piece that was *Tea-Time* Metzinger reprised those qualities in the large work *Woman on a Horse* (plate XV), shown at the Indépendants of 1912. Through its fussy geometry we can discern a nude woman, her limbs and upper torso picked out in sensuous chiaroscuro, perched side-saddle on a studio prop-horse and stroking its mane (visible top right), either in a wooded, sunlit glade or a studio mockup of one – the artifice of which seems significant, for it is in keeping with the decorative details that punctuate the composition, relieving its scaffolded complexity in the manner of Picasso's post-Cadaqués iconic signs: the locks of hair and necklace of the woman at the top of the

work answered by the leaves, grass and flowers at the bottom. Contemporary crit-
ical commentary on the picture helps to fill out this inference: Allard noted
Metzinger's 'refined choice of colours' and the 'precious rarity' of the painting's
'*matière*', but his response to those qualities – understandably, given his classicist
preferences – was to caution the artist against mannerism, and he saw the composi-
tion as 'a little complicated'.[6] Salmon too noted 'the knowing and refined use of
colour' in the *Woman on a Horse* and, warmer in his appreciation of its qualities as
befitted a former *fantaisiste* poet, praised its 'French grace', thanking Metzinger for
having, for the first time, 'illuminated a cubist figure with the virtues of a smile'.[7]

In the absence of more evidence than such brief snatches of commentary in
wide-ranging salon reviews can provide, we can only speculate as to whether
Metzinger intended, or its initial audience read, the provocative juxtaposition in
this painting of naked woman with horse, and of natural with cosmetic adornment,
as a follow-up to *Tea-Time*'s essay on sensation and the viewer's apprehension of it.
What is, however, clear – and became clearer to these critics with his next exhibited
works – is that he was at last both making Picasso's cubism his own, and revealing
his particular decorative gifts and technical skills as he did so. Apollinaire's con-
demnation of his appropriation of the gallery cubist style at the 1910 Salon
d'Automne, that this was 'a jay in peacock's feathers', was both accurate at the time
and, if only in its choice of metaphor, was proving to be unwittingly apposite of this
new work.[8] For in the autumn of 1912 Metzinger showed three new paintings that
revealed his delight in the make-up and fancy dress, the preening and display, that
characterised fashionable city living – and in exercising the taste that participation
in it, as well as representation of it, demanded. These were *Dancer in a Café*, shown
at the Salon d'Automne simply as *Dancer* (plate XVI); *Woman with a Fan*, which
was hung in the decorative arts section of the same salon, in the *Cubist House*
ensemble and *The Yellow Feather* (figure 4.1), one of twelve works that Metzinger
included in cubism's own rival exhibition held at the same time, the Salon de la
Section d'or.

All three paintings depict women dressed in striking, fashionable clothes.
Although none of them is small, much the largest and – as a group composition, too
– presumably the most ambitious project of the three is the *Dancer*. Its subject is a
café or café-concert, where two women and a man seated at a round table, and a
man standing behind them, watch a dancer on a low stage in front of them take a
bow with her bouquet. All are fashionably dressed and coiffed: the dancer in a
directoire-style caped dress with her hair in an elaborate chignon; the watching
clients variously in elegant lace-edged dress and patterned suit, ostrich-plumed
hats, fedora and black tie; and each figure is subdivided, like the picture surface as a
whole only more densely and minutely, into a complex geometry of reticulations,
over which a crazy web of spidery lines is laid. In the light of Metzinger's earlier
codifying of the facetting and multiple perspective of gallery cubism as the pro-
grammatic means to the representation of Bergsonian *durée*, and of his demonstra-
tion in *Tea-Time* of the distinction between idea and sensation, we can read the

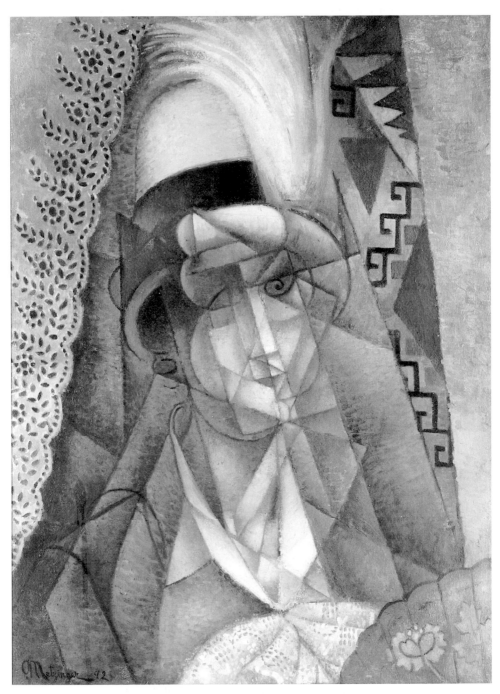

4.1 Jean Metzinger, *The Yellow Feather*, 1912

Dancer in a Café as an ambitious re-assertion of cubism as an art of conception, the forms of which together with their meanings are to be distinguished from the superficial pleasures of fashion, 'remote from the imagination of the crowd'.

The stakes of this contest have now, however, clearly been raised. Metzinger thus presents, or suggests to the viewer's imagination, a set of pleasurable sensations that run the gamut of the sensory faculties: the fragrance of the flowers and the women; the taste of beer, cigarettes and lemon; the allure of the dance (and its implied musical accompaniment); the textures of luxury fabrics and feathers; the atmospheric glow of the lamps; underpinning all of which is the visual richness of their colour and detail. Yet, in depicting these, he deploys a panoply of cubist devices that register the distinction between such sensations and the viewers' knowledge of them – thus the diagrammatic representation of the central still-life suggests the idea of its pleasures, and the cinematographic suggestion of movement in limbs and facial profiles an intuition of their temporal, and vital, attractions; perhaps, too, the geometric regularity of the patterning of cape trimming, check and corner carpet counterposes their conceptual order to the sensuous excess around them.

That Metzinger should have chosen, in the *Dancer* and the two single-figure paintings, to confront the charms of fashion (and of fashionable women) in mid-1912 was not just a result of the stylistic 'evolution' of his painting, or the ascendancy of gallery cubism within the Puteaux group, during those months. There was also a set of interrelated contemporary developments that must have made such a confrontation a matter of importance to him. The most general of these was the rise of consumerism that I noted earlier, the principal agents of which were the department stores, whose increasingly persuasive marketing of a widening range of merchandise in a decade of rising middle-class affluence was rapidly extending not only the square-metrage of their store space but their influence on the social and cultural life of the capital. One dimension of this was the growth of the fashion industry and, through it, the change in sartorial appearance of many Parisians, as the city's couturiers reaped the benefits of its reputation as the capital of luxury, and as new textile technologies and ready-to-wear retailing methods brought *haute couture* within reach of middle-class women.[9]

Related to this growth of consumer demand and of markets was the growing momentum of contemporary campaigns, born of mounting nationalist anxieties and competitiveness, to revitalise the decorative arts industries. Increasing numbers of artists were turning to decorative projects, encouraged by critics for whom the avant-gardism of the time was a source of concern rather than of excitement,[10] and prompted by the widening discourse of the decorative within painting itself; a development that, originating before the turn of the century, was greatly stimulated by the arrival in Paris in 1909 of one of its own international manifestations: Diaghilev's Ballets Russes. Diaghilev's sumptuous sets and costumes attracted to the Ballets Russes' annual *saisons* not only the social elite of *le Tout-Paris*, but also their hangers-on – including artists, such as Maurice Denis, Pierre Bonnard and

other members of the former *nabi* group of the 1890s, and couturiers such as Paul
Poiret.[11] Thanks partly to the activities of artist Léon Bakst, who designed both sets
for the ballet and the dresses for its *balletomanes*, the line that divided fine artists
with decorative interests from decorative artists became increasingly blurred, and
Poiret blurred it further by borrowing from both: aping the hedonistic orientalism
of the Ballets Russes' production of *Schéhérazade* of 1910 in his dress designs, and
securing the collaboration of artists such as Raoul Dufy and Paul Iribe in designing
textiles for his fashion house.[12] But he was not alone: 1912 saw the founding of what
has been called 'an entirely new type of fashion magazine', with the appearance of
three new periodicals: the *Gazette du Bon Ton*, the *Modes et Manières d'Aujourd'hui*
and the *Journal des Dames et des Modes*, each of which presented not only fashion
reports, society columns and fashion plates of the couturiers' latest designs, but
also additional plates depicting imaginary clothing invented by artists such as Iribe
and Bakst themselves. By 1914, avant-garde style had become modish enough for
La Gazette du Bon Ton to publish a fashion plate by Boussingault that, as Valerie
Steele has noted, gave only the vaguest sense of the construction and details of the
Poiret dresses ostensibly being illustrated, but that drew knowingly if formulaically
on cubist painting (figure 4.2).[13]

As this last case indicates, Metzinger's attempt to draw more clearly the line
between cubism and consumer culture had little success, but it is in the context of
the proliferation of the latter, and the threat it posed to avant-garde art practices

4.2 Jean-Louis Boussingault, *Robes de Paul Poiret selon Boussingault*

ROBES DE PAUL POIRET SELON BOUSSINGAULT

such as the former, that his staging of the contest between fine art and fashion in the *Dancer*, the *Woman with a Fan* and *The Yellow Feather* must be seen. It has to be said, however, that the result, to say the least, does little to further his intentions, if these they were. For Metzinger shows himself, despite the punctilious Bergsonism of his cubist conceits, to be a supremely decorative painter. Not only is the display of patterns, textures, colours and fashions captivating, but he handles those conceits – the transparency of planar shapes, the play of arbitrary *chiaroscuro*, the repeated slippage of linear signifiers – to considerable decorative effect. And it was those qualities on which the paintings' critics seized, whatever their opinions of the results. Reviewing the Salon d'Automne, Allard commended 'the finesse and distinction of [Metzinger's] palette', once again noting, however, 'a certain meticulousness ... which lends his canvases a mannered air', and concluding, with a characteristic acuity which recognised the tensions between the painter's aesthetic principles and his predilections, that these 'almost justify the word "droll" to describe such "spiritualist" painting'.[14] Maurice Raynal found the same qualities in the paintings by Metzinger that he saw at the concurrent Salon de la Section d'or: responding – as had his *bande à Picasso* associate André Salmon – more favourably to these, he singled out Metzinger as 'certainly ... the man of our time who knows best how to paint', noting the seductive charm and sureness of execution of *The Yellow Feather*, and the refined sensibility of its author, the grace and playfulness of whose painting he compared to Renoir.[15]

In the last analysis, however, both components of the contest that Metzinger staged, in the *Dancer*, *The Yellow Feather* and the *Woman with a Fan*, between the conceptualism of cubist painting and the sensory pleasures of fashion function together to signify a modernity that is perhaps his primary subject. Clearly he invested much in the contemporaneity of these paintings' iconography. The style of the clothes is meticulously up-to-the-minute: the ostrich feathers of the hats in all three pictures were the height of fashion in 1912;[16] the cut of the dresses, and the relatively uncorseted silhouettes they permitted their wearers to display, owe much more to Poiret than to Worth – indeed the check of one figure in the *Dancer* and the polka dots of the *Woman with a Fan* anticipate the post-war geometries, if not the colour harmonies, of Sonia Delaunay's fabrics, while the open-collared sportiness of the dress and cloche-style hat in *The Yellow Feather* look forward to the 1920s. Such details are hardly unconsidered, any more than is the casual, informal pose of the *Dancer*'s (foreground) seated figure on her unadorned upright chair. And the busy geometry of planar fragmentation and juxtaposed perspectives has a more than reflexive function, for the symmetrical patterning of its reticulations (as in the dancer's *décolletage*) and their rhythmic parallel repetitions suggest not only movement and diagrams but also, metonymically, the mechanised object-world of modernity. Here, too, however, these paintings inscribe an ambivalence, in that geometry itself had, for Metzinger, both modern and traditional connotations. It will be remembered that *Du 'Cubisme'*, written probably as these paintings were being made, gestured somewhat obscurely to non-Euclidean concepts, and

Riemann's theorems; as Linda Henderson has shown, these references betray not an informed understanding of modern mathematics but a shaky hold on some of their principles, culled (indeed plagiarised) from Henri Poincaré's recent book *La Science et l'Hypothèse*.[17] The authors themselves had little clear idea of how such mathematics related to their art, except as a vague synecdoche for 'modern science'. On one level, the geometry of the *Dancer* functions in the same way, and is comparable in this to the 'lines of force' that the futurists included in their pictures, and discussed with equal vagueness in their manifestos, of the same time. Yet in the context of Puteaux discussions, the *Dancer*'s geometry had also profoundly traditional implications, for there was much interest at those meetings in proportional systems. Metzinger was in the thick of such discussions, and it seems likely that, as in the case of Juan Gris, he made use of the golden section or other ratios in his painting of this time; thus the not always clearly motivated linear scaffolding of the *Dancer* in particular might not only gesture towards such a traditional anchorage but be based in part upon it.[18]

A further ambivalence turns on gender. For the consumerist modernity that Metzinger clearly delights in registering was one constructed as, and around, the feminine. As Andreas Huyssen has argued, the notion that 'mass culture is somehow associated with woman while real, authentic culture remains the prerogative of men' gained ground during the nineteenth century, nourished by the Nietzschean vision of the masculine 'artist–philosopher–hero who stands in ... opposition to modern democracy and its inauthentic culture', and by fears of the hordes of nascent socialism and feminism rattling the gates of civilisation.[19] In the newspaper and periodical press of the late nineteenth and early twentieth centuries, he notes, as well as in influential treatises like Gustave Le Bon's *The Crowd* (*La Psychologie des Foules*, 1895), 'the proletarian and petit-bourgeois masses were persistently described in terms of a feminine threat. Images of the raging mob as hysterical ... of the swamp of big city life, of the spreading ooze of massification, of the red whore at the barricades – all of these pervade the writing of the mainstream media'.[20] And as Mica Nava and many others have noted, the department stores, then reaching the first flood-tide of their influence, provided a new kind of public space that catered primarily to women, turning feminised consumption into spectacle through the increasingly lavish displays of their goods; more generally than this, Rita Felski has suggested that 'the modern woman's status as consumer gave her an intimate familiarity with the rapidly changing fashions and lifestyles that constituted an important part of the felt experience of being modern'. Moreover, Felski adds, the emergence of a culture of consumption 'helped to shape new forms of subjectivity for women, whose intimate needs, desires and perceptions of self were mediated by public representations of commodities and the gratifications they promised'.[21]

Yet that subjectivity was shaped also by the responses of men to the slow but broad-based social, professional and sexual emancipation that women were then experiencing: the phenomenon of the 'new woman' was demonised as it threw

turn-of-the-century masculinity into crisis, and the unbridled and by implication licentious excesses of the feminine consumer driven by desire was one of its most influential figures, against which men constructed a figure of masculinity whose cardinal qualities were those of reason, vigour, sobriety and control. The emergent field of the avant-garde was as shaped by these discursive pressures as was everyone else – indeed, as Carol Duncan and others have stressed, the avant-gardist rejection of bourgeois habits invariably entailed a regression to pre-bourgeois social relations of sexuality – and in this context Metzinger's insistence on the cognitive and aesthetic superiority of conception over sensation, and on 'the control of intelligence' over the creative process in cubist painting, should be seen as having a gendered basis, a means of keeping at bay both banal–ephemeral consumer culture and dangerous femininity. But this, of course, is hardly what these three pictures of mid-1912 manage to do – or really wanted to do.

Sonia and Robert Delaunay: modernity, gender and the public sphere

Metzinger's engagement with fashion and entertainment as a marker of twentieth-century modernity was enthusiastic, but it was confined to painting. Sonia Delaunay,

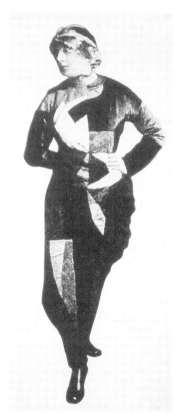

by contrast, followed the logic of a similar delight in Parisian spectacle to its conclusion, first by making for her husband and herself clothes that sported the forms and colours of their contemporary paintings, and second by wearing those clothes to the popular dancehalls, such as the Bal Bullier, that provided the subject matter for some of them (figure 4.3). Although few took it so far, the Delaunays were not alone in such sartorial adventurism: the futurists, Severini in particular, also occasionally flashed a colourful waistcoat or bright-hued mismatched socks, while Braque was noted for a sharp dress sense (which, nevertheless, he was prepared occasionally to abandon in favour of *bleu mécano*, the workmen's overalls in which he and Picasso liked to visit Kahnweiler's gallery, to collect their 'pay packets' from *le patron*[22]). All of which love of fancy dress has been taken customarily as evidence of an embrace of popular culture by the artistic avant-garde which extended into the work it produced, in a gesture of cultural allegiance that blurred the distinctions

4.3 Sonia Delaunay, *Simultaneous Dress*, 1913

between 'high' and 'low' forms and practices, setting the innovations of modernism alongside the inventiveness of the vernacular and in opposition to the pretensions and ossified conventions of legitimised fine art. Such assumptions need to be questioned, however, the more so in that this recognition of the vitality of popular culture resonates profoundly in the present moment of another new century and a new technological revolution. There are specificities to hold on to, if a historical understanding of the pre-1914 avant-garde and its art is not to be forfeited: namely, those of the heterogenous and emergent character both of that avant-garde as a formation and of that increasingly mechanised and commercialised 'popular' culture; of the relation between them; of the discourses of class, gender, nation and tradition through which both were shaped. The character and the trajectory of Sonia and Robert Delaunay's engagement with these specificities are instructive.

The Bal Bullier was situated at the southern end of the boulevard Saint-Michel, at a point of intersection between the largely student population of the Latin quarter, the boulevard Montparnasse and its *quartier* (whose cafés were before 1914 beginning to attract groups of avant-garde writers and artists, and an increasingly fashionable crowd of their associates and patrons) and the more outlying 13th and 14th *arrondissements* where the *cités d'artistes*, ramshackle buildings full of low-rent studios, jostled working-class tenements. The dancehall clientèle was a corresponding mixture of students, artists, poets and workers of all kinds. From late 1912 Sonia and Robert Delaunay and their friends Blaise Cendrars and Arthur Cravan liked to go there every Thursday to dance the tango and the foxtrot, which had been introduced to Paris two years earlier. If her dancing enthusiasms followed fashion, Sonia's clothes were more idiosyncratic: 'Sonia was not interested in the fashions of the day, nor was she out to create a new fashion', explain her biographers. 'She simply wanted to brighten the art of clothing by re-using materials in various colour contexts'.[23] Indeed, while her 'simultaneous dress' shared with Poiret's and Paquin's designs the 'hobble' skirt – surely an impediment to successful tangoing – that they had introduced,[24] and probably allowed its wearer an equivalent degree of uncorsetted freedom to breathe, there the similarities end. Enlivened by a patchwork of straight- and curved-edge forms that line up around a central vertical plumbline-like seam, following and enhancing the contours of Sonia's figure, her design appears to have sought less to flatter herself than to offer the greatest scope for the interaction of colour and bodily movement – an effect that Cendrars for one appreciated, as his poem about it, *Sur la Robe Elle a un Corps* of February 1914, clearly shows.[25]

Although dress designing was a new activity for her in 1912–13, this initiative was not an isolated departure from her fine art practice. Soon after marrying Robert in 1910 she had all but given up painting for two years; although trained as a painter in academies in Germany and Paris, and with a foothold in a gallery (in 1908–9 she showed works in a fauvist, Gauguinesque style in a group exhibition in Wilhelm Uhde's left-bank gallery[26]), she turned instead to the design and making of objects of decorative art in a number of media, including embroidery, quilting

and bookbinding. The immediate reason for this change of direction was her preg-
nancy and early motherhood (the couple's son Charles was born in 1911) which, it
is reasonable to assume, made more difficult the single-minded concentration that
painting demanded. But the fact that she had already made an embroidery work
soon after her relationship with Robert began suggests that there were other factors
involved.

One of these was gender. I noted earlier that women in pursuit of an artistic
career within the avant-garde formation faced, on the one hand, educational and
market-related obstacles and, on the other, the constraints of a masculinist con-
struction of avant-gardism; in such circumstances the only available roles for them,
with few exceptions, were those of muse, mother and manager of their men's
careers. Sonia was one of the exceptions, but she too felt the pressure to conform.
'From the day we started living together', she later recalled, 'I played second
fiddle.'[27] While her partnership with Robert gave her a prominence that was untyp-
ical for a woman, it also constructed her artistic subjectivity. The conventional rela-
tionship in male–female artistic partnerships within the twentieth-century
avant-gardes has been characterised as a 'double-voiced discourse containing both
a "dominant" and a "muted" story'; in the Delaunays' partnership that of Robert
was constructed as dominant – his notoriously competitive inclinations being
underwritten by the masculinist assertiveness that characterised avant-gardist self-
promotional strategies.[28] In this context Sonia's maternal responsibilities only
increased existing pressures on her as a woman to take up decorative art. The cam-
paign conducted in the 1890s by decorative arts organisations, primary among
which was the Union centrale des Arts décoratifs, for a return to the *ancièn régime*'s
tradition of aristocratic women as makers of luxury crafts had reinforced both the
republican pedagogic policy of gendered differences in art education and assump-
tions that decorative arts skills were part of the expected accomplishments of
young ladies; it is thus significant, as Sherry Buckberrough notes, that around 1909
Robert's mother was turning her own such accomplishments to financial advan-
tage, designing floral embroidery motifs for sale.[29] While the perception that spread
rapidly from around 1909 of a crisis in the French decorative arts industries led, as
I suggested in chapter 1, to their remasculinising – as being too important a
problem to be delegated to women – the expectation persisted that, on a domestic
level at least, middle-class women would exercise their decorative skills.

Gender was not the only factor, however, for Sonia's turn to the decorative arts
was in keeping with the strong current of populism that characterised the *art social*
initiatives by means of which, among others, the ethos of inter-class collaboration
of the Bloc des Gauches had been disseminated and which, after the latter's parlia-
mentary demise, had been its sole surviving expression. Indeed, Roger Marx's
championing of 'an art ... intimately joined to a society's collective life ... the art of
the hearth and the garden city, of the castle and the school, of the precious jewel and
of peasant embroidery ... the art of the soil, the race and the nation'[30] was quite
closely congruent with Robert's declared allegiance, noted ealier, to the artistic

tradition of which his friend Rousseau was the 'precious flower'. These values were also implicit in his and Sonia's art practice, as regards both the art they made and their strategies for showing it. For from the spring of 1912 his painting, and hers when she returned to it later that year, fell into two seemingly distinct categories: first, small pictures whose elements became steadily less representational and through which both artists pursued their shared preoccupation with the constructive pictorial role of light and colour; these, which evolved from Robert's *Windows* series that I discussed in the previous chapter, and Sonia's *Simultaneous Contrasts* of late 1912 (figure 4.4), through Robert's *Sun, Moon* works to his extraordinary *First Disc* of 1913 (figure 4.5), were exhibited not in Paris but in numerous exhibitions on the expanding avant-garde circuit across Europe. The second consisted of large paintings of recognisable subjects drawn from popular entertainment or public events: dancehalls, carousels, sport, aviation, political scandal. Distinct in these material respects, the two categories of work *appear* to represent equally distinct sets of interest – indeed, contrary ones in art market terms, the first representing a pictorial practice similar to that of Picasso and Braque during 1910–12 and promoted by the artists via a strategy identical to that pioneered by Kahnweiler, the second closer in practice to the salon cubism from which Robert had distanced himself and addressing a sector of the market that Kahnweiler actively ignored. The Delaunays, however, saw them as complementary; keenly aware, as his correspondence reveals, of the inaccessibility of the paintings of the first category, Robert acknowledged the need to assist public comprehension and enjoyment of their work, writing as much to Kandinsky in April 1912, as we have seen.[31] The salon *machines* appear to have been the means to this, their subject matter deliberately chosen on criteria of topicality, modernity and popular reach,

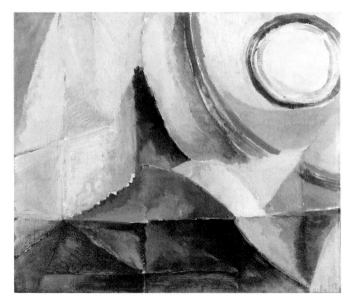

4.4 Sonia Delaunay,
Simultaneous Contrasts,
1912

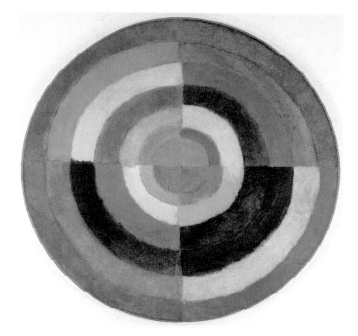

4.5 Robert Delaunay,
The First Disc, 1913

as Sonia later recalled,[32] and exhibited exclusively at the un-juried Salon des
Indépendants, to which they remained loyal as a mark of affection for Rousseau,
whose preferred salon it was.

 This series of populist pictures was prefaced, however, by a huge work the status
of which differed from either category. *The City of Paris* (plate VIII) represented a
statement of his artistic position, at once a resume of the themes and advances of his
previous two years of work, an ambitious assertion of the public (indeed, epic)
scope of contemporary painting, and a declaration of his opposition to the sim-
plistic ultra-modernolatry of the futurists. A montage of three emblematic images
of the city, the picture pointedly looked back to the city's past as well as to the mod-
ernistic promise of its present. Thus the left-hand of these images represents at
once a view of old Paris, with a view of houses piled picturesquely above a bridge
and a riverboat on the Seine, and a homage to Rousseau, from whose *Myself –
Portrait–Landscape* (figure 4.6), shown in the old painter's posthumous retrospec-
tive at the Indépendants the previous year, the scene was adapted[33] – and thus
inscribes Delaunay's own affiliation to French popular art traditions. The central
motif of the three graces, taken from a Pompeiian fresco in a Naples museum of
which the artist had a postcard, represents in their elongated and graceful propor-
tions the perceived feminine qualities of Paris, but also declares its classical heritage
and gestures, unmistakably in the discursive space of that moment, towards a cul-
tural nationalism that would have complemented its avant-gardist rebuttal of the
futurists' demand for 'the total suppression of the nude in painting'.[34] The right-
hand motif, the Eiffel Tower, is the most conspicuously modern and forward

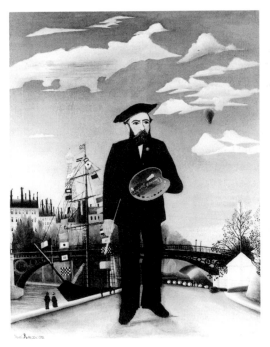

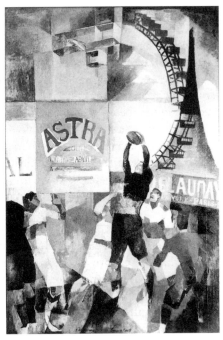

4.6 Henri Rousseau, *Myself – Portrait – Landscape*, 1890

4.7 Robert Delaunay, *Third Representation: The Cardiff Team*, 1912–13

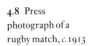

4.8 Press photograph of a rugby match, *c.* 1913

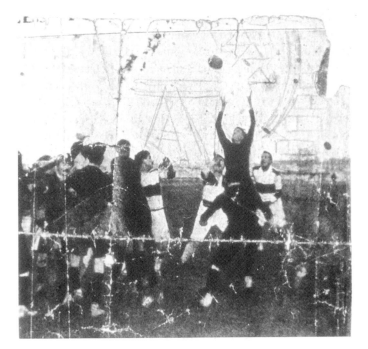

looking of the three, and one taken from the cutting edge of Delaunay's own oeuvre, a reprise of the final painting of his second and most recent series on this theme, which was still incomplete when photographed for the catalogue of his galerie Barbazanges joint exhibition with Marie Laurencin in February.[35]

The City of Paris was not included in that showcase of his work, perhaps because it was not yet finished. The vast canvas appears to have been painted in the few weeks between the opening of the futurists' exhibition at galerie Bernheim-Jeune in early February and that of the Salon des Indépendants in the middle of March; its remarkably rapid execution owed much both to Delaunay's apprenticeship with the Ronsin theatrical studio, where he had learnt the skill of quickly brushing back-drops for stage productions, and to his reliance on earlier paintings and studies for its compositional elements – though in the process of reprising, enlarging and inte-grating these he made significant advances on them, such that in formal terms, as in its thematic elements, *The City of Paris* looked forward to the 'Windows' series of the spring as well as back to the *City* and *Tower* series. Michel Hoog has demon-strated that the picture and its composition were constructed on a broad corre-spondence to the golden section ratio, and infers from this a deliberate gesture on Delaunay's part toward Renaissance traditions, an association that Apollinaire also made in his enthusiastic response to the work in his salon review.[36] Balancing this reference is a play of harmonies and contrasts between greens, blues, terracottas and purples, especially in the middle third of the canvas, which develops from that adumbrated in the recent *Window on the City No. 3* (figure 3.7) and anticipates the first canvases of the 'Window' series.

The following year both Robert and Sonia sought to build on the foundations that *The City of Paris* had thus laid for a kind of painting that could present their formal experimentation to the public without creating 'stumbling-blocks in the way of its enjoyment'. For the Indépendants Roberts painted *Third Representation: The Cardiff Team* (figure 4.7),[37] which combined the themes of rugby football, avia-tion and advertising, Eiffel Tower and ferris wheel. Taking once again as his starting-point a photograph made for mass consumption, in this case a news photo of a rugby match (figure 4.8), he integrated its components with the formal means of simultaneous contrasts of colour and geometric grid that also characterised the *Windows* series, harnessing their spatial subtleties – as well as the insistent flatness of the yellow billboard – to the emblematic accessibility of its subject. For her part, Sonia chose to represent the dancehall, and did so in the painting *Bal Bullier* (figure 4.9) which gathers the undulating forms of the Bal Bullier's dancing couples into a pattern of simultaneous contrasts and harmonies of spectral hues, whose luminous points of origin are the white electric light globes and their multicoloured haloes that punctuate the picture's upper edge. The *s*-shapes of the dancers' movements counterpoint the regularity of a background pattern of rectangles, swaying repeti-tively through them across a canvas so wide that from any normal viewing distance it occupies one's entire visual field, immersing the viewer in its rhythms as are the dancers in the music on the ballroom floor.

4.9 Sonia Delaunay, *Bal Bullier*, 1913

The two paintings are clearly closely related, both stylistically and in their orchestration of colours, suggesting a close working partnership between Robert and Sonia at this moment, of a kind that invites comparisons with the temporary anonymity that Braque and Picasso shared in 1911.[38] However this is to be construed, it yielded the even closer pairing of their entries to the 1914 Indépendants, Robert's *Homage to Blériot* and Sonia's *Electric Prisms* (figures 4.10 and 4.11) both almost exactly the same (large) size and unusual (square) format, both orchestrated around a scintillating play of spectral colours whose repeated circles closely reprise the quartered colour scheme of Robert's *Disc* of the previous summer (figure 4.5).[39] This time it was Robert's image that was the more legible, with Blériot's monoplane unmissable in the foreground, its propellor seeming to generate the helicoidal and circular patterns of loosely-brushed liquid colour that float shimmering across the picture surface like soap bubbles in a breeze before giving way to the equally unmissable biplane and Tower, quoted from his previous year's picture. Sonia's painting, by contrast, gives only hints of its thematic origin in the electric

4.10 Robert Delaunay, *Homage to Blériot*, 1914 4.11 Sonia Delaunay, *Electric Prisms*, 1914

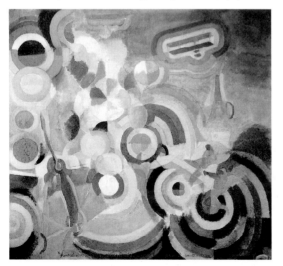

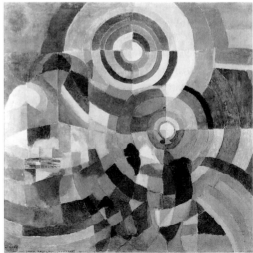

streetlights and passers-by on the boulevard Saint-Michel; the linear ordering of her composition sharply separates and juxtaposes her colours, pressing them into an insistent flatness that is relieved only by the little checkerboard of the flyer for the *Prose on the Trans-Siberian*[40] that reads like a distant billboard and throws the surrounding blocks of colour into deep perspective.

However they varied its balance from picture to picture, what was common to all of these projects was the determination of the Delaunays to hold together their profound commitment to avant-gardist formal experimentation and the public address of monumental paintings sanctioned by the institutions of the mainstream art world – in other words, while accommodating and exploiting the dynamic new discursive spaces of modernism and its market, to re-assert painting's public role and modernise its means of communication.[41] As such, these pictures represented an ambitious challenge to the new technologies of newspaper photography and newsreel film that were taking over from painting and illustration the role of documenting historic events, and were dictating the terms of visual representation of public life. The mounting of such a challenge was, in a sense, a development of their art practices from the populism that had been inseparable from Robert's championing of Henri Rousseau, but it was also a move – if mediated by the latter's enthusiasm for the emblems of modernity – away from an attachment to that small-town traditional culture, the 'precious flower' of which they saw to be the douanier, to a populism that celebrated the spectacular character of twentieth-century Paris, at the centre of which was the proliferating culture of the marketing and display of consumer goods of all kinds. Sonia's diversification into the decorative arts, for the reasons I have discussed, was itself a stimulus to the further development of this project into one of bringing avant-garde art practices into the centre of daily life. Her innovations in book-cover design, and especially her 1913 collaboration with Cendrars on the *Prose on the Trans-Siberian*, were both an extension of Robert's enterprising promotion of his paintings around the European avant-garde art market and prototypes for the projects of the business group La Corporation nouvelle that she established in Portugal in 1916. During the year prior to the war this orientation to commerce became more pronounced and kept pace with their increasing pictorial engagement with emblems of modernity; indeed, given the ubiquity, by 1912, of billboards in Paris, it must have seemed a short step for Sonia from representing and utilising them as constructive elements in paintings such as her *Electric Prisms* or Robert's *Cardiff Team* to designing the advertisements themselves – thus from embracing commodified popular culture to participating in its production. Having been launched in this direction by her own flyer for the *Prose*, she continued it through 1913–14 with posters for Pirelli and Michelin tyres, Zenith watches, Dubonnet and the Printemps store – designs that were, however, neither commissioned nor adopted by the companies in question (figure 4.12).[42]

By 1914, then, the Delaunays already viewed consumerism in ways that differentiated them clearly from the aestheticist and traditionalist side of Metzinger's engagement with modernity: in consumer culture they could see not a threat of

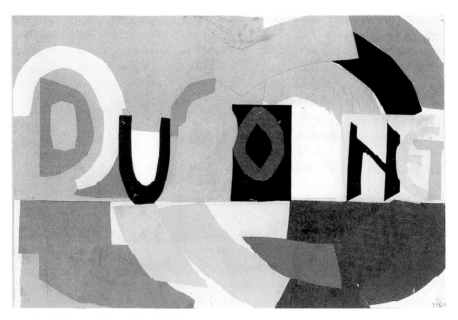

4.12 Sonia Delaunay, *Poster Design for Dubonnet*, 1913–14

banality but a means of disseminating the gains of artistic experimentation, and Sonia's application of their pictorial innovations to graphic design and other media sought to realise the opportunities presented by that culture, by collapsing the distinction between them. This initiative was overtly counter to the emphases of the Puteaux circle, distilled in *Du 'Cubisme'*, on the artist's superiority to and detachment from 'the masses', and of fine from decorative art, and it must have contributed to a widening of the distance between them. Yet Puteaux had its own interests in the decorative – indeed, it was around an ambitious decorative arts project, involving the design of furniture, ceramics, wallpaper, textiles and interior fittings, that the circle's collective identity was first publicly manifested, at the Salon d'Automne of 1912. A detailed consideration of it would take us too far from cubist painting,[43] but it may be observed that the participation of cubist painters in the *Cubist House* project reveals not only the tensions and contradictions within the cubist movement at that moment, but also the complex relations between the discourses of modernism, decoration and modernity in Paris, in the first two decades of the twentieth century.

'Papery procedures'

In an essay entitled 'Words', Kirk Varnedoe commented that 'having perfected an exquisite, chamber-music harmony, Braque and Picasso seem to have decided that the perfect next step was to add a kazoo counterpoint'.[44] This observation about the change in their cubism in late 1911 from the austerity and remoteness of paintings such as *Man with a Guitar* and *The Accordionist* (plates V and VI) to an enthusiastic

engagement with the disposable delights of the commercial and popular culture of
city newspapers and entertainment captures succinctly the surprise and the sense of
ridiculousness that must have been occasioned in their immediate audience. Yet,
extraordinary though this new and discordant note of vulgarity (and often humour)
was, it entered their compositions quietly enough at first and, as Varnedoe suggests,
with an ambivalence that was entirely appropriate: it is not certain which of the two
paintings to which Braque added stencilled lettering in late 1911 – 'BACH', in
Homage to J. S. Bach, and 'BAL' (standing for a popular dance) in *Le Portugais (The
Emigrant)* (figures 4.13 and 4.14) – came first.[45] If Braque had been the first to breach
this line, it was, characteristically, Picasso who seized the transgressive opportuni-
ties the opening offered, writing 'Ma Jolie' ('My Pretty') in hand-painted lettering at
the bottom of a half-length portrait of his new girlfriend (figure 4.15). Functioning
not only as a title for the painting within the work itself – and thus an ironic acknowl-
edgement of how unflattering and indeed inadequate, as a portrait, this almost illeg-
ible picture was – the endearment also referenced a sentimental culture beyond its
frame, for it was the opening of a popular song then on everyone's lips.[46]

　　Such an abrupt juxtaposition of cultural registers did not immediately deflect
Picasso from his searching engagement, in *Ma Jolie* as in the works from Céret,
with the process of representation,[47] but the popular reference was repeated, and
joined by a multiplying portfolio of others, in his paintings of the next several
months, as they were in those of Braque. Their enthusiasm at exploring the ramifi-
cations of thus referencing the vernacular and the rivalry that this fuelled are both
evident in the rapidity of their mutual borrowings of motifs and devices. Braque's
Homage to J. S. Bach had been among the first paintings in which he employed a
technique which his house-painter father had taught him, of painting imitation
woodgrain (in the lower left corner), and he added above this the trick-of-the-trade
use of a comb to achieve the same effect; both are again clearly visible in the little
Violin and Clarinet of the spring of 1912 (plate XVII), their vertical disposition and
location in the composition suggesting a background plane in front of which the
still-life is displayed. Within weeks Picasso had appropriated those devices for his
own – and different – use. Thus *Souvenir of Le Havre* (plate XVIII), painted in
May 1912 following a long-weekend visit with Braque to the latter's home town in
April, deploys the imitation woodgrain brushwork but, as Pierre Daix notes, this is
'pure information' dissociated from any object, like the colours of the French flag it
abuts.[48] In a composition whose still-life elements can be partly deciphered, but
whose spatial co-ordinates remain ambiguous, settling into neither the vertical
wall-hung orientation suggested by the positioning of the title on its label at the
base of the oval, nor that of the table-top implied by the glass and central bottle,
these horizontally oriented patches of woodgrain could reference wall-panelling,
table, canvas surface, or all three at once.

　　The ambiguity thus inscribed in this painting had further implications, which
some modern historians of cubism have seen as of radical importance for the next
direction that the cubism of both Picasso and Braque, but especially the former's,

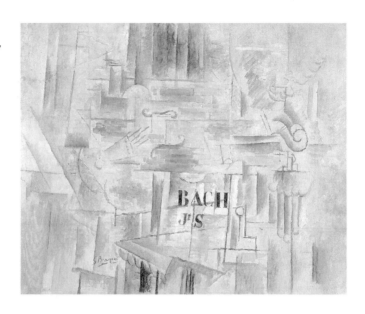

4.13 Georges Braque, *Homage to J. S. Bach*, 1911

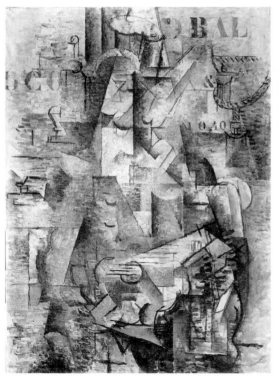

4.14 Georges Braque, *Le Portugais (The Emigrant)*, 1911

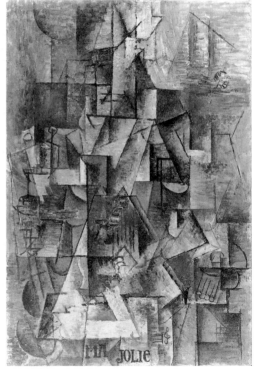

4.15 Pablo Picasso, *Woman with a Zither or Guitar ('Ma Jolie')*, 1911

was to take. One of the works that Picasso made on his return from Le Havre was
the little oval painting, framed with a piece of rope like a marine souvenir, *Still Life
with Chair Caning* (figure 4.16).[49] Pasted to the canvas is a piece of oil-cloth with an
industrially printed woven-cane pattern, the representational status of which is
uncertain. Whether it stands for its own presence in the illusionistic space, dis-
posed horizontally as an oil-cloth covering a table on which are the elements of the
still-life (among them a glass, a lemon, a newspaper, a knife), or as the table surface
itself, made of such a woven-cane pattern; or, vertically, as the back of a chair –
which would imply, as Christine Poggi has suggested, that the canvas surface must
be read as a mirror[50] – is a question Picasso leaves open. The picture thus effects,
even more radically than do the patches of imitation woodgrain in *Souvenir of Le
Havre*, what Yve-Alain Bois describes as the collapse of the vertical into the hori-
zontal; in this collapse, Bois suggests, 'what Picasso is inscribing is the very possi-
bility of the transformation of painting into writing – of the empirical and vertical
space of vision, controlled by our own erect position on the ground, into the semio-
logical and possibly horizontal space of reading'.[51] As Rosalind Krauss has
observed, the oval shape of the picture itself helps to provoke such a collapse, as it

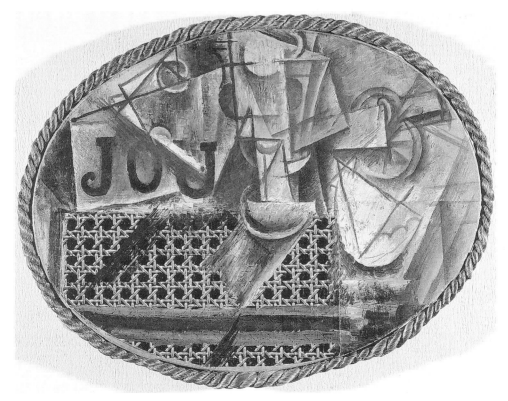

4.16 Pablo Picasso, *Still Life with Chair Caning*, 1912

can be read both as a round table-top seen from an angle (much as someone sitting at it would see it), and as 'an upright frame which fans the content of the visual field across its enclosed surface'.[52]

Picasso's use of the oil-cloth can also be seen as a riposte to Braque's introduction of house-painters' tricks, a raising of the ante in their competitive de-skilling of the art of painting that also rendered this yet more anonymous than had their abstention from visible signatures of the previous year. As such, it was in keeping with his turn, in early 1912, to Ripolin enamel house-paint in some of his pictures alongside his usual oils (as in *Souvenir of Le Havre*, where he used it for the tricolore colours) not only for its non-fine art associations but for its material properties: vivid colours, and a smooth, impersonal surface when dry that, as Varnedoe suggests, 'denied any sense of painterly finesse'.[53] And both recourses to artisanal materials were, in turn, in keeping with Braque's and Picasso's fondness, as reported by Kahnweiler and noted earlier, for turning up at his gallery in labourers' *bleu mécano* overalls and demanding their 'pay' from 'the boss'.[54] All of which gestures can be interpreted, as Varnedoe also suggests, as a 'slap in the face' of the ideals of the proponents of *art social* and others who promoted the beautification of modern life by artists-turned-decorators, such as the *Cubist House* team, in reaction to the degradations of commerce and mechanisation.[55] But these were not, on the other hand, simply reciprocal gestures of affection on Picasso's part, or on Braque's, for popular culture, or of identification with its predominantly working-class consumers; as I have cautioned, to assume that they were is to ignore the specificities of the emergent heteronomous artistic avant-garde, of that commercialised culture and of inter-class relations in pre-1914 Paris. In the post-Bloc des Gauches, post-Moroccan crisis conjuncture, when, as I noted, the communities of the artistic avant-garde and those of the working class were each turned in on itself and engaged in the consolidation of an autonomous identity, such cross-identification was not a readily available position. Moreover, it was, firstly, in relation to mainstream culture that, along with every other artist who identified with the emergent field of the avant-garde, these two cubists sought to position themselves; or rather, against whose practices and products they sought to distinguish their own. Pierre Bourdieu has argued that the conflicts between artists and intellectuals over the definition of culture 'are only one aspect of the interminable struggles among the different fractions of the dominant class to impose the definition of the legitimate stakes and weapons of social struggles'.[56] The appropriation by Picasso and Braque of the techniques and materials of popular culture was inseparable from that contestation: Bourdieu further argues, as I have shown, that it is 'a second-degree delight which transforms the "vulgar" artifacts abandoned to common consumption ... into distinguished works of culture'.[57] Secondly, their appropriation of emblems of the popular was a means of positioning themselves within the field of the avant-garde. Whatever 'second-degree delight' the two cubists may have taken, as young middle-class men in the metropolis, in the ephemeral and unpretentious pleasures of the popular – and the anecdotal evidence

of their enjoyment of the cinema, the circus, the music-hall and the café is a staple component of biographical accounts of their early careers – its referencing in their art practice was a function of, and contributed to the development of, that discursive field. As Bourdieu, again, insists:

> The *space of literary or artistic position-takings*, i.e. the structured set of the manifestations of the social agents involved in the field – literary or artistic works, of course, but also political acts or pronouncements, manifestos or polemics, etc. – is inseparable from the *space of literary or artistic positions* defined by possession of a determinate quantity of specific capital (recognition) and, at the same time, by occupation of a determinate position in the structure of the distribution of this specific capital.[58]

In those years of close collaboration and rivalry between Braque and Picasso, the motifs, materials and behaviour of popular culture were thus reworked, acquiring their private connotations as part of a process of distinction and positioning in relation both to mainstream culture and to the forcefield of the avant-garde. In this reworking, their mechanics' overalls, house-painters' tricks, Ripolin enamel and collaged oilcloth stood for a rejection of artistic orthodoxies: respectively, of an outmoded 'bohemian' sartorial style,[59] of the *belle peinture* associated with fashionable art, of the notion of art as dependent on craft skills and on what was known as the *patte*, or paw, of the painter. And in this context, the titling of *Ma Jolie* amounted not only to a private appropriation of the public and ephemeral but, reciprocally, to a register of the gulf that separated the private concerns of Picasso's art – as opposed to his heart – from popular culture. It is important not to collapse the first of these concerns into the second.

The complexity of these discursive fields and dynamics needs to be borne in mind in consideration of the next phase of gallery cubism's engagement with the popular. After some months of experimentation with mixing sand with his oils, or adding plaster to the canvas surface, in the interests of sharpening the contrasts and contradictions in his paintings that his house-painters' tricks had heightened between depth and flatness, *trompe l'oeil* illusion and material reality – conception and vision, in the then-current critical parlance – Braque pasted some pieces of industrially printed imitation-woodgrain wallpaper to a canvas, raising thereby onto a different plane the above contradictions in a little still-life he had just completed (figures 4.17 and 4.18).[60] For this 'first-ever' *papier-collé*, Braque's *Fruitdish and Glass*, sharpens the separation of form from colour and imitation from conception, leaving the display of the former to the ready-made commercial material and freeing his charcoal mark-making to play with suggestions and negations of volume, transparency, depth and surface. It was a momentous step, as Braque seems to have been aware: summering in Sorgues with Picasso and their respective partners at the time, he waited until his friend had left for a short visit to Paris before buying the wallpaper, which he had spotted in a shop in nearby Avignon, and making use of it for the first time.[61] But it was a step consistent with the earlier initiatives that he had taken in experimenting with extraneous materials and

techniques; as William Rubin has meticulously demonstrated, he preceded Picasso by several months in making sculptures out of paper (which he had possibly previously painted).[62] There is some evidence for his having constructed the first of these as early as mid-1911, and almost certainly by early 1912;[63] none, however, survive, and it appears that Braque regarded them chiefly as an aid to his painting, rather than as either autonomous or a new departure.[64]

That Braque should act so secretively over his experimentation with *papier-collé* indicates both his sense of its import and the degree of rivalry between himself and Picasso (it also suggests that, while their collaboration was still at its closest, their commitment to anonymity was fast disintegrating). That he was prudent to do so, in the light of such rivalry, is suggested by the outburst of creative energy and imagination with which Picasso responded to this new procedure, in a series of works of late 1912 and early 1913 which modern scholarship has established as of fundamental significance for the development of gallery cubism, indeed, for some, its profoundest achievement: the moment of the critical shift (in parlance to which I shall return) from 'analytic' to 'synthetic' cubism.

The response was not immediate, however; Picasso in his turn waited for a month, and his return to Paris and a new studio, leaving Braque in the south, before reporting to him: 'I've been using your latest papery and powdery procedures. I'm in

4.17 Georges Braque, *Fruitdish and Glass*, 1912 **4.18** Georges Braque, *Fruitdish 'Quotidien du Midi'*, 1912

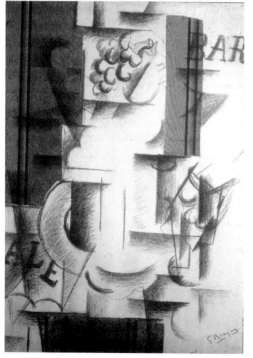

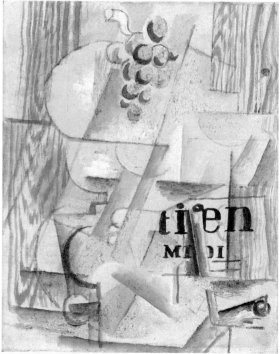

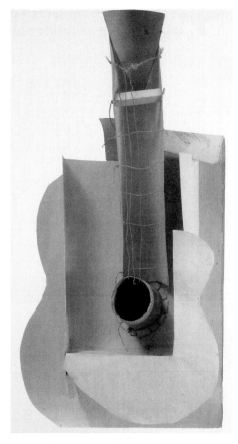 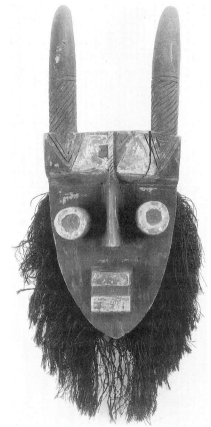

4.19 Pablo Picasso, *Guitar*, 1912 **4.20** Grebo mask, Ivory Coast, West Africa

the process of imagining a guitar and I'm using a bit of earth on our dreadful canvas.'[65] As Rubin notes, it is not certain to which of his most recent works this refers – at that critical moment, the possibilities which Braque's recent material innovations had begun to suggest to Picasso were bearing fruit of several kinds – but the circumstantial evidence suggests that one of them was the cardboard *Guitar* (figure 4.19) now dated by art-historical consensus to that October at the earliest.[66] Edward Fry was the first to insist on this dating, and on the relation of the *Guitar* to Picasso's first experiments with *papier-collé*, on stylistic and material grounds,[67] while Yve-Alain Bois developed an insight voiced by Kahnweiler – namely, that Picasso's purchase in the summer of 1912 of a Grebo mask from the Ivory Coast of Africa (figure 4.20) had been the catalyst in the shift to 'synthetic' cubism – into the contention that the *Guitar* was paradigmatic for the breakthrough which followed, to a semiological understanding of cubism inscribed by Picasso's *papiers-collés*.[68] If his analysis tends to overstate the abruptness and completeness of this transition (a point to which I return in chapter 7), it helps us to understand, and locate to the

autumn of 1912, the end of the hermetic, or 'analytic', phase of gallery cubism during the course of which this shift was explored and its implications assimilated. It also helps us to distinguish from it the stage of that cubism in which this lexicon of signs provided the point of departure for each picture, rather than its destination.

What has become known as synthetic cubism began with the *Guitar* and the works that immediately followed, in Braque's invention (and his and Picasso's manipulation) of *papier-collé*; for the medium enabled the latter in particular to transfer to two dimensions the system of non–illusionistic signs for spatial depth, surface and transparency that his cardboard construction had first posited in three dimensions. Picasso's quick grasp of the semiotic potential of the new medium is indicated by a pair of closely related pieces that were among the first in which he adopted Braque's new materials, respectively sand (figure 4.21) and pasted papers (figure 4.22). The little oil-and-sand painting seems to have come first, since it was probably one of those on which he reported using Braque's 'powdery procedures' in early October, while the *papier-collé* was probably assembled in early December;[69] yet its configurations are so close to those of the *papier-collé* as to reveal how carefully Picasso planned the details of the latter. The differences are telling: substituting a guitar for the violin enabled him to simplify the disposition of the white circle, allowing a disc of white paper lying discernibly proud of the surface to stand for its opposite, a black sound-hole; similarly (as Bois notes), replacing

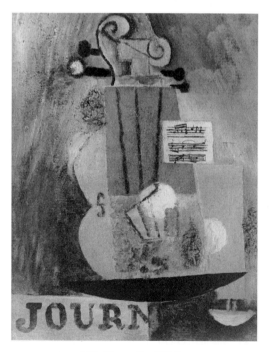

4.21 Pablo Picasso, *Small Violin*, 1912

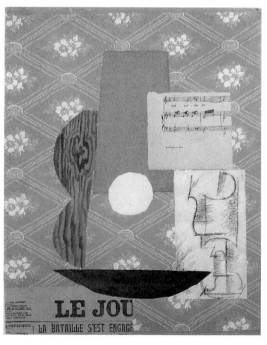

4.22 Pablo Picasso, *Guitar, Sheet Music and Glass*, 1912

the loosely brushed (and sanded) ground, and part of the body, of the violin with a printed wallpaper pattern made the trapezoid section of it that is sandwiched between the glass and the wood-grain paper 'at once a sign of depth and, being utterly flat, its absolute negation'.[70]

Reading the news

Yet there was more at issue in this transcription of motifs than semiotics, for the fragments of pasted papers inescapably referenced the world beyond the picture, and both Picasso and Braque seized, from the start of their exploration of this new medium, on the play of meanings that the content of newspaper clippings, above all, invited. Since Robert Rosenblum's seminal essay 'Picasso and the typography of cubism' of nearly forty years ago, the extended debate that it inaugurated has centred on this play of meanings and its significance not only for gallery cubism but for modernism itself.[71] Taking issue in one way or another with Rosenblum's claim that *papier-collé* represented 'the first full scale absorption into high art of the typographical environment of our century', but following him in focusing on Picasso's rich and varied engagement with the medium at the expense (with very few exceptions) of any but the briefest consideration of that of Braque, contributors to this debate have offered a wide range of assessments of just how, if at all, and with what consequences, the supposedly 'high' art of gallery cubism met the 'low' culture of early twentieth-century commercial vernacular.[72]

More recently, Molly Nesbit has both extended and questioned the terms of such explorations of gallery cubism's engagement with popular culture. Challenging, on the one hand, what she suggests is their unduly narrow focus and, on the other, the assumptions of a cultural hierarchy implicit in many of them – and more generally, in the governing analytical framework of 'high' and 'low' itself – she offers instead an imaginative and wide-ranging attempt to seize the character, complexity and dimensions of an avant-guerre 'common sense' that provided the discursive framework for both the elaboration of cubist devices and their reception. Such 'common sense' included notions of geometry, drawing, line and language inculcated at various levels of the French education system and deployed differentially across its industrial sectors, as well as a sophisticated and interactive engagement on the part of consumers with the wordplays and/or image manipulations of newspaper advertising.[73] She argues that Picasso's own engagement with them should be seen as having been shaped by, and part of, that common sense rather than by an assumed binarism that privileges 'the in-house terms of poets and art critics'.[74]

Where, then, has the debate left our understanding of these *papiers-collés*? How are we to decide between interpretations of Picasso's deployment of pasted papers and charcoal drawing as the elaboration of a sophisticated and systematic semiotics, encoding a neo-Mallarmist resistance to the social forces that would reduce them to the shabby status of commodities, and those for whom these works articulate a profound engagement with the political and/or popular aspects of these forces? The

answer, as I have suggested elsewhere in an argument which here I only summarise, is twofold.[75] First, by recognising that if a contemporary understanding of Picasso's pasted papers is to avoid reading back the ambivalences of the present towards the modernist project into visual texts that were produced at a moment when that project was viewed quite differently, attention should be paid to the conjuncture of late 1912–early 1913, of which that project, and those texts, were a part (and the character of present interest in the latter acknowledged). Second, by understanding the multi-accented character of Picasso's *papiers-collés*, and their available meanings for both the artist and his audience(s), as constructed in the discursive space inhabited by each, within that conjuncture.

Public discourse in that Paris of late 1912 with which this book opened was dominated by nationalism. Originating among the right-wing leagues, this had by 1912 come to dominate the French political landscape, co-opting all shades of political opinion except that on the Left, in the complex movement of ideological and political integration and elision, embracing among others the salon cubist milieu,[76] that I have charted. Classicism was one discourse through which these complexities were figured in the signifying practices of dominant culture both within and outside of the avant-garde formation, engendering the contest between Maurrasian, Barrésian and gallo-celticist versions of a specifically French classicism which, as I have shown, dominated aesthetic debate in its literary and artistic coteries, and through the medium of which the innovations of Cézanne and other artists and writers of the previous generation were refracted. Picasso's relation to this discourse was oblique and equivocal: its specifically nationalist connotations meant little to him, as a Spanish artist surrounded by his compatriots and other émigrés; yet, as his repeated bouts of engagement with it from 1905 on make plain, the classicist aesthetic and the classical canon held deep attraction for him.

Only the organised working class resisted the hegemony of nationalism prior to 1914. The syndicalist movement, disillusioned by the experience of the Bloc des Gauches, replaced this with self-reliance and autonomous action, and after the socialists' espousal of anti-militarism in 1907 had aligned them with syndicalists in opposition to an increasingly bellicose nationalism, there opened up an ideological gulf between the organised working class and the rest of the nation.[77] The high point of syndicalist agitation came at the end of 1912, with the decision of the CGT's congress in late November to call a general strike for 16 December in protest at the slide towards a pan-European war that seemed to be the imminent outcome of the Balkan conflict; its failure marked the turn of the tide of anti-militarism, though not the end of working-class opposition to war.[78] Thus the last weeks of 1912, in which Picasso made his first experiments with pasted paper in his 'Balkan' series, were also the moment of the syndicalist movement's most acute pre-war isolation – an isolation not only from its former collaborators in the Bloc des Gauches, for the collapse of the Bloc had led also in 1907 to the break between anarchism and syndicalism. By 1913 moreover, if not before, the co-optive force of nationalism had polarised the ranks of the anarchists and anarchist sympathisers in

the Parisian avant-garde coteries, with some articulating a *patriotisme esthétique* – for example, André Salmon, whose earlier links with anarchist milieux have been well documented, but who appears by 1913 to have been attracted by the modern beauty of military colours and military discipline – while others, such as Léon Werth, sought to escape the 'ivory tower' by voicing their outspoken opposition to the patriotic clamour and outlining, in the collective effort of the construction of an alternative aesthetic which they sought to ground in working-class culture.[79] Between the positions taken by Werth and his small circle of associates who aligned themselves self-consciously with syndicalism, and those of Salmon and others in the gallery cubist milieu, there existed a gulf which was the equivalent of that between syndicalism and the rest of the nation.

To assume, therefore, that Picasso's inclusion in his pasted papers – such as the *Glass and Bottle of Suze* (figure 4.23) of late 1912 – of press cuttings about socialist and syndicalist anti-militarist demonstrations and the war in the Balkans indexes his support for the former and his opposition tó the latter, and that such works thus

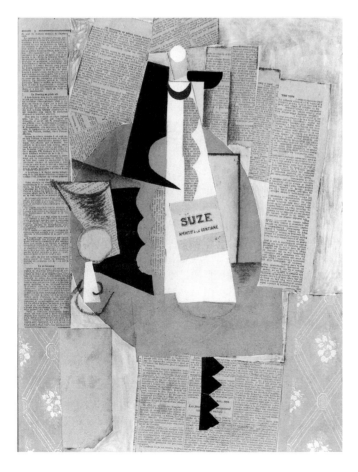

4.23 Pablo Picasso, *Glass and Bottle of Suze*, 1912

articulated a counter-discourse that stood with those movements in political opposi-
tion to the dominant,[80] is to ignore those features of the discursive terrain which sep-
arated his milieu from the movements of the French Left in 1912. Similarly, to
assume that his engagement with the proliferating commercial vernacular of news-
paper advertising was shaped wholly by an endlessly mutating and interactive
'common sense' is to ignore both the degree of consolidation achieved before 1914 by
the avant-garde formation, and the degree to which 'popular culture' was by then
delineated and stratified by the resources, customs and ideologies of different
classes. For all the artist's earlier anarchist allegiances, the means to any identifica-
tion that he felt or wished to express with either anti-militarism or the working class
were shaped, as they were for everyone else, by a field of social, economic and cultural
relations whose pressures were pushing individualistic aesthetic practice away from
engagement with collective political action, intellectuals and artists from workers,
middle-class from working-class consumption, French men and women from for-
eigners. On this level of signification, the pasted newspapers in the *Glass and Bottle of
Suze* registered – could only register – not an affiliation but a *dislocation* between
Picasso and the Left, the stories of the Balkan War and the protest demonstration
serving as the formal and figurative background of events to a *private* life symbolised

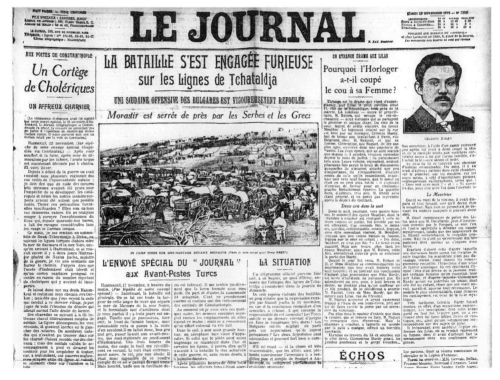

4.24 Page (upper section) from *Le Journal*, 1912

both in the objects of the foreground and in the esoteric manner of their depiction; a dislocation that was also, more generally, between the artistic and political avant-gardes, between aesthetic experimentation and everyday common sense.

This dislocation provided the axis along which Picasso's appropriation and adaptation of the 'popular' were deployed. Thus the very first papier-collé that the artist made, *Guitar, Sheet Music and Glass* of November 1912, includes an unambiguous metonymic reference to the Balkan War, secured in a newspaper fragment by the single word 'CONSTANTINOPLE'. As with other works which included war-related material, this reference was clearly deliberate: had Picasso not intended it, he could have cut it off, for that section of the clipping serves no other purpose (figures 4.22 and 4.24). But it is this anchoring of one pole of meaning in the public discourse that gives the other textual elements their resonance; without it, the ambiguities of 'LE JOU' and 'LA BATAILLE S'EST ENGAGÉ[É]' would lose much of their allure of private sub-cultural play.[81] At the centre of that play, the key term in the transformations that these *papiers-collés* effect is wit: the juxtaposition of these slippages of the signifier from one private allusion to another against the fixity of public events turns on Picasso's own creative imagination – profiles it, both against the craft-based skills of the fine artist, which the dominant cultural discourse privileged, and against the banality of public discourse and the ubiquity of its media.

Seen as a practice shaped by the discursive field of 1912, Picasso's engagement with the 'popular' in the materials and motifs of his pasted paper works thus emerges as both more complex and more ambivalent in its cultural significance than recent interpretations have suggested: neither a purely Mallarmist refusal of the aesthetic of the newspaper and the social forces that this represented, nor yet a wholesale critique of the aesthetic hierarchies of dominant culture, its pretensions to counter-discourse compromised to the degree of its complicity with them. For all the evident iconoclasm of his appropriation of the vernacular, an understanding of this complexity demands due attention to the particularities and dynamics of that discursive field, and of the avant-garde formation within it. Newly emergent though this formation was in pre-1914 Paris, it was already fragmented by the social forces I have outlined, pulled into a plurality of positions *vis-à-vis* a dialectic of dominant and popular culture that the conjuncture of our newly turned century has made more sharply visible, perhaps, than at any time since that of the last. The heightened clarity brings its attendant shadows, however, and throws its objects of analysis into a pattern of relief specific to the co-ordinates of the present; the available meanings and connections between them are ours, not those of that avant-guerre, and we need to acknowledge the former as we seek to recover the latter.

The cubist movement:
from consolidation to dissolution

Consolidation: writing cubism, 1909–12

When City Councillor Lampué launched his campaign against the presence of cubism in the 1912 Salon d'Automne, he could count on widespread public and critical sympathy not only because his objections rode the rising tide of avant-guerre nationalism, but because the movement's notoriety already had another source of buoyancy: the conventions of ridicule and suspicion with which the Parisian art public greeted any manifestation of aesthetic unorthodoxy. As Jeffrey Weiss has noted, 'expressions of incomprehension occupy a far greater share of the period literature on modern art than any other kind of interpretation'; indeed, he suggests, 'it might justifiably be called the dominant aesthetic condition of the [pre-1914] period'. Such expressions helped to create the discursive spaces of avant-garde art; by the time of cubism's emergence the 'truisms of incomprehension' were, Weiss argues, 'governing principles of anxiety and confrontation, reflexive fears which preceded a new illegibility of pictorial form'.[1]

These governing principles and those that guided emergent avant-gardism need to be seen, I would add, as reciprocal strategies: declarations or consolidations of collective identities defined each against the other – that of the artists, through an appeal to values of originality and creativity which the careerism of the mainstream art market and the conservatism of its clientele had marginalised; that of the art public, through its shared and ritualised rejection of the unorthodox as dishonest practical jokery. Both parties to this relationship found confirmation of these identities in the marketing strategies proliferating from the turn of the century as consumerism gathered momentum. The publication, within a few weeks of each other in early 1909, of Marinetti's founding manifesto of futurism (on the front page of *Le Figaro*, for which he paid, like any advertiser of a product) and Mauclair's essay condemning 'the prejudice of novelty in modern art' marked a significant moment in the perceived congruence of avant-gardism and advertising.[2]

From then on, journalist critics and their readers understood the two as sharing the same character of self-interested and dishonest hyperbole, while ambitious artists within the milieux of the avant-garde sought ways to emulate or outdo

Marinetti's promotional coup. Thus the space for the sceptical reception of cubism had been well prepared in advance; indeed the term itself entered the critical lexicon a full two years before the room 41 debut of the salon cubists (at around the time of the appearance of the texts by Marinetti and Mauclair), its jargonistic absurdity signifying such illegibility even while it as yet lacked any specific referent.[3] If this generalised culture of incomprehension (to which Weiss is an indispensable guide) provided the discursive terms in which that referent was first received, however, the meanings cubism had acquired by the autumn of 1912 were the product of contestation between two sectors of the critical field that had helped to generate them – and of two stages in that field's development.

The first of these sectors was that of the professional art critics who wrote for the mass-circulation and other daily and weekly Parisian newspapers. Increasing in numbers with the expansion of both the newspaper industry and the Paris art market from the late nineteenth century, and correspondingly also increasingly professionalised, the art journalists who wrote for the general public had neither sufficient column-inches in which to elaborate or nuance their critical judgements nor the readerships who would wish them to do so.[4] Instead their role was to guide the latter through the bewildering variety of artistic styles on offer in the proliferating exhibition outlets of the city, and to entertain them as they did. They were committed as much, if not more, to those readerships as they were to the artists whose work they reviewed; none was close to the cubists, and as individuals they had no influence on its development. Collectively, however, they drew on the existing culture of incomprehension to create for the movement a climate of reception that grew stormier with each showing of cubist painting after the 1911 Indépendants.

Not that they all agreed on the terms in which the absurdities of such painting should be condemned. Most ridiculed it as a departure from common sense and sensibility – indeed, from the domain of art itself for some critics: Michel Puy reported that 'people say the cubists no longer work in studios but in laboratories', and that the colours in their paintings are based on the observation not of nature but of chemical reactions 'at the bottom of retorts and test-tubes', while Régis Gignoux argued that their 'geometric speculations' and 'mathematical division of colours' would be better employed in industry than in art.[5] And they outbid each other for the wittiest *mot juste* with which to dismiss them, a contest surely won by Louis Vauxcelles's mockery of 'these bipeds of the parallelepiped [with] their lucubrations, cubes, succubi and incubi'.[6] But a minority deplored precisely that obsession with sensation which they saw as governing the tastes of the mainstream: as Arsène Alexandre put it:

> There is concern for nothing else besides decoration, ornament, the colourful, or rather, coloured, atmosphere of everyday life; superficial, electric, materialistic, whirling, torrential life, vibrant with impatience, avid for shock, incapable of meditation, unfit for contemplation, hostile to thought, which is what we believe our life to be.[7]

Unlike the majority, Alexandre called for more intellect in art; but he shared with them the distrust of the formal innovations by means of which the cubists were seeking to introduce precisely that quality, dismissing the latter as mere jokers. For across the gamut of journalistic critical opinion those innovations signified only empty hype, as Vauxcelles indicated:

> 'To think that next year perhaps, when a new ringleader all of eight years old has dis-
> covered a new and still more amazing system, the cubists will be seen as *pompiers*! It's
> the fate of all overblown promotion. The cubists disregard the fauves. Who will dis-
> regard the cubists?'[8]

This critical storm with which cubism was met had, in turn, an influence on the way its artists promoted, justified and even regarded their own work. Prior to their salon debut in the spring of 1911, only Le Fauconnier and Metzinger had, as I have said, thought to publish their ideas, the former in the form of an impenetrable text, laced with pseudo-mathematical jargon, for the catalogue of the September 1910 exhibition of the NKV in Munich which he had been invited by Kandinsky to join, the latter in an essay of about the same time for a little literary review.[9] Both state-ments were intended primarily for (and surely reached only) the restricted audi-ence of their authors' artistic and literary acquaintances, gestures that established their claims to pre-eminence within the self-validating field of the avant-garde. Following the uproar that greeted room 41, however, this motivation was joined by others. Albert Gleizes later recalled the artists' surprise at the art public's response to their work:

> No-one could have thought that this would be the object of scandal. And we were the
> last people who would have wished it. At that epoch one had more modesty, and the
> act of exhibiting paintings conceived in a spirit somewhat different from that of sur-
> rounding work in no way indicated, in itself, the intention to provoke the public. And
> we were greatly surprised when, at the vernissage, there was an outcry.[10]

Their reaction was to write, this time not only for an avant-garde readership but for a broader public, in defence of their painting – to seek to legitimise its inno-vations in the eyes of the critics. Thus Metzinger's article '"Cubism" and tradi-tion' of August 1911, discussed in earlier chapters, was published in the mass-circulation daily *Paris-Journal*; he followed this up shortly before the opening of that year's Salon d'Automne by explaining cubism to certain jour-nalist critics, who retailed his ideas, with varying degrees of commentary, to their readers.[11] Perhaps taking his cue from this, Gleizes entered the critical lists that autumn with three statements, one of them an interview with a critic for a daily newspaper, the other two review essays for little magazines.[12] Common to all four articles was a stress on the qualities that placed cubism within tradition: Metzinger appealed to the old masters whose glory was to set the paradigm for beauty, and declared that 'those whom people call the cubists are trying to imi-tate the masters, to fashion new types';[13] Gleizes, for his part, referenced a clearly

classical tradition that included Giotto and Raphael but which he repeatedly defined as specifically French – adding to this appeal to nationalism an insistence that the ideas of the cubists were 'just as respectable, after all, as those of the "impressionists" and the "pointillists"'.[14]

Respectability was an odd goal for an avant-gardist, but it was one produced, like the nationalist emphasis, by the discursive pressures of the moment. So, too, was the increased salience, from late 1911, of a second sector of the critical field, that of the poets and other *littérateurs* of the little magazines whose numbers and activities were then multiplying, as I noted earlier. The launch of salon cubism, and the hostility it met with from journalist critics, had by that date made this new painting style both an issue on which any ambitious but marginalised young writer with access to the pages of a *petite revue* might take a stand, thereby to establish an aesthetic position and/or a critical reputation, and a stake in a more serious contest between the avant-gardist values around which the milieux of these magazines rallied and those of the mainstream, for the ridiculing of the cubists was an attack on aesthetic innovation and experiment in general.

Moreover, with nationalist sentiments currently fanned to a blaze by the second run-in with Germany over Morocco (the German Government's dispatch of a warship to the protectorate's port of Agadir in July 1911, ostensibly to protect German commercial interests, was seen in France as a provocative gesture), there was an increasing tendency from that moment for such experimentation to be perceived as a threat to France's cultural – and by extension social – order.[15] Moderate critic Gabriel Mourey likened the cubists in late 1911 to anarchists and anti-militarists; a year later that equation had developed into the alarmism and xenophobia of Lampué's campaign against the Salon d'Automne. All vanguardists worthy of the name owed it to themselves to defend them, and over the intervening months several young writers threw their hats into the critical arena with articles that contested the terms in which cubism was to be understood. Most, but not all, sought like Metzinger and Gleizes to legitimise it, though they did so on different and often contradictory grounds. As the debate progressed, its terms consequently slipped steadily further from its artistic referents, and articulated more than aesthetic concerns alone. It is important to distinguish the 'cubism' that was thus constructed as an object of criticism in 1912, both by professional writers (whether journalists or poets) and in artists' writings, from that which was exhibited in gallery and salon.

The newcomers were preceded, as I have noted, by Roger Allard and Guillaume Apollinaire, whose championing, respectively, of salon and gallery cubism contributed significantly to both the public profile and the aesthetic orientation of each; though this was more true in the case of Allard, who was a member of the post-Abbaye circle and played a key role, as I have shown, in developing the Bergsonist interpretation of classicism that characterised much of the work of its members in 1910–12. Apollinaire's art criticism in these years was less influential, in aesthetic terms, with either wing of cubism than were his promotion and support

of them, on the one hand, and his aesthetic erudition and example, on the other.[16] His critical writing prior to 1912 championed above all Picasso, whose painting he lauded from as early as 1905 in terms of a symbolist aesthetic that also fuelled his poetic writings of the period.[17]

A key year in both respects was 1908: it saw the publication not only of two of his major poems of these years,[18] but of three of his general aesthetic statements which combined declarations of idealism and opposition to realism with a commitment to tradition and implicitly classical values. After extolling the living tradition of French poetry (especially symbolism) in a discussion at that April's Indépendants,[19] he chose a catalogue preface for an exhibition in June of work by a motley group of artists to celebrate 'the three plastic virtues, purity, unity and truth' which 'stand triumphantly over vanquished nature', condemning attempts 'to seize the too-fugitive present', and painters in particular for their enslavement to the phenomena and fashions of the material world.[20] That November another catalogue preface, for Braque's solo show at Kahnweiler's gallery, was the occasion both for the espousal of 'a more noble, more measured, more orderly and more cultivated art' that we encountered earlier, and for an interpretation of Braque's paintings in anti-realist terms and elevated symbolist language: Braque was 'an angelic painter. Purer than other men, he does not pay heed to anything foreign to his art that would make him fall from the paradise he inhabits.'[21] This remained Apollinaire's position through 1910 – an exhibition review of June that year condemned, once again, 'that modern malady which makes all those it afflicts consider that the sole aim of art is to express contemporary life',[22] and he continued to take every opportunity to champion Picasso's art in symbolist terms.[23]

By the spring of 1911, however, in the wake of salon cubism's launch, Apollinaire had changed tack; reviewing the works of room 41 in April he welcomed, without a blush, Metzinger's 'cinematic' depiction of 'plastic reality', while in a catalogue preface to accompany their next group appearance two months later he praised the salon cubists for the epic themes of their paintings, 'the vast subjects that yesterday's painters did not dare to undertake, leaving them to the presumptuous, outmoded and boring daubers of the official salons'.[24] And, by October, he felt obliged to put down his marker as their leading supporter, declaring: 'I find myself practically alone among art critics in defending a group of artists whose efforts I know about and whose works I like.'[25] At a time when half a dozen others were doing the same, this took considerable brass neck,[26] and indicates the level to which the stakes in the contest over the meaning of cubism were then rising. For a contest it was certainly becoming in late 1911, as two newcomers to cubism's critical lists sought to harness the new painting to their own more overtly ideological concerns. The first was Jacques Rivière, editorial secretary of the *NRF* and Maurrasian sympathiser, whose merciless dissection of cubism's perceived shortcomings I discussed in an earlier chapter; the second was Olivier Hourcade, a young writer from Gascony committed to a politics of regionalism and with ambitions to promote this in literature. The first issue of the magazine Hourcade

founded to that end carried an essay in which he championed salon cubism in terms both of idealist philosophy and of racial identity: focusing on the painting of Gleizes and Lhote as sons of Gascony whose work revealed 'the profound truths of a race [and] a locality', he also introduced into cubist criticism references to Kant and Schopenhauer, citing them for what he saw as cubism's distinction between essence and appearance.[27] Between them these two essays, written probably in late 1911 and published early the following year, at once registered the rise in the critical temperature and raised it still further.

Dissemination: new members, new meeting places

With the Société Normande exhibition that opened in the rue Tronchet a fortnight after the close of the Automne, there opened also a new stage in the development of the salon cubist group itself. For this was an open challenge to Kahnweiler's stable, taking salon cubism and its growing band of associates into a commercial gallery for the first time, and on the dealer's home turf. Thirty-three artists were listed in the catalogue, among them all of the recent exhibitors in room 8 at the Automne. Moreover, a series of lectures by critics was arranged to accompany the event: Apollinaire, René Blum, Louis Nazzi and Gabriel Reuillard were those listed, though press reports (of which there were few) mention only Apollinaire, who explained cubism on 24 November in terms of Nietzsche and the fourth dimension, so annoying one member of the audience in respect of the latter that he stormed out.[28] Ironically, the reference was one that was new to Apollinaire's criticism, and itself indicates both the widening terms of the interpretation of cubism and their influence on the lively discussions that had recently begun within the salon cubist milieu.

The occasions for these discussions were the Sunday afternoon gatherings at Jacques Villon's house in the suburb of Puteaux which, together with the Monday *soirées* that Gleizes established around the same time in his studio just across the river in the suburb of Courbevoie, attracted a growing number of artists, including the new recruits from the Salon d'Automne showing and several others belonging to the Société Normande. Themselves among the newcomers to the group in the autumn of 1911, the Duchamp brothers brought to it both some useful connections (it was probably through their auspices that the rue Tronchet show became a platform for cubism) and a profound intellectual curiosity whose promptings each followed differently. Common to them all was an interest in mathematics, a topic then at the cutting edge of scientific enquiry and of the popular assimilation its results;[29] it was an interest shared, as I have said, by Jean Metzinger, and also by an associate of the group – who, it seems, knew several of its members already in the years immediately prior to their coalescence as a group – the young 'amateur mathematician' Maurice Princet.[30] As a result, although the Puteaux discussions ranged widely across the philosophies of Bergson and Nietzsche, the social purpose and epistemic status of art, the questions of dynamism and modernity, it was mathematics – or, more narrowly,

number and geometry – that provided the intellectual cement which, for a brief period, held these considerations together.

It did so because it could be applied to painting in different ways that it will be useful to summarise here, although I have touched on them already. An interest in the development of an abstract vocabulary of both visual and verbal expression based on the rhythm and structure of a painting or a poem had been a characteristic of the post-Abbaye circle: the 'rhythmic constant' that Duhamel and Vildrac saw as the key to *vers libre* was transposed to painting in Le Fauconnier's *Abundance* to convey a Bergsonian intuition of *élan vital*, and adopted too by Gleizes and Léger in their work of 1911.[31] Further, the structuring of pictorial composition according to a proportional system gave a painting the unity and autonomy that were consistent with the anti-decorative emphasis of Gleizes and Metzinger's *Du 'Cubisme'*, and brought to the formal innovations variously improvised by the cubists a conceptual rigour and visual order that accorded well with their reaction against impressionism. Certain members of the group were attracted, for differing reasons, to those aspects of both number and geometry that belonged to the tradition of arcane and occult knowledge, a tradition that had fascinated the symbolists, its promises of non-material truths veiled in obscurity and accessible only to initiates, satisfying both their aesthetic idealism and their vanguardist elitism. Apollinaire, as is well known, was deeply interested and widely read in the history of the occult, and the poems of his Montmartre years, such as *Les Fiançailles* and *Le Brasier*, reveal its profound importance for him. Others in the Puteaux circle were similarly steeped in arcane and irrationalist knowledges:[32] neo-platonism held a fascination for several – the importance it accorded to symbolic geometries, of which the golden section was the best known, as the bearers of mystical truths, led Villon and others in the group to explore this and other systems, and to apply them in their pictures.[33] Classical tradition, of course, also valorised such compositional schemas – this perhaps, rather than neo-platonism, was what had initially sanctioned the searching compositional analyses to which, as Gleizes later recalled, he and Le Fauconnier had subjected the works of David and Ingres in 1909–10, though the author of a text such as 'L'oeuvre d'art' was unlikely to have been immune to the appeal of the recondite geometries of neo-platonism; for his part, Gleizes was increasingly drawn, by the nationalism that was by then colouring debate in the cultural arena as every other, to redraw that classicism in exclusively French terms.

Discussions such as those on mathematics at Puteaux thus brought together not only a range of disparate and even divergent views on contemporary aesthetics and their relevance for cubism, but also the discursive forces that had shaped them. For the first time, salon and gallery cubism shared a milieu, and to a large extent the passionate disagreements between the members of this 'far from homogeneous group' (the phrase is Duchamp's) – in discussions on which, as another participant later recalled, 'it seemed the future of the human spirit depended'[34] – were the product of the ideological and institutional incompatibilities between these two wings of the movement: between, that is, different orientations to the art market, to

the heritage of symbolism and the cultural militancy of the Bloc des Gauches, to the nationalist call to order, to the pressures and potential of avant-gardism. Over the course of the year and more that the Puteaux Sunday gatherings lasted, however, the enthusiasms and the aesthetic ideas associated with Metzinger and, through him, with gallery cubism steadily gained the ascendancy in this engagement. There were several reasons for this. Metzinger was one of the central figures in the group – the leader, with Gleizes, of what Ribemont-Dessaignes saw as one of two tendencies within it (the other being that epitomised by his friend Duchamp, by whom he had been introduced to Puteaux); he described Metzinger as 'small, slight and precious, wielding paradoxes with a mind that was sharp, often cutting and quick with ingenious *reparti*, but too inclined to throw himself into abstract discussions'.

With Gleizes, Metzinger sought 'to pull, if not the chestnuts from the fire, at least the laws, and construct a monument out of cubism'.[35] *Du 'Cubisme'*, indeed, was surely what Ribemont-Dessaignes was thinking of here, since this pamphlet by Gleizes and Metzinger, probably written during the first half of 1912,[36] represents precisely such a set of laws: by far the most ambitious statement of cubist principles to date, in its range of reference this was a compendium of the objects of Puteaux's aesthetic and intellectual interests. It was structured loosely around a series of doctrinal assertions that combined elements of the philosophies of Bergson and Nietzsche with references on the one hand to a pictorial tradition that they traced back from Cézanne, through Courbet, David and Ingres, to Leonardo and Michelangelo, and on the other to non-Euclidean geometry, Henri Poincaré's *Science and Hypothesis*, and recent colour science, and which dismissed in passing – at greater or lesser length – the ideas of the neo-impressionists, the futurists and various unnamed critics who had presumed to explain cubism on the painters' behalf. The tone was elitist, its language at times suffused with the colours of symbolism:

> It is in consummating ourselves within ourselves that we shall purify humanity, it is by increasing our own riches that we shall enrich others, it is by setting fire to the heart of the star for our own intimate joy that we shall exalt the universe.[37]

In this respect as in most of the others, however, it is evident that *Du 'Cubisme'* was the work far more of Metzinger than of Gleizes. Its Nietzschean emphases reflect an acquaintance with the philosopher's writings that can be found in the Bateau-Lavoir milieu of which Metzinger had been a peripheral member (as John Nash notes, Nietzsche was the only philosopher quoted in the art criticism of Apollinaire and Salmon[38]) but that is nowhere evident in Gleizes's thinking of the time. The well-informed discussion of recent advances in theories of colour, and the knowing references to *n*-dimensional geometries are, again, in keeping with Metzinger's youthful apprenticeship to neo-impressionism and his long-standing fascination with mathematics, while Gleizes's repeated emphases on classical values in his statements on cubism of the previous autumn, and their increasingly nationalistic tenor, are entirely absent from *Du 'Cubisme'*.

Yet the main themes of the pamphlet were also those associated with gallery cubism and the *bande à Picasso*. Despite the strategic position within the salon cubist circle that Metzinger had achieved (as I noted earlier, in the eyes of sympathetic art journalists like Salmon and Warnod, he had tacitly replaced Le Fauconnier as its spokesperson and theoretician by late 1911), his aesthetic position remained unchanged from his Bateau-Lavoir days. The terms in which this was articulated in *Du 'Cubisme'* – its elevated, symbolist language, its suggestion that the ultimate goal of art was non-imitative 'pure effusion',[39] its indifference to that engagement with the dynamism of modern life which characterised salon cubism, even its choice of 'light' as a metaphor for creative revelation – were those that Apollinaire, in particular, had made his own. Ironically, then, Metzinger could be said to have been less a 'jay in peacock's plumage', as Apollinaire had charged in his review of the 1910 Salon d'Automne, more a Montmartre cuckoo in the Montparnasse nest of salon cubism, and as such instrumental in establishing the aesthetics of gallery cubism at the centre of Puteaux thinking. He was so, too, in an indirect way, for it seems likely that either his example as an intermediary between the Bateau-Lavoir circle and the post-Abbaye milieu or his friendship with Juan Gris from his days in the former drew the Spanish painter into the Puteaux discussions early in 1912.

Gris had arrived in Paris in 1906 and from 1907 until the war he worked prolifically as a caricaturist, producing over 450 drawings for satirical and humorous magazines such as *L'Assiette au Beurre*, *Le Rire* and *Le Charivari* during that time.[40] In 1908 he moved into a studio in the Bateau-Lavoir, and followed closely the work of Picasso and Braque from then on; it was his compatriot's example that decided him to take up painting in 1910, and in January 1912 he showed fifteen works at the gallery of Picasso's former dealer Clovis Sagot. That aside, Gris made his public debut as a painter – and a full-fledged cubist – at the Indépendants in March 1912, with three paintings, including *Homage to Pablo Picasso* (figure 5.1).[41] This was a substantial painting, an impressively resolved exercise in a style that, as Christopher Green notes, was indebted both to the innovations of gallery cubism (its most obvious point of reference being, as Green suggests, Picasso's *Portrait of Vollard*[42]), and to their codification by Metzinger in *Tea-Time* (figure 2.29). Its qualities not only of bold experimentation but of a clear interest in pictorial order grounded in geometrical systems would in its own right have ensured him a ready welcome in Puteaux; as John Golding notes, if a little one-sidedly, this intellectualism made Gris 'the ideal figure to take over from Metzinger the task of transmitting the principles of [gallery] cubism to the other painters'.[43] But it is also likely that shared intellectual interests in both the rational and neo-platonic aspects of number and geometry were already the basis of a friendship with Metzinger that was to last for several years. Over the next several months, it will be seen, it was the latter's painting and ideas to which those of Gris related most closely.

The momentum generated by the discussions at Puteaux seems to have carried over into other spaces within the field of the avant-garde – or perhaps Puteaux should

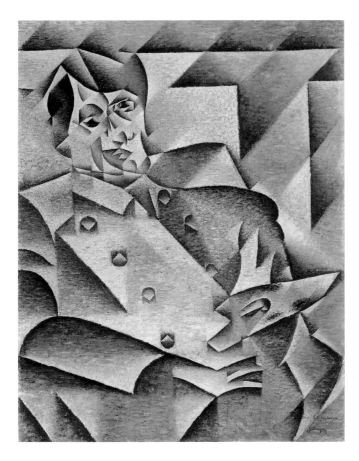

5.1 Juan Gris,
*Homage to Pablo
Picasso*, 1912

be seen as both a contributor to and a register of the consolidation of that field, for the first time, on a European scale. For the months of its existence saw the dissemination of cubist principles and styles across the Continent, as artists networked hectically between the nascent anti-academic cultural communities of many cities. I can note here only some of the means of that dissemination, the proper exploration of which would fill a second volume. Among them were the private Parisian *académies* – La Palette in particular, where (as noted) Le Fauconnier and Metzinger taught from 1912, and where in that year Liubov Popova and Nadezhda Udaltsova, among others, came from Moscow to study (and whence they returned the following year, equipped with salon cubist precepts whose correlation with those they could infer from the Picassos and Braques in Shchukin's Moscow mansion was fundamental for suprematism and constructivism).[44] Alongside these, critics such as Apollinaire and Alexandre Mercereau encouraged, selected work for or even organised foreign exhibitions of cubist paintings; the latter's tireless proselytising for his salon cubist associates was matched only by the more commercial concern of Kahnweiler to place the work of his stable in exhibitions all over Europe.[45] Their efforts were congruent with

those of artists elsewhere to gain access to Parisian modernism, and cubism in partic-
ular (and to measure their own work against it), by mounting group shows in which
this featured: thus, in 1912 alone, the Donkey's Tail in Moscow, Fry's second post-
impressionism exhibition in London, the Moderne Kunst Kring in Amsterdam, the
Group of Plastic Artists in Prague, among others, showed recent paintings by both
salon and gallery cubists. As yet, moreover, gallery cubism's ascendancy over salon
cubism was by no means as evident, nor its terms understood in the same way, as in
Paris, and the readings (and paintings) that resulted from such encounters varied far
more than cubist historiography has acknowledged – for reasons that I explore in
chapter 6.[46]

Dissent: aestheticism and its discontents

The ascendancy of the aesthetics of gallery cubism was not secured without con-
testation within the Puteaux milieu, however. The omission from a pamphlet to
which he put his own name of all of the arguments that Gleizes had only recently
been making for cubism's legitimacy and traditional foundations may have led
him to seek redress independently, for the publication of Du 'Cubisme' was accom-
panied, and followed over the winter of 1912–13, by a spate of exegetical state-
ments by Gleizes that returned to and developed these arguments. Even before
the pamphlet appeared, Gleizes trailed its main themes in a newspaper interview,
but put a nationalist spin on its appeal to art history by arguing that cubism stood
'in the purest tradition' of French painting that ran from the gothic – 'the art that
is most essentially French, the art of our race, born spontaneously on our soil' – to
the present by way of Poussin and Delacroix.[47] This Mithouardian emphasis on
the gothic, and the Barrésian tenor of its terms, were both at striking variance with
the complete absence of nationalism from Du 'Cubisme' and new for Gleizes, and a
departure from his earlier claim of a lineage from Giotto and Raphael. By the end
of the year the departure had developed into a contradiction: replying to an
enquête about cubism, he distinguished this 'true path of French tradition' from
'the detestable Italian influence, sad heritage of the sixteenth century Renaissance,
that outrage against our national genius', to which it was 'violently opposed'.[48]
Such immoderate language was reprised, and the argument elaborated, in his
essay 'Le cubisme et la tradition' that was published in the first two issues of the
magazine Montjoie! the following month, and which offered a potted history of
French art, the narrative of which was driven by a succession of heroes and vil-
lains. The latter, once again, were the artists of the Italian Renaissance, but they
were joined by the French court of Fontainebleau and its aristocracy that had
encouraged the 'forced and unnatural mannerisms' of artists such as Rosso
and Primaticcio; the heroes were 'the old image-makers' and their 'robust and
honest descendants', from François Clouet through the Le Nain brothers to
Chardin. These embodied 'a whole race full of vitality', whose origins lay in the
celtic past.[49]

Gleizes thus claimed for cubism a lineage that was at once populist and national-istic to the point of racism. The emergence of such emphases in the immediate wake of *Du 'Cubisme'*, and in the face of gallery cubism's ascendancy, suggests not just profound uncertainty on his part over the latter, but the discursive pressures of a narrowly celtist understanding of nationalism. As Mark Antliff has shown, this current, informed by Barrésian populism, had a steadily widening currency in the many milieux of the Parisian literary and artistic avant-garde from around the middle of 1911;[50] stimulated perhaps (along with all of French society other than the syndicalist and socialist movements) by the Agadir crisis, and perhaps also goaded as an avant-gardist by the gauntlet thrown down by futurist polemic, as well as by criticisms of cubism as 'munichois', Gleizes thus found in the achievements and inheritance of the gothic masons a lodestone for his sharpening sense of a cul-tural nationalism that distinguished a 'True France' from the broader identity offered by the latinate classical tradition. Perhaps the increasing stridency of his assertions was influenced, as Antliff suggests, by the activities of Robert Pelletier's Celtic League. Established around the mid-point of 1911, the League quickly gained adherents in post-Abbaye and neo-symbolist circles, and, Antliff argues, sought to counter the growing influence in avant-garde milieux of the latinism of Action française.[51] Yet the narrowing of nationalism thus registered should also be seen in more general terms, as Herman Lebovics and others have noted, as the product of a broader discursive dynamic that saw also the growth of ethnography and folklore studies, the embrace of rural and provincial values and the positing of a 'True France' against the increasingly urban and cosmopolitan emphases of the modern republic.[52] 'The modern world has become Breton, and is proud of it', Mithouard had insisted in 1904.[53]

Others within or close to the Puteaux circle traced the same lineage, if in tones less shrill. Thus, having lamented the poor state of French decorative arts in 1912,[54] Raymond Duchamp-Villon saw the remedy to lie in such values; extolling the gothic in terms similar to those of Gleizes in his essay 'Architecture and iron' of the following year, he equated the medieval mason with the modern engineer in their common avoidance of a suffocating academic training, and Notre Dame with the Eiffel Tower as emblems of 'a similar dream of superhuman exaltation'.[55] Apollinaire, never slow to cover his bets, also declared in May 1912 that

> today's art is linked to gothic art through all that is truly French in the intervening schools, from Poussin to Ingres, from Delacroix to Manet, from Cézanne to Seurat, from Renoir to the douanier Rousseau, that humble but so expressive expression of French art[…]
> The vitality of this energetic and infinite art, which issues from the soil of France, offers us a marvellous spectacle.[56]

Apollinaire was at that time close to Robert Delaunay, who had earlier that year reg-istered his attachment to the gothic, spending three weeks in Laon sketching its cathedral, and may well have been influenced by the latter's enthusiasms.

Apollinaire's remarks appeared in *Les Soirées de Paris*, the magazine with which he was particularly associated and whose second series he would edit,[57] and it is significant that the other *petites revues* that were close to the Puteaux circle – especially Ricciotto Canudo's *Montjoie!* and Henri-Martin Barzun's *Poème et Drame*, both founded in the winter of 1912–13 – also gave space to this cultural nationalism. The former declared itself on its masthead to be 'the organ of French cultural imperialism' and, as I have noted, carried Gleizes's 'Le cubisme et la tradition' in its first two issues; the latter (which in its turn published an excerpt from *Du 'Cubisme'* in its first issue, and another in its third) was launched with a manifesto, 'D'un art poétique moderne', by its founder–editor, that rejected a narrowly latinist definition of classicism alongside the empty pastiches of past art that contemporary neo-classicist and academic artists alike had produced, and celebrated the art 'of our *Gallo-Celtic* race'.[58] But Barzun had big ambitions, and he combined this nationalism, somewhat paradoxically, with an internationalist appeal to 'the young creative elites of the whole world', whose works it was the aim of *Poème et Drame* to anthologise, and whose intercommunications it would seek to facilitate: 'It is up to us, in this year 1912, to raise cohorts of athletes and legions of pioneers to till and seed the soil of this new century, to reveal the New Era.'[59] To that end, he also organised, from July 1912, *les dîners de Passy*, a series of dinners and lectures that sought to harness the rich literary associations of that quarter of Paris to the debates around new art and writing. These occasions and their participants were reported on fullsomely in *Poème et Drame*, the seventh issue of which, of January–March 1914, also reported on the magazine's success over the previous eighteen months in promoting 'the New Era' and its pioneers.[60] Clearly Barzun sought with these activities to establish himself at the centre of the avant-garde network, or at least of that sector of it whose centre of gravity was in Puteaux. But he was too much of a one-man-band to prosper in this effort; unlike, say, Apollinaire, whose intellectual curiosity, gregariousness and inclusive aesthetic sympathies (not to speak of his own poetic abilities) had indeed placed him at the centre of the action, Barzun succeeded only, as noted in an earlier chapter, in progressively alienating potential comrades-in-arms with his demagoguery.

If *Du 'Cubisme'* was the most lasting of Puteaux's initiatives, it was not the most substantial. The exhibition organised in late 1912 by members of the circle, and to which they gave the title 'Le Salon de la Section d'or', was a major promotional event (the opening of which Gleizes and Metzinger's pamphlet was intended to accompany). But it was also a complex and contradictory one: originating as a market initiative intended to counter the growing salience of Kahnweiler in the promotion of cubism, one of its ultimate effects was to consolidate still further the ascendancy of the wing of cubism with which he was associated. Even in market terms it was curiously hybrid: for its prime mover and financial backer, the independently wealthy Picabia (drawn into the Puteaux milieu by his friendships with Apollinaire and Duchamp), it seems to have been an attempt to secure for its participants the advantages of freedom from commercial dependence on the salons

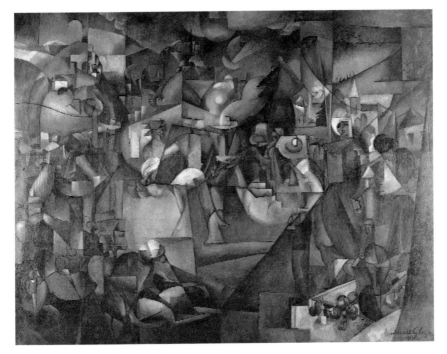

XI Albert Gleizes, *Harvest Threshing*, 1912

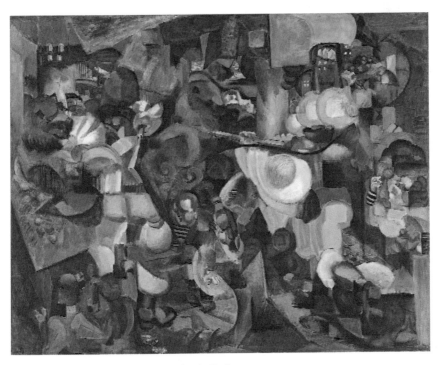

XII Henri Le Fauconnier, *Mountaineers Attacked by Bears*, 1912

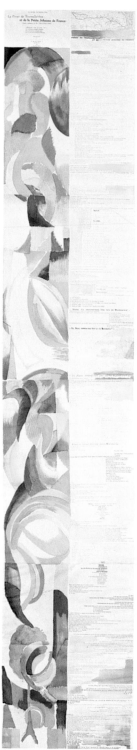

XIV Sonia Delaunay and
Blaise Cendrars,
*Prose on the Trans-Siberian
and of Little Jéhanne of
France*, 1913

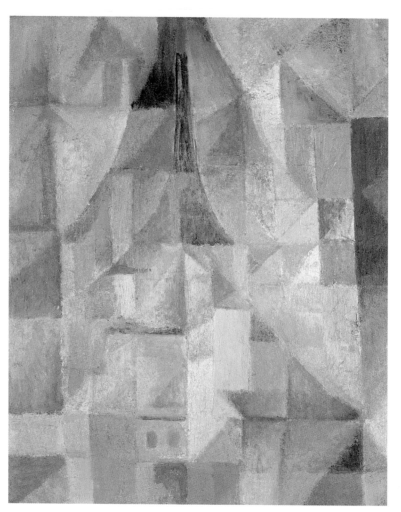

XIII Robert Delaunay, *Windows*, 1912

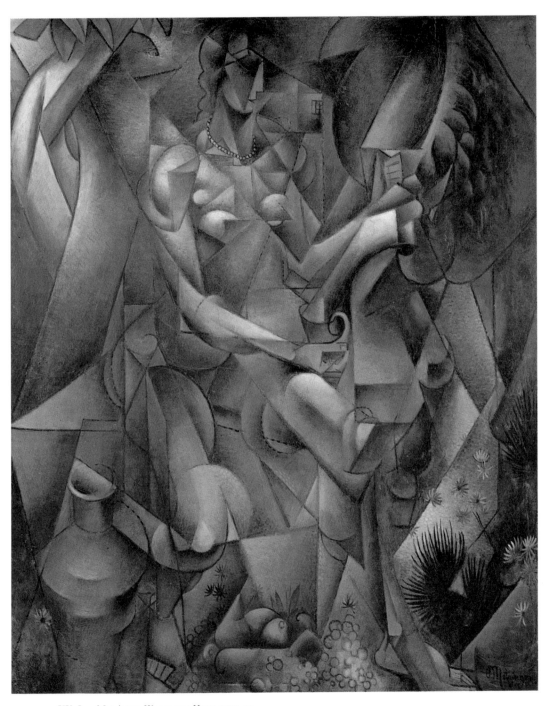

XV Jean Metzinger, *Woman on a Horse*, 1911–12

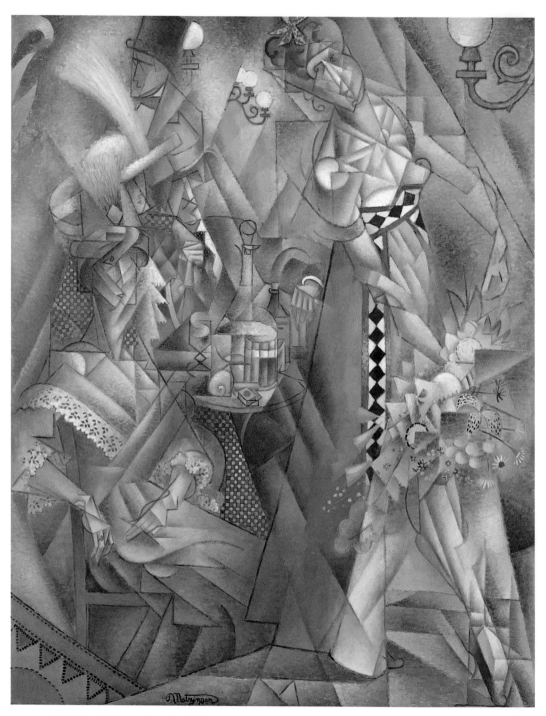

XVI Jean Metzinger, *Dancer in a Café*, 1912

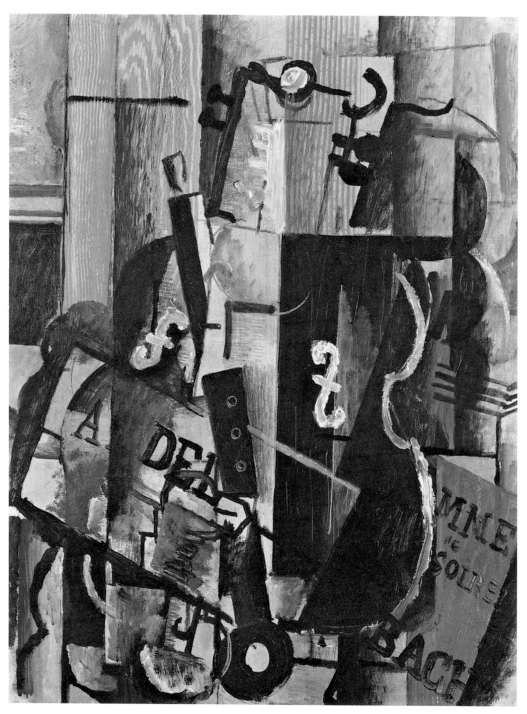

XVII Georges Braque, *Violin and Clarinet*, 1912

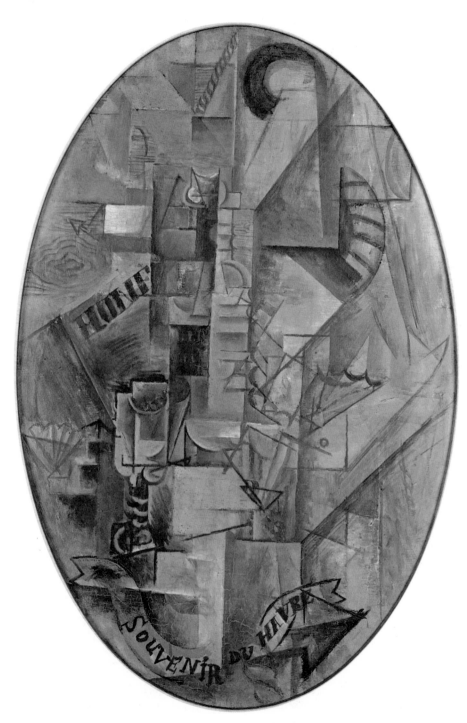

XVIII Pablo Picasso, *Souvenir of Le Havre*, 1912

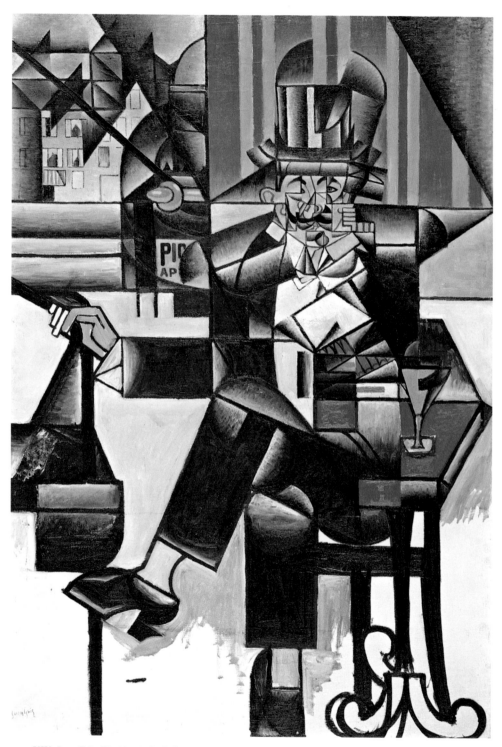

XIX Juan Gris, *The Man in the Café*, 1912

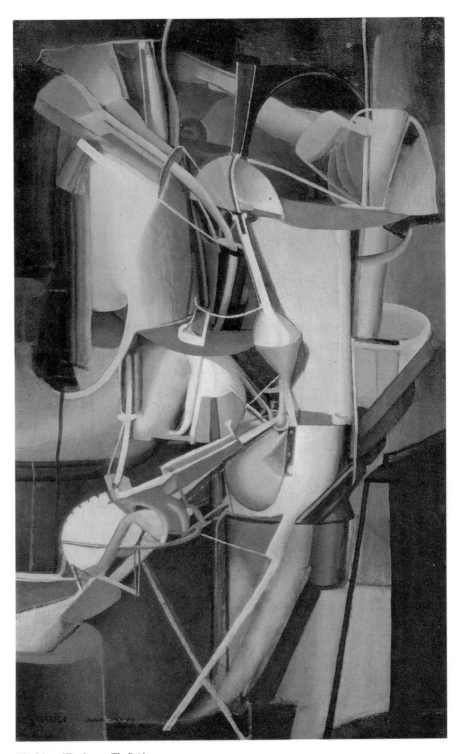

XX Marcel Duchamp, *The Bride*, 1912

that his own successful early career as a *retardataire* impressionist had given him; yet the show's organisation, from its selection and hanging to its promotional material, underscored a group identity of a kind that Kahnweiler had studiously avoided cultivating for his artists, and that was best suited to the conditions of salon exposure.[61] As Maurice Raynal declared in a catalogue essay for the periodical *La Section d'or*, the single issue (as it turned out) of which accompanied its opening, this group character was the exhibition's chief characteristic, and to underline this the aesthetic of cubism was propounded, as it had been a year earlier at the rue Tronchet exhibition, in a series of lectures (by Apollinaire, Raynal and René Blum), while the publication of *Du 'Cubisme'* had been planned for the same moment. Such avant-gardist assertions of a group identity bore comparison with the futurists' initiative of the previous February, and it is inconceivable that the Salon de la Section d'or was not intended as, *inter alia*, a reply to the Italians; yet its very size and the diversity of the work on show militated against its being as coherent; it was closer, indeed, to the many 'salonnets', curtain-raisers to the annual salons, that had recently proliferated. At least thirty-one artists showed around 200 works, and although the Puteaux group formed the core of these (Gleizes, with 15 exhibits, was the best represented, Gris and Picabia had 13 each, Metzinger 12, Léger and Duchamp 6 each) there were many hangers-on, some of whom showed similar numbers.[62]

If any tendency within this loose compendium of the cubist movement had a higher profile than others, it was gallery cubism; in the glaring absence of Braque and Picasso (despite the efforts of Apollinaire to secure their inclusion, which was presumably vetoed by Kahnweiler, for reasons of *exclusivité*[63]) it was Metzinger and, above all, Gris who represented, and further consolidated, the ascendant axis. In the months that had intervened between the Indépendants in March and the Section d'or in October, Gris had sustained the momentum of his salon debut, and the thirteen works he showed included two or three that represented a major advance both for him and for cubism, paintings in which he exploited the skills he had displayed as a cartoonist, and explored the relation between such a 'low' art practice and the 'high' practice of painting, to great effect.[64] *Homage to Pablo Picasso* (figure 5.1) had made telling use of the qualities of graphic flair and visual economy characteristic of the former, elegantly and succinctly condensing the form and features of its subject into the crisp orthogonals of a grid derived from the 1910–11 paintings of Picasso and Braque; yet those qualities had also set limits on its success, in that the reticulations they produced, in the facial area especially, departed too far from legibility to work as a portrait, and came close to a stylisation in which the demands of the grid overpowered all other considerations. Comparison might be made with Braque's *Mandora* of 1909–10 (figure 2.13), to whose similar shortcomings the latter seems to have responded by regaining a more tenacious hold on the specificities of his motifs.[65]

Gris's response was different. Newly introduced to the Puteaux circle, he found in their discussions of number and geometry, and in the example of his friend

Metzinger – especially his painting *Tea-Time* with its programmatic juxtaposition of viewpoints and concatenation of ideas and sensations – the means to make of the gallery cubist grid the organising principle for analysis itself,[66] and to put his skills as a caricaturist at the centre of his painting. Thus *The Man in the Café* of mid-1912 (plate XIX), one of his Section d'or entries, replaces the *Homage*'s attempt to hang on to elements of Picasso's appearance while squeezing them into the grid, with a grid whose points of departure are those elements themselves. Unencumbered by the need for resemblance (*The Man in the Café* had no specific sitter), his juxtaposition of profiles, features and details sets the figure wittily into a busy motion that captures most effectively the image of a café-terrace dandy. Yet the motion is not evoked as a sensation, but conceptualised; and the complicated jigsaw of its components is anchored by a severe geometry ordered, as William Camfield has proposed, according to the proportions of the golden section.[67] This is the territory of *Tea-Time*, but the wit and acuity of Gris's articulation of this thematic show up the bombast of Metzinger's. In the year since *Tea-Time*, Metzinger too had moved on, and recent paintings such as *Dancer in a Café* and *The Yellow Feather* (plate XVI and figure 4.1) – the latter shown in the Section d'or salon – are close to Gris's picture in their linear scaffolding and complicated facetted features. Yet while they were altogether less ponderous than the previous autumn's demonstration piece, Metzinger lacked Gris's deftness of characterisation that could capture a personality in the profile of an eyebrow, and the faces of his figures are their most laboured elements. He lacked also Gris's clarity of purpose in subordinating the devices of caricature to the demands of cubist painting. Coming, as he had, from the former to the latter, and to Puteaux via Picasso's deepening engagement with the popular, Gris had meditated closely on the relations of 'low' and 'high', and on their different discourses; if the reciprocal strategies of art-public ridicule and avant-gardist iconoclasm with which this chapter opened were bringing these discourses to intersect in 1912, he – like Picasso, as noted – had no doubt as to where his allegiance lay. Where Metzinger seems, as I have suggested, to have vacillated between the sensuous charms of fashion and the severer ones of intellect, Gris took care to contain the humour of his café dandy within a compositional armature that insists on the painting's status as a picture above all else.

This clarity of purpose enabled him to introduce abrupt contrasts of representational convention, as well as 'low' and non-art materials, into his pictures, to surprising and subversive effect; thus *The Washbasin* (figure 5.2) of mid-1912, also shown in the Section d'or salon, juxtaposes a curtain rendered with orthodox legibility against the diagrammatic grid of the bathroom still-life that it is swept back to reveal – a *repoussoir* reprise of Braque's *trompe-l'oeil* nail conceit in the *Violin and Pitcher* (plate III) that both sharpens and simplifies this polarity of means. It also incorporates a fragment of mirror that not only stands for itself but reflects each viewer who stands before it.[68] While the principle of such collage was derived, it is generally understood, from Picasso's *Still Life with Chair Caning* (figure 4.16) that predates *The Washbasin* by a few months, the tacit involvement of the viewer in the

completion of the picture was an innovation of startling radicality that both posed succinctly the challenge to the status of painting that Picasso's collage had implied and anticipated the further challenge to artistic authority that would be presented by Duchamp's ready-mades. (Gris not only repeated but developed the conceit the following year, incorporating an engraving of a painting into his *Violin and Engraving* of April 1913 (figure 5.3) and suggesting to Kahnweiler that the purchaser should feel free to replace this with any other of his or her preference. Alarmed at the subversiveness of this proposal, the dealer took pains to persuade him of its lack of wisdom.[69]) Yet while such conceits indicate Gris's alertness to ideas about the status of painting and the nature of authorship that were in the air, in the milieux of both Puteaux and gallery cubism, as well as the deftness with which he addressed them, they – and the questions they raised – were kept in their place by the controlling authority of his pictures' compositional geometries.

The accomplishment and authority of Gris's contribution to the Section d'or salon, and the common ground it shared with that of Metzinger, did much to underscore the salience of this axis of the movement. Equally influential, though, were the critical accompaniments of Apollinaire and, especially, of Maurice Raynal, a relative newcomer to the critical arena who was to become one of cubism's most articulate and influential advocates in the inter-war years. Raynal came to the

5.2 Juan Gris, *The Washbasin*, 1912

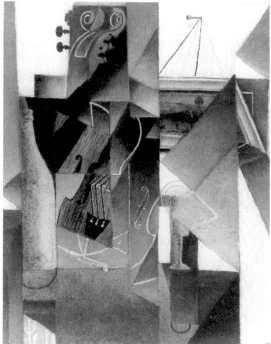

5.3 Juan Gris, *Violin and Engraving*, 1913

movement via the Bateau-Lavoir milieu; he had met Picasso and Braque through a mutual friend, the Spanish sculptor Manolo, as early as 1905, and became friendly in particular with Gris, who painted his portrait in 1911 and that of his wife the following year.[70] By that time, however, he had made contact also with the Puteaux circle, for his critical debut was the catalogue essay for the Société Normande's third exhibition, held in Rouen in June–July 1912. Drawing on contemporary discussions in both camps, this added a distinctively austere and intellectual note to cubist criticism. 'The élite of today rightly considers', he declared, 'that the artist, at the same time as he sees, must conceive the object he proposes to represent ... '. Thus, 'Before all else', the cubist painters

> separate out – according to their own analytical methods and to the characteristics of the object – the principal elements of the bodies they propose to translate. Then they study these elements in accordance with the most elementary laws of painting, and reconstruct the objects by means of their elements, now known and strictly determined.

Moreover:

> They have called to their aid that law of synthesis which – though they have been so much reproached on its account – today governs all conscientious speculation. They have endeavoured, in the reflection preceding their works and in the works themselves, to proceed from principles to consequences and from causes to effects.[71]

This explanatory model, as chapter 6 shows, was to prove as influential as it was timely, providing the terms for the interpretation – and narrative ordering – of the achievements of cubist painting that have dominated its historiography for much of the subsequent century. In the immediate context of the debates of 1912 it placed the defence of this painting on a firmer footing than that provided by the lofty but imprecise symbolist rhetoric of Apollinaire, and it offered in place of the acute and thoughtful Bergsonist classicism of Allard, which had underwritten the paintings of the salon cubism of 1911–12, a pairing of the concepts of analysis and synthesis whose putatively Kantian usage took the reference to the latter beyond the loose appeal made by Hourcade and answered the objections to cubism raised by Rivière – and that in doing so implicitly privileged the explorations of gallery cubism. Raynal developed this emphasis, and in particular the distinction between conception and vision, in an article with that title in August that succinctly, if unintentionally, summarised the tensions between 'realist' and 'autonomist' interpretations of cubism that Puteaux encompassed. 'If ... it be admitted that the aim of the artist is to come as near as possible to the truth, the conceptualist method will bring him there', he argued, but then added: 'The beautiful must be, in Kant's excellent phrase, a "finality apart from any end".'[72]

This last was the emphasis around which Raynal's celebration of the diversity of cubisms on display at the Section d'or was established. 'What finer idea than this conception of a *pure* painting', he asked in his keynote article for *La Section d'or*,

one that is in consequence neither descriptive, nor anecdotal, nor psychological, nor moral, nor sentimental, nor pedagogical, nor, finally, decorative? I do not say that these latter ways of understanding painting are negligible, but it is incontestable that they are inferior. Painting, in fact, should be nothing other than an art derived from the disinterested study of forms, that is, free from any of the purposes I have mentioned.[73]

Once again the terms privileged gallery cubism, and excluded from consideration the epic themes of salon cubist painting, above all that of Gleizes, whose huge *Harvest Threshing* (plate XI) dominated his extensive contribution to the exhibition. Although Raynal hailed the wide range of artistic personalities that cubism by then clearly encompassed in the language of self-consciously heroic avant-gardism, and had some good words for each of a dozen individuals, his warmest praise was reserved for only one or two. The first was Metzinger, whose painterly skills Raynal likened to those of Renoir and who was 'perhaps the man who, in our epoch, knows best how to paint' – the careful phrasing suggesting that the 'captivating charm' Raynal found in his work was, for him, a limiting factor on Metzinger's achievement.[74] The second was Gris, whose champion Raynal was to become in the years immediately following the First World War; here the painter was 'certainly the fiercest of the purists in the group', and his conceptual rigour was both original and impressive, though his friend remained disquieted by the iconoclasm of the mirror collage of *The Washbasin* (as also, he implied, were others, Kahnweiler doubtless among them).[75] Aside from these, his comments on individual artists, for the most part salon cubists and Puteaux regulars, were, on balance, critical: Léger was inclined to be seduced by 'the slightly perverse charms of sensual vision', and had to work to control a tumultuous imagination and a violent temperament; Duchamp's work was marred by 'incoherence' and lacked force; while Gleizes's major painting, *Harvest Threshing*, had 'even a "museum" air about it'.[76]

Apollinaire also acknowledged the diversity of cubism on display, though, it would seem, somewhat reluctantly. His brief Introduction to the single-issue *La Section d'or* emphasised the unity of the cubists and, in a tone that was at once defiant and defensive, insisted on their traditionalism (indicated by their choice of title for the exhibition), scorning the 'blind hostility' of their critics for their inability to perceive it.[77] In keeping with this emphasis, he had apparently intended to stress their common aims in the lecture which accompanied the show's opening, but his close, if temporary, engagement with the work and ideas of Robert and Sonia Delaunay at that time seems to have forced the realisation that the interests of the movement's original protagonists were now too divergent for this to be credible; instead, the lecture was on the diversification of cubism into what he saw as four categories: scientific, physical, instinctive and orphic.[78] The text of this talk no longer survives, but its immediate outcome was a pamphlet on cubism that became, if inadvertently and on misleading terms, Apollinaire's best-known piece of art criticism, and in which the four categories were reiterated. *Les Peintres cubistes: Méditations esthétiques* is a hybrid little volume, made up largely of sundry essays by

Apollinaire from the previous few years, with the addition of some paragraphs on individual artists that were based on conversations held over the summer of 1912, plus part of the October lecture. Perhaps the poet saw it as a riposte to Gleizes and Metzinger's avant-gardist attempt to set the terms of the interpretation of cubism, since he appears to have been put out that not only *Du 'Cubisme'* but Salmon's survey *La Jeune Peinture française*, both published in late November 1912, beat his pamphlet into print.[79] Yet, as he stressed in a letter to the Italian painter and critic Soffici soon after its publication, he never saw *Les Peintres cubistes* as an explanation of, nor even primarily about, cubism; it was intended instead as a 'meditation' on art (and it was at Figuière's insistence that the order of the title phrases was reversed).[80] The categories into which he divided cubism were correspondingly idiosyncratic, and had their origin less in close observation and analysis than in a combination of pragmatism and his own predilections; the former resulting in the creation of a catch-all category of 'instinctive cubism' into which any innovative avant-gardist of note in Europe might be slotted, the latter in his championing of Picasso as contributing, uniquely, to both of the main categories, 'scientific' and 'orphic' cubism.

This last, indeed, was the product of both motivations. Defined by Apollinaire as 'the art of painting new structures out of elements which have not been borrowed from the visual sphere, but have been created entirely by the artist himself, and been endowed by him with fullness of reality',[81] it owed much to a recognition of the originality of Robert Delaunay's current painting and emerging asthetic, but it also articulated the poet's own deep interest in artistic creativity and, as Virginia Spate notes, his return to this as a subject in contemporary poems such as *Zone*.[82] Yet it also reflected Apollinaire's recognition that several artists were pushing their formal experimentation in the direction of non-figurative painting, for a variety of reasons, and this led to what Spate aptly describes as his 'rather desperate juggling' with the names of its representatives, eventually including for pragmatic reasons Duchamp, Léger and Picabia, but reserving Delaunay and Kupka for a future volume on orphism (that never did appear) in the 'Tous les arts' series.[83]

Dissolution: departures

Apollinaire had reason to be defensive in his presentation of cubism at the Section d'or salon, and perhaps ambivalent about its divergences. For not only did the response of journalist critics (and politicians) to cubist painting reach new heights of indignation that autumn – Vauxcelles in particular, despite calling for a vow of silence over cubism on the part of his colleagues in the hope that this would bring an end to its notoriety, returned obsessively to the assault – but sympathetic poet critics, too, saw this as the moment to settle their accounts. Roger Allard used his review of that year's Salon d'Automne as the occasion to stake his claim to priority in articulating cubism's aesthetic position, adding that 'this precision might have been omitted if certain efforts which I shall discuss below did not oblige each to

recognise his responsibilities'. The 'efforts' – to which he did not, in the event, return – were in all likelihood those that led to the Section d'or salon, then due to open in ten days, and in which neither he nor his favoured cubist Le Fauconnier played any part.[84] Hourcade was more outspoken. Responding to a recent account by Apollinaire of the beginnings of cubism in which he accorded priority to Picasso and Derain and explained the work of Gleizes, Léger and Metzinger in conceptualist, 'pure' painting, terms, borrowed from Raynal, that privileged gallery cubism,[85] Hourcade protested that 'some ... of my friends tend to confuse cubism and cubism'. They were not all alike, he insisted:

> When a fellow critic thus says that the painting of his favourite is 'pure' painting, I see no problem. But to say, further, that the art of Metzinger, that of Gleizes, that of Le Fauconnier, that of Léger, is exclusively pure painting – that is not absolutely correct. And it is however those four painters who, with Delaunay, in 1910 and especially at the 1911 Indépendants, *created*, and truly still are, cubism.[86]

Such objections could, however, affect the direction in which the cubist movement was developing, and served only to draw a denial from Delaunay that he had been a creator of cubism (from which he was now seeking to distance his painting[87]) – thus to exacerbate existing tensions within the movement. Significantly, perhaps, this was Hourcade's final critical intervention – he was killed in the war that was soon to begin. Allard, too, found the critical discourse of cubism slipping beyond his terms of analysis, and from that point on he wrote from the sidelines, in magazines and newspapers which had little leverage within the movement, displaying increasing exasperation both with its ascendant axis and the market-driven avant-gardism that seemed inseparable from it.

More significant, however, than such critical demissions were the defections of artists from the group. The Delaunays were perhaps the first (Robert had written to Kandinsky in April 1912 declaring his rupture with cubism[88]), but they were closely followed by Le Fauconnier who had, like Robert, taken little interest in the Puteaux gatherings and had been pursuing independently a strategy of exhibiting his work outside of France. In particular, he had made contacts and found patrons in Amsterdam, and in preference to showing at the Section d'or – if he was ever asked – opted for a retrospective exhibition of around three dozen of his paintings which began in that city's Moderne Kunst Kring salon at the same time and toured Europe during 1913.[89] Marcel Duchamp, too, decided to go his own way after the rebuff in March of his *Nude Descending a Staircase No. 2*[90] (figure 5.7), even though he entered not only this but more recent work in the Section d'or exhibition – including *King and Queen Surrounded by Swift Nudes*, the title as much as the appearance of which provoked Vauxcelles to apoplexy.[91] This was, however, his last participation in an exhibition in Paris, cubist or otherwise, prior to the war. His disinclination to identify his art with the art of the group was less outspoken than that of Robert Delaunay, but his decision indicates perhaps more clearly (since it was not, like the latter's, driven by an alternative promotional strategy) the tensions

within an avant-gardist movement such as cubism that were the price of insisting on unity in the face of its widening sphere of influence. Yet Duchamp was never an ideal candidate for the cubist team, for several reasons. In the first place, he was predisposed to approach the phenomenon of avant-gardism, whose perceived opportunities and promises were for his generation already starting to clarify and harden into obligations and orthodoxies, with a certain detachment. With a precocious talent, an artist for a grandfather, and his older brothers preparing the way for him, he was provided with a sure foundation for his artistic identity. As his stepson Paul Matisse suggested, 'He needed neither fame, nor money, nor status. He didn't even have to paint in order to be happy.'[92] Yet he had also acquired an artistic education which opened an oblique perspective on that identity and status: after a desultory five months at the Académie Julian in 1904–5 he had spent the following five working somewhat harder as an apprentice engraver, passing a trade examination in October 1905, and from then until 1909 (after a year's military service) he followed his brother Gaston (Jacques Villon) in drawing cartoons that he submitted to humorous newspapers in Paris.[93] If this combination of middle-class security, artisanal training, popular art practice and sibling dynamics disinclined Duchamp to embrace what he often later called 'the religion of art' with the single-mindedness that contemporary aestheticist avant-gardism demanded,[94] it also fostered an engagement with the making of art in which an intellectual turn of mind and technical curiosity went together with disregard both for art's social relevance and for a public audience for his work.[95] Within the milieu of Puteaux, such a position and (to use Bourdieu's term) disposition were almost unique, and they resulted in a two-year trajectory through cubism, a prologue to a life's work – and the avoidance of it[96] – whose playful yet profound subversions of the status of art and the artist have both attracted great attention from scholars in recent years and yet – partly in consequence – remained open to an extraordinary range of interpretations.

Not the least reason for this openness was the eclecticism and idiosyncracy of Duchamp's approach to painting almost from the beginning of his career. *Young Man and Girl in Spring* (figure 5.4), one of two paintings of 1911 he showed in that year's Salon d'Automne, at the time when he and his brothers were drawn into the salon cubist milieu, is an amalgam of the flat, bright colours and simplified forms characteristic of fauvism, and the compositional and iconographic qualities of symbolist painting: a hieratic symmetry and compartmentalisation of images suggestive of illuminated manuscripts, and a provocative opacity to interpretation.[97] The fact that it was painted (or at least given) as a wedding present for his sister Suzanne, who was married that summer, has led to inferences of sexual symbolism; certainly the triangle (lower centre) and the modelled areas on each side can be read as a woman's thighs and pubis, in a startling shift of scale that invites an attempt to read the little landscape with seated figure and nude-in-a-bubble in sexual terms.[98] Moreover the painting that accompanied it on the wall of the Automne, *Portrait (Dulcinea)* (figure 5.5) has been universally taken to be sexual in reference: a sequence of repeated images, gathered into the conical shape of a bouquet of

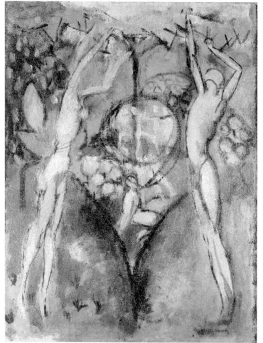

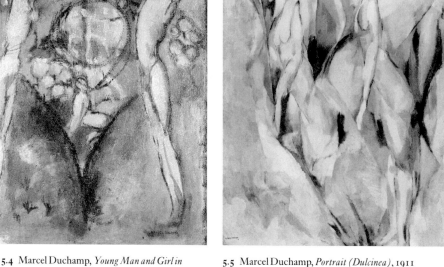

5.4 Marcel Duchamp, *Young Man and Girl in Spring*, 1911

5.5 Marcel Duchamp, *Portrait (Dulcinea)*, 1911

flowers, of a woman in (what appear to be) states of progressive undress; the representation of a flâneur's fantasy, as Duchamp himself later explained.[99] Yet the sexuality in both is a mental matter, and is joined in *Dulcinea* by an equally cerebral representation of movement: it is not the sensation of this that Duchamp conveys, but the *idea* of it. The combination of these concerns, variously inflected, was to be a *leitmotif* of his work over the next two years. *Portrait of Chess Players* (figure 5.6), painted late in 1911, recapitulated earlier works on the theme but adapted the figural fragmentations and transparencies of gallery cubism, with which Duchamp had recently become acquainted via the Puteaux circle, to suggest the cerebral character of the game. And in a series of subsequent pictures, of which his *Nude Descending a Staircase No. 2* (figure 5.7) is perhaps the most resolved and certainly the most celebrated, he deployed and developed these conceits to confront directly the paradoxes of the pictorial representation of movement: to paint not the impossible – the futurists' 'dynamic sensation itself' – but, far more subtly, the 'abstraction' that the idea of movement is 'a deduction articulated within the painting', as Duchamp later put it.[100]

As David Joselit persuasively argues, this can be read also as a concern to explore the translation of the carnal into the semiotic that Picasso and Braque were (as others have suggested) then undertaking.[101] For the *Nude* is constructed of the colours and,

especially, the flattened geometric shards that were already the hallmark of their work from Cadaqués through the previous summer in Céret to *Ma Jolie* of the winter just past, the result of their impassioned drive to put illusionism through its paces. But, suggests Joselit, whereas for Picasso in particular the imperatives of acknowledgement of the conventional character of representation required the relinquishing of the sensuous attractions of resemblance in favour of the arbitrariness of linguistic signs (in *Ma Jolie* leaving 'only a residue – a flickering – of chiaroscuro as the now obsolete means of evoking a volumetric body'[102]), Duchamp's cerebral engagement with sexuality and representation led him to seek to hold on to both, thus to fasten on the moment when the idea of the former becomes the basis for a language of the latter. And his intellectual curiosity provided him with a means to image this, in the chronophotography of Etienne-Jules Marey. Over the course of the last third of the nineteenth century Marey had invented photographic apparatuses for inscribing human or animal movement on film, transforming his subjects not only into the ghostly traces of their own passage through time and space but, as such, into writing machines. 'The graphic system translates all of these changes in the action of forces into a striking figure', he declared, 'that one could call the language of phenomena themselves, in that it is superior to all other modes of expression.'[103] It was a 'language' that suited Duchamp well, for it furnished a system of notation that was both immanent to the body and an extreme reduction of it, and whose 'elementary parallelism' (a term used by Marey that Duchamp borrowed) carried associations of the

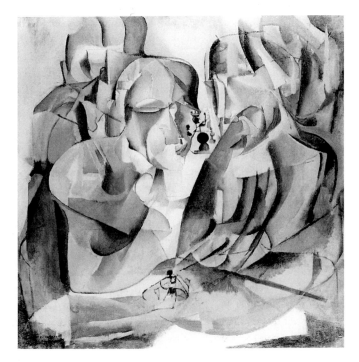

5.6 Marcel Duchamp, *Portrait of Chess Players*, 1911

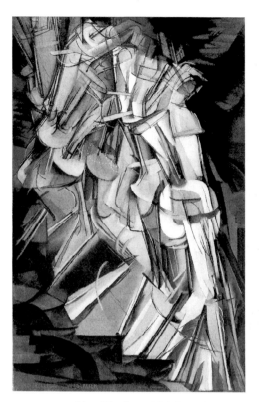

5.7 Marcel Duchamp, *Nude Descending a Staircase No. 2*, 1911–12

mathematics that he was also fascinated by – and, by metonymic extension, of science and technology in general.

Nude Descending a Staircase No. 2 thus marked a key moment for Duchamp's art, which brought together some of the main threads of his aesthetic practice and ideas; as I have shown, the response to it provoked the decision which confirmed him in the independence, the mistrust of the doctrinaire potential of systems and the increasingly private play of word and image that were to characterise all his subsequent activities. He took himself off to Munich for a solitary few weeks, but before doing so he attended in May 1912 a performance of Raymond Roussel's play *Impressions of Africa* with Apollinaire, Francis Picabia and the latter's wife Gaby. Unlike him in every other way, Roussel shared with Duchamp two enthusiasms, one for the power of language and another – if less ironic than the latter's – for the capacities of science and technology; these came together, in a sense, in his play which, as Jerrold Seigel has noted, 'turned language into a kind of machine able to crank out unheard-of objects and images', by means of an elaborate set of word-plays and rules, or 'procedures', that turned around double meanings and ambiguities.[104] Perhaps the example of *Impressions of Africa* brought home to Duchamp, even as he completed the quasi-futurist *King and Queen Surrounded by Swift Nudes*, that he was more interested in such linguistic play than with explorations, however ironic, of painting's retinal appeal, and that Roussel's challenge to the conventions (and communicative function) of language corresponded to his own subversion of those of painting.[105] He had already gestured in this direction with *Sad Young Man in a Train*, whose title in French (*Jeune Homme triste dans un train*) echoed in its alliteration the 'elementary parallelism' of the figure's swaying movement, and by all accounts he had at this time a deep interest in symbolist poetry, especially that of Jules Laforgue whose puns, alliterations, repetitions of sounds and nonsense words he would have found reprised in Roussel's play.[106] Experience of the latter at that particular moment may have provided the incentive to break radically from the cubists' common (if variously pursued) engagement with the conventions of visual representation and their adequacy to the experiences of modernity.

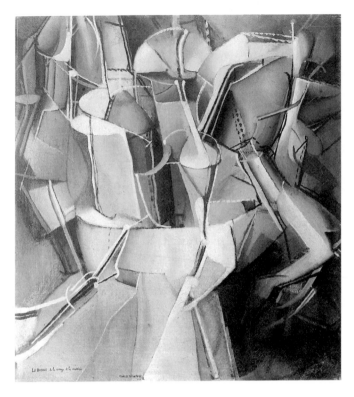

5.8 Marcel Duchamp, *The Passage from Virgin to Bride*, 1912

From the start of his stay in Munich Duchamp pursued instead an idiosyn-
cratic yet systematic testing of the semiotic and epistemic implications of that
engagement, and of the privileging of conception over vision that cubism often
declared but never fully delivered. The sequence of works through which this
project was conducted – from the paintings of mid-1912 through the first 'ready-
mades' of 1913–14 to the beginning of the 'Large Glass' in 1915, together with
their accompaniment of drawings, sketches and epigrammatic notebook reflec-
tions – has generally been agreed to mark not only a rupture with cubism but a
moment of fundamental importance for Duchamp's subsequent oeuvre, indeed
for modernism in general: the moment, as Thierry de Duve once succinctly put it,
of painting's demise as craft and its instant rebirth as idea.[107] As such it has been
the subject of innumerable studies, especially in the last decade as the paradigm
shift from modernism to postmodernism has been worked through, which have
accumulated into an interpretive matrix of such range and complexity that any
attempt to survey it here would be both futile and presumptuous. Yet the two pic-
tures from his Munich summer of 1912 in which this rupture was first registered,
The Passage from Virgin to Bride (figure 5.8) and *The Bride* (plate XX), were them-
selves not only consistent with Duchamp's earlier concerns – both as regards what
Jerrold Seigel describes as 'the long-standing tensions between expression and

incomprehensibility in his work'[108] and in their continuing preoccupation with the cerebral dimensions of sexuality – but in their appropriation and elaboration, for the pursuit of these concerns, of the style and devices of post-Cadaqués gallery cubism they extended the reach and implications of cubism itself. As David Joselit has argued persuasively, in *The Passage from Virgin to Bride* and *The Bride* the spatial and figural ambiguities of hermetic cubism are deployed (with considerable painterly panache, it must be noted) to represent a visceral matrix whose 'lines swell into organic growths, or fleshy agglomerations are attenuated into lines: there is no way, as in the *Nude*, to extract one vocabulary from the other'.[109] This lack of identifiability, he suggests, holds the carnal and the semiotic in suspension. More than this: in these two paintings, Joselit claims, to his project of producing language from the body itself Duchamp added a social dimension through explicit reference to the exchange of women through marriage – an exchange that is semiotic in economic and sexual as well as linguistic terms.[110] Whether this interpretation corresponds to any self-conscious set of intentions on Duchamp's part, and whether the argument through which it is presented amounts to 'an attempt to outline the discursive field of painterly strategies available to artists interested in the same or similar problems ... in this case, those that may be grouped under the term *cubism*' (a claim that Joselit makes for it) are questions to which I return.[111] Either way, it helps us to understand how Duchamp's departure for Munich at once helped to set cubism as a movement in the past and to open it as a paradigm to the future.

PART II

READINGS

Building high modernism: the 'analytic–synthetic' paradigm

Foundations: Kahnweiler's Kantian cubism

'Between 1912 and August 1914 cubism was a movement with many futures', suggested Christopher Green in his authoritative account of its subsequent history, noting that many historians have seen in its various formal innovations the origins of distinctive features of de stijl, suprematism, dada and surrealism, to name but four of the major formations of inter-war modernism. He continued: 'Whatever the validity of this species of historical picture-making, it throws into sharp relief one point which is difficult to question ... that cubism between 1912 and 1914 was characterised by a diversity that could stimulate a wide range of positive responses, often contradictory.'[1] This judgement does indeed seem incontrovertible; as I showed in the last chapter, the range of work and ideas that were generated by the movement diversified as it grew, from the Salon de la Section d'or through the Indépendants of 1914, to become the dominant force within the field of the Parisian avant-garde. It is, moreover, one underwritten by Roger Allard's observation of autumn 1913 that while the influence of cubism now stretched across the whole of contemporary artistic production, 'the painting by groups, programmatic painting, has disappeared; the dismemberment of the cubist empire is a *fait accompli*'.[2]

But that is a judgement – and Allard's is a critical view – which takes account only of the synchronic distribution of cubist initiatives; as I have also argued, beneath their surface diversity the current was running strongly in favour of an aesthetic that rested on the perceived foundations of gallery, rather than salon, cubism, and its effect was steadily to narrow, rather than widen, the terms of cubist art practice and its interpretation. That the Delaunays, Le Fauconnier and Duchamp had already gone their own ways, Léger had joined Kahnweiler's stable, Gris had joined Metzinger at the strategic centre of the movement with a foot in both camps, and Allard himself had withdrawn to the sidelines of the debate, is indicative of this dynamic. With the advent of war and mobilisation in August 1914 gallery cubism's ascendancy was further enhanced, as the French artists and critics who had formed the nucleus of the salon cubist and Puteaux milieu departed either

for the front or into temporary exile,[3] leaving the field to those whose lack of interest in an art that engaged directly with the experiences and emblems of modernity – whether to hymn or to condemn them – was compounded by disinclination to confront either the horrors of the battlefields or the mundanities of civilian city life. As Green himself observes, 'with the need to evade went the complementary need to distil their art, and with both went a growing accentuation of the division between art and life'; by the end of the war 'that division ... had become the key to cubist orthodoxy'.[4]

Of the artists, critics and others who spoke for cubism in these wartime circumstances, it was Kahnweiler who, though exiled in Switzerland for its duration and thus *hors de combat* in both military and avant-gardist respects, made the most decisive contribution to establishing the terms of its future interpretation and influence. His pamphlet *Der Weg zum Kubismus*, written in 1914–15 but not published in full until after the war,[5] offered an analytical narrative of the several phases of the elaboration of the pre-war pictorial style shared by Braque and Picasso that was based on his close familiarity, as their dealer, with their paintings of those years and the many conversations he had with them. It differed in this important respect, but also in its clarity and closeness of focus, from the several previously published first- or second-hand accounts of cubism, including those by Gleizes and Metzinger, Apollinaire and Salmon. It also brought to cubism Kahnweiler's own intellectual predilections and commercial *parti-pris* – with significant consequences, as will be seen, for the historiography of cubism as a style and as a movement.

During his stay in Switzerland, Kahnweiler later recalled, he devoted much of his time to the study of philosophy, and his essay began with the statement of a dichotomy which reflected that engagement:

> The nature of the new painting is clearly characterised as representational as well as structural: representational in that it tries to reproduce the formal beauty of things; structural in its attempt to grasp the meaning of this formal beauty in the painting.
>
> Representation and structure conflict. Their reconciliation by the new painting, and the stages along the road to this goal, are the subject of this work.[6]

For behind this declared opposition, as Daniel Robbins notes, lay another: that between the world of sense and the laws of reason – the categories of the empirical and the *a priori* that were fundamental to Kant's philosophy[7] – and it was this paradigm which guided both Kahnweiler's interpretation of the pre-war paintings of Picasso and Braque, and the logic of development through which he organised their chronological sequence into a coherent narrative of progressive achievement and ultimate triumph.

As he read it, these two painters sought to resolve the conflict that he identified by understanding it 'in the strictest and highest sense': 'Not the simulation of form by chiaroscuro, but the depiction of the three dimensional through drawing on a flat surface. No pleasant "composition" but uncompromising, organically articulated structure.'[8] On the one hand this led Picasso towards an approximation to the

qualities of technical drawing, and thus to geometric forms, in his search for the means to represent three dimensions in two, and subsequently – in his Cadaqués summer of 1910 – to that 'piercing of the closed form' that 'was the decisive advance which set cubism free from the language previously used by painting'.[9] On the other hand it led Braque to seek to retain the qualities of illusionism through the introduction of 'realistically' painted details of things observed into the increasingly illegible structure of that geometry. 'Combining the "real" stimulus and the scheme of forms, these images construct the finished object in the mind', with the result that 'the rhythmisation necessary for the co-ordination of the individual parts into the unity of the work of art can take place without producing disturbing distortions, since the object in effect is no longer "present" in the painting'.[10] Putting the two together, Kahnweiler explained, freed the artists from conventional verisimilitude and enabled them to present at once a fully articulated pictorial structure and a representation of things in the world. And he added:

> This was the great advance made at Cadaqués. Instead of an analytical description, the painter can, if he prefers, also create in this way a synthesis of the object, or in the words of Kant, 'put together the various conceptions and comprehend their variety in one perception.'[11]

In Kant's epistemology, the terms 'analytic' and 'synthetic' summarised two types of judgement. In analytic judgements, that which is predicated of the subject adds nothing new to it, 'merely breaking it up into these constituent concepts that have all along been thought in it', in Kant's words[12] (an example might be 'All brides are female'); synthetic judgements, however, 'add to the concept of their subject a predicate which had not in anywise been thought in it'[13] (thus, 'this bride has a sister'). Kahnweiler's application of these terms to the cubism of Picasso and Braque was felicitous, for two principal reasons. Firstly, it did appear to summarise effectively that sequence of changes in their painting styles from about 1908 through which, in an initial phase, the objects, figures and landscapes they depicted were dismantled by means of juxtaposed views, broken contours, geometricisation, *passage* and so on, in a process of painterly 'analysis'; and in the second phase of which the flat, interpenetrating planes that resulted from such 'analysis' were the starting-points for a process of 'synthesis' which reconstituted those subjects anew. It thus provided a coherent and progressive narrative for an otherwise bewildering and increasingly illegible body of work. Secondly, it drew both on an already-existing neo-Kantian current within contemporary aesthetics that, as I noted earlier, had played a large part in constructing cubism as an object of critical discourse, and on the fairly wide currency that the terms 'analysis' and 'synthesis', used either separately or together, then had in writing about art. As a result, Kant's formulation resonated widely, and provided a paradigm for the understanding – and historical ordering – of cubism that continues to shape scholarly and artistic assessment of it. How it did so, and with what consequences for the latter, are questions that deserve to be explored.

Although Kahnweiler had not plucked his pair of terms out of the air, he did give a sharper and narrower definition to their usage. In the decade prior to 1914 they were staple but slippery elements of the art-critical lexicon; deriving partly from the *lycée* and *école* education and philosophical predilections of art critics, partly from the *synthétisme* of Gauguin and his *nabi* followers (codified by the writings of Aurier and Denis) – in which that term referred to the anti-naturalistic simplifications of form, line and colour characteristic of their painting – 'analytic' and 'synthetic' were subject to varied and often contradictory application. Thus Louis Vauxcelles in 1908:

> Matisse and Picasso have caused havoc in the naïve brains of their little successors. I could cite ten, fifteen of these infants who all begin by having 'genius'. A little talent would not be unbecoming to them. I draw their attention to this fruitful saying of a great French writer, Fustel de Coulanges: 'One must give ten years to analysis before consecrating an hour to synthesis.'[14]

This 'fruitful saying' was echoed in a 1911 remark by Camille Mauclair, a double citation suggesting that not only its implicit Kantian meaning but its appropriation by nationalist historian Coulanges were both in circulation at the time.[15] But by the time of Mauclair's usage the terms had been reinterpreted in an application of their useful binarism to cubism. In November 1910 Allard wrote the sympathetic account of the paintings of the emergent salon cubist group that I discussed in an earlier chapter, paintings whose 'pictorial plenitude offers to the spectator the elements of a synthesis situated in time (*la durée*). The analytic relations between objects and their mutual subordinations matter little from now on, since they are suppressed in the painted representation'.[16] The frame of reference here is clearly Bergsonian, and in keeping with the creative enthusiasm with which the philosopher's ideas were taken up and adapted by the artists and writers of the post-Abbaye milieu; the following year Metzinger restated Allard's explanation (though without using the terms in question) and, a month later, Gleizes developed this into a two-stage process to describe Metzinger's own working practice: 'He seeks to develop the visual field by multiplying it, so as to inscribe it into the space of the canvas itself: here the cube plays a role, and Metzinger then uses it as a means to re-establish an equilibrium that these audacious inscriptions have momentarily ruptured.'[17] Yet when Metzinger himself reached for the term 'synthesis', his usage equally clearly owed more to Hegel than to either Kant or Bergson; in an essay that appeared in the same month as Allard's piece above, he wrote of Picasso: 'He experiences, understands, organises: the picture is neither transcription nor schema, we contemplate in it the sensible and living equivalent of an idea, the total image. Thesis, antithesis, synthesis, the old formula undergoes an energetic reversal in the substance of its two first terms: Picasso declares himself a realist.'[18]

What is quite evident from this brief survey is that in the pre-1914 period this pair of terms generated convenient and adaptable metaphors, applicable to artistic procedures in general but also offering, in particular, the means of conceptualising

the complex studio-based and exploratory innovations being hazarded by the salon cubists. During the course of 1912, however, the neo-Kantian interpretive framework put in place by Hourcade, Rivière and Raynal began to replace the Bergsonism elaborated by Allard, Metzinger and Gleizes: the distinction between *conception* and *vision* common to the newcomers' essays, and elaborated especially in the quick sequence of texts that marked Raynal's entry into the critical lists in the third quarter of the year, gained steadily wider acceptance and underpinned his restatement of the binarism in terms which prepared the way for Kahnweiler. The cubists, declared Raynal,

> have called to their aid that law of synthesis which, though they have been so much reproached on its account, today governs all conscientious speculation... Before all else, they separate out, according to their own analytical methods and to the characteristics of the object, the principal elements of the bodies they propose to translate. Then they study these elements in accordance with the most elementary laws of painting, and reconstruct the objects by means of their elements, now known and strictly determined.[19]

What Kahnweiler brought to Raynal's formulation was not only greater precision and detail in its application to particular paintings, but – and crucially – the authority of his own place in the history he was recounting, and an air of objectivity that was the product of his contemporary distance from the events in his narrative.[20] Partly but not solely because of that authority, however, this objectivity was misleading, in several respects. Perhaps the least important of these was that, as Paul Crowther has demonstrated, Kahnweiler's appropriation of Kantian concepts (like that of Raynal and the other critics) was loose to the point of slipshoddiness: to write, for example, of cubist 'analysis' as if the paintings concerned were concepts already 'thought' in the objects they depict is to ignore the visual particularities of such representations that are the very basis of artistic style; similarly, to equate the cubist 'synthesis' of different representations with the process described by Kant is to ignore that each such representation is itself a complex synthesis of apprehensions.[21] While this is strictly true, it was not as philosophical demonstrations that such appropriations functioned, even though they may have been offered as such, but as heuristic models requiring that some of the differences between philosophy and painting (such as their definitions of 'representation') be taken as given and set aside. That these critics were 'bad' Kantians was less important, in the discursive context in which they functioned, than that their deployment of these concepts made sense of cubist paintings and the relations between them – as well as sounding good, and offering an intellectually substantial rationale for the style.

More significant was Kahnweiler's construction of the narrative of cubism exclusively around the work of his own stable of cubist painters – primarily Picasso and Braque – and, within it, his analysis of that work in narrowly formalist terms. The first of these had the consequence of simply ruling out as irrelevant the paintings of that salon cubist group of artists whose preoccupations, as I have shown,

had other discursive origins but were converging on similar and overlapping stylistic and technical concerns. That from around the middle of 1911 this group found in certain innovations and devices of gallery cubism some of the means, suitably adapted, by which to articulate those preoccupations did not warrant Kahnweiler's reduction of this rich and complex interchange to tidy binarisms such as *representation–structure* and *analytic–synthetic*. Of course, his interest – in both the intellectual and material senses of this word – in the work of Picasso and Braque was that of their (erstwhile) dealer, and he had less concern to recover and acknowledge that complexity than to invest in, exploit and secure the returns on the symbolic capital which this position offered,[22] but it required a denial of a considerable body of testimony both written and painted; a denial made easier (as will be seen) by the intervening war, but made possible only by that hegemony of gallery cubism established (as we have seen) in the immediately pre-war years.

But even within the frame that he imposed, Kahnweiler's interpretation refracted gallery cubism through the lens of his own predilections, in ways that I explore more fully in the remaining chapters. First, his formalist emphasis removed from consideration all questions of iconography and of context. His analysis of *Les Demoiselles d'Avignon* (plate I) was exemplary in this respect: describing it simply as 'a strange large painting depicting women, fruit and drapery', Kahnweiler noted that the nudes, 'rigid, like mannequins', were painted in 'the style of 1906', with the exception of the foreground in which, 'alien to the style of the rest of the painting, appear a crouching figure and a bowl of fruit ... drawn angularly'. 'This is the beginning of cubism', he declared, 'the first upsurge, a desperate titanic clash with all of the problems at once.' The problems were quite unrelated, however, to the picture's subject of an encounter with five naked staring whores (even though Kahnweiler's choice of adjectives seems to have registered its affect); they were instead 'the basic tasks of painting: to represent three dimensions and colour on a flat surface, and to comprehend them in the unity of that surface'. Kahnweiler's assessment was that the two styles used in the painting did not add up; the painting 'thus never constitutes a unified whole' and was thus unsuccessful.[23] In such an interpretation, not only of this work but of cubism in general, entire domains of meaning – such as the complex relationship between Picasso's sexual, racial and artistic identities, or gallery cubism's reflections on the status and role of art, craft, decoration and imagination in an increasingly consumerised and mechanised visual culture, or the relation between avant-garde art and the discourse of nationalism – were excluded from consideration, and indeed were lost to cubism's historians and amateurs for the half-century that followed.

In such an interpretation, moreover, the bewildering changes of style and focus that characterised the painting of Braque and Picasso from *Les Demoiselles* to the war were marshalled into a narrative that ran from the latter's 'rash attack' on all the problems of painting at once, through their triumphant resolution in Picasso's 'great advance' at Cadaqués to the 'amalgamation of painting and sculpture' in his and Braque's collages and constructions of 1913–14.[24] This has been an influential

and durable interpretive model; but, as T. J. Clark observes, it has been 'driven by a basic commitment to narrative continuity, by a wish to see Picasso's work from 1907 to 1912 as possessing a logic or forming a sequence, as not being broken or interrupted in any important way – not, above all, encountering failure'. Clark adds: 'I would say that these wishes and structures are what cubism *is*, discursively speaking; and they seem to me tied in with (maybe to produce) the final telltale blankness of writing on cubism in the face of the moment it most wants to cele-brate.'[25] This is a critique to which I shall return; Clark offers an important correc-tive to this interpretation's implicit refusal of the possibility of uncertainty or irresolution on the part of Picasso and Braque, any reading of retreats, dead-ends or departures from the high road in the paintings they made; and he proposes instead, as I noted earlier, that Cadaqués be seen as 'cubism near freezing point', a moment when Picasso's painting was 'at the end of its tether'.[26]

His critique leaves in place, however, the key binarism around which the con-ventional narrative turns; perhaps because, for all the hesitations and interruptions that Clark reads in that painting of 1910–12, the concept of 'analysis' giving way to 'synthesis' provides a framework without which that narrative would be difficult to sustain at all. Thus whether the transition in Picasso's painting from, say, *Girl with a Mandolin (Fanny Tellier)* (figure 2.14) of spring 1910 to the *Woman with a Mandolin* (plate IV) of that summer marks a breakthrough to a radically non-mimetic representational system or a teetering on the brink of indecipherability, the assumption remains of a '*before* Cadaqués' when Picasso and Braque were reducing the depicted forms of their subjects to progressively fewer and more schematic motifs in a process that could be described as analysis, and an '*after* Cadaqués' in which they combined those motifs with more recognisable details in a process of synthesis.

Yet things were rarely as clear-cut and coherent as this, as is revealed by close examination of the sequence of images across which the configuration of Braque's and Picasso's paintings developed. Pepe Karmel's invaluable analysis of the hun-dreds of drawings that Picasso made all through the pre-war cubist years alongside – often in dialogue with, or as preliminary studies for, particular paintings – uncovers a working method in which 'analysis' and 'synthesis' were not sequential, exclusive and irreversible procedures, but cohabited in the same work or series of works, and across several years of practice. 'It is evident from Braque's and Picasso's work', Karmel states, 'that they were *not* concerned with representing the "eternal and constant" forms of things'; indeed, their cubism 'took as its starting point precisely the contrary idea: that any object displays a variety of different aspects, and that these aspects can be represented in a variety of ways. Virtually any detail might serve as the starting point for a new figuration.'[27] Karmel stresses that 'there is no consistent set of 'essential' qualities represented by the changing forms of Picasso's pictures. Rather, the reading of a cubist picture depends on the viewer's readiness to become immersed in and relive the process by which the artist arrived at the figuration of that particular picture.'[28] *Woman with a Mandolin* is a case in

point: as Karmel notes, viewed in bright light the painting reveals numerous *penti-menti* suggesting an originally more legible, albeit geometric, figure. In the process of painting this became a nearly abstract composition of overlapping planes, in which the negative spaces between arm and body were transformed into positive shapes – tilted, angled planes – that take up the representational function of the forms they have replaced. 'There is no clear-cut distinction between planes representing the form of the body and planes which are merely "arbitrary"', Karmel observes. 'Rather, the final state of the composition results from a process of reworking in which representational elements become abstract, and abstract components become representational'[29] – an exchange that itself became a key feature of Picasso's working process, and underpinned the 'unlimited metaphorical potential of [cubist] figuration'.[30]

To be fair to Kahnweiler, his schema did not originally require a categorical separation of analytic *before* and synthetic *after* – in *Der Weg zum Kubismus* he appears to have made use of the pairing, like Raynal and most others before him, to distinguish phases in the elaboration of single pictures rather than in the development of cubism as a representational system – but his account of Cadaqués as a breakthrough does invite the latter inference. By the time of his later accounts of cubism he clearly understood it thus, although he had changed his mind over the moment of changeover from the one mode to the other: in a 1929 essay on Gris (later included in the French translation of *Der Weg zum Kubismus*, published in 1963) he located this in 1913–14, while giving no precise explanation as to why or how it had occurred then.[31] Already by the time of his original pamphlet's publication in 1920, moreover, the *analytic–synthetic* binarism had been assimilated to a historicising of pre-war cubism. As Christopher Green suggests, this had its beginnings in that analysis by Gleizes, quoted earlier, of a 'two-stage process' in the painterly practice of Metzinger, but was generalised as a result of the trauma of the war years: thus, 'analytic' was 'identified with a notion of pre-War dissolution to set against subsequent integration: the collective "call to order" of L'Effort Moderne'.[32] This last was, of course, the name of the gallery run by Léonce Rosenberg, who from 1915 had taken over the mantle of the exiled Kahnweiler as the cubists' dealer, and whose series of solo exhibitions of their work in the six months following the November 1918 armistice mounted a sustained response to those critics and artists, the most vocal among whom was Louis Vauxcelles (now making a new career out of his hostility to cubism) who proclaimed its death and celebrated a return to the freedom and sanity of painting based on 'natural' appearances.[33] The opposition between these two camps was, as Green demonstrates, the primary feature of the avant-garde field during and immediately after the war.

As I have noted, war, mobilisation and exile in August 1914 dispersed the erstwhile salon cubist grouping; in so doing it almost completely effaced that simultanism – already eclipsed by the aestheticism of gallery cubism – which had brought together a concern to engage with the emblems of a mythic modernity and a determination to critique the conventions of its representation. Even before the

war the inclusiveness of simultanism had been tested, as the movement and its influence grew, by the adherence of artists whose commitment to both concerns was weak; its disappearance left the field polarised. On the one hand those who sought to reintegrate certain of cubism's formal innovations with those conventions it had critiqued, in a return to 'natural' appearances, made common cause with those for whom even these innovations were anathema, an 'array of recipes';[34] on the other hand, those for whom the artifice of cubism, its freedom from observed reality and its distance from that very 'nature' were its strengths rallied to its remaining representatives. Picasso, of course, was the chief of these, and his solo exhibition at the galerie de l'Effort Moderne, which closed the above series, underlined his pre-eminence; but during the last two years of the war he had drifted away from the cubist group, both socially and artistically, towards the milieu of the Ballets Russes. Indeed in 1917–18 he was increasingly abroad. In his absence, at the centre of the cubist camp – their practice underwritten by the promotional initiatives of Rosenberg and the critical and theoretical writing of supportive critics such as Pierre Reverdy, Paul Dermée and Maurice Raynal – were the painters Gris and Metzinger, and the sculptor Lipchitz.

Just as, in Puteaux, the authority and imagination with which Gris elaborated his particular version of gallery cubism had taken him, in very short order, from newcomer to key participant, the same qualities placed him at the head of this group, at once cubism's definitive practitioner and its spokesperson; the theoretical and historical interpretations of it that were offered during the war and in the postwar years turned around his work and ideas, and the emergence of a historicising interpretation of the *analytic–synthetic* binarism can correspondingly be traced in relation to both. In March 1915 Gris wrote to Kahnweiler expressing satisfaction at his painterly progress: 'my canvases are beginning to have a unity that they previously lacked', he reported. 'They are no longer those inventories of objects that used to discourage me so much',[35] and (as Christopher Green argues in a detailed assessment of Gris's painting between 1915 and 1919) two large still-lifes of that month indeed display a closer relation than had his previous work between the represented objects and the geometrical armature of the composition in which they are arranged (figure 6.1).[36] Over the next three to four years, in an open series of still-life paintings, he pursued this integration of what Kahnweiler was concurrently describing, it will be recalled, as representation and structure – in what his poet friends Reverdy and Dermée were characterising, somewhat differently, as a process of the 'purification' of painting of the traces of observed reality[37] – aligning the signs that stood for the objects ever more closely with the compositional structures that contained them. By the spring of 1918, it seems, he had developed a way of working in which the signs were generated from the structures, and this procedure determined most of his paintings in 1919 (see figure 6.2).[38]

When Gris met Kahnweiler, for the first time in five years, on the latter's return to Paris in March of the following year, he described this working method, as the dealer later recalled: "'I begin by organising my picture; then I qualify the objects.

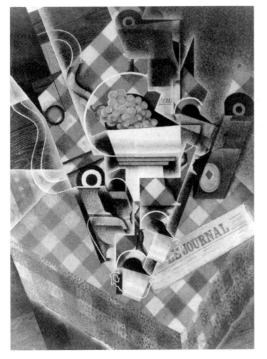

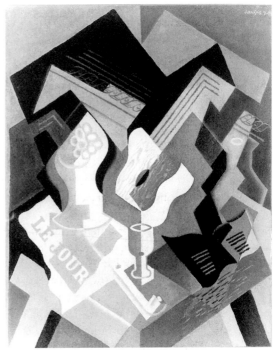

6.1 Juan Gris, *Still-Life with Check Tablecloth*, 1915

6.2 Juan Gris, *Guitar and Fruitdish*, 1919

My aim is to create new objects which cannot be compared with any object in reality. The distinction between synthetic and analytical cubism lies precisely in this".'[39] A year later he published a statement that re-affirmed the terminology: 'I work with the elements of the mind', he declared; 'I try to make concrete that which is abstract ... Mine is an art of synthesis, a deductive art ...'.[40] And four years after that, replying to a questionnaire, he characterised the distinction as one between phases of the development of cubism:

> Now I know perfectly well that when it began cubism was a sort of analysis which was
> no more painting than the description of physical phenomena was physics.
> But now that ... the analysis of yesterday has become a synthesis by the expression
> of the relationship between the objects themselves, this reproach is no longer valid.[41]

It was on the basis primarily of these statements, and the working method that they summarised, that the historicising of cubism – its periodisation into analytic and synthetic phases – was developed during the 1920s. Gris's formulation of this had two implications: first that, in contrast to the merely descriptive work of analysis, synthesis was a process in which paintings were constructed from components that did not derive from the observation and analysis of their subject-matter; second, following from this, that the development of cubism had been a

progression from the necessary but provisional stage of the former to the creative freedom and unity of the latter. Both implications were contained in the 1929 essay by Kahnweiler on Gris mentioned above; moreover, acknowledging that the solutions which Picasso and Braque were finding to the problems (as he saw them) raised by the introduction of foreign materials to their canvases amounted also to synthetic cubism, Kahnweiler suggested that Gris alone followed to its conclusion the logic of the 'antagonism between what is to be represented and the organism that absorbs it – the picture'.[42] He closed his essay with a declaration that assimilated the latter's art to a conventional classicism: 'If in art historical terms one of the essential goals of cubism has consisted in the return to the unity of the work of art, in the will to create not sketches but autonomous and compete organisms, then no cubist has pursued this goal with greater success and determination than Juan Gris.'[43]

Kahnweiler's formulation was in turn adopted by a close friend, the German poet Carl Einstein, in a number of contributions to the magazine *Documents* in 1929–30, edited in Paris by Georges Bataille. One of these – a 'Notice documentaire' periodising Picasso's artistic career to date into a sequence of 'epochs' that may well have been produced in collaboration with Kahnweiler[44] – distinguished a period of analytic cubism (1910–14) – 'the "heroic" phase of cubism', characterised by 'the description of objects by means of separated details, the sum of which reconstituted them' – from a (1914–18) phase of 'what is frequently termed synthetic cubism' in which objects 'were rendered in a less enumerative manner'.[45] Unlike Kahnweiler, however, Einstein implied no valuation of synthetic over analytic cubism; indeed, in a searching and extremely interesting essay on cubism of the previous year he had offered an interpretation of the style that tacitly challenged the dealer's formulation as much it borrowed from it. In *Der Weg zum Kubismus* Kahnweiler, as we have seen, had explained the combination of Picasso's geometric schematisations of objects with Braque's introduction of 'undistorted real objects' as resulting in 'a stimulus which carries with it memory images. Combining the 'real' stimulus and the scheme of forms, these images construct the finished object in the mind. Thus the desired physical representation comes into being in the spectator's mind.'[46] For Einstein, however – a Marxist who had been an associate of the overlapping political and artistic avant-gardes of Berlin dada – the function of such memory images was to ensure the continuity of objects in the world and thus to ensure the stability of a superficial and bourgeois sense of identity: 'Objects are precious, like stable signs for our actions', he wrote; 'we appreciate resemblance as an assurance of life. The world as a tautology.'[47] For:

> The possibility of repeating things used to calm those who feared death. The world of pictorial doubles answered a need for eternity ... A cult of ancestors was practised with regard to objects; in still-lifes, symbols of the joys of ownership, people eternalised slaughtered turkeys, grapes and asparagus ... What a sham eternity![48]

This comfort came at a price, however. 'Astonishment of miracles, feelings of incompleteness, multiplicity of the sense of objects, all this vanishes for the sake of a reassuring repetition ... But the cost of this tendency to reproduction is a diminution of creation.' It was here that Einstein saw the value of cubism:

> It was the cubists who unsettled the always self-identical object, that is, the memory in which notions are adapted to each other. Their chief merit is to have destroyed mnemonic images. Tautology gives the illusion of the immortality of things, and it is by means of descriptive images that one seeks to avoid the annihilation of the world by forgetfulness.
>
> They separated the image from the object, eliminated memory, and made of the motif a simultaneous and planar figuration of the representation of volume.[49]

Where Einstein did concur with Kahnweiler was in his stress on the autonomy of the picture that resulted from the cubists' procedures. 'One cannot render the sensations of a table itself, but only one's own sensations', he argued.

> And a table represented in a picture has no sense unless the sum of the very mixed sensations that one calls *table* is submitted to the technical conditions of the picture. The mnemonic inheritance of objects must be destroyed, that is, they must be forgotten, and the picture becomes not the fiction of another reality, but a reality with its own conditions [...]
>
> The first condition is the surface. One no longer works between two imaginary levels that exceed the canvas. Now, the totalisation of the picture works through its unverifiability, and the fact both that the spectator does not leave the reality of the picture, and that the vision of the artist is not interrupted by observation. One cuts oneself off and one forgets.[50]

This sounds very close to Kahnweiler's (and Gris's) understanding of synthetic cubism; yet Einstein made it clear that 'this manner [of painting] that we are discussing is that of the analytic cubism of around 1911'.[51] Evidently, in his desire to see achieved the fragmentation of what he regarded as the shallow and indeed false identities secured for us by mundane habits of perception, he was drawn to the centrifugal characteristics of gallery cubism *circa* 1911; but in his determination also to understand cubist paintings as autonomous, and as such the products of a more fully realised humanity – 'It is a matter of mortality', he insisted in a passage that followed the last quoted above, 'and it is the seer who commands, not the motif'[52] – he appropriated for analytic cubism qualities that Kahnweiler had suggested to be synthetic. The consequence was perhaps, as T. J. Clark has suggested, a misreading of Picasso's attachment, in that cubism, to the world of things; but in the politically charged conjuncture of 1929–30 Einstein's reading offered an alternative to the reductive and conventional formalism of Kahnweiler's.[53]

The dealer's dissemination of his understanding of cubism had other immediate progeny besides this, in the cultural ferment of Europe in the interwar years. Two in particular are worthy of note here, even though neither made use of the

analytic–synthetic model. One of them, that of Vincenc Kramár, ironically enough stood in diametrical opposition to the ideas of Einstein. Kramár, a Czech art historian living in Prague, had met Kahnweiler in the autumn of 1910, on his first visit to Paris. Already a collector of nineteenth-century French, German and Czech art, he had studied in Vienna under Riegl and Wickhoff and, though specialising in the medieval and baroque periods, had absorbed the latter's conviction that the experience of contemporary art aids the historian's ability to understand that of earlier epochs; he was consequently keen to gain a close acquaintance (financed by an inheritance) with new developments in Paris.[54] He found his way to the rue Vignon gallery by way of Durand-Ruel, Bernheim, Blot, Vollard and Berthe Weill, buying contemporary work from each; introduced by Kahnweiler to the artists of his stable, Kramár snapped up paintings, prints and drawings by Derain, Vlaminck, Van Dongen and Picasso. From then until the war he returned regularly to Paris, quickly narrowing his interests almost exclusively to the latest work of Picasso and amassing by August 1914 a probably unrivalled collection of his cubist paintings from 1910–13.[55] Perhaps he was guided in this by Kahnweiler – surviving correspondence between the two reveals the dealer's commercial astuteness in playing Kramár against rival clients for gallery cubist painting, such as Shchukin, and in enticing him with news of Picassos newly-arrived at the rue Vignon – but the Czech was anyway predisposed to such a selection: his art historical training only reinforced an attachment that was shared by gallery cubism's other *aficionados*, to art whose aesthetic daring was the expression of genius and yet was rooted in tradition (qualities reflected in their own *dénicheur* discernment).[56]

Yet Kramár's understanding of cubism differed significantly from that of Kahnweiler, even while it depended on it. In a book of 1921 that appears to have been both one of the earliest and one of the least-known substantial analyses of cubism,[57] and which began as a review of *Der Weg zum Kubismus* (published the year before) he added to the formalism of Kahnweiler's analysis a metaphysical interpretation – of the still-lifes of 1911–12 especially, on which his own collection centred – that read Picasso's forms as distillations of the spirituality that resided in the homely objects he chose to paint:

> Picasso likes to gaze at objects which are beautiful in themselves, which are a work of art themselves, thus something formed, something more or less spiritual, such as a violin, guitar, mandoline [*sic*] or other musical instrument [...]
>
> The lines already born of the spirit, became more spiritual still, like the essence of the most fundamental thing which can only be understood with the inner organs ...[58]

While Kramár, following Kahnweiler, emphasised that to Picasso 'the choice of the subject for depiction appears quite indifferent' because 'the subject is not the theme', he also stressed that this theme was not – as it was for Kahnweiler – the reconciliation of representation and structure, but 'the lyricism overall',[59] that is, the way in which the quintessential beauty of specific subjects was captured in his paintings:

Sometimes it seems as if the artist can never get enough, so much of his idea of the
subject does he amass onto the canvas; at other times he restricts himself only to a few
lines or shapes which present the very last trace of his [*sic* – its?] essence. It is these
little things, seemingly so simple but basically the leaven, the flower and the result of a
long and complex development, which are among the wonders of Picasso's art. They
have the brightness and purity of Mozart's music and the sublimity and compactness
of lyrical verse.[60]

As Vojtech Lahoda has astutely suggested, Kramár's own attachment to the
humble beauties of familiar objects, evident in this and other passages in *Kubismus*,
might be characterised as *Biedermeier* – that strand of German and central
European taste that, from the mid-nineteenth century, had embraced the values of
family life and of domestic, private activities such as writing letters, playing the
piano or other instruments, and that found representation in art and interior design
that celebrated or furnished these simply and soberly. Named after a fictitious poet,
Biedermeier originated in the years between the fall of Napoleon and the 1848 rev-
olutions, as the German middle class gained in security and confidence and sought
to establish its cultural identity on the ground of such private, as against public,
intellectual activities. As Lahoda demonstrates, Kramár as a collector was drawn to
Biedermeier painting of the nineteenth century, while as an art historian he argued
(in the same year as *Kubismus* was published) that the 'small cabinet masters from
the 17th and, in particular, the 18th centuries' could show that 'modern painting
owes a debt to the 18th century'.[61] Four years later he returned to the subject of
Picasso's still lifes of 1911–12: 'On the whole', he wrote,

these are objects of everyday use, things with which the artist is surrounded in his
home, things to which, for all their simplicity and often also their primitiveness, we
have become too accustomed and to which we grow too fond of to be able to replace
them with other, perhaps more artistically valuable, objects. Our eyes know them, our
hands know them and we like them as friends whom we never consider whether they
are beautiful or not. They calm us with their constancy when we return to seclusion
from the bright bustle of the world; they are a real part of our life.[62]

The values inscribed here were those of the bourgeois collector of *bibelots*, of
unconsidered trifles or as yet unesteemed paintings by artists on the margins –
those of the *dénicheur*, in a word – related, if at a generation's remove, to those of the
Goncourts and the late nineteenth-century Parisian rococo revival, and entirely
congruent with the values and functioning of the emergent dealer–collector–critic
system. As such, there could hardly be a more succinct expression than this by
Kramár of precisely what Carl Einstein valued 'analytical' cubism for 'unsettling'.

Yet Kramár's purpose in collecting cubism was not exclusively private, for it
appears that he also saw it as a means of educating Czech artists, of acquainting
them with work at the cutting edge of modernism, and to that end he energetically
promoted gallery cubism in Prague, lending photographs of Picasso's paintings
(courtesy of the galerie Vignon) to local magazines, and the paintings themselves

to exhibitions which he helped organise.[63] Almost certainly more than his writings, these activities disseminated the work of Kahnweiler's stable among artists in the nascent avant-garde of Prague, and contributed greatly to the emergence of Czech cubism. In this Kramár paralleled the role of Shchukin, who, as an industrialist, was himself uninterested in publishing accounts of his collection, but who, as I have noted, threw his Moscow mansion open one day a week to viewing by the general public, prominent among which were the young artists of the city's nascent avant-garde.[64]

The parallel was not, however, exact. The very scale of the Russian's collection and its depth of coverage of Picasso's painting in particular (by 1914 he owned fifty-one works by that artist) gave Moscow artists a degree of access to gallery cubism rivalling that available in Paris itself. This acquaintance with Picasso's art came, moreover, at a singular moment in that avant-garde's emergence. In the politically repressive and industrially backward society that Russia was in the century's first years, and following the crisis of the 1905 revolution, disaffected fractions of the rising middle class nurtured a restless generation of writers, artists and scholars. Brought up in the shadow of an etiolated symbolist aesthetic, many young poets of Moscow and Petrograd found in the mixture they avidly absorbed of the iconoclastic wordplay of Italian futurist poetry and gallery cubism's pictorial experimentation a heady stimulus for their own radical rejection of the cultural baggage of the *fin-de-siècle*.[65] Making common cause with scholars frustrated by the unimaginative and sterile empiricism that prevailed in literary studies,[66] they threw themselves into exploration and celebration of the autonomy of language. Rejecting the symbolist doctrine of an 'organic' relationship between the sound of a word and its meaning, Russian futurist poets such as Mayakovsky and Kruchenik sought, from around 1912, to 'emancipate' the word, to invest words with meanings that were dependent only on their graphic and phonetic characteristics, while – following them from around 1915 – linguists such as Jakobson (in Moscow) and Shklovsky (in Petrograd) explored the functioning of poetic speech, its 'poeticity'. For both, 'poetic creation became a matter of technology rather than of theology'.[67]

It was this discursive space, vectored most immediately by exploration of the craft and character of poetry, and by close familiarity, courtesy of Kahnweiler via Shchukin, with gallery cubism's pictorial syntax (and a corresponding absence of engagement with that simultanism, in all its varieties, which motivated the salon cubists), which produced another substantial interpretation of that cubism in the immediate wake of its elaboration, one that, like Kramár's *Kubismus*, deserves to be better known than it is. Poet, critic and literary theorist Ivan Aksenov's *Picasso and Environs* was written in 1915 and published in 1917 by the Moscow futurist group Centrifuge.[68] Primarily a treatise on aesthetics by a significant and briefly influential figure of late pre-revolutionary Russian futurism, its engagement with Picasso's art and its evolution comes only in an appendix entitled 'Polemical supplement',[69] but the fewer than ten pages of this are extraordinarily acute and sophisticated. Aksenov focused on the formal devices of Picasso's cubism 1909–13,

and in particular the interrelationship of graphic and painterly marks in them. Where Kramár saw such paintings as transcribing the lyricism of their subjects, Askenov read them as functioning in purely formal terms and, in keeping with his poetic interests and the methodology of his milieu, his analysis inferred on Picasso's part a linguistic understanding of their devices that strikingly anticipated the semiotic readings which have dominated their recent interpretation. In his work from 1911 onwards, Aksenov argued,

> Picasso set himself the task of expressing the perspective of volume by primarily painterly means, refusing to reduce to an enclosed relief the planes which charac-terise an object. Every such plane came to be regarded as an independently valuable element, its place in the picture space being determined not by the obligation to reproduce nature photographically, but by its compositional link with the other ele-ments of the picture. The space within the picture frame became a special world with its own laws ...[70]

If this suggests that Picasso was beginning to explore, in his paintings of 1911, that systematic deployment of the Saussurean (symbolic) sign which Yve-Alain Bois has also there identified, Aksenov yet acknowledged, as T. J. Clark has noted, that it was not without difficulty: 'the elements of the picture continued to be volumes', he noted, 'stubbornly refusing to give up their third dimension to the will of the painter who created them'.[71] Indeed Picasso's introduction of letters, imitation wood-grain and marbling in his work of 1912 was, as he saw these devices, grounded in an acknowledgement of iconicity that countered that shift to symbolic signs:

> The letter represents an immutable visual impression. If the hieroglyph represents the most extreme generalisation of the object depicted by it, then the letter – the sur-viving line of a hierogram which has been blown away – represents the canon of graphic devices. But absolute generalisation is possible not only in the field of drawing: age-old representation of certain objects has created their organic synthesis and brought about the canonisation of their colours in the field of decorative painting. This relates mainly to wood and marble.[72]

Aksenov also appears to have anticipated later analyses of cubism in another respect, insofar as he perceived and explained a set of changes he saw to be funda-mental, in Picasso's paintings of 1912: in the way in which their planar configura-tions were articulated, the role of enamel house-paint in this, and the reintroduction of higher-keyed colours:

> The reproduction of the enamel shop-window signs was exact. Picasso stencilled them in lacquer and enamel – this arose also from the need for opacity. The technique brought about by the new materials differed essentially from the technique of oils; it represented one smooth layer – a device belonging to the canon of the house-painter. This lettering was absolutely flat. It then became clear that the apparent depth of the articulations resulted from his multi-layering technique: each sector represented not

a 'surface', but a series of combined planes; absorbing light, each in its different way, they also gave a feeling of depth. The cause had been found and the struggle began.

Light-absorbing polyhedrons were replaced by light-reflecting ones: the smooth layer of lacquer and enamel no longer had a subsidiary function. With the simplification of execution the need arose for greater complexity of colour ...[73]

Aksenov thus identified, without recourse to Kahnweiler's analytic–synthetic model (indeed before it had been made public), that perceived shift, from a phase of cubism in which 'flatness' was a quality arrived at to one in which it was a point of departure, which would soon become, as will be seen, cubism's dominant interpretive paradigm. But it is important to note that he did so in terms that were not only both coherent and personal, but also a product of their specific discursive space, in which an insistence on the autonomy of painting's means, on the artifice of art, was at the same time a declaration against the interpretive models that prevailed in Moscow. 'What will happen next?' Aksenov asked in closing:

> We shall see. At least we know that we shall not see anything that does not belong in the exclusively plastic nature of his creation – not mysticism, nor demonism, nor the fourth dimension were ever present in the work of Picasso, are not and never will be. Here we have surveyed Picasso's entire career and have found that the problems which determined its development were exclusively pictorial – the problems of the painter's craft.[74]

Superstructures: mid-century USA

At the moment when Carl Einstein was publishing the ideas outlined earlier, the analytic–synthetic foundations on which they were built were being adopted, and were soon developed, to support a theoretical edifice that differed fundamentally from his, but which closely, if unwittingly, resembled that of Aksenov. The Museum of Modern Art (MoMA) was opened in New York in 1929, an initiative that represented the consolidation of the authority of a key group of collectors and patrons of modernist art, at the centre of which was the Rockefeller family and its fortune, at a crucial moment in the critical debate over that art which was being conducted in the USA.[75] Alfred Barr was appointed as its first director, a young art history graduate of Princeton and Harvard whose methodological grounding was in formalism and connoisseurship; his Harvard professor, Paul J. Sachs, was a close friend of Bernard Berenson who brought to his seminars the systematic, rational yet subjective determination of quality that Berenson espoused, and Barr seems to have been the first to adapt this method of connoisseurship to modern art.[76] His appointment at MoMA thus extended into the modern field, and into the contemporary art arena, a methodology that constructed the history of art around a narrative of stylistic change, driven by an internal logic that was independent of social, political and personal pressures and accessible only to those with the discernment to make qualitative judgements about individual works. As with Kramár's Vienna school's insistence on the organic link between contemporary art and tradition, it was a methodology consistent with

the values and functioning of that dealer–collector–critic system then establishing its ascendancy in the modern art market over the increasingly cumbersome and sclerotic apparatus of salons and state patronage,[77] and Barr worked to consolidate both with the establishment of an ambitious programme of thematic exhibitions at MoMA designed to map the sprawling field of modern and contemporary art according to the coordinates they provided.

The first of these, the 1930 'Painting in Paris from American Collections', systematised the history of early twentieth-century art in that city on the basis of formal characteristics and their development, Barr noting in his catalogue essay: 'Any attempt to classify modern artists must lead to treacherous simplification. But it may not be too misleading to suggest a chronology and some description of terms, trusting that the paintings themselves will contradict inevitable error.'[78] It was followed in 1932 by 'A Brief Survey of Modern Painting', which organised the history of European and American painting since impressionism into a sequence of categories such as 'psychological and decorative', 'the "wild animals"', and 'Picasso and cubism, futurism, abstract design, super-realism'. As Susan Noyes Platt observes, both of these exhibitions were in keeping with a US critical climate in which legibly representational painting was received more warmly than was abstraction, and Barr gave prominence in both to su(per-r)realism.[79] Unlike most US critics, however, he had spent several months in 1927–28 in Europe, meeting not only 'most of the major figures in German contemporary art, such as the Bauhaus group, the Neue Sachlichkeit, and the dealers and critics that supported them',[80] but also visiting Russia and meeting the members of the avant-garde there. As a result, he had an awareness of the vitality and range of abstract as well as representational art in those countries, which deepened into strong sympathy during a second stay in Europe in 1932–33. There he lived for a time in Stuttgart, where he seems to have experienced the growth of a Nazi-led intolerance towards modernism and an enthusiasm for Hitler that raised his awareness both of the threat this development posed for avant-garde artists and of the political ramifications of a rejection of abstraction in favour of traditional realism. In his absence from New York, in the summer of 1933 MoMA had staged an exhibition, 'Modern European Art', in the planning of which he perhaps participated but which he summarised in MoMA's *Bulletin* that October; both the exhibition and his summary displayed a shift in approach, criticising surrealism as part of a 'Romantic Reaction' against the innovations of 'pure design'.[81]

This was the institutional and personal context of the 1936 'Cubism and Abstract Art' exhibition, in which Barr brought together his didactic inclinations, formalist method, connoisseur's acuity and personal awareness of the precarious position of avant-garde art into a display and explanation of what he saw as the main currents of modernism, whose influence on Western, and in particular Anglo-American, scholarly and critical understanding of that modernism has not since been matched.[82] The mix of these qualities yielded something of a paradox: although Barr remarked in his catalogue essay that it and the exhibition 'might well

be dedicated to those painters of squares and circles (and the architects influenced by them) who have suffered at the hands of philistines with political power',[83] and preceded this dedication with a cogent two-page summary of the worsening relations between abstract artists and the nascent states of the Soviet Union and Nazi Germany, he stepped lightly over the aesthetic dimension of the politics of abstraction, simply distinguishing 'art in the narrow sense of the word' from 'typography, photography, posters, movies, engineering, stage design, carpentry – anything but painting or sculpture',[84] and this was the first and last encroachment of questions of politics – for all the inseparability of these from the aesthetics of many of its participants – into a project the interpretive framework of which was rigorously formalist. The map that Barr provided of the field it displayed – the 'chart of modern art' (figure 6.3) which has since become notorious as a metonym for that formalism – was prominently posted throughout the exhibition and on the catalogue dustjacket, the framework within which Barr elaborated a set of analytical concepts and procedures, and proceeded with these to sketch out his modernist edifice. The keystone of this was cubism, and specifically the analytic–synthetic pairing, around which its history was, following Kahnweiler, Gris and the now-established convention of 1920s' interpretation, seen to turn. As Daniel Robbins notes, however,

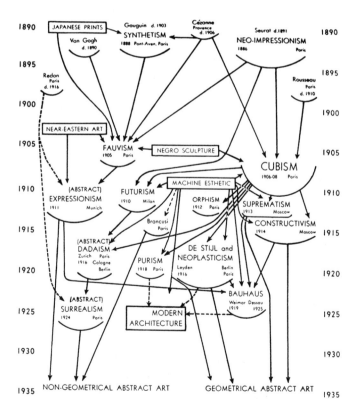

6.3 Chart prepared by Alfred H. Barr Jr for the exhibition catalogue

Barr's application of these terms 'neutralised' the philosophical idealism funda-
mental to them, replacing it with a narrative of formalist progression grounded in a
discussion of the work of Picasso and Braque, unprecedented in its specificity of
reference to particular paintings and devices, and to a chronology.[85] Thus Barr
defined analytic cubism not in terms of any conceptualising of essential or primary
qualities, or of durational continuity, in its subject matter, but in those of a 'pro-
gressive tearing apart or disintegrating of natural forms', in which 'the disinte-
grated image of the natural object gradually took on a more and more abstract
shape'.[86] 'The Cubists seem to have had little conscious interest in subject matter',
he observed. 'They used traditional subjects for the most part, figures, portraits,
landscapes, still life, all serving as material for Cubist analysis.'[87]

In this analysis – Barr used the term loosely and metaphorically, and as already
current ('The development of Cubism during its first six years from 1906 to 1912
has been called analytical'[88]) – the painters' subject matter was first 'systematically
broken down into facets like a cut diamond' (Barr cited Picasso's *Head of a Woman*
of 1908–9[89] and Braque's *Harbour in Normandy* – figure 6.4 – of early 1909 as exam-
ples). In a second phase later in 1909 these facets were allowed to 'slip, causing fur-
ther deformation' (he cited Picasso's *Portrait of Braque*[90]), which led to a 'third
stage of disintegration' (as in Picasso's 1911 *The Poet* – figure 6.5) which Barr did
not summarise; thence to a fourth in which, as in Picasso's *Arlésienne* (figure 6.6),
the head was 'made up of flat, overlapping, transparent planes, almost rectangular

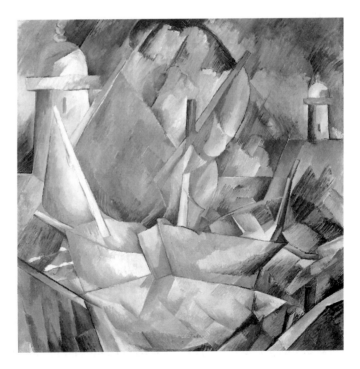

6.4 Georges Braque,
Harbour in Normandy,
1909

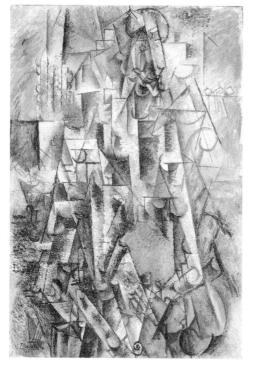

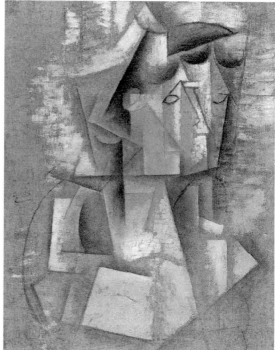

6.5 Pablo Picasso, *The Poet*, 1911 **6.6** Pablo Picasso, *Arlésienne*, 1912

in shape'. Acknowledging that the superimposition in this painting of frontal and profile views illustrated 'the principle of "simultaneity" – the simultaneous presentation of different views of an object in the same picture' – Barr however showed no interest in pursuing that principle or its implications (this indeed was his only reference to it in the essay), instead moving straight on to the fifth stage, which marked 'the end of "Analytical" Cubism and the beginning of "Synthetic" Cubism', and was characterised by 'two-dimensional, flat, linear form, so abstract as to seem nearer geometry than representation'.[91]

The capitalising of the initial letter of the twin terms is emblematic of Barr's reworking of them to function not as philosophical concepts but as stylistic and periodising markers, clearly distinguishing and dating (if allowing some overlap between) cubism's cardinal moments and their characteristic features. His precise and detailed chronologies for each located the 'apogee of Analytical Cubism' in 1912, and the 'transition to Synthetic Cubism' in the following year.[92] This was a further significant departure from the model provided by Kahnweiler, whose *Weg zum Kubismus* had suggested Cadaqués as the transitional moment; while Kahnweiler had amended this in his 1929 essay on Gris, relocating it in 1913–14 in the light of the latter's explanations of cubism, he had offered no analysis of the works of this period to support his revised claim, and his observations on the role

played by *papier-collé* and collage in the development of gallery cubism, though provocative, were undeveloped: Picasso and Braque introduced new materials into their canvases in order to 'eliminate the use of colour as *chiaroscuro*, which had still persisted to some extent in their painting, by amalgamating painting and sculpture';[93] that was all. Barr, by contrast, saw in such new media 'an emphasis not upon the reality of the represented objects but upon the reality of the painted surface'; their use, together with the construction of those objects out of 'geometrical shapes [that] are so remotely related to the original form of the object that they seem almost to have been invented rather than derived', effectively replaced a process of 'breaking down or analysis' with one of 'building up or synthesis'.[94] His claim recapitulated the 'autonomy thesis' on which the Kahnweiler–Gris definition of 'synthetic' had been based, but placed this on the firmer and more specific foundations of *papier-collé* and collage – and Barr showed no interest in the 'conceptual reality' thesis by which that definition had been coloured; synthetic cubism was, fundamentally, a matter of texture, 'a logical culmination of the interest in simulating textures' that Braque and Picasso had earlier shown.[95]

Barr's conception of synthetic cubism was integral to his overall thesis, that cubism was a key phase of the development of 'the impulse towards abstract art during the past fifty years', the 'widening stream' through which the more important of the two currents by which this impulse was manifested found its way from 'its sources in the art and theories of Cézanne and Seurat' to 'its delta in the various geometrical and constructivist movements that developed in Russia and Holland during the [First World] War and have since spread throughout the world'.[96] Although it led him to underplay the degree of the gallery cubists' engagement with the materiality of the things they painted, and to ignore (despite his qualification, noted above) their iconographic implications, it underpinned a formalist reading of their work that for the first time, as Daniel Robbins notes, accounted for its method, followed that method in detail across stages and embedded it in the history of modern art.[97] This is perhaps one reason why *Cubism and Abstract Art* provided a paradigm that, developing and replacing Kahnweiler's, shaped the historiography of cubism for more than a generation, and why his reworking of the analytic–synthetic pairing he inherited from the latter became a universally accepted descriptive code.

It is not, however, the only reason. In the light of the ascendancy of gallery cubism, and its consequences, as I have traced them, there is unintentional irony in Robbins's assertion that this exhibition catalogue 'could only have been written by an American, moreover one who was a trained historian, who sought objective truth [and] was not partisan to the currents and counter movements of European, especially Parisian art politics'.[98] There is nevertheless substance in his implication that it was a product not only of its time and place, in the ways I have outlined, but of a broader dynamic: one in which an influential fraction of the dominant class in the USA would over the next three decades institutionalise modernism, separating its aesthetics from the domain of the social and harnessing the 'impulse towards

abstraction' identified and fostered by Barr to preserve it from contamination by commercial culture. MoMA was itself a crucial vehicle for this dynamic; its well-resourced promotion of 'Cubism and Abstract Art' ensured widespread coverage, and the didactic clarity of both the exhibition and its catalogue provided educational resources for contemporary artists, while the purchase in 1939 of *Les Demoiselles d'Avignon*, a painting that Barr had placed at the start of his narrative of cubism but had been unable to include in the exhibition, reinforced that narrative's immediacy. The 'European art politics' was not so easily disengaged from it, however; not only had it been formed in part by these, as I have shown, but as the Nazi and Stalinist regimes drove increasing numbers of avant-garde artists out of Germany and the Soviet Union from the mid-1930s they, and their politics, followed their art to New York,[99] and out of this heterogeneous population, alongside MoMA and in part a product of its activities (or at least a leading beneficiary of them), there developed over the next decade an increasingly informed, sophisticated and politicised discourse of contemporary art criticism.

One of its key participants appeared in print in 1939 for only the second time with an essay that has since been recognised as the first articulation of what was to become the dominant interpretation of modernism of the second half of the twentieth century.[100] Clement Greenberg's 'Avant-garde and kitsch', published in *Partisan Review* that autumn, picked up Barr's autonomy thesis and the formalism that underpinned it, developing the political ramifications that these had marginalised in a direction influenced by the socialist vanguardism of Trotsky. Greenberg sketched a history of an avant-garde formation driven, since its emergence in the mid-nineteenth century, by resistance to and critique of the culture of advanced capitalism, inwards into specialisation around the unique propertiers of its respective arts:

> Picasso, Braque, Mondrian, Miró, Kandinsky, Brancusi, even Klee, Matisse and Cézanne, derive their chief inspiration from the medium they work in. The excitement of their art seems to lie most of all in its pure preoccupation with the invention and arrangement of spaces, surfaces, shapes, colours, etc., to the exclusion of whatever is not implicated in these factors.[101]

Greenberg saw in the popular commercial culture of capitalism a mortal threat to this 'formal culture': 'Capitalism in decline finds that whatever of quality it is still capable of producing becomes almost invariably a threat to its own existence.' Moreover: 'Advances in culture, no less than advances in science and industry, corrode the very society under whose aegis they are made possible.'[102] Arguing – seemingly with a keener sense of dialectics than of irony – that no culture can develop without a social base and a stable source of income, he noted that the ruling-class elite which provided these for the avant-garde was 'rapidly shrinking', and warned: 'Since the avant-garde forms the only living culture we now have, the survival in the near future of culture in general is thus threatened.'[103]

Greenberg made no mention of cubism in this essay, and there is only a passing reference in another keynote article of the following year, 'Towards a newer

Laocoön', in which he fleshed out his thesis,[104] but it quickly became apparent both that it was a touchstone for this and that Barr's formalist history and autono-mist emphasis provided the model for his understanding of it, although one from which he was to depart in significant respects. Following Barr (and, via him, Kahnweiler), cubism – which 'defined and isolated' the 'basic tendencies of recent western painting' – for Greenberg was gallery cubism, and primarily that of Picasso and Braque.[105] It held the highest value for him: the 'cubist mission and its hope, coincident with that of Marxism and the whole matured tradition of Enlightenment' was that of 'humanising the world'; 'cubism remains', he declared, 'the epoch-making feat of twentieth-century art, a style that has changed and determined the complexion of western art as radically as Renaissance naturalism once did'.[106] Originating not only from the art that preceded it but from the optimism, self-confidence and scientific outlook of 'the highest stage of industtrial capitalism',

> cubism, by its rejection of illusionist effects in painting or sculpture and its insis-tence on the physical nature of the two-dimensional picture plane ... expressed the positivist or empirical state of mind with its refusal to refer to anything outside the concrete experience of the particular discipline, field or medium in which one worked; and it also expressed the empiricist's faith in the supreme reality of concrete experience.[107]

This was a clear departure from Kahnweiler's idealism – if not from Barr's for-malism – for Greenberg developed the latter's identification of 'flatness' as a car-dinal feature of synthetic cubism into cubism's single governing principle, and made (what he saw as) Braque's and particularly Picasso's determination to strip painting of every quality that contravened it into the motor that drove painting from analytic to synthetic cubism and beyond into abstraction:

> It was of the essence of cubism after its initial stage to situate the image or rather the pictorial complex, *ambiguously*, leaving the eye to doubt whether it came forward or receded. But the ambiguity itself was weighted, and its inherent, irrevocable (and his-torical) tendency was to drive the picture plane forward so that it became identical with the physical surface of the canvas itself ... It belongs to the importance of cubism, to that which makes it the most epochal school of painting since the Renaissance, that it conclusively liquidated the illusion of the third dimension. It did not have to wait for Malevich or Mondrian to do that. Pre-figuring the furthest extremes of abstract art in our time, Picasso as a cubist already contained everything that abstract art has since made obvious.[108]

From the end of 1948 Greenberg's distinctive interpretation of cubism, and its differences now from that of Barr as well, became clearer as he addressed its formal developments more specifically. Reviewing an exhibition of collages by Picasso, Braque, Arp and Schwitters at MoMA that November, he tacitly disagreed with Barr's account of the introduction of new materials by Braque and Picasso in 1912, arguing that it was not a matter of 'more varied texture', as Barr had inferred, but of

an insistence on 'the physical reality of the work of art'; *papier-collé* and collage 'made that reality the same as the art'. The collage medium was thus 'the most succinct and direct single clue to the aesthetic of genuinely modern art'.[109] Returning to this article ten years later, cannibalising and amending its phrasing for a more extended essay on the same subject, he went further. Directly challenging the inference, by then conventional in the Kahnweiler–Barr interpretive lineage, of a realistic intention in Braque's and Picasso's turn to *papier-collé* and collage,[110] Greenberg extended his insistence on flatness as the guiding concept back into Picasso's and Braque's cubism of 1909–11, reading the innovations of 1912–14 as necessitated by an inexorable logic: 'there seemed no direction left in which to escape from the literal flatness of the surface – except into the non-pictorial, real space in front of the picture'; this 'seems quite apparent by now – so apparent that one wonders why those who write on collage continue to find its origin in nothing more than the Cubists' need for renewed contact with "reality"'.[111]

The pugilistic tone of this was a product of more than confidence in his own aesthetic judgement. For between the two versions of his assessment of collage, Greenberg's political views had undergone an about-face from his earlier Trotskyist allegiance to an active anti-communism (he was a founder-member in 1950 of the American Committee for Cultural Freedom, established for that purpose, with headquarters in Paris),[112] and his writing on art changed accordingly. In the mid-1940s his commitment to the importance of cubism rested on the general foundations of his argument in 'Avant-garde and kitsch', that the autonomy of avant-garde art from, and its implicit resistance to, the banalities of commercial–capitalised culture was vital; even if the sense of conscious resistance by the avant-garde to that culture had weakened since the 1939 essay, a sense of its detachment remained. An essay of 1947, 'The present prospects of American painting and sculpture', in *Horizon* suggested that in France, industrialisation was not so complete that it did not still permit the individual 'a little confidence in his own private solution, a modicum of space in which personal detachment could survive and work up its own proper interestingness'. As a result, 'in the preserves of Bohemia, the impressionists, fauvists and cubists could still indulge in a contemplation that was as sincere and bold as it was largely unconscious'.[113] In the USA, by contrast, there were no such spaces; there the industrialisation and rationalisation of culture was more comprehensive. While the fear Greenberg had earlier expressed over the threat posed by kitsch had receded, it had been replaced by that of 'general middlebrow taste', the very improvement of which – as a result of that rationalisation – was 'itself a danger':

> Whereas high art used to remain untempted, simply because it had no chance whatsoever of complying with the market demand, today the new mass cultural market created by industrialism is seducing writers and artists into rationalising and packaging for mass distribution even the most pretentious products.[114]

In consequence:

High culture – which in the civilised past has always functioned on the basis of sharp class distinctions, is endangered – at least for the time being – by this sweeping process which, wiping out the social distinctions between the more and the less cultivated, renders standards of art and thought provisional ... At the same time that the average college graduate becomes more literate the average intellectual becomes more banal, both in personal life and professional activity.[115]

Yet for all the continued perception of a high culture under threat, the politics that informed it had shifted decisively; indeed Greenberg's readiness to replace his former Marxist beliefs with such clear nostalgia for class distinctions is almost shocking. More than this: the qualification 'at least for the time being' presaged a further shift around 1950, as – like many of the New York intellectuals with whom he associated – Greenberg became a cold warrior who equated American capitalism with democracy and supported it as a bulwark against totalitarianism. As John O'Brian observes, in his long 1953 essay 'The plight of our culture', Greenberg's disdain for middlebrow culture gave way to an optimism that the rising wealth of the new managerial class in America would transform it into high culture, producing, 'for the first time in history, high urban culture on a "mass" basis'.[116] O'Brian notes:

> The central paradox of modernism, high art's attachment to and estrangement from the arrangements of capitalism, was therefore stripped of its former political cogency. What remained was modern art's self-reflexivity, its fixation on its own field of competence, its absorption with questions of delimitation and of medium.[117]

Hence Greenberg's insistent narrowing down, in 'The pasted paper revolution', of the terms of the narrative of cubism's development to the single criterion of flatness, and his rejection of any idea that an engagement with 'reality' had anything to do with it. Reductive almost to the point of caricature, this reading became the cornerstone of an understanding of modernism and a broader narrative of its history since Manet which Greenberg put in place over the next decade; most notably in his essay 'Modernist painting' and his collection of heavily revised articles from the 1950s, *Art and Culture*, both published in 1961. Reiterated like a catechism by countless proselytisers for 1960s' 'post-painterly abstraction' and its successors, elaborated and enriched by critic–historians such as Michael Fried, Greenbergian modernism and the genealogy it offered enjoyed a hegemony over an entire generation of historical writing on twentieth-century art and contemporary criticism.

Institution: high cubism

Central though cubism was to Greenberg's critical thinking, 'The pasted paper revolution' was, in its revised version in *Art and Culture*, his last extended assessment of its character and significance.[118] In the decade between his first adumbration of that assessment and its elaboration, other histories of cubism were offered, on both sides of the Atlantic, that filled out the received narrative and, in their

different ways, threw into relief the shortcomings of the critic's reading – indeed, even before Greenberg had arrived at the formulation of his 1948 review of MoMA's collage exhibition, the chief authors of that narrative had returned to it, to consolidate and extend their respective versions. Barr's 1946 book *Picasso: Fifty Years of His Art* re-affirmed the analytic–synthetic historical framework of *Cubism and Abstract Art*, acknowledging the inexactness of both terms but recapitulating his earlier definition of them in close readings of some of their defining pictures.[119] He softened the transition between the two phases, stressing that it was gradual, and that analytic and synthetic elements could co-exist in the same work, giving the (*papier-collé*) *Guitar, Sheet Music and Glass* (figure 4.22), with its synthetic guitar and analytic glass, as an example.[120] In the same year Kahnweiler, too, consolidated his interpretation of the terms for which he was largely responsible, in his mono-graph on Gris,[121] taking the opportunity it presented both to take issue with the assumptions of a geometrical basis to cubism (in tacit response to Barr's 1936 thesis) and to reiterate the Kantian character of its representational procedures; in passing he also emphasised the superiority and primacy of his stable of cubists over those of the Salon de la Section d'or.[122]

Kahnweiler's monograph was published the following year in an English trans-lation by Douglas Cooper, a work that marked both the first extended introduction of Gris to an English readership and the first of a series of books that associated its translator with the gallery cubists. Cooper was a wealthy British connoisseur and art historian who had begun buying the work of Kahnweiler's cubists in the early 1930s at the age of 21, devoting a substantial part of a considerable inheritance to building one of the major collections, private or public, of their art – by the end of that decade alone he had amassed at least 35 works by Picasso, 32 by Léger, 22 by Gris and 7 by Braque.[123] His passion for collecting these cubists' works extended to writing about and exhibiting their art, beginning with articles, reviews and cata-logue essays in the late 1930s and issuing in the late 1940s monographs on three of these painters that brought a familiarity with, and an enthusiasm for, cubism to an English art world in which both were rare.[124] But it was a cubism defined, like that of Kahnweiler from 1915, by his own interests – again, in both senses of the word – as a collector. Cooper's purchases in the 1930s were made from those dealers and other collectors who had acquired their cubist paintings either from the sequence of sales held between 1921 and 1923 of the sequestered stock of Kahnweiler and Uhde, or from Léonce Rosenberg who had, as I have noted, taken over Kahnweiler's stable of artists during the latter's wartime exile and who himself bought many of the items in these sales.[125] Cooper viewed the group of aficionados which coalesced in those years as 'a small percentage of visually alert members of the art-conscious public', who recognised 'true Cubist painting ... to have been the beginning of a stylistic revolution which was inevitable', and he defined their aethetic interest in such painting as the ability to 'see and admire the fine quality of execution and feel in Cubist painting a new and serious approach to pictorial repre-sentation'.[126] But their material interests were also a factor in this recognition, for

the Uhde and Kahnweiler sales – especially the last three of the latter, in 1922 and 1923 – disposed of their gallery cubist contents at very low prices;[127] even before those sales, as Cooper notes, the paintings of the former salon cubists were 'far more sought after' and fetched higher prices,[128] and the simultaneous release to the market of scores of works by Braque, Gris, Léger and (to a lesser extent, as his reputation was more able to sustain his prices) Picasso widened the differential still further. It was thus a matter of financial as well as aesthetic acumen that the particular qualities of gallery cubism should be recognised and an aesthetic hierarchy established on the basis of which that differential might be reversed.

In 1932 Cooper acquired these interests along with his inheritance:

> It was a favourable moment for a collector to buy because the earlier boom had turned into a terrible and long-lasting slump, with the result that the prices for paintings by the four masters of Cubism had again fallen, having been pushed upwards in the later 1920s ... I took advantage of the situation for myself as best I could and in 1932 began to buy true Cubist paintings with the intention of forming a substantial collection of my own.[129]

Such interests guided a lifetime of writing on cubism in which, as his preferred terms for it indicates, he followed Kahnweiler in defining cubism as the exclusive creation of the artists whose work he bought – though he outdid the latter in the peremptoriness of his dismissal of other members of the cubist movement.[130] And yet for all the decisiveness of this hierarchisation, Cooper's understanding of gallery cubism was by no means innovative; indeed, he followed Kahnweiler in much of this as well, and in the extended accounts of cubism that he wrote late in life kept largely to the received narrative.[131] The chief departure from this was a product as much of a collector's attachment to the concept of artistic genius and reverence for the object of his regard as it was of analysis: Cooper disliked (though occasionally used) the analytic–synthetic concept for its signification of a stylistic basis for a cubism that he preferred to see as an unmediated, intuitive expression of the individual personalities of its creators, 'not a "manner", but "a state of mind"'.[132] Instead, he suggested – and borrowed from Renaissance studies – the evolutionary distinctions of 'early', 'high' and 'late', applying them with reference principally to the cubism of Picasso and Braque, periodising this precisely, yet refraining from offering a rationale for this terminology beyond a declaration that 'the divisions which count are historical'.[133] Perhaps the real value for him of this borrowing lay both in its lack of stylistic specificity and in its connotative value, which is considerable: suggesting, first, an evolutionary (and, ironically, ahistorical) narrative of substantial, full and resolved development, and, second, serious quality – in 'high' cubism 'Picasso and Braque developed "true" Cubism to its purest and fullest expression'.

If Cooper was one of the chief agents of the hierarchical understanding of cubism, and certainly the most emphatic of its protagonists, it was thus partly because he belonged to a generation – and, within it, to a sector of the discursive

field of modernism – for which the contestation over the significance and the legacy of cubism was still very much alive, and the stakes high in aesthetic, material and (as the example of Greenberg has shown) overtly ideological terms. For modernist art historians of the generation that followed, this frame of reference remained in place but the contestation was less urgent; perhaps because the battles had been won. In consequence John Golding's *Cubism: A History and an Analysis 1907–1914* (1959) was able to offer a broader view of the relation of 'true' cubism to the cubist movement (Golding retained the term 'true cubism' from Cooper, who had been one of two supervisors of his 1956 Ph.D thesis, at the Courtauld Institute of Art in London, from which his book emerged), and a less categorical analysis of the stages through which the painting of Braque, Picasso and Gris developed.

Furnished with access to new archival material and grounded in scholarship that balanced empirical rigour with theoretical reflection, Golding's book delivered the combination that its titled promised so successfully that it became, and remains, the standard text on its subject, the gateway to cubism for a generation of students of whom the present writer was one. It derived its authority chiefly from its meticulous analyses of specific paintings in which, as Virginia Spate (another such student) observes, 'he presented its material without concealment or pretension so that it embodies his struggle to understand the paintings and invites the reader to participate in the process'.[134] Yet Golding's history and analysis did not radically challenge the received narrative, succeeding rather in accommodating both Kahnweiler's Kantianism and Barr's empiricism. Thus he reiterated the former's theorisation of cubism as a project of reconciliation between structure and representation, and in his unstated but clear implication of its intellectual, conceptual and rational character re-affirmed Kahnweiler's characterisation of cubism as classical.[135] Accepting the analytic–synthetic terminology of the received narrative, he also extended Barr's 1946 nuancing of this, indicating the differences in the propriety of its application to Gris, Braque and Picasso, and discussing in detail the role of *papier-collé* in the shifting balance of emphasis between analytic and synthetic systems of representation. Here, Golding insisted, against the notion of a break between these two systems, that 'while papier collé involved new methods of work ... it did not involve any fundamental change of aesthetic'.[136] In the final analysis his interpretive inclinations were with Kahnweiler's insistence on the realism of the (gallery) cubist project as against Barr's emphasis on the autonomy of its paintings: if 'analytic cubism was one of the roads leading to abstraction', nevertheless cubism 'continued to be an art of realism'.[137]

If the qualities of Golding's scholarship – its empiricism, visual acumen and orthodoxy – were perhaps typical of the institution of which it was a product, the same was true *a fortiori* of the major American contribution of his generation to cubism's historiography. William Rubin took up Alfred Barr's scholarly and curatorial mantle at MoMA from the mid-1960s; by the time of his first extended engagement in print with cubism, the volume *Picasso in the Collection of the Museum of Modern Art* (1972), he had succeeded him as chief curator of its Painting

and Sculpture Department. To this and subsequent work he brought a degree of analytical precision and a scholarly attention to detail that drew on MoMA's unrivalled research resources and curatorial authority, developing Barr's formalism into a methodical, if prosaic, approach to his subject that would become a model for Anglo-American modernist art history over the next two decades. The Picasso book remained faithful, with few exceptions, to Barr's interpretive framework, going so far as to reprint the latter's then twenty-five-year-old analysis of *Les Demoiselles d'Avignon* as still unsurpassed in the literature on that painting,[138] but it fleshed out significantly the sometimes skeletal explanations Barr had offered for that framework. Thus, borrowing perhaps from Cooper, whose *Cubist Epoch* had been published a year earlier, Rubin divided analytical cubism into 'early' and 'high' periods (perhaps similarly responsive to the sanctifying and institutionalising connotations of this terminology), and codified it with unprecedented precision. Early analytical cubism, of which Picasso's 1909 Horta paintings (see plate II) were the 'first fully defined statement', was characterised, he argued, by *chiaroscuro* modelling suggestive of bas-relief, a use of *passage* whose conceptual clarity 'distinguishes it from its intuitive Cézannian origins', and spatial and perspectival ambiguity.[139] Its 'classical language' of sculptural illusion was superseded in the summer of 1910 by the 'painterly art' of high analytical cubism – again defined in terms of specified formal qualities, although alongside these, and contrasting uneasily with their precision, were gestures towards extra-formal concerns: Rubin pointed to the 'expressive purposes of the pictorial configurations' and suggested 'profoundly metaphysical' qualities in paintings such as *Ma Jolie* (figure 4.15), whose Rembrandtesque 'inner light is ultimately a metaphor for human consciousness'.[140] Such inferences, although generalised, were a departure from the Barr paradigm, and Rubin developed them in his analyses of the punning wordplays in fragments of newspaper that lent an extra-formal dimension to Picasso's 1912–13 *papiers-collés* (here he acknowledged the initiative of Robert Rosenblum, whose landmark reinterpretation of them was then in preparation[141]); but his distinction between 'analytic' and 'synthetic' cubism remained exclusively formalist. Reiterating but also qualifying Barr on this, Rubin dated the shift between them to winter 1912–13, stressing both the greater abstraction that his predecessor had claimed for synthetic cubist works and their greater legibility. He summarised this paradox succinctly with a formula – 'cubism based on allusion rather than illusion' – the proto-semiotic implications of which he did not, however, follow up.[142]

The frame of reference of the Picasso book gave the account of cubism that Rubin offered a somewhat one-handed character, but he more than made up for this five years later in an essay for the catalogue for a MoMA Cézanne exhibition that came to define what was perhaps his particular contribution to the study of cubism. 'Cézannisme and the Beginnings of Cubism' presented for the first time in the historiography of the movement a closely reasoned argument, grounded in equally close formal analysis, for Braque's primacy over Picasso in the creation of analytic cubism.[143] Revising his earlier acceptance of Barr's view that *Les*

Demoiselles d'Avignon was 'the first cubist picture',[144] Rubin cited the views of Golding, Rosenblum, Cooper and Leo Steinberg in support of a two-pronged argument: first, that the painting, to be fully understood, had to be seen in terms other than those of the cubism that followed it;[145] and, second, that this cubism was more properly the work of Braque, building on Cézanne in his own fashion – indeed, he argued, 'Braque would have created early Cubism had Picasso never existed, and ... his commitment to a Cézannist syntax kept his painting more stylistically unified and more advanced in the direction of what proved to be High Analytic Cubism than Picasso's until at least the summer of 1909.'[146] If Picasso's robust eclecticism and visual imagination raised his friend's narrow enterprise to 'heroic heights', nevertheless Braque's paintings of the high analytic period of 1910–12 could 'hold their own next to Picasso's in terms of pure quality' – a quality made possible because 'in passing from a sculptural to a painterly phase, the movement had finally aligned itself with Braque's greatest gifts'.[147]

Rubin's argument was driven – as before, only in even closer focus – by a formalist analysis that traced Braque's adoption and development of Cézanne's key device of *passage*, from a previously little-known and unregarded *Landscape with Houses* which Braque had painted in late 1907, through his work of the next nine months to *Houses at L'Estaque* of 1908 (figure 2.1), reading this as the putting in place of a reversed-perspective schema that built an illusion of low relief forward out towards the viewer, eliding solids and their ambient volumes as it did so.[148] The fine grain of his analysis, its meticulous, indeed relentless, focus on the details of formal changes from picture to picture produced an argument that was unanswerable – but only within the terms of a reading of cubism whose teleological and programmatic (and, at an institutional level, legitimising) character evacuated much of the adventure from the cubist story. So, at any rate, it was felt by Leo Steinberg, who responded eighteen months later with a two-part essay contesting frontally Rubin's claims for Braque, and insisting not only on Picasso's primacy but on the integral relation in his paintings of 1908–9 of formal, expressive and iconographic concerns.[149] Rubin responded to this rebuttal, reiterating his own argument but also – in a significant acknowledgement of the way the wind was turning in modernist art history – recognising the importance of that iconographic approach to cubism which Steinberg had initiated, and underlining his own 'extensive' consideration of this in his earlier study of Picasso.[150]

Rubin's 1979 riposte was, it turned out, the high-water mark of a formalist approach to cubism, at least in its narrower version; not, however, of his own contribution to cubist studies. Through the next two decades he would progressively broaden his methodology, integrating extra-formal considerations with a commitment to formal analysis in some magisterial essays that enriched the literature on gallery cubism. His 1983 article on Picasso's *Bread and Fruitdish on a Table* of 1909 (figure 2.11) as an example of 'a peculiarly modernist situation, where iconography turns inward to engage style',[151] shed valuable light on the artist's transition from the 'narrative' schema that governed his paintings from the rose period through

early cubism, to the 'iconic' conception that underlay the work of mid-1909 through 1912; while this transition was read, as always, in formal terms (a substitution of vertical for horizontal compositions, greater use of frontality, a shift from dispersed to concentrated forms), these were for the first time grounded in an iconographic as well as stylistic analysis of *Les Demoiselles* – one that, *inter alia*, marked the beginnings of a project in which Rubin made use of newly available archive material to present a book-length and definitive account of that seminal picture.[152] Alongside this project, another came to fruition: 'Picasso and Braque: Pioneering Cubism of 1989–90' was Rubin's valedictory exhibition at MoMA, and it fulfilled one of his long-standing ambitions. For the catalogue he wrote an introductory essay, and he chaired a major symposium whose proceedings he co-edited: the former, concise yet richly informative, drew on and integrated a variety of recent approaches to its subject with an elegance and generosity that perhaps obscured the orthodoxy of the narrative of cubism that it reprised; the latter complementing it with a discussion that, while it ranged widely, did little to disturb the hegemony of that narrative.[153]

Given its longevity and the institutional authority it can marshal, it is unlikely that the analytic–synthetic interpretive paradigm will ever be dislodged. Nor is this wholly to be regretted, since it does have considerable explanatory merit, in ways that this chapter has shown. But as it has also shown, the paradigm at once limits our understanding of the range and complexity of cubism in stylistic and historical terms, brackets out of consideration significant and sometimes major articulations of its most fundamental formal conceits, and privileges meanings – and systems of meaning – other than those that were privileged, or even available, at the time of its elaboration. And it needs to be insisted that this (like any) interpretive model has a history of its own, was a product of interests external and posterior to that elaboration. The broad and interdisciplinary deconstruction of modernism that has been underway for some years within the field of cultural history has called into question the assumptions of autonomy and avant-gardism of which it was one product, but thus far this interrogation has hardly dented the teflon-coated complacencies of cubist historiography's master narrative. It is probable that the widespread acceptance of any alternative and more historically adequate model will have to await the ascendance of appropriate interests equally external to that field. That might take some time.

Other criteria

Forms and figures

During the twenty years that separated the beginning of the Cold War from the anti-Vietnam demonstrations of the late 1960s, American formalist criticism and art history constructed a modernist narrative that arched over the century from Manet to the flourishing gallery culture of mid-town Manhattan, with a gallery cubism purged of all extra-pictorial reference as its keystone. The edifice was the product not only of an anti-communist ideology that repudiated the political commitment of the pre-war avant-gardes and sought an aesthetics that would transcend all engagement with the social, but of the institutionalisation of cubism through the activities of museums and university art-history departments – a new generation of whose students took formalism's reductions and exclusions as the foundation for scholarly work that disengaged the cubism of Picasso and Braque still further from its history and discursive origins.[1] But from the early 1960s cracks were beginning to appear in this structure, as the vitality of post-war American commercial culture and the efforts of those artists, on both sides of the Atlantic, who variously engaged with its products and practices – plus the very success with which gallery cubism had been institutionalised – opened perspectives on the broader discursive spaces that this cubism had once occupied.

The first signs of a break in the monolith came with the publication of Robert Rosenblum's *Cubism and Twentieth-Century Art* in 1960. The title itself suggested the reach of its author's interpretive ambitions; while these appeared to extend gallery cubism's hegemony still further, with chapters on early-to-mid-century art movements that took this beyond Barr, Rosenblum also gave some consideration to its avant-garde contexts. Indeed he showed a preference for attention to cubism's interdisciplinary reach over close formal analysis, suggesting analogies with the musical and literary experimentations of such contemporaries as Stravinsky, Joyce and Woolf.[2] His readings of specific pictures replaced meticulous analysis of developments in cubist syntax with imaginatively metaphorical descriptions that explored their symbolic and iconographic implications and sometimes gestured to the widest horizons,[3] and he offered an eloquent account of *Les Demoiselles* that stressed the expressiveness of its distortions, 'the savagery that dominates the painting'.[4]

In structural terms, too, Rosenblum's analysis went against the grain of the received narrative. He downplayed the concern with flatness that Greenberg had made the hallmark of cubism, instead fastening on the ways in which Picasso and Braque subverted the conventions of pictorial representation, and drawing on a discourse of semiotics that was then only nascent in English-speaking cultural analysis.

> Confronted with these various alphabetical, numerical and musical symbols [in works such as *Ma Jolie* (figure 4.15)], one realises that the arcs and planes that surround them are also to be read as symbols, and that they are no more to be considered the visual facsimile of reality than a word is to be considered identical with the thing to which it refers.[5]

This perception led, in turn, to a downplaying of the significance of the 'analytic–synthetic' interpretive model: noting its sometimes misleading implication of a break between these phases, he suggested that their differences were more of degree than of kind.[6] For cubism, as Rosenblum understood it, was a continuous 'dialectic between art and reality',[7] and the introduction of collage techniques around which the shift from 'analysis' to 'synthesis' had increasingly been theorised served to enrich further its longstanding engagement with the paradoxes of representation. 'It is probably more to the point, then', he suggested, 'to think of synthetic cubism, not primarily in terms of a dubious reversal of the cubists' relation to nature but, rather, in terms of a demonstrable reorganisation of pictorial structure'; and he summarised the character and significance of that reorganisation: 'Beginning in 1912, the work of Picasso and Braque – and, ultimately, most major painting of our century – is based on the radically new principle that the pictorial illusion takes place upon the physical reality of an opaque surface rather than behind the illusion of a transparent plane.'[8]Not only did collage (by which term Rosenblum also understood *papier-collé*) raise the viewer's awareness of the independent reality of the artists' pictorial means, but the 'destruction of the traditional mimetic relationship between art and reality' that this new principle entailed was made even more emphatic by the choice of materials that in themselves offered a deception.[9]

Yet for all these departures from both script and plot, Rosenblum's history of cubism retained key features of the received narrative. *Cubism and Twentieth-Century Art* adopted from Kahnweiler and Cooper the ahistorical and unreflective structuring of the development of cubism on a paradigm that impressionism purportedly established, and while he gave more space to the wider cubist movement, Rosenblum's condescension to the 'little masters' grouped in the 'Parisian satellites of cubism' was not far removed from their outright dismissal of the salon cubists *en masse*.[10] It was only by ignoring, as had Kahnweiler and Cooper, the ways in which the painting of Léger and Gris was shaped by the discursive pressures of the post-Abbaye and Puteaux milieux, respectively, that he could accommodate accounts of their work into his narrative framework, while the complexity

and independence of Robert and Sonia Delaunay's relation to both wings of cubism was reduced to an assumed borrowing of 'Picasso's and Braque's most advanced work of 1910'.[11]

Overall, however, such representations of salon cubism and its associated artists erred more through the omission of ideas and information than by their distortion; Rosenblum acknowledged the need for a more thorough study of Parisian cubism, and it is clear from his approach that he was comfortable neither with formalism's narrow focus nor with its criteria of assessment. If he was too respectful of the received narrative in 1960 to challenge them directly in *Cubism and Twentieth-Century Art*, his essays of around 1970 on cubist *papier-collé* and collage, especially 'Picasso and the typography of cubism'(1973), developed so convincingly the interpretation of this work which that book had adumbrated as to indirectly call into question the adequacy of a formalist interpretation.[12] As Wendy Holmes has noted, what Rosenblum adroitly demonstrated in 1960 was the co-existence, overlap and interpenetration, in the *papiers-collés* and collages, of different varieties of signs and modes of visual and verbal signification. If his approach did not in itself amount to a systematic, and therefore semiotic, exploration of them ('in the sense of orienting investigation or organizing findings according to some general theory of signs or some encompassing framework of semiotic distinctions'[13]), it showed how their use was brilliantly particularised in individual works. His 1973 essay[14] took this further, offering a comprehensive catalogue of the games that Picasso, in particular, played with the words that he pasted or painted into his pictures from 1912 and their interrelations with the images, materials and other signs that they there accompanied; it leaves the reader (of both essay and pictures) in no doubt of the artist's subversive delight in those aspects of his new-found medium. At the same time, however, it raises the question of what criteria, replacing those of formalism, might enable some discrimination between possible readings of such word-and-image plays: if the quality of flatness was more Greenberg's obsession than Picasso's, could the same be said of the many lascivious puns that Rosenblum identified in his *papiers-collés*?[15] (See figure 7.1.)

The approach that Rosenblum took in his essay on collage both contributed to and benefited from the perception of formalism's shortcomings, and before it was published in its final form these had been exposed from another perspective. Leo Steinberg's collection of essays *Other Criteria*, published in 1972, effected, it will be seen, such a change in interpretive habits that my appropriation of his title for this chapter is only fitting. In the essay which furnished that title he mounted a frontal assault on both the aesthetics and the ethics of formalist criticism.[16] Assimilating its qualities and procedures to the attachment to practicality and efficiency that he saw as characteristically American,[17] Steinberg declared his opposition to formalist critics: 'I mistrust their certainties, their apparatus of quantification, their self-righteous indifference to that part of artistic utterance which their tools do not measure. I dislike above all their interdictory stance – the attitude that tells an artist what he ought not to do, and the spectator what he ought not to see.'[18]

In the longest essay of the collection, on Picasso, he took this fight to the received interpretation of cubism. 'It is now apparent that cubism sought neither a three-dimensional nor a 'scientific' grasp of depicted form. Whatever objects or portions of objects remained recognizable during its 'Analytical' phase (1909–12) were not facetted to demonstrate real structures, but the better to absorb their dismembered parts in the field.'[19] Thus dismissing one half of that reconciliation between *representation* and *structure* that Kahnweiler had placed at the centre of the cubist project,[20] he then challenged the presumed defining quality of the other half: Picasso's and Braque's facetting of forms was intended 'not to fortify the masonry of inter-locked forms' (Kahnweiler had stressed 'the co-ordination of the individual parts into the unity of the work of art'[21]) 'but on the contrary, to disassemble their think-able parts, so that conceptual disjunction parallels the visual fragmentation of the whole field'. And to make this crystal clear he continued:

> In other words, in a cubist picture the here and there of divergent aspects is not designed to consolidate body surfaces, but to impress the theme of discontinuity upon every level of consciousness. Never is a cubist object apprehendable from sev-eral sides at once, never is the reverse aspect of it conceivable, and no object in a work of 'Analytical' cubism by Picasso or Braque appears as a summation of disparate views.[22]

In place of Kahnweiler's classicising–legitimising explanation, Steinberg insisted on seeing 'what he ought not to see' in cubism, above all in the *Demoiselles*

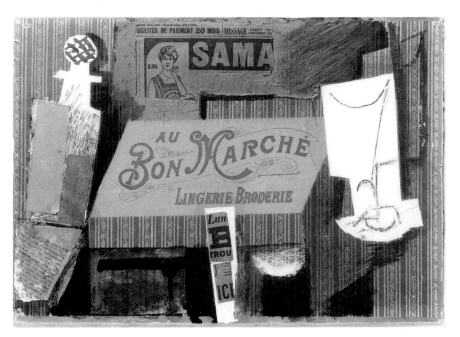

7.1 Pablo Picasso, *Still-Life 'Au Bon Marché'*, 1913

(plate I) and pictures with which Picasso followed it in 1907–8. Dismissing the received formalist interpretation of the *Demoiselles* with incredulity, he insisted on its subject matter as crucial, stressing the 'tidal wave of female aggression' with which it engulfed the viewer,[23] and on its inseparability from the compression of space that made the picture 'like the inside of pleated bellows ... The whole picture is an oncoming space charged with heat and urgency by the massed human presence.'[24] Focusing on the squatting figure (lower right), Steinberg argued that its rejection of the idealisation, fixed viewpoint and psychic distance that characterised the tradition of the nude was the 'moment of art's devenustation', or de-aestheticisation – the removal of the cultural prophylactic that separated art from sex. This figure above all bound the viewer into the scene as an active participant: 'The observer's presence, any man's presence, is understood without any man being painted in. Everybody can see that the ladies are having company.'[25]

Beyond its refreshing vivacity, its ingenuity and eloquence, Steinberg's outlining in this essay of an interpretive model that challenged formalism's reductivism had immediate and far-reaching effects. His elaboration of it in another long essay, 'The philosophical brothel', published in two parts in the autumn of 1972, marked a watershed in cubist historiography, replacing formalism with iconography as its dominant interpretive methodology almost single-handedly, as Rosalind Krauss later noted.[26] She also pointed out, however, that it was not only in his consideration, for the first time, of the sexuality of the painting's subject matter that Steinberg's essay was so iconoclastic: it was also – and inseparable from it – in his insistence of the role of the viewer in constructing its meaning and affect. 'The unity of the picture, famous for its internal stylistic disruptions, resides above all in the startled consciousness of a viewer who sees himself seen', he declared,[27] and from this observation he developed a phenomenological reading of *Les Demoiselles* which sought to understand how that viewer's body might be 'choreographed' by its representational field.[28] Yet this body was, in Steinberg's assumption, necessarily male, as I noted in an earlier chapter. Tracing the evolution of the *Les Demoiselles*' project, in the 'philosophical brothel' essay, through its many preparatory studies, he noted that the original composition included, at left, a male figure as participant in the drama. In the final painting this had been replaced by the female nude pushing a curtain aside, and the brothel inmates 'are through her made to react to us'. Steinberg pondered the consequences:

> As the action turns through 90 degrees to confront the viewer, the picture ceases to be the representation of an adventure enjoyed by one or two men and becomes instead an experience of ours, an experience, that is, of the painting ... [The picture] declares that if you wholly accept and undergo the aesthetic experience, if you let it engulf and 'frighten' you ... then you become an insider. It is in the contagion of art that the types of knowledge, the external and engaged, are fused, and the distinction between outsider and insider falls away.

He went on to turn this experience back on to the painting's maker:

Not every picture is capable of such overriding contagion. Few works of art impose the kind of aesthetic experience which the young Nietzsche called 'a confrontation with stark reality'. And this, surely, is why Picasso strove to make his creation a piece of 'wild naked nature with the bold face of truth.' He wanted the orgiastic immersion and the Dionysian release.[29]

All of his language – his choice of terms and of metaphor, his analytical thrust, as it were – in 'The philosophical brothel' is assertively gendered, and nevertheless universalised, as if for Steinberg there was no question of a female identity for the viewer caught up in the drama, or for the artistic imagination that forged *Les Demoiselles*' expressive devices. This assumption was fundamental for him. In the 'Algerian women' essay he developed the implications of his reading of the concatenation of desire and artistic creativity in Picasso, noting that the expressive distortions and simplifications of the female nudes that populated his paintings of the next eighteen months were mapped, like the clichéd crudities of a million graffiti, on their erogenous zones, with the consequence that their brutality and erotic charge accord with their formal power.[30] Six years later, Steinberg took this interpretation a stage further, arguing in a searching essay on Picasso's *Three Women* of 1907–8 (figure 2.6) that the appropriation of Cézannist bas-relief and subdivided forms through which the protagonists of that painting are fused together was a means to a meditation on the mutability of sexual identity.[31] This interpretation of a libidinal investment by Picasso in the syntactical explorations of his cubism climaxed in the second part of the essay, in the claim that his paintings of 1907–10, 'whatever their ostensible subjects, whether landscapes, still-lifes or figures, become simulacra of sexual acts'.[32]

After the exhilarating, horizon-widening journey on which Steinberg had taken his readers in these essays, the banality of this conclusion – the reductivism of which equalled that of the formalist interpretive model he had done most to dislodge – was disappointing; the more so in the light of the work by feminist art historians that, like the women's movement at large, became increasingly visible through that decade, and in particular of Carol Duncan's pioneering essay – nearly contemporary with Steinberg's own writings – discussed in an earlier chapter, which made clear the regressive social relations of sexuality that pervaded early twentieth-century avant-garde culture. As I noted, Picasso can be seen as the paradigm of the avant-gardist type identified by Duncan, 'the earthy but poetic male, whose life is organised around his instinctual needs', and whose art 'depicts and glorifies what is unique in the life of th[is] artist – his studio, his vanguard friends, his special perceptions of nature, the streets he walked, the cafés he frequented'.[33] Yet in a sense Steinberg's masculinism was an inevitable corollary of his approach, for his celebration of just those qualities, and his equation of Picasso's earthiness with his poetry, were constitutive of his estimation of Picasso's genius – an estimation that governed his assertion in 'The Algerian women' that Picasso's cubism was more like his other work than it was like other cubism, his insistence in 'The polemical part' that it was, furthermore, far superior to that of Braque, and his passionate

defence of Picasso's art against its latter-day detractors, in a postscript to the 1988 republication of 'The philosophical brothel'.[34]

Bodies and signs

Despite their masculinism, however, Steinberg's insights proved fruitful, not only in the licence they gave to iconographic interpretations of Picasso's cubism that increased awareness of its discursive complexity, but more particularly in the way they overlapped with, and were developed in, the writing of his colleague and fellow critic–historian Rosalind Krauss. As Krauss noted not long after her magazine had republished his essay on *Les Demoiselles*, Steinberg had there closed his analysis of the painting with the observation that its space

> is a space peculiar to Picasso's imagination. Not a visual continuum, but an interior apprehended on the model of touch and stretch, a nest known by intermittent palpation, or by reaching and rolling, by extending one's self within it. Though presented symbolically to the mere sense of sight, Picasso's space insinuates total initiation, like entering a disordered bed.[35]

As I noted earlier, Krauss herself had made the same distinction between touch and sight in a 1971 review of Douglas Cooper's 'Cubist Epoch' exhibition in Los Angeles. Although her judgement of the exhibition as a whole was coloured by the formalist certainties and *ex-cathedra* dismissals of the unelect characteristic of the Greenbergian criticism she then wrote, this review also sketched the outline of an interpretation of Picasso's cubism that Krauss would build on over the next two decades. In the pictures she saw in Los Angeles, she reported, there was evidence 'that in these years Picasso was plagued by a kind of skepticism about vision ... about whether there can ever be direct access to depth through vision – whether anyone can really *see* depth'.[36] She concluded that there was in Picasso's scepticism 'more fear than pleasure' – differing here from Steinberg, then writing his analyses of *Les Demoiselles* in which he accentuated the positive implications of such discontinuities – and extended this perception into an apprehension of a 'tragic sense of loss' that 'resonates' in his paintings of 1910–12. Although in those years' 'hermetic' pictures, as she read them, 'touch and sight, the two warring faculties of sense, [were] increasingly fused or processed through the independently given reality of the picture surface', and the latter stood as a metaphor for consciousness, this equation held only uncertainly: a painting such as the portrait of Fanny Tellier (figure 2.14) exuded for Krauss, as I have said, 'an acute sense of emotional cost as shards of the most sensuously affective parts of the body ... are stranded as dessicated shape above voluptuous chasms of a depth which can no longer be wedded to the contours that would give depth meaning'.

Krauss moved to espouse the phenomenology that underpins both this interpretation and that of Steinberg in the early 1970s, firstly out of a growing realisation of the teleological character of Greenbergian formalism and of its inability to

account for the history of twentieth-century sculpture,[37] and secondly from a con-
viction that the work of the most important contemporary sculptors demanded an
embodied response from the viewer.[38] But it was in the structural linguistics of
Saussure, and the semiotic principles that he extrapolated from this, that Krauss
found an explanatory system to replace that with which formalism had once fur-
nished her. Her application of Saussurean concepts to cubism had its first outing in
two overlapping essays: 'Re-presenting Picasso', published in December 1980; and
'In the name of Picasso', of April 1981.[39] Elaborated as a critique of an 'art history of
the proper name' that she saw as a dangerously fashionable methodology,[40] the
latter selected Rosenblum as a scapegoat for its ills, misrepresenting his 'Picasso
and the typography of cubism' as an example of a 'semantic positivism' that facili-
tated cubism's assimilation by it, and opposing to it 'a rather more exacting notion
of reference, representation and signification'.[41] Rosenblum's sin, for Krauss, was
to have inferred that the names printed on the fragments of gallery cubism's pasted
papers could be read as identifying objects in the manner of labels.[42] For this notion
of the sign-as-label, she argued, not only gratuitously introduced the nominal par-
ticulars of a modern world that was extraneous to the significance of *papier-collé*,
but its 'simple semantics of the proper name'[43] was 'a perversion of the operations
of the sign', since 'the label merely doubles an already material presence by giving it
its name'.[44] Fundamental to those operations in the linguistic sign, and in Picasso's
collage in particular, was, on the contrary, the structural condition of absence – a
sign *is* a sign, argues Krauss, because it stands in for an absent referent.

She gives as an example 'the appearance of the two *f*-shaped violin sound-holes
that are inscribed on the surface of work after work from 1912–14' (figure 7.2), the
disparity in size between which presents a sign for foreshortening, of rotation into
depth, on a surface that is implacably flat; '"depth" is thus written on the very place
from which it is – within the presence of the collage – most absent. It is *this* experi-
ence of inscription that gives these forms the status of signs.'[45] Similarly, Picasso's
use of newsprint in many *papiers-collés*, Krauss suggests, constructs a sign for that
broken colour or stippled brushwork with which painters such as Rembrandt or
Seurat created the illusion of atmosphere, thereby inscribing transparency on to
the most opaque element of the surface of these works. Devices such as these pre-
sent 'the first instance within the pictorial arts of anything like a systematic explo-
ration of the conditions of representability entailed by the sign'.[46] The richness of
the interpretive system that Krauss here puts on display, the acuity of her analyses
of these formal devices and the succinctness of her theorising of the system they
establish indicate that in such an application of the principles of structural linguis-
tics she had developed an adequate successor to the formalist methodology with
which she had begun as a critic. 'That method[ology] demanded lucidity', she had
written in 1972. 'It demanded that one could not talk about anything in a work of
art that one could not point to ... It involved a language that was open to some mode
of testing.'[47] The Saussurean model, in her adaptation of it, shared those qualities,
and added to them a far greater explanatory power.

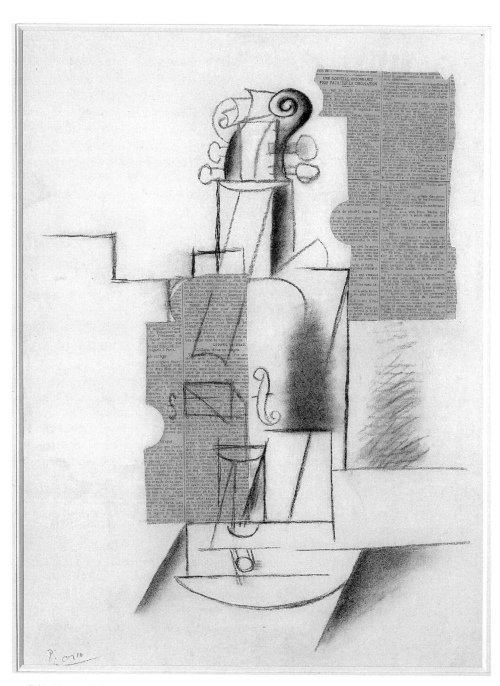

7.2 Pablo Picasso, *Violin*, 1912

Reflection on the interpretive framework sketched in the 1981 essay, however, led her to an understanding of cubism, first laid out in a paper at the MoMA 'Picasso and Braque' symposium of 1989, that brought the phenomenological insights sketched in her review of 'The Cubist Epoch' together with the semiotics of a decade later into an interpretation of Picasso's evolution through cubism that was both consistent and profoundly suggestive. The first half of Krauss's paper[48] recapitulated and expanded on the analysis of Picasso's cubism between the summer of 1909 and that of 1912 which she had outlined in the 'Cubist Epoch' review. There, as I have noted, she had remarked on the sense of loss registered in Picasso's paintings; reprising this observation, she noted that the work of 1910–12 in particular returns obsessively to the human figure, indeed to the figures of Picasso's friends and lovers, for its subject-matter, and remarked on his declaration to Kahnweiler of June 1912 that he would write his love for Eva Gouel on his paintings:

> For it to have gotten to the point that the carnal dimension – depth – is so unavailable to one of the most accomplished figure painters of his age that he must render his passion for a woman by *writing* it on his pictures is certainly one of the great ironies in the history of illusionist painting.

'But', Krauss adds, 'it is also one of the great watersheds.'[49] For Picasso's adoption of the techniques and materials of collage represented

> the point of no return within this process. With its evacuation from the pictorial field of wave after wave of modelling, of the cacophony of slightly canted planes, collage ironed out the fabric of illusionism, rendering the object's existence within the visual field as inexorably flat as an insect crushed between two panes of glass.[50]

In the *papiers-collés* of 1912–13 in particular, what was no longer representable illusionistically – depth, chiaroscuro, warmth, touch – was inscribed on their surfaces (semiotically) by means of those (symbolic) signs, identified earlier, for luminosity, transparency, opacity, etc. Krauss emphasised the brilliance with which Picasso produced the binarisms that were the structural prerequisite for linguistic meaning – and which, as such, secured in his art the 'conversion from one whole representational system, roughly called iconic, to another, roughly called symbolic'.[51]

Krauss was not alone in adapting and elaborating the semiotic model to the analysis of cubism, for this perceived moment of conversion from an 'iconic' to a 'symbolic' system in Picasso's art was also the focus of Yve-Alain Bois's attention. The moment coincided, of course, with that transition from 'analytic' to 'synthetic' cubism constructed – with differences of emphasis – by the Kahnweiler–Barr narrative. In his essay 'Kahnweiler's lesson' (1987), as I have said, Bois took pains to emphasise the dealer's pioneering role, not only in explaining cubism[52] but especially in recognising the crucial stages of its development – above all, the epochal nature of the year 1912: the role played in the 'epistemological break' that it represented[53] by Picasso's acquisition in mid-year of a Grebo mask from the Ivory Coast of West Africa (figure 4.20) and his subsequent fashioning of his cardboard *Guitar*

(figure 4.19) of that autumn on the principles he saw embodied in it; and his identification of those principles as semiotic in nature. 'It was the [Grebo] masks which opened these painters' eyes', wrote Kahnweiler in the late 1940s about Braque and Picasso's cubism, and he explained that these masks

> bore testimony to the conception, in all its purity, that art aims at the creation of signs. The human face 'seen', or rather 'read', does not coincide at all with the details of the sign, which details, moreover, would have no significance if isolated[...]
>
> The epidermis of the face that is seen exists only in the consciousness of the spectator, who 'imagines', who creates the volume of this face *in front of* the plane surface of the mask, at the ends of the eye-cylinders, which thus become eyes seen as hollows.[54]

Kahnweiler saw the same principles at work in cubist reliefs that he dated to 1913 and 1914:

> For example, the hollow of the guitar in some of Picasso's reliefs is marked by a projecting lead cylinder, in others by a plastilene cone. How can we fail to recognize in these the means (identical in the first case) by which the Ivory Coast artists create a volume whose limits they only indicate by the height of the cylinders representing the eyes?[55]

Following this logic, and Edward Fry's argument from documentary evidence that Picasso probably bought his Grebo mask in Marseilles in August 1912, Bois insisted on the importance of Picasso's cardboard-and-string *Guitar* of that year, not only for the emergence of synthetic cubism, but for 'almost all this century's sculpture, and, to a great extent, the semiological investigation called abstraction'.[56] As such, it was vital to date it accurately, and Bois took issue with the received assumption that it was made shortly before Picasso's *Still Life with Chair Caning* (figure 4.16), in the spring of 1912: 'If we graft peremptorily the *Guitare* onto the problematic of the first collage ... we will not comprehend its full force and effect'; instead, it had to be seen as immediately preceding the first *papiers-collés*, for it introduced, for the first time in Picasso's work, a fully semiotic understanding of the working of signs. To demonstrate this, Bois developed Kahnweiler's acute but unsystematic insights, applying to them the principles of structural linguistics that Saussure had established at the very moment, coincidentally, of analytic cubism.[57] He began by identifying three as fundamental. First, there was the arbitrary relationship within the linguistic sign of the signifier to its signified (and not, he stressed, of the sign to its referent, a question that Saussure did not address) – and thus the dependence of the meaning of a sign on its difference from other signs in the same system: its 'differential' nature; second, its 'value' in that system, which is conferred by its function within it (Saussure likened this to the value of a piece, such as a knight, in a chess game) and related to the number of signs the system comprehends; third, the 'relative motivation' of a sign – its specific relations with cognate signs which limit its arbitrariness – which demonstrates, Bois observed, 'that not everything is possible in a given system of values'.[58]

Furnished with these tools, he returned to the Grebo mask to argue that what Picasso recognised in it was, once again, three things in particular: first, the differential nature of its signs (such as that of a cylinder standing for 'eye') – which Bois emphasised was a matter not simply of their lack of resemblance to the features of a face but of their value within its sign-system – that is, the weight and function each has within the mask's limited repertoire of signs; second, that the relations between those signs, their relative motivation within a 'system of values' which remained figurative, allowed for an immense variety of significations; and, third, the principle that 'a sign, because it has a value, can be entirely virtual, or non-substantial' – thus his sculpture could 'formally employ space, transform emptiness into a mark, and combine this mark with all kinds of signs'.[59] In sum, it was the possibility of an 'infinite combination of arbitrary and non-substantial signs at the heart of a finite system of values'[60] that had been the lesson Picasso took from his Grebo mask; brilliantly encapsulated in his little cardboard, string and wire *Guitar*, its principles would provide the basis for the exploration of his new-found technique of *papier-collé* with which Picasso followed it. And the recognition of those principles was the lesson that, in his turn, Bois took from Kahnweiler.

Two years later, Bois had an opportunity to develop his own insights. 'The semiology of cubism', a paper for the MoMA's 1989 'Picasso and Braque' symposium, was a full-dress demonstration of the interpretive model that he was elaborating alongside Krauss; together with her 'Motivation of the sign' paper which it complemented and occasionally overlapped, it presented a resolved, sophisticated and challenging explanatory framework for gallery cubsm.[61] Recapitulating the argument of his earlier essay and its insistence on the rupture that 1912 represented Bois, however, greatly extended his analysis with a broader narrative of the semiotics of the work of both Picasso and Braque between 1907 and 1913, and paralleled Krauss in arguing that 'what we could call a "semiological attitude" had been at the core of what is usually called cubism right from the start'. But he insisted that it was only with Picasso's papiers-collés of late 1912 that cubism became fully semiological. Before turning to these, however, he noted that one work in particular 'prepared the way' for this development: the little *Still Life with Chair Caning* that Picasso made in the spring of 1912. As I explained in chapter 2, this is significant for Bois not because of its introduction of heterogeneous elements (the oilcloth and the rope frame) into painting, but – more important than the questioning of the pictorial conventions and protocols insulating art from popular culture that such heterogeneity declared – because of 'the collapse it effects ... of the empirical and vertical space of vision, controlled by our own erect position on the ground, into the semiological and possibly horizontal space of reading'. For in so doing 'Picasso is inscribing the very possibility of the transformation of painting into writing'.[62]

With this argument Bois implicitly paralleled Krauss's interpretation of the shift from iconic to symbolic signs in Picasso's cubism as a transcription of 'carnality' into 'language'; also like her, he chose one of the earliest *papiers-collés* as an

exemplification of this shift. Where in the *Violin* of late 1912 Krauss saw 'depth'
written where its quality is most absent, via *f*-holes and newsprint, Bois saw the
equivalent non-substantial character of the sign inscribed in the *Guitar, Sheet
Music and Glass* (figure 4.22) of the same moment, in the polysemy of its elements:
thus the trapezoid section of decorative wallpaper sandwiched between the picto-
graphic glass and the woodgrain paper 'becomes at once a sign of depth and, being
utterly flat, its absolute negation', while the black section of a circle that forms its
lower boundary can be read alternately as guitar, drop-leaf table and dish.[63] And in
subsequent pages, he develops this insight into an assessment of Picasso's *papiers-
collés*, at least through the spring of 1913, as explorations of 'the minimum level of
semantic articulation a shape is obliged to perform to be read as a sign'. Thus, no
longer controlled by the *a priori* systems of indexicality or iconicity, these signs
'take on a life of their own'.[64]

Words and pictures

The semiotic interpretation pioneered by Bois and Krauss has been understand-
ably influential; developing formalism's strengths of engagement with the visual
particularities of paintings, it adds to these a metadiscourse of considerable sugges-
tiveness, even profundity. But it is also flawed, in a number of ways. Some of these
flaws derive from the two writers' attachment to a Saussurean, as opposed to a
Peircean, semiotics, for as several art historians have observed, the latter furnishes a
more comprehensive, flexible and dynamic model for the systematisation of visual
signs than does the former, with its insistence on the paradigm of verbal language.[65]
Although both writers, and especially Bois, make use of Peirce's categories – in par-
ticular his most familiar triad of indexical, iconic and symbolic signs – and
acknowledge an equivalence between the last of these and the Saussurean under-
standing of a linguistic sign, both insist on the shift from iconic to symbolic signs as
marking the key moment of Picasso's (and to a lesser extent Braque's) cubism.
Indeed, it was the founding act of twentieth-century modernism: it is only with his
deployment of visual signs which are predominantly unmotivated and differential
that Picasso's painting becomes 'fully semiological'. Yet there are at least two prob-
lems with this assertion.

The first, and more general, problem is that (as James Elkins and others have
noted) the visual marks that characterise painting are not easily susceptible to the
division into discrete units of meaning, or morphemes, as the Saussurean linguistic
paradigm requires; unlike the distinguishable words in a sentence, or sentences in a
paragraph, they are usually 'dense': interfused, consolidated, inseparable. In the
analyses of some semioticians of art, brushstrokes, lines, marks and traces are thus,
in themselves 'subsemiotic' – technical elements of a painting that contribute to its
meaning but do not usually carry meaning in themselves;[66] for others, they do carry
meaning, but meaning of kinds and in carried ways not adequately seized by semi-
otic analysis.[67] It is thus hasty, to say the least, to assume the appropriateness of the

linguistic model without taking these specific properties of painted and graphic marks into consideration.

The second problem is more specific: even from the perspective of semiotic analysis – and the complexity of Peirce's taxonomy of signs arguably makes allowance for the 'density' of painters' mark-making – it is not as clear as Bois and Krauss assert that Picasso's cubism shifted decisively from iconic to symbolic signs in late 1912. To take just three examples: if it is arguable that the projecting cylinders in the Grebo mask (figure 4.20), which Bois sees as provoking Picasso's 'epiphany', signify symbolically as eyes because of their differentiation and value, they *also* do so iconically by virtue of the circularity of their cross-section. In the constructed *Guitar* (figure 4.19), the immediate product of that epiphany, the instrument's contours are decisively dependent on resemblance, and this iconicity is fundamental for the play of signification that Bois observes in it. And while Picasso makes deft use of sound-holes as a symbolic sign for depth (as Krauss equally deftly observes) in his *Violin* (figure 7.2), he also counterpoints it with the draughtsmanly flourish of the pegs and scroll, depicted illusionistically – indeed, in so doing, he turns the scroll through 90 degrees in *precise* iconic reciprocation of the 'Saussurean' *f*-holes. These, and any of the many other examples that could be cited, suggest not only, as Stephen Scobie argues, that iconic and symbolic signs are not free of each other's qualities but rather 'interact with each other in a relation of necessary supplementarity', but more broadly that, as Umberto Eco succinctly demonstrates, the very notion of the *iconic* as a category of sign is unstable – and this, by extension, places the tenability of signs *per se* in question.[68] Leaving aside this conclusion, it seems clear that throughout the period in which gallery cubism was elaborated, Picasso and Braque mixed and juxtaposed different kinds of signs – a practice which Bois himself acknowledges when he suggests that what was at stake for Picasso, at least before his 'epiphany', was 'the elasticity of iconicity'.[69] In other words, the character of their exploration of the semiotic implications of their cubism was closer to Rosenblum's reading of a playful polysemy in the *papier-collés* and collages than it was to the systematisation of visual and verbal signification around a structure of binary oppositions which Bois and Krauss find there.[70]

That systematisation, it must be said, is persuasive in its elegance and conceptual coherence. But it wins those qualities at the expense not only of accuracy, but of connotative richness; as in Bois's analysis of the *Still Life with Chair Caning* which brackets off, as of secondary importance, what he calls the 'whole issue of heterogeneity' raised by Picasso's introduction of oil-cloth and rope. For he thereby misses the integral relation of that heterogeneity – the juxtaposition of emblems of a vernacular visual culture against the codes and devices of an esoteric and technically radical art style – to the semiotic play that he addresses: integral because a primary *purpose* of that play, both in Picasso's paintings and drawings of 1910–12 that Karmel examines so minutely and in the *papiers-collés* that are the object of Rosenblum's attention, appears to be to exploit the possibilities for

metaphor and *détournement* that it affords. Picasso's delight in the visual and verbal punstery of which his developed cubist style was capable has been likened by some to a cartoonist's sensibility, and the comparison is indeed richly suggestive, for the humour, imagination, irreverence and criticism (in a word, subversiveness, at once aesthetic and social) that characterises cartooning was also a cardinal quality for him.[71]

If the shift from iconic to symbolic signs in Picasso's first *papiers-collés* is not as marked, then, as Bois and Krauss argue, or indeed if the two categories of sign co-exist in these works as in earlier paintings, then, as Malcolm Gee notes, there is probably less fundamental difference between early and late (or between 'analytic' and 'synthetic') gallery cubism than they claim.[72] And that begs the question: why insist on this shift in 1912, which flies in the face of substantial visual evidence? The answer appears to be that it serves as the cornerstone both of a particular idea of modernism and of Picasso's unique position within modernism. For Bois, as I have said, the 'epistemological break' of the cardboard-and-string *Guitar* was of fundamental importance for 'the semiological investigation called abstraction'; in this context it is interesting that, as Mark Roskill observed in discussion with him, Bois's narration of Picasso's cubism through a series of (proto-)semiotic stages seems to be equally appropriate to the development of the work of Malevich in the second decade of the twentieth century. Indeed Bois's acknowledged indebtedness to Roman Jakobson's comparison of cubism with Saussure's ideas supports Roskill's inference that the terms in which the Russian artistic and associated literary avant-gardes of the 1910s (of which Jakobson was a member) interpreted Picasso's painting – terms which took their own work from cubo-futurism into abstraction and linguistic enquiry – had a formative influence on his construction of that narrative.[73] The similarities with Aksenov's reading of this painting, noted in chapter 6, are thus no coincidence (though it might be added that Bois's interpretation of cubism is more partial – in both senses of the term – than that of the Russian futurist). For Krauss, the 'extraordinary contribution of collage' to modernism was its 'systematic explorations of the conditions of representability entailed by the sign', for 'it is collage that raises the investigation of the impersonal workings of pictorial form, begun in analytical cubism, onto another level: the *impersonal* operations of language'.[74] It is the pleasures afforded by the analysis of those workings and operations that have been, throughout her career, among the motivations for Krauss herself and 'the new critics – that group of determined "formalists"' – who [have] gloried in the ambiguity and multiplicity of reference made available by form'.[75] The analytical tools made available by structural linguistics enabled her to re-emphasise that ambiguity and polysemy in the face of what she saw in the 1980s as a growing tendency to reduce the ground of interpretation to the biographical: an 'art history of the proper name'.[76]

It is then ironic, given this shared attachment to the impersonal operations of the linguistic, that Bois and Krauss should so insistently privilege Picasso over Braque in their narratives of gallery cubism, concurring with Steinberg in

asserting the superiority of the former (and, in Bois's case, repeating also Steinberg's assertion of the continuity of Picasso's concerns from cubism onwards, as against the perceived post-cubist 'decline' in Braque's work).[77] 'The semiology of cubism' in particular misses few opportunities to contrast the work of the pair at each stage of their shared pictorial explorations to Braque's disadvantage, in an argument that becomes steadily more critical of the latter, until finally Bois makes his reasons clear: 'One way of stating the difference between the two artists', he suggests,

> would be to say that Braque's concept of the sign always remained synecdochical (hence fundamentally iconic), even during the phase of Synthetic Cubism, while Picasso's notion, becoming strictly semiological at that time, allowed him to explore in painting the possible confluence and constant *chassé-croisé* of metaphor and metonymy, of the two axes of language defined by Jakobson, that [*sic*] of *selection* and *combination*.

And he adds: 'A simpler way to state the difference between the two artists, finally, would be to say that Picasso is a structuralist, while Braque is not.'[78] Clearly this characterisation is fundamental for him, but the perception is hardly objective: not only is this distinction between the iconic and the symbolic less tenable than Bois assumes, as I have suggested, but it is no more the case that Braque 'failed' to move beyond the iconic than that after 1912 Picasso consistently did so.[79] In several *papiers-collés* of 1912, such as the *Guitar* (figure 7.3), a single piece of imitation-woodgrain wallpaper reads ambiguously as both figure and ground, as the eponymous instrument and/or the table on which it rests; functioning in this example, indeed, at once iconically (as the corner of the table) and symbolically (as the guitar, its rectilinearity standing differentially for the instrument's curves), if not also indexically (its right-angled corners referencing the picture's own boundaries). As his use of pasted papers became, like that of Picasso, more elaborate and intertextual over the next eighteen months, moreover, Braque displayed a delight in semiotic play that was as evident, if not as scabrous, as that of his partner – as in the *Violin and Pipe* of 1913–14 (figure 7.4), where the curl of the pipe's stem, rhyming with the tail of the letter Q and standing also for the violin's *f*-hole and the table's leg, is deployed against printed papers that read variously as figure and ground, light and shadow.[80]

While neither Krauss nor Bois have to date registered, far less answered, the above criticisms of their application of Saussurean linguistic semiotics and its implications,[81] the debate provoked by these has arrived at a consensus view: namely, that while it now seems clear not just that a semiotic reading provides crucial insights into gallery cubism, but that this cubism was always an art of semiotics, it is also apparent that a non-structuralist semiotics, such as Goodman's or Peirce's, is a far more appropriate model for exploring its operations than that of Saussure.[82] In short, that not only was Braque not a structuralist, but neither was Picasso – unlike Bois. I would add 'and Krauss', had not the latter ended her 'Motivation of

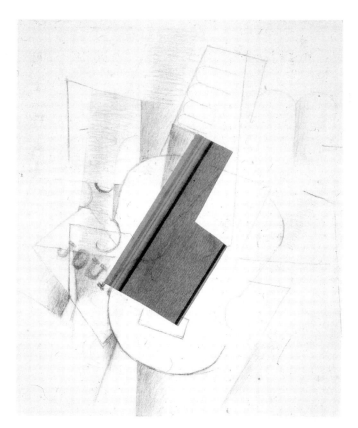

7.3 Georges Braque, *Guitar*, 1912

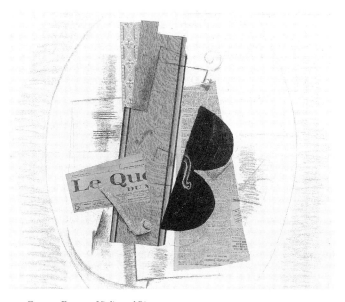

7.4 Georges Braque, *Violin and Pipe*, 1913–14

the sign' essay with an argument that shifts the ground of her analysis away from Saussure in order to address a critique that had been developing from another direction: the charge made by social historians of art that the Saussurean interpretive model brackets off (as I have shown in Bois's analysis of the *Still Life with Chair Caning*) the social dimension of the *papiers-collés* – that is, the gallery cubists' enjoyment, evidenced by these works, of commercial–vernacular culture, and the character of their engagement with it. As a means both of replying to the charge and of underpinning her case for Picasso's critical distance from that culture, Krauss calls in aid the 'sociological poetics' of Mikhail Bakhtin, a model for understanding the operations of language that, as she suggests, 'holds out a way of analysing the social context's immanence to the work of art'.

> Suppose we follow Bakhtin in viewing any utterance, enlarged here to include aesthetic decisions – like the interjection of newsprint within the pictorial medium – as a response to another utterance. If we do so, it will not be possible for us to think of such a decision as a direct reflection of a material, such as newspaper, or of a theme, such as popular culture or the Balkan Wars, but rather as something always-already mediated by the voice, or utterance, or decision, of someone else; another speaking or acting subject for whom this issue – newspaper – counts.[83]

Krauss then proposes not one but two candidates for such a subject: the poets Apollinaire and Mallarmé. Counterposing the former's embrace of popular culture, and the newspaper in particular, in poems such as *Zone*, written in late 1912, with the latter's condemnation of the newspaper for its amorphousness and crudity, she suggests that the Bakhtinian model encourages an understanding of Picasso's own approach to this 'as totally mediated by the issues formulated in the terms of the Mallarmé/Apollinaire axis' – that is, of the 'specificity of Picasso's utterance' as constructed 'within the intertextual space of this debate'.[84] This adaptation of Bakhtin is developed further in her subsequent extended assessment of the *papiers-collés* in *The Picasso Papers* (1998), as a means of rebutting the argument, put forward principally by Patricia Leighten, that the newspaper clippings (especially those about the Balkan Wars) in these works referenced Picasso's political views: that, as Leighten suggested, he constructed with them a counter-discourse against the newspapers' own commodification of current affairs.[85] Krauss's emphasis throughout her chapter on the *papiers-collés* is on the way in which the signs that Picasso constructed in these *papiers-collés* circulated around many possible meanings, and she draws crucially on Derrida's analysis of Mallarmé's poetic language, for whose free play of signifiers he introduced the concept of 'dissemination'.[86] To this she joins Bakhtin's concept of 'polyphony', taking her cue from his study of the 'polyphonic' novels of Dostoevsky which identified and anaylsed their juxtapositions of multiple 'voices' or types of speech; once again, Krauss argues that this offers 'striking parallels with Picasso's invention'.[87] Instead of the 'monologic' reading of the *papiers-collés* proposed by Leighten, she suggests:

> The polyphony that Bakhtin sees in Dostoevsky ... is what we have seen happen in what I have been characterising as Picasso's circulation of the sign. And this whirl of signifiers reforming in relation to each other and reorganising their meanings seemingly out of nothing, in an almost magical disjunction from reality, this manipulation at the level of structure, can also be appreciated – and once again the parallel with Dostoevsky is welcome – at the level of the textual representation of the 'voice'. Each voice, in dialogue at least with itself, is doubled and dramatised by becoming the voice of another.[88]

Characteristically inventive though this argument is, the appropriation of Bakhtin on which it relies is highly selective, and it rests on a fundamental misunderstanding of his theoretical model, the assimilation of which to a Derridean interpretation of Picasso's *papiers-collés* is surely untenable. Firstly, Krauss misreads Bakhtin's key concept of *heteroglossia* as intertextuality, and thereby reduces the notion of *dialogis'*, from which it subtends, to dialogue; as Patricia Leighten observes in a withering critique of 'The motivation of the sign', this simply replaces Braque with Apollinaire (strictly, with Mallarmé as well).[89] For it is a cardinal feature of Bakhtin's model of language, and one that he tirelessly reiterated, that it is a *social* phenomenon – 'social throughout its entire range and in each and every of its factors', as he insisted at the start of his long essay *Discourse in the Novel*.[90] Structured by oppositions between those social and ideological 'centripetal' forces that work to construct a unitary language and those 'centrifugal' forces working to diversify discourse, stratified into the languages and dialects of social groups, professions, generations, periods, etc., verbal discourse is characterised by (indeed is the product of) a multiplicity of (often contested) meanings. This is the quality to which Bakhtin gave the term 'heteroglossia'. And thus, he explained,

> every concrete utterance of a speaking subject serves as a point where centrifugal as well as centripetal forces are brought to bear ... the utterance not only answers the requirements of its own language as an individualised embodiment of a speech act, but it answers the requirements of heteroglossia as well; it is in fact an active participant in such speech diversity ... the environment in which it lives and takes shape is dialogised heteroglossia, anonymous and social as language, but simultaneously concrete, filled with specific content and accentuated as an individual utterance.[91]

To consider an utterance of Picasso, as Krauss does, solely in the context of an individualised dialogue with Apollinaire or Mallarmé, far from applying Bakhtin's model, is thus wilfully to misread it; indeed, more than this, it is to misappropriate it for purposes that are directly counterposed – to bracket off from that context precisely those 'material[s], such as newspaper, or theme[s], such as popular culture or the Balkan Wars' that are, *inter alia*, the very vehicles of heteroglossia's endless regeneration and (centrifugal) dispersal. Nothing, perhaps, better illustrates this counterposition than a paragraph from *Discourse in the Novel* that inescapably calls to mind Mallarmé's celebration in 'Crise de vers', quoted in an earlier chapter,

of the incantatory power of words as these took the initiative, 'mobilised by the collision of their inequalities, kindling reciprocal reflections like the flashes of fire between precious stones'.[92] Bakhtin, writing not of poetic but everyday (and also novelistic) language, argued thus:

> The way in which the word conceives its object is complicated by a dialogic interaction within the object between various aspects of its socio-verbal intelligibility. And an artistic representation, an 'image' of the object, may be penetrated by this dialogic play ... If we imagine the *intention* of such a word, that is, its *directionality toward the object*, in the form of a ray of light, then the living and unrepeatable play of colours and light on the facets of the image that it constructs can be explained as the spectral dispersion of the ray-word ... in an atmosphere filled with the alien words, value judgements and accents through which the ray passes on its way toward the object; the social atmosphere of the word, the atmosphere that surrounds the object, makes the facets of the image sparkle.[93]

Secondly, Bakhtin has other observations about the novel to which Krauss does not refer, but which are also, if differently, applicable to Picasso's *papiers-collés*, and which point up the incompatibility between his ideas and those of Derrida. Writing of the tradition of the comic novel from Rabelais and Cervantes, through Smollett and Sterne, to Dickens – a frame of reference that is surely as applicable to Picasso's pasted papers as to Dostoevsky's writings – he noted the indispensability to its comic style of a stratification of language, a diversity of speech, through which the intention of the author was refracted. While this play of languages often completely replaced the direct discourse of the author (much as Krauss sees the play of voices and circulation of signs as replacing Picasso's discourse), Bakhtin insisted that it 'in no sense degrades the general, deep-seated intentionality, the overarching ideological conceptualisation of the work as a whole'; indeed, underneath the 'parodic stylisation of incorporated languages' that novels of the comic tradition deployed, there often lay 'a principled criticism of the word as such'.[94] Seen in the light of these observations, Picasso's own comic intentions, and the relevance for his cubism of the paradigm of cartooning mentioned a little earlier, both emerge in sharper relief, and the integral relation of the 'heterogeneity' of collage and *papier-collé* to the semiotic play from which Bois sought to separate it (in the above example of the *Still Life with Chair Caning*) also becomes more evident; for the different representational conventions, both material and semiotic, that Picasso juxtaposes in these works might similarly be seen as stratified languages, parodically stylised in ways that, like cartoons, subvert hierarchies which are social as well as aesthetic. In the case of a sub-category of his *papiers-collés*, moreover – those which make use of newspaper clippings about the Balkan Wars – Bakhtin's analysis might be applied more specifically. Within his discussion of the comic novel, Bakhtin assesses the device of using a 'concretely posited author ... or teller' as the point of focus of a narrative, as against the open juxtaposition of a series of incorporated languages. 'The posited author and teller assume a completely different significance', he argues,

where they are incorporated as carriers of a particular verbal-ideological linguistic belief system, with a particular point of view on the world and its events ... This particularity, this distancing of the posited author or teller from the real author and from conventional literary expectations ... may vary in its nature. But in every case a particular belief system belonging to someone else, a particular point of view on the world belonging to someone else, is used by the author because it is highly productive, that is, it is able on the one hand to show the object of representation in a new light (to reveal new sides or dimensions of it) and on the other hand to illuminate in a new way the 'expected' literary horizon, that horizon against which the particularities of the teller's tale are perceivable.[95]

Picasso's repeated use, over a period of weeks, of clippings about the Balkan Wars can be seen in this sense, as the introduction of a 'posited' voice, that of *Le Journal*'s contribution to public discourse about pressing current events, against the fixity of which the slippages of the signifiers from one private allusion to another (as in 'La bataille s'est engagé' [*sic*] in the *Guitar, Sheet Music and Glass,* figure 4.22) gain an allure of witty sub-cultural play that at once illuminates this background of events and subverts its centripetal language.

Bakhtin's model thus indeed provides, as Krauss recognises, an invaluable means of understanding the semiotic operations of the *papiers-collés* – in terms, however, that not only call into question the structural linguistics on which her own analysis has been based but insist, against the Derridean notion of 'dissemination' that informs her most recent restatement of this, upon the socially grounded nature of that semiotics. As such it has proved a very helpful tool for that exploration of (in Krauss's phrase) 'the social context's immanence to the work of art' that has proccupied increasing numbers of historians of modernism in recent years. For one residue of the politicisation of the universities and of academic discourse of the late 1960s and early 1970s has been the subsequent development and spread of art-historical methodologies whose practitioners have sought to understand their discipline and its objects – images and practices alike – as a part of history, not as isolated (or insulated) from it. Much of this work has been grounded in principles, and has drawn on precepts, derived from Marxism, and the Marxist inheritance of the Bakhtinian model has been one reason for its attractiveness. But this does not characterise all of it; the 'social history of art' is a fairly glib label that has been too widely, and too uniformly, applied to a range of approaches whose differences from each other are as substantial as their common emphasis on the historical determinants and character of art works and practices. The diversity of these recent contributions to the historiography of cubism is explored in chapter 8.

Other stories:
cubism and 'new art history'

Epic visions

The moment that produced John Golding's and Robert Rosenblum's revisionist histories of cubism also produced an altogether more radical account of it, one that was not content merely to enrich the terms of its received understanding with the former's scholarly evenhandedness and the latter's synoptic breadth of vision, but challenged its very scope. Daniel Robbins began a PhD on Gleizes at the instigation of Robert Goldwater in 1958, at a time when the expansionary momentum both of the New York art market and of post-war art-historical scholarship in the USA were creating a favourable climate for the recovery of salon cubism. Of more immediate significance to him, however, were, firstly, the publication in the previous year of a section of the painter's memoirs, which had offered a glimpse of an artistic milieu in pre-1914 Paris that had been more or less sealed off for half a century, and, secondly, the judicious but limited use that Golding, a year later, was to make of these (and other still-unpublished sections), in an account of cubism which gestured towards other interests within the nascent movement than those acknowledged in the received narrative but did not otherwise alter its plot.[1] The lineaments of another story of cubism, or at least a missing chapter of its history, that these publications suggested were more clearly revealed by Robbins's own research in Paris at that time: this included interviews with Gleizes's widow and the examination of his unpublished papers, its first fruit being the retrospective exhibition of Gleizes's work that Robbins curated for the Guggenheim Museum in New York in 1964, for which he wrote the catalogue essay.[2]

The essay was a mixture of the iconoclastic and the deferential. Robbins boldly charged 'an historical tradition which regards the *Demoiselles* as the origin of cubism' with being unhistorical, and insisted on both a distinct set of interests, and a separate artistic genealogy, for the group of artists within which Gleizes's work and ideas developed. The lack of history consisted in the reductivism and exclusivism of a view that, placing Picasso's picture at the beginning of cubism's formal development, under-acknowledged or ignored the symbolists' interest in geometry, the particular structure and subject matter of neo-impressionist paintings and the

parallel concerns of writers and social thinkers, and misread the relation of Braque's fauvism to his subsequent work.[3] The distinct interests of the artists of Gleizes's circle, for their part, were registered by the commonalities of subject matter that Robbins identified in their paintings.

> These involved the interaction of vast space with speed and action, with simultaneous work, commerce, sport and flight; with the modern city and the ancient country, with the river, the harbour and the bridge and, above all, with time, for the sense of time – involving memory, tradition, and accumulated cultural thought – created the reality of the world.[4]

The breadth of reach and apparent coherence of this agenda, its 'synthetic preoccupation with epic themes',[5] are impressive, and Robbins argued that such an iconography explained in part why there was no period in the work of Gleizes, Robert Delaunay, Léger and Le Fauconnier 'corresponding closely to the analytic cubism developed by Picasso and Braque'.[6] It explained also the move of the first two into abstraction, and their sympathy with the theoretical notions of artists such as Kandinsky and Mondrian. The separate genealogy Robbins traced, by means of careful research that started from the indications given in Gleizes's memoirs, through the primarily literary milieux around Mercereau, Paul Fort's *Vers et Prose* and the Abbaye de Créteil, out to broader currents of post-symbolist and politically engaged aesthetic thinking around the turn of the century and after in France and Western Europe at large. He had laid down the initial markers of this network of filiations a year earlier in a pioneering but brief article that brought the history of the Abbaye for the first time to an Anglo-American art historical readership and characterised its efforts as a 'search for [a] synthetic modern art' that could give expression to social ideas.[7] The Guggenheim essay developed this suggestion into the above ambitious agenda, which Robbins summarised as 'a synthetic view of the universe, presenting the remarkable phenomena of time and space, multiplicity and diversity'.[8]

Thus seizing the opportunities presented by the first major retrospective of a key salon cubist, Robbins's essay, even more than this exhibition, dramatically opened the field of cubist studies to new approaches, and his example was invaluable, as will be seen, for a rising generation of historians of modernism. It did little, however, immediately to unsettle the certainties of the received narrative, which (as I have noted) gathered, rather than lost, both momentum and authority through the 1960s, and reached another peak with Cooper's 'sheep-and-goats' 'Cubist Epoch' exhibition (and, more lastingly, its accompanying book) of 1970. There are perhaps three reasons for this lack of impact. The first might be Robbins's unquestioning acceptance of the terms in which gallery cubism had been established as paradigmatic: that 'analytic–synthetic' binarism whose complex but steady ascent I have traced. Loose though it was, and contradictorily applied by its various proponents, this in the early 1960s was still too authoritative a construction for a tyro curator to challenge, and he instead readily acknowledged

the 'clear applicability' of these terms to the work of Picasso, Braque and Gris.[9] Thus largely ceding to the historians of gallery cubism the terms in which the characteristic formal devices of cubist – and thus of much twentieth-century modernist – painting were to be understood, Robbins sought instead a revaluation of the cubist movement on the basis of that shared iconography itemised above. But (and this might be a second reason) his efforts to group the five principal debutants of room 41 in this way lacked specificity, and thus persuasiveness. There is little evident iconographic overlap between Delaunay's Eiffel Tower, Léger's sylvan nudes and Gleizes's interior with a figure, after all, and his claims on behalf of these artists tended both to conflate those quite distinct artistic trajectories (and their different stages) that I have analysed in earlier chapters, and to avoid the close pictorial analysis that alone could have secured his argument.[10] Thirdly, in the absence of such analysis, the several sharply perceptive observations that Robbins offered about Gleizes's formal and stylistic concerns and devices did not present a systematic rebuttal of the assumptions of derivativeness and academicism that characterised the dominant view of salon cubism, and were contributory to its marginalisation. In consequence, his essay can, perhaps, too easily be read as an apologia for this cubism, grounded in an evident partisanship that, simply reciprocating as it does the equal partisanship of the dominant interpretive tradition, undercuts the many brave and important points that it makes.

There is a fourth reason that could be offered for the lack of impact of Robbins's critique, namely that it was – ironically – in its very introduction of a broader and more adequately historical frame of reference for the understanding of cubism than had previously been considered, that his approach failed to be radical enough. It would be inappropriate to single out this essay for such criticism, since there was little enough engagement with history in modernist art historical scholarship of the 1960s, but Robbins's tracing of connections between artistic and political radicalism in France around and after the turn of the century was limited in its reach largely to the milieux of the then burgeoning literary and artistic avant-gardes of Paris, and took little account of the complexities of that conjuncture and of the discursive forces that shaped these. Lacking any consideration, that is, of such factors as the rise of right-wing nationalism and working-class militancy, the relation of both to the parliamentary Bloc des Gauches, the ideology of *solidarisme* and the forms of its extra-parliamentary expression – and the constitutive effect of all of these on the nascent formation of the avant-gardes – the historical landscape in which he sought to locate the emergence of cubism remained strangely featureless and generalised, and in consequence less compelling than the picture of that emergence offered by the discourse of formalism then dominant, as we have seen, in the overlapping circles of US (principally New York) modernist art history and contemporary art criticism.

Perhaps because these efforts to redress the historical balance in cubist studies remained so isolated and ran so directly counter to that formalism, it was twenty years before Robbins took up this argument again, at any substantial length, in

public.[11] The PhD on Gleizes, begun in the late 1950s but stalled by other commit-
ments, was eventually completed in 1975; although more than a reiteration of the
Guggenheim essay because of the depth and detail of its archival research and sug-
gestive visual analyses, this unpublished text nevertheless remains within the same
interpretive framework. In the mid-1980s, however, he was invited to contribute a
major essay to a (rare) retrospective of the work of Metzinger, and this gave him the
chance to take his argument a stage further. In contrast to the broad generalisations
with which the Guggenheim essay had mapped it, Robbins's text focused on two
issues: the question of gallery cubism's influence, or lack of it, on salon cubism's
beginnings, and the terms in which Metzinger – alone of the latter group, as has
been seen, to be also close to the former – interpreted and promoted the work of
both groups.[12] The first of these Robbins addressed through a meticulous recon-
struction, via archival and published primary sources, of the chronology of the
relations between members of the emergent salon cubist group *c*.1906–11 and of
their initial encounters with the paintings of Braque and Picasso at Kahnweiler's
gallery, from which he deduced that the latter occurred as late (in Gleizes's case, at
least) as autumn 1911;[13] not only did this enable him, finally, to rebut the charges of
derivativeness levelled at the room 41 work, but in the course of this reconstruction
he identified the specific contributions of, and the differences between, supporting
critics such as Allard and Apollinaire. Moreover, an analysis of Metzinger's 1910
article 'Note sur la peinture' demonstrated the influence of this on the developing
responses of both critics to salon cubism, and indicated the painter's acuity (as well
as his critical primacy) in exploring the commonalities and differences between the
concerns of Picasso, Braque, Robert Delaunay and Le Fauconnier in terms of their
engagement with the portmanteau concept of *simultaneity*. Metzinger's observa-
tion of these four artists, that 'their reason is balanced between the pursuit of the
fugitive and the mania for the eternal', Robbins saw both as summarising this
understanding and, later, as characterising the painter's own works of 1912 such as
Dancer in a Café (plate XVI), the distinctiveness and charm of which only
Rosenblum had preceded him in noticing.[14]

It was to the cause of Le Fauconnier, however, that Robbins devoted his greatest
efforts in the long term. His interest in the painter had been provoked during the
course of his PhD research in the late 1950s, as he later recalled, by the intriguing
(and, as he then felt, uncubist) title of one of the painter's canvases of 1912, the
Mountaineers Attacked by Bears (plate XII). At that time the whereabouts of the
painting was unknown – another challenge – but two reproductions of it that he
tracked down made it clear that the painting was huge and complex.[15] Although he
was not to find it for another twenty years, the work and its author became central
to Robbins's project of recuperating the salon cubists, and for the rest of his career
until his untimely death in 1995 he researched both with unwavering enthusiasm,
following every available lead and clue that he could uncover. The result was the
largely single-handed recovery for scholarship and critical attention of an *oeuvre*
and an artistic career that had for a few years been among the most highly regarded

and influential in Europe, and an accompanying pair of essays that sought to restore Le Fauconnier to what Robbins saw as his rightful place in modernist art history. The first – and shorter – of these, a catalogue and essay for a New York private gallery retrospective of the artist's work in 1990,[16] provided a critical biography of his cubist years that underlined the distinctiveness and significance of Le Fauconnier's work and ideas within the cubist movement, and offered a reading of the *Mountaineers* which was the highlight of the exhibition. Succinct but searching, Robbins's deciphering of this painting's complicated and obscure iconography was based on painstaking research and fieldwork conducted in the region of the Haute-Savoie in south-eastern France where the artist's ideas for it originated. Uncovering 'a considerable local literature about the appetite of the great brown bears who once populated the forest of Doussard' that lined le lac d'Annecy, 'and who enjoyed the fruit of the vine and orchard as much as the human inhabitants',[17] he interpreted that iconography as figuring the 'brute instinct' of nature in the wild, which was yet also 'victim of the bestiality of man', and he likened the painting in this respect to Picasso's *Guernica*.[18]

The second, and much longer, essay, unfinished at Robbins's death, took up this reading but enriched it considerably with interpretive suggestions that were based on new and detailed research in the region. Fieldwork enabled him to identify the specific motifs, in the lac d'Annecy region, of some of the mountain landscapes Le Fauconnier had painted in the summer of 1911, en route from a stay in Italy, and the iconography of these suggested that the painter had invested not only the *Mountaineers* but all of his major paintings from *Abundance* on with previously unconsidered layers of allegorical meaning.

> Le Fauconnier deliberately sought to revive the idea of the truly important painting, a densely compacted statement with layers of meaning as rich in compounded content as it was in the manner of its painting, as fascinating and provocative in the mysteries it established as it was in the structure created to carry this complex synthesising burden.[19]

This claim was made *à propos* of *Abundance*, its depiction of what Robbins identified as an Haute-Savoie castle owned by a family with militantly Catholic forebears prompting him to read the painting as not merely the Bergsonian manifesto that prior scholarship had indicated but as a specific underwriting of Catholic faith, equated with human and vegetable regeneration as part of 'the natural order of things'.[20] It was, however, a sense of order and an ambition for painting that Le Fauconnier elaborated upon, as Robbins argued, in *The Huntsman* and the *Mountaineers*, to present, with the latter, a dense and layered 'synthesis of natural history, zoology, anthropology, mythology and legend, local historical incident, even autobiography in painting'. This was, he concluded of the *Mountaineers*, 'Le Fauconnier's masterpiece of Epic Cubism'.[21] Such lofty conclusions had been prepared for in the course of a wide-ranging argument that drew on additional research into Le Fauconnier's biography, to present (alongside an entertaining

account of the detective work entailed) a richly informative critical history of his progress as a painter in the years that preceded these three pictures. The artist who emerged from Robbins's narrative and analyses was far more erudite, inquisitive, independent and passionate than he had previously been considered.

Unprecedented in the extensive historiography of cubism in its nuanced and imaginative reconstruction of the aethetic outlook, affiliations and ambitions of Le Fauconnier, and through him of the milieu for which he was, briefly, central, this essay set the seal on (although it should have opened another chapter of) a body of work of seminal importance for the following generation of cubism's historians, myself included. Independent – indeed, against the grain – of concurrent scholarship and critical writing, Robbins's tirelessly researched reiteration of the historical case for due consideration of salon cubism provided the foundation for much of the work that has since been accomplished in recovering the complex history of the cubist movement before 1914 and in re-assessing its significance for modernism. But the terms in which he made that case reveal its limitations as well as its strengths, in two respects. The moment of Robbins's formation as an art historian was one in which the establishment of an artist's conscious intentions for the meaning of a painting, beyond (or, at the most, prior to) any extra-aesthetic considerations, and the sensitive interpretation of its formal and iconographic qualities in the light of those intentions alone, provided a powerful methodological paradigm for art historical analysis, and one that was underwritten by the influential methodology of iconographic research and iconological interpretation introduced into American art history by Erwin Panofsky and other refugee German scholars in mid-century.[22] Robbins's reconstructions of the painterly practices of Gleizes and, especially, Le Fauconnier are accordingly grounded in a concern to recover *their* artistic intentions as fully as possible by identifying, and tracing as far as imagination will allow, the ramifications of the aesthetic ideas and enthusiasms that may have circulated in their milieux, and to read their pictures as inscriptions of them. The results are often inventive and iconoclastic, as we have seen; but in the absence of a consideration of any factors that could corroborate his identification of the relevant ideas and enthusiasms – the discursive determinants, noted above, of those spaces of the avant-garde between which these percolated – they place often undue weight on the available circumstantial evidence, and produce readings of paintings whose appeal to intentionality approaches the tautological. There is a tendency for speculations to generate hypotheses that of their own accord harden into certainties, without the assistance of reasonable evidence, and the interpretive edifice thus created is impressive in iconological terms, but not always convincing.[23]

Such problems of methodology are compounded by the apparent partisanship that, as I have suggested, coloured Robbins's essay on Gleizes and which also obstructs acknowledgement of Le Fauconnier's shortcomings as a painter. While a refusal simply to acquiesce in a dominant taste that values painterly bravura over the painstaking build-up of forms is laudable, a reading of the ungainly figuration of *Abundance*, with its laboured and awkward depiction of her lower torso and

thighs, as giving 'a masterful appearance of feigned ease and fluidity' lacks plausi-
bility.[24] Even his closest colleague Gleizes declared Le Fauconnier (in 1911) to be a
better thinker than a painter,[25] and while his and others' testimony indicate that the
progress of *Abundance* was followed closely by the proto-salon cubist circle, this
had perhaps more to do with the boldness of its aspirations and their theoretical
underpinnings than with the felicities of Le Fauconnier's brushwork. The pictures
painted (or finished) over the next few weeks by both Gleizes and Léger, who were
among the most attentive of these observers, borrowed or adapted the fragmenta-
tion of forms and surface rhythms of *Abundance*, but not its facture, and while the
handling and brushwork of each grew progressively more nuanced over the suc-
ceeding months as their pictorial syntax grew more complex (plate X and figure
3.17), that of Le Fauconnier remained heavy and uninflected, even as he too sought
to accommodate the spatial layering, imbrication and juxtapositions that the repre-
sentation of simultaneity entailed. As I have suggested, the result, in the
Mountaineers, was a confused image that betrayed an inability to manage, articulate
and differentiate between the components and spaces of the picture's ambitious
and complicated *mise-en-scène* that even Robbins's perceptive and painstaking
visual analysis can clarify, but not redeem.[26]

An expanded field

The single-mindedness with which Robbins developed his apologia for salon
cubism, and Le Fauconnier in particular, largely insulated him from the work of a
new cohort of historians of early twentieth-century art that was by the early 1970s
hard on his heels, exploring in a number of ways the expanded field of cubism he
had done much to open up. This generation of scholars distinguished itself from
its predecessors not so much in any radical departures in methodology as in the
way it registered the progressive institutionalisation of modernism within the
academy – that is, the consolidation of cubism as an object of disinterested acad-
emic research (as opposed to connoisseurial or curatorial enthusiasm), and the
recognition of its relations with cognate fields, in particular that of literary history.
Following the logic of the scholarship of the previous decade and exploiting the
archival resources thereby uncovered, the work that resulted gave new breadth
and depth to the historical understanding of the cubist movement. Thus
Christopher Green's *Léger and the Avant-Garde* (1976)[27] brought the scholarly
meticulousness and analytical acumen that had characterised John Golding's
History and Analysis to this wider field, exploring the ideas circulating in the over-
lapping milieux of the artistic and literary avant-gardes of Paris from the perspec-
tive of Léger's developing art practice.

The product of his PhD, then just completed , based on new primary research
and close visual analysis, it remained within the frame of reference proposed
by Robbins, but added to it an engagement with the wider discourses of
modernity and their representation in modern consumerism, entertainment and

communications that was more specific and sustained than the generalisations of the latter, if still viewed exclusively through the optic of avant-gardist preoccupations. Covering literary ground that Robbins had first opened up in his article on the Abbaye de Créteil a dozen years earlier, Green's exploration of the relations between the post-symbolist writing that was appearing in the proliferating *petites revues* and the ideas of the nascent cubist movement drew on and added to the accumulated evidence and conjecture to reconstruct this network of shared aesthetic concerns with unprecedented vividness, and viewed the cross-overs and distinctions between salon and gallery cubism with less evident partisanship than had Robbins – yet also with an unquestioned, if understated, acceptance of the received understanding of the cubism of Braque and Picasso. Illuminating as it was in many of these respects, *Léger and the Avant-Garde* was most radical, however, in the time-frame it covered: for it bracketed its narrative not within the conventional limits of emergent proto-cubism and the start of the First World War but between Léger's own first engagement with contemporary modernist concerns around 1909 and his participation in the manifesto-like project of Le Corbusier's 1925 *Pavillon de l'Esprit nouveau*. This focus on the continuities, as well as the changes, between pre- and post-war concerns within the cubist movement and its immediate successors in France was salutary in calling into question the assumption, embedded in the received narrative of cubism since at least Barr, that August 1914 effectively brought cubist innovation to an end. As Green demonstrated, the discourse of the avant-garde, and within it the cubist movement, had a momentum both intellectual and institutional that could not be checked even by wholesale mobilisation for war; an understanding of the significance of cubism for the painting of a key member of the movement such as Léger could not be complete without a consideration of its wartime and post-war developments. It was an important argument, and one that Green has since elaborated, most ambitiously in *Cubism and its Enemies* (1987),[28] which mapped the post-1914 history of cubism in relation to the other art groupings and aesthetic positions that rivalled it within the Parisian avant-garde formation. Here Green showed, first, not only that the cubists' capacity for innovation was not extinguished by 1914, nor was cubism as a movement over by the early 1920s as had previously been understood, but that both were active until late in that decade, and, second, that the development from the wartime years of the concept of cubism as a 'pure' and autonomous art (what he calls 'the core Modernist principle'[29]) was not an internal dynamic but the product of that rivalry, a position taken in part out of resistance to alternative modes of art practice including naturalism, abstraction and surrealism.

This research was invaluable, but the underlying argument was made, and the 'autonomy thesis' that is central to it was privileged, at the expense of the equally important emphasis on how the character of cubism changed crucially during the first months of the war, and on what that change left behind. As the full dimensions of the mechanised and bureaucratised horror of the war began to be apparent through 1914–15, any optimism that had fuelled the cubists' engagement with the

mythic emblems of an urban and industrialised modernity was extinguished, and the diversity of pre-war cubist practices collapsed into a concern with formalist experimentation. The shared experimentation with the concept of *simultaneity* which had brought together an enthusiasm for that engagement and a determination to critique the conventions of its representation, already by 1914 eclipsed by the aestheticism of gallery cubism, was moreover fatally dissipated by the subsequent mobilisation and dispersal of its leading participants, and remaining non-combatant cubists withdrew their professional attention from the world beyond the studio.[30] Green noted the 'diminution' of the theoretical positions within cubism in passing at the outset of *Cubism and its Enemies*, but regarded it also, and crucially, as a 'distillation' of these – a metaphor that ironically not only muddied this process but masked the equivalent 'collapse' that it itself effected at the level of interpretation.[31]

The above two emphases are not irreconcilable, but Green's was inseparable from an understanding of modernism as founded on autonomy; as he declared: 'I take the history of Modernism to be not necessarily the history of a nineteenth and twentieth century obsession with the pictorially or sculpturally literal, but the history of various attempts to achieve and then theorise a kind of aesthetic isolation.'[32] And he added: 'If one thinks more flexibly in terms of a Modernist will to aesthetic isolation and of the broad theme of the separation of culture and society, it is actually cubism *after* 1914 that emerges as most important to a history of Modernism.'[33] Indeed it does, if – as his upper-case 'M' suggested – that history is the one written largely by American critics and art historians in the third quarter of the last century.[34] But over the quarter-century which followed, the hegemony of that history was increasingly contested, not only by a view of modernism as encompassing critical engagement both with the conditions of representation and with the contradictions of a non-art world, but by an art history which drew *inter alia* on Adorno's insight that the autonomy of art in bourgeois society was at once real *and* socially determined.[35] In the light of this revisionism it has come to be recognised that cubism's modernism was both more complex than Green's 'core principle' suggested and, inescapably, a product of the discursive formations of early twentieth-century Paris – and the second emphasis of those outlined above, on how that modernism changed, is congruent with that recognition. Ultimately, of course, the two emphases are not only reconcilable but should be seen as complementary. The corollary of Green's view of (M/m)odernism, however, was his decision to assess the conflict and contestation out of which 'pure' cubism emerged on the basis of that assumed autonomy of the 'discourse of culture' to which, as he showed, it contributed – thus his field of enquiry was restricted, like that of *Léger and the Avant-Garde*, to what he there understood that avant-garde to be: 'a loose-knit and shifting group of groups whose members constantly affected each others' way of seeing art and the city'.[36] What remained to be clarified were the socially determined character of the avant-garde formation and the specific discursive forces that also – and often more fundamentally – affected those ways of seeing.

In the meantime, there have been studies of aspects of cubism and the cubist movement that have addressed the complexity and heteronomy of both in ways which have been extremely valuable. Paralleling Green's earlier researches, Virginia Spate's *Orphism* of 1979, while careful to distinguish its object of study from cubism as then understood, traced the separate strands of the aesthetic matrix that wove together, briefly, the work of Léger, Kupka, Apollinaire and the Delaunays, and the process of their disentanglement and dispersal.[37] Her nuanced delineation of fine differences of position between these individuals, acute and lucid responses to specific texts, and recovery of the filiations that linked these Parisian explorations with their contemporaries elsewhere in Europe and the USA provided an important corrective to the generalisations, assumptions of derivativeness and narrow focus which characterised the received narrative, although it, too, took the avant-garde formation as a given. Following Green and Spate closely, Kenneth Silver's work on the relations between the Parisian avant-garde, its audiences and the experience of the war and its aftermath was a more radical departure: his *Esprit de Corps*, first presented as a PhD thesis in 1981 but not published until 1989, opened an initial breach in the autonomy thesis, demonstrating with the aid of much new visual material drawn from across the high–low cultural divide how the innovations of the avant-garde contributed to, and were shaped by, the different currents of nationalism that circulated in the French capital.[38] Silver's argument benefited in the interval between thesis and book from Green's work on cubism in the same period, as the latter had previously from his own, although the difference of emphasis brought significant rewards; *Esprit de Corps* focused not on the art of the cubist avant-garde *per se* but on the consolidation during wartime of a patriotic consensus over its role which Silver saw as reversing many of its emphases of the pre-war years. His argument tracked back and forth between this art and the work of cartoonists and illustrators, and succeeded in mapping the discourse of nationalism with a degree of detail that gave a clearer understanding than anything before it of several of its aspects, and of their impact on avant-garde art practice. And yet, paradoxically, it shared with Green's approach a lack of engagement with the broader historical conjuncture within which both of these developed and diversified, and some grasp of which is essential if the relation between them is to be understood. Whether he was discussing the political or the artistic avant-gardes Silver made few differentiations between the groupings within them, referring to 'the right', 'the left', even 'the nation' as if such formations and concepts were unproblematically unitary. The result was sometimes to confuse the anti-establishment attitudes of the artistic avant-garde with political radicalism, at others to elide the different varieties of classicism on offer in those years and thus to miss the significance of such differences.

If Silver's study thus only partially breached the citadel wall of the autonomist interpretation of modernism, its foundations were being undermined elsewhere. Malcolm Gee's PhD thesis on the dealers, critics and collectors of modern painting in Paris, completed in 1977, covered both the pre- and post-war periods, complementing Raymonde Moulin's earlier study of the French art market, but with a

specificity of attention to the period 1910–30 and an exploration of much new primary source material, both of which were quite independent of it.[39] Gee examined the dynamic of the division between salons, auction houses and private galleries, assessing the sometimes fine distinctions and differences of function and protocol in the gradations between 'official' and 'unofficial' salons, old and new, right-bank and left-bank dealers, those at the top end of the hierarchy and those at the bottom, exploring the role and variety of critics, collectors and collector-dealers, and mapping onto this complex and evolving structure the distribution of contemporary art practices in Paris, and its changes in this twenty-year period. The information and assessments he provided shed a direct light on the structure and discreet operations of this market in a crucial phase of its transition from a largely salon-centred system to one whose centre of gravity was the hierarchy of private dealers, their collector clientele and associated critics, and on its relation to the painting of the avant-garde. Yet Gee seems to have hesitated to draw the conclusions that his own research and observations invited, about the role of the factors he so exhaustively profiled in constructing the spaces of that avant-garde – ultimately he was more interested in the ways in which its products were consumed than in the forces shaping their making – nor did he pursue the implication of some of those suggestions about the interests (material as well as aesthetic) of the players in this game, in the direction of any consideration of other discourses with which that of the market intersected. Perhaps the thoroughgoing empiricism informing his study (and made it an invaluable resource for subsequent research, including my own) did not lend itself readily to such speculations, or to the engagement with theoretical models of cultural practice which they would have entailed; perhaps the moment and the context in which his research was conducted were not yet conducive to considerations like these. Either way, Gee's work, together with that completed in the same decade by Silver, Spate and Green, offered both platform and opportunity for a more comprehensive assault on the citadel.

New horizons

Clear evidence that new work on cubism was being done across a broad front of approaches came at the end of 1988 with an issue of *Art Journal* devoted to the theme of 'revising cubism' and guest-edited by Patricia Leighten.[40] Its eclectic mix of articles by established and younger scholars, juxtaposing semiotic analysis with consideration of the market for avant-garde art, readings of cubism that linked it with Bergson's philosophy and current debates at the cutting edge of scientific experimentation, and assessments of the political and ideological underpinnings of cubist art and its historiography – led off, symbolically, by an essay from Daniel Robbins – signalled, as Leighten claimed, 'a major shift in critical attitudes among scholars of cubism'; she might have added, in methodological predilections as well. Leighten observed: 'what has begun to emerge is a view of cubism in relation to its larger intellectual and social culture', which she suggested had been prompted

originally by 'the repoliticization of American culture in the 1960s'.[41] This view was perhaps a little parochial, in that although all but two of the contributors were from the USA (and one of those two was based there), the remaining contribution – my own – had been shaped by experiences closer to home: those political and cultural developments in Britain since the 1960s which had prompted, on the part of cultural historians, a wide spectrum of revisionist approaches to modernism (a representative collection of which had been published, under the banner of 'the new art history', two years earlier[42]). Nevertheless her selection of essays represented fairly adequately the variety of ways in which the politicising of culture and the academy since the 1960s on both sides of the Atlantic was being registered within the restricted field of cubist studies.[43]

Leighten herself was an appropriate standard-bearer, since she was among the first of the newcomers into the field, with three path-breaking and/or polemical articles on the work of Picasso to 1914, and a book that brought together much of the research and argument of those articles, published between 1985 and 1990.[44] Her guiding emphasis through all of this writing was on the consciously political character of Picasso's art and ideas from his first work as an avant-gardist in *fin-de-siècle* Barcelona through the cubist years in Paris to August 1914. Nourished first by the vitality of anarchist culture and politics in the Catalan capital and subsequently by the anarchist aesthetics of his circle in Paris, she argued, Picasso's radical cubist style responded to Kropotkin's call on artists to create a revolutionary art with his own 'liberating assault on tradition, on the past, and hence, as contemporary critics of cubism did not fail to notice, on society'. In particular, Leighten claimed 'These anarchist motives are most manifest, not only in style but in content as well, in the collages of autumn, 1912, which came to fruition during the First Balkan War, when Picasso and his bohemian milieu were deeply agitated by world events and preoccupied with issues of pacifism, militarism and war.'[45] The premiss of her argument, that Picasso's intentions were consciously political, Leighten summarised in her Introduction to *Re-Ordering the Universe*: 'Picasso's relation to the progressive historicism of the nineteenth century in general and the revolutionary utopianism of anarchism in particular was entirely deliberate, both conscious and self-conscious, however inconsistent, idiosyncratic, or (to any beholding eye) lacking in rigour.'[46] Elsewhere she counterposed this understanding to that still dominant, which saw the progression of his cubism as intuitive and instinctive, and which 'represents a profound distrust of our ability to understand artistic consciousness ... [a] distrust of the artist-as-intellectual', a position from which, also, 'conscious responses to social forces seem as irrelevant as "ideas"'.[47] To dismantle these underpinnings of a received narrative of cubism that read in it only considerations of style and form, she argued, we 'need to study the social context of avant-guerre Barcelona and Paris in order to understand the world against which Picasso struggled and out of which his art, including his cubism, emerged'.[48] Such a study is what *Re-Ordering the Universe* offered, a history of Picasso's cubism to 1914 that read it for the first time not only as

heteronomous, but as specifically so – integrally and self-consciously related to the revolutionary utopianism of the anarchist movement.

The project was pioneering and ambitious, but it was also problematical. In the first place, Leighten's reconstructions of the milieux of the avant-garde in which Picasso moved, and of the social and political dynamics of the period, were built on shaky historical and interpretive foundations. Thus her consideration of anarchism in both Barcelona and Paris neglected to distinguish sufficiently, on the one hand, between the intellectual or philosophical anarchism that was articulated within those milieux and the militant revolutionary anarchism in Barcelona (and anarcho-syndicalism in Paris) whose working-class rank and file had little time for it and, on the other, between conservative and anarchist currents in Catalan politics.[49] Nor are such shortcomings a matter simply of detail, for some of Leighten's more general assertions were also problematic: to claim, for example, that the succession of Radical Ministries in France which began with that of Waldeck-Rousseau from 1899 represented 'a serious and permanent governmental swing to the left'[50] was misleading to say the least since within a few years, from the collapse of the Bloc des Gauches in 1905–6, the swing was precisely and unequivocally in the opposite direction, with the consequences for the consolidation of an artistic avant-garde that I have suggested earlier. Within that avant-garde, as regards the milieux of the cubist movement itself, it is crucial, as I hope this book has shown, to distinguish between the public wing of the movement, against which most of the critical invective of the period was launched, and the private wing, of which most critics were then only indirectly aware. Yet Leighten repeatedly treated all contemporary commentary on cubism as if it were addressed to Picasso above all. One consequence of this was to misconstrue the character of the *bande à Picasso* that provided the immediate subcultural context and audience for his art practice; when the critical and anecdotal evidence regarding the views (aesthetic or otherwise) of this *coterie* are disentangled from that *à propos* the salon cubists there remains little to support her claim that in 1912 'Picasso and his bohemian milieu were deeply agitated by world events and preoccupied with issues of pacifism, militarism and war'.[51]

Such oversights and omissions sprang ultimately from a decision by Leighten, surprising in the light of her declared interest in the social context of Picasso's art practice, to leave out of consideration key elements of this. 'How market forces worked themselves out in Picasso's oeuvre, to what degree he remained within the confines of bourgeois art patronage ... are not the subject of this book', she stated in the Introduction to *Re-Ordering the Universe*.

> My efforts to retrieve a lost political context for his early career have nothing to do with analyses of market forces and patronage, nor with an attempt to offer a theory of Picasso's relations to ruling-class (or other) ideologies ... My study is not Picasso as an object of historical forces ... but Picasso as a self-conscious agent in history.[52]

Yet from the perspective of an insistence on the formative influence on that self-consciousness of the turn-of-the-century discourse of anarchism, it is hard to see

how these can be separated; the group of friends who purportedly shared Picasso's deep anxieties over militarism and war was constituted, in part, by the dynamics of an art market that drew adventurous dealers, critics and collectors to new art, and by shared ideological affinities that were integrally related to the 'historical forces' of the time. Putting such factors out of court led Leighten both to a simplistic equation between aesthetic and political radicalism and to a manichean binarism that collapsed everything other than (bad) formalism into (good) self-conscious politics; as if the only possible engagement with political content has to be an embrace of it.

If such assertions and assumptions are problematical, the overall emphasis on the social dimension of Picasso's art practice on which they rested was both important and, like Robbins's proselytising for salon cubism a generation earlier, courageously counter-hegemonic in its ambitions. Leighten's academic feistiness, indeed, has been most in evidence more recently in her explicit challenges to dominant readings of cubism, especially that of the Saussurean semiotics of Krauss: a polemic of 1994 took the latter sharply to task for that attempt, which I outlined in the last chapter, to shore up her defences against the charge of ahistoricity by deploying the ideas of Bakhtin. Krauss's interpretation of these ideas was idiosyncratic to say the least – as Leighten cogently argued – and in riposte she appropriated Bakhtin's concept of *heteroglossia* in support of her own view that Picasso's cubism contributed to an anarchist-inspired counter-discourse.[53] Yet insofar as they reprised her book's insistence on Picasso's self-conscious and deliberate engagement with Left politics, her arguments remained strangely old-fashioned. For Leighten's apparent refusal to acknowledge the determining role of 'historical forces' in the shaping of that self-consciousness suggests an antagonism towards that methodology which, drawing, *inter alia*, on the Marxist notion of hegemony and the Foucauldian concept of discursive formations, has been so influential in the contemporary counter-discourse of the 'new art history', and marks a point of methodological difference between herself and most practitioners of that social history of art on to which her own work, and evident interests, opened.

The reasons for this lie perhaps on an institutional level, since much of the momentum that the new art history gathered came from the writings and discussions of British scholars, working in an academic environment whose radicalisation in the 1960s and 1970s was comparable to, but distinct from, that of universities in the USA. To the general politicising of campuses (as well as culture) that was common to both Europe and North America from the mid-1960s as higher education expanded was added a set of changes more specific to art history as it was studied in Britain. Spreading rapidly with the establishment of the new 'plate-glass' universities such as East Anglia and Sussex, the discipline entered into dialogue, and sometimes joint-degree courses, with cognate subject fields such as literary or film studies, and through them into a progressively deep engagement with theoretical and philosophical frameworks then current in mainland Europe, particularly France and Germany. In addition, the introduction of an obligatory

component of art history and theory into art and design courses during their 1960s' expansion, and the absorption of these into the degree-awarding sector of higher education in the following decade, brought new demands and interests to bear on art history's fundamental assumptions. By the end of the 1970s, as Rees and Borzello note, its centre of gravity had shifted from Oxbridge and London's Courtauld and Warburg institutes to the polytechnics and the new universities,[54] and the twin emphases on the historical and theoretical determinants of art practice and their contemporary political relevance had constructed a new paradigm to challenge the aims and methods that dominated art historical scholarship. Among its first exemplars was a pair of books by T. J. Clark – published, on the same day in 1973, with unparalleled *chutzpah* – that played a critical role in establishing the priorities for a future social history of art.[55] Clark wrote in one of them:

> What I want to explain are the connecting links between artistic form, the available systems of visual representation, the current theories of art, other ideologies, social classes, and more general historical structures and processes ... If the social history of art has a specific field of study, it is exactly this – the processes of conversion and relation, which so much art history takes for granted.[56]

Clark's example was soon followed by others who sought to make and explore similar connections. Nicos Hadjinicolaou's *Art History and Class Struggle*, published in French in 1973 and in English translation five years later, was an application of Althusserian notions of ideology to the field of art that, although as polemical and unsubtle as its title, provoked widespread debate, and in doing so consolidated an understanding, among leftist scholars in Britain, of the problematics of a Marxist art history.[57] This was both disseminated and sharpened in the field of English literature during the same decade by Raymond Williams and his erstwhile protégé Terry Eagleton. The former's *Marxism and Literature* (1977) provided a cogent and closely reasoned overview of the key concepts and developments of a cultural materialism that both extended and was enriched by Williams's own characteristic preoccupation with the material history of language and his socialist commitment.[58] Eagleton's *Criticism and Ideology* (1976) presented a critique of and a contribution to contemporary Marxist literary theory; more *engagé* than Williams's and more reflexive than Hadjinicolaou's, it offered among other things a systematic and independent account of the relations between literary texts, ideologies and modes of production.[59] For many art historians, myself included, these books offered theoretical models and concepts of cultural and historical analysis that could be applied to the field of the artistic avant-garde; in ways that both complemented and challenged Clark's approach, they helped me, for one, to think through those 'processes of conversion and relation' that he had identified, with regard to the historical conjuncture of pre-1914 France and the spaces of the cubist movement within it.

Through his teaching at Leeds and UCLA in the 1970s and 1980s, almost as much as through his own writing, Clark's inflection of Marxist methodology

became widely influential in both the USA and Britain.[60] His follow-up to the books of 1973, *The Painting of Modern Life: Paris in the Art of Manet and His Followers* (1985),[61] mapped the relations between consumerism, spectacle and the spaces of new art in the Paris of the Second Empire and the early Third Republic; Haussmann's drastic alterations to the city's fabric and its social relations yielded among other things a set of signs for modernity, Clark suggested, that fore-grounded the pleasures of commodified leisure yet rendered its social meanings more ambiguous or opaque. *The Painting of Modern Life* integrated a broad histor-ical vision, sharp social observation and close visual analysis with a cogency that provided a model for subsequent work in its field. Yet in the interval between this book and its predecessors other avenues of enquiry had opened up within the social history of art that threw into relief key issues that were absent from Clark's consid-eration, most notably questions of the role of relations of gender, and of the mate-rial conditions of the production and distribution of art, in the construction of historically possible meaning.[62] Moreover, as Adrian Rifkin observed in a com-bative review of *The Painting of Modern Life*, Clark's reading of the art of Manet and the impressionists in terms of late nineteenth-century Parisian class dynamics did not lead him to question received judgements about their place in the canon; on the contrary, argued Rifkin, 'the one spectacle of modern capitalism of which he refuses any criticism is the museum form of avant-garde art as a source of cultural value, or as the object of specialised attentions, whether from the historian, the dealer, the critic, the collector or the politician'.[63]

If *The Painting of Modern Life* represented a developed and coherent model of the research programme announced by Clark in 1973 it was also, it seems, its high-water mark. Far from addressing these perceived lacunae, since that time he has been progressively less interested in its systematic pursuit: progressively more focused, in a series of essays, on fragments of it – in teasing out, through close reading, the historically possible meanings of a few paintings from a particular moment in the work of selected blue-chip modernists. His essay on cubism, pub-lished in 1999, is one such. 'The best I can offer on cubism, it turns out, is a medley of *pensées détachées sur la peinture*', Clark there acknowledges, 'a series of stabs at description, full of crossings out and redundancies.'[64] The self-deprecation is rhetorical and at least partly ironical, for not only is this fragmentary quality, he suggests, 'a bit like the cubist grids I am trying to find words for', but such discon-nectedness captures the essence of Clark's argument, which is to emphasise – against the grain of the received and still dominant modernist interpretation of Picasso's cubism – the discontinuities and ruptures in his painting of 1910–12.[65]

It is a brilliant essay, profoundly iconoclastic in its calling into question of that interpretation through a reading of half-a-dozen of Picasso's paintings from 1909 to 1912, sustaining a closeness and detail of engagement with these, and an atten-tiveness to the implications of what that engagement yields, that is without prece-dent in the literature on cubism; liberating, even, in the independence of Clark's insistence on the *pretence* that was at the heart of this work, on the 'deep, wild,

irredeemable obscurity' of the project of which they were a part and on cubism's ambition for that obscurity, 'its seeming certainty about the mad language it used'.[66] For this insistence loosens that obligation, which the authority of the modernist narrative imposed, to understand the alternative 'object-world' that this cubism appears to propose (and the 'general revision of perception' through which it is glimpsed) as coherent and real 'if only we knew how to look (and maybe the pictures will prove to be lessons)'.[67] There is no such 'otherwise', Clark suggests, but the pretence of one is necessary to keep painting alive in the face of the inexorable decline of its power to convince as a mimetic system, and 'the pretending in cubism is done with such imaginative vehemence and completeness that it constantly almost convinces – both the viewer and no doubt the painter in the first place'.[68] But the ambition of this project gave it at times a desperation that led Picasso to dead-ends and even failure. Cadaqués, Clark argues, was one such time: 'painting at the end of its tether' – 'cubism near freezing point'[69] (see plate IV). Confronted by an abyss of non-representation, which he was 'the last person' to want to explore, Picasso 'made his way back to the world of phenomena. He put together a great counterfeit of everything that had, at Cadaqués, evaporated under his brush.'[70]

Imaginative and unorthodox, Clark's reading of this body of work, his insistence on Picasso's commitment to the quiddity and materiality of the things he represented, offers a valuable counter-balance, as I have noted, not only to the assumed seamlessness of the received modernist narrative but to the persuasiveness of the semiotic reworking that Bois and others have given this. Yet, it too is a partial interpretation of cubism only, in both senses of this term: both incomplete and partisan, and as such more limited in its scope, as well as more limiting in its implications for any reassessment of cubism (and thus of modernism), than the ambitions for art history adumbrated in his 1973 declaration seemed to have promised. That Clark should have no interest in addressing the work of the salon cubists or the wider cubist movement – indeed should appear to consider these worth not even a passing mention in an essay on cubism – comes as no surprise, given his consistent preference for focusing on canonical modernists, and it would be labouring the obvious to charge him with incompleteness in this respect, however wilful his disregard of them in an essay entitled 'Cubism and collectivity'. But his summary diminution of the role of Braque to that of junior partner in the cubist performance, who 'just imitates or reproduces ... not very well' the inventions of Picasso,[71] more critically disregards his essay's own frame of reference, straying beyond its close-woven texture of visual analyses into assumptions that are untroubled by consideration either of the material and discursive conditions of gallery cubism's shared art practice or of the sustained pictorial interchange that resulted. It is here that Clark's partisanship is clearest and most limiting, grounded as it appears to be in an ahistorical figure of the modernist hero whose obsessions and anxieties can too easily read as a projection, and whose motivation – whose modernism – is a given, unexamined, unquestioned. 'Many of these issues will recur apropos of Jackson

Pollock, in whose art "irreducible individuality" and endless, anonymous sameness confront one another nakedly', he writes in a conclusion that offers some sharp, if all too brief, insights into the anonymities of gallery cubism in 1911–12. 'Though of course by then the tone is agonised, not investigative. It is as if van Gogh himself had happened upon Céret-type cubism and made a last, desperate effort to turn it to his purposes.'[72] The juxtaposition of the three names, the reference to three of modernism's cardinal moments in one sentence, is provocative, but even if deployed in a knowing shorthand whose gaps we are left to fill, the assumptions seem too complacent that the readings available to this viewer and 'no doubt the painter in the first place' – the meanings that modernism held then and now – are one and the same. Hal Foster's warning against an art history that takes the aesthetic transformations of modernism as 'fully significant and historically effective in the first instance', as if a work of art 'happens all at once, entirely significant in its first moment of appearance', is worth recalling in this instance: avoidance of that error surely entails, among other things, giving due attention to the material circumstances and discursive spaces in which each was made.[73]

In the period since *The Painting of Modern Life*, as Clark's interest has moved away from that systematic engagement with 'processes of conversion and relation' between artistic form, systems of visual representation and historical structures and dynamics that was at the centre of his initial programme, others have taken up his mantle across the field of modernist studies. Among scholars of cubism Mark Antliff has done much, in a number of essays from the early 1990s on, and in his book *Inventing Bergson: Cultural Politics and the Parisian Avant-Garde* (1993), to reconstruct the texture of intellectual life within that formation in the pre-1914 decade, and to trace the interconnections between the philosophical, artistic and political discourses that helped to shape it.[74] Combining close readings of the aesthetic declarations that emerged from its proliferating coteries with assiduous recovery of the complex network of filiations (and, as complex, the ruptures) between them, this work has shown comprehensively both how thoroughly the spirit of Bergsonism coloured attitudes to modernity and its representation within this growing population, and how it harnessed the political momentum of the assorted nationalisms then circulating in Paris. These are important emphases, and our present understanding of the discursive spaces of cubism is greatly advanced by them. Antliff's project, however, is not that of Clark. His interest is above all in the ideas that were circulating, and their currency in philosophical and ideological terms, and less in that engagement with the material and visual specificities of paintings that typifies the latter's essay on cubism; less still in the art practices of cubism, those studio customs and protocols that give painting its particularity and save painters from behaving like philosophers *manqués*. Nor is he very interested in those broader conjunctural dynamics that Clark addressed so effectively in *Image of the People*; his pursuit of the political ramifications of avant-gardist Bergsonism, tenacious and subtle though it is through the thickets of its home ground in the literary and artistic coteries of Montparnasse, dissipates both

momentum and focus when it ventures beyond these into the broader discursive field of political nationalism. In that respect the approach is less like Clark than Robbins, whose pioneering explorations of these avant-garde milieux were similarly close and narrow in focus, and took little account of the bearings which could have been provided by the salient features of that broader landscape; for both, the result (to risk straining this metaphor) is some occasionally wayward reading of the cultural compass.

A case in point is Antliff's account of the attachment on the part of Gleizes and others in the Puteaux milieu in 1911–13 to celtic nationalism, and his interpretation of its implications for the cultural politics of that group of artists and writers.[75] Tracing the evidence of this attachment in fine detail through the aesthetic declarations and connections of Puteaux familiars – Gleizes prominent among them, voicing his cultural nationalism in the sequence of essays of 1912–13 that I discussed in an earlier chapter – Antliff argued that this 'neo-symbolist' avant-garde 'became allied with a celtic nationalist movement', which represented 'a concerted attempt to counter the trumpeting of a greco-latin culture by the Action française'.[76] Far from participating in that aestheticist withdrawal of the avant-garde from the political activism of the Bloc years that I have traced in chapter 1 and elsewhere,[77] Gleizes and other Puteaux cubists were, in this attempt, declaring their politics even more insistently than before. As he concluded in his 1992 article: 'rooted in radical republican and syndicalist ideology [they] interpreted Mallarméan symbolism from a Bergsonian and "Celtic" perspective in order to counteract the right-wing ideology of the Action française'.[78] By the time the revised version of this argument was published, a year later, Antliff's reading of Gleizes's politics had swung round 180 degrees – this was no longer leftist and by association revolutionary in character, but a reactionary, indeed racist, inflection of Bergsonism[79] – but the broader point remained, that Gleizes's political militancy was undimmed in 1912–13. Yet here as elsewhere, the considerable gains made in understanding the character of Gleizes's cultural nationalism by such a close and acute focus on the primary texts and their immediate milieux are offset by its corresponding narrowness. For, firstly, the identification of Puteaux artists and intellectuals with celtic culture needs to be seen as part of a broad discursive dynamic that saw an explosion of interest in gallo-celtic aspects of French history in the pre-war decade, that was registered at one end of the cultural spectrum by the publication in 1907 of the first volume of Camille Jullian's monumental *Histoire de la Gaule*, and at the other by a huge proliferation of popular imagery such as postcards illustrating gallo-celtic history,[80] and that encompassed the growth of ethnography and folklore studies, the embrace of rural and provincial values and the positing of a 'True France' against the increasingly urban and cosmopolitan emphases of the modern republic.[81] Articulations of racial nationalism that claimed identity with 'nos ancêtres les gaulois' (and hence celts) were made from across the political spectrum, and as Eugen Weber noted, the 'celtic card' was played by solidarists as readily as most;[82] in light of this,

Gleizes's and his friends' declarations were neither exceptional nor distinctively militant. Indeed, and secondly, Gleizes's own playing of that card can be seen as a culturalist alternative to (or replacement for) the class collaborationism of his youth;[83] the *Ligue celtique française* with which he was, as Antliff suggests, involved had no links, it seems, with the realities of celtic nationalist politics, which (as Anne-Marie Thiesse has shown) were centred on campaigns for Breton independence,[84] and chose no forum for its pronouncements beyond the restricted world of the little magazines and their associated banquets.[85] This isolation of the cultural debates, the details of which Antliff usefully traces, from any wider political discourse is surely more telling, in conjunctural terms, than the fervour of its participants.

Present perspectives and prospects

Studies such as those outlined above have contributed fundamentally to deepening present understandings of cubism. They have compelled some measure of acknowledgement from even the most *retardataire* of scholars both of the complexity – and instability – of its coalition of interests and ambitions, and of the soundness of that insistence on grasping its heteronomy which has characterised the methodologies of the 'social history of art' which they have (variously) represented. There remains much to be done, and to be gained, within this frame of reference; but times change, and in the post-Cold War, post-structuralist, conjuncture of the past decade or so art history, like other disciplines (if a little more belatedly than most), has benefited from that 'theoretical turn' through which the implications of its political and epistemic upheavals have been worked. As a result, the premises of a social history of art, indeed the very value of the notion of a 'conjuncture', have themselves been called into question.[86]

Among the best pieces of historical work on cubism to emerge from this reassessment have been those which combine theoretical acumen with a nuanced attention to discursive specificities – for example, David Joselit's interpretation of Duchamp's engagement with cubism between 1910 and 1913, which offers, as I have noted, a searching and fine-tuned reading of this body of work through the lens of a semiotics that is broadly and imaginatively defined.[87] Marshalling concepts from Saussure, Lyotard, Marx, Simmel, Levi-Strauss and Irigaray to underpin a deployment of the concept of *semiosis* that combines linguistic, economic and sexual dimensions, Joselit's interpretation illuminates Duchamp's preoccupations with sexuality, movement and language, and the relation between them, with unprecedented clarity, and positions them in a staging of modernism from Manet to Man Ray as 'the translation of the body into a semiotic field of exchange'.[88] This is a reading whose scope, acuity and coherence are impressive – yet also provocative, for these very qualities give Duchamp's project itself a clarity and a logic that inescapably invite the question of to what extent it was his own rather than Joselit's and what evidence there is for taking it as such. Offering his

own answer, Joselit describes his argument as 'outlin[ing] the discursive field of painterly strategies available to artists interested in the same or similar problems – in this case, those that may be grouped under the term *cubism*', and suggests that this effort is 'is more productive than a simplistic recounting of direct influence'.[89] Indeed it would be, if that were what he had achieved; but Joselit's framing of 'cubism' is too uncritically premised on that of the received 'Picassiste' narrative, and specifically on the semiotic intepretations of his cubism given by Bois and Krauss, to address adequately the breadth of that discursive field; in place of its complex intersections and spaces his argument posits a binarism between Duchamp and gallery cubism which, repeatedly and reductively, casts Picasso as Duchamp's 'other'.

Yet the neatness of the argument that this exclusivism allows is immensely appealing – as is the narrative arch of modernism from *Olympia* to Man Ray's *Violon d'Ingres* of 1924, within which this (gallery) cubism is positioned as the key-stone, establishing 'an equilibrium between the body and the sign', and marking 'the crossing point of two countervailing tendencies in the 19th century: the slip-ping away of the carnal body and the emergence of a full-scale semiotic market-place'. 'Here', argues Joselit, 'in the friction between semiotic dimensions, in the changing registers of superimposition peculiar to a historical moment, the modern translation of the body into a semiotic field of exchange takes place.'[90] Like an architect's drawing, this structure is elegant and even compelling in its coherence; like such an image, though, it leaves too much out, has too little time for the messy contingencies of any adequately conceived 'historical moment', to be fully con-vincing. Hal Foster's criticism of Peter Bürger's conception of history, as presented in his *Theory of the Avant-Garde*, as 'both *punctual and final*', comes again to mind: 'Thus for him', he argues, 'a work of art, a shift in aesthetics, happens all at once, entirely significant in its first moment of appearance'; against this, Foster empha-sises that the 'status of Duchamp ... is a retroactive effect of countless artistic responses and critical readings'. 'Did Duchamp *appear* as "Duchamp"?' he asks. 'Of course not, yet he is often presented as born full-blown from his own fore-head.'[91] There is an element of this punctuality in Joselit's account; although bril-liant and groundbreaking, it demands too much sacrificing of contingency and discursive complexity on the altar of its system; narrativising the history of (the first half of) modernism with draconian reductiveness, Joselit fashions from what he selects a Duchamp whose preoccupations overlap uncannily with those of con-temporary cultural–academic discourse. It should be noted in passing that it is the momentum of this discourse – a momentum generated by the force of post-struc-turalist and feminist challenges of the late twentieth century to the perceived phal-logocentrism of prevailing epistemologies – that has driven so much current art historical scholarship in the modern field towards dada and surrealism, and within them to an emphasis on gendered, sexual, somatic and liminal dimensions of meaning; Duchamp in particular, as the key link between the two movements, has been the object of a flood of publications.[92]

The resulting insights have opened new perspectives on those cultural forma-
tions, but they too beg the question of to what extent Duchamp shared these preoc-
cupations – or, more generally, how characteristic they were of the discursive
landscape of 1910s' and 1920s' Paris as opposed to our own. Ironically perhaps, one
of the more substantial and sustained individual bodies of work on Duchamp of
recent years draws relatively little on contemporary theoretical frameworks. Linda
Dalrymple Henderson's 1983 book on the fourth dimension and early twentieth-
century art placed his *Large Glass* in the context of both popular and avant-garde
enthusiasm for this notion; her equally encyclopaedic *Duchamp in Context* subse-
quently widened this already broad discursive frame to that of science in general.[93]
Both books provide – with a grasp of their subject that, in the case of the latter espe-
cially, is hugely impressive – a richly detailed map of turn-of-the-twentieth-cen-
tury scientific knowledge and its currency, and the insights offered thereby into the
ways in which Duchamp's work and ideas may have signified through this
'common sense' (as Molly Nesbit, following Gramsci, appositely terms it) are
many and rewarding. If they are to compel concurrence, however, such a wide-
angled view of cultural practices and enthusiasms needs to be complemented by
other optics: an equivalent attention to the specificity of the position of the field of
the avant-garde (and – in this instance – of Duchamp within it) in the social and
cultural order of avant-guerre France, and to the forces that were holding that
order in place. If the erudition and range of Henderson's empiricism is a valuable
corrective to the ahistorical indulgences of some contemporary theoretical dis-
course, such empiricism cannot by itself secure a historical understanding.[94]

Because, of course, contemporary discourse is where all historical inquiry starts,
and is the point to which it returns. If, moreover, that inquiry is to obtain any pur-
chase on the present, its grounding in the here and now needs to be reflexively
articulated. Without this, the articulation in turn of the distance between the pre-
sent and the particular past under study is not possible; thus, for example, contem-
porary postmodernist enthusiasm for Braque's and Picasso's flirting with the
vernacular in their *papiers-collés* of 1912–14 becomes confused with, and misrecog-
nises, the very different motivations for that flirting that, as I have argued, their
avant-guerre modernism produced. Of all the approaches that the 'new' art history
has brought to bear on its subject field, those that draw in different ways on the
contemporary discourse of feminism have been the most telling in this regard, with
scarcely any aspect of the discipline untouched by their challenges to patriarchal
hegemony. Recent work which, building on Carol Duncan's groundbreaking essay
on the socially regressive sexuality of the avant-guerre avant-garde, explores the
ramifications of the masculinist construction of modernism in this period has, as I
have noted in earlier chapters, compelled acknowledgement both of the achieve-
ments of many women artists previously marginalised by that construction and of
the institutional factors that have contributed to it. What has been less directly
addressed is the role of questions of gender in the history of cubist painting at the
level of the asthetic: in the ways in which these shape the interrelation between the

discourses of masculinity, race, decoration and what might be called 'profession-alism', or *métier*, in the studio practices and the painterly (and – *viz.* the above example – pasted-papery) decisions of gallery and salon cubism. A start has been made by Anna Chave in her polemical and iconoclastic essay on the *Demoiselles*, but as she was quick to acknowledge, this raised as many questions for feminist analysis as it answered;[95] her suggestions regarding the phenomenology of spatial percep-tion in Picasso's hermetic cubist paintings and its intersection with Rosalind Krauss's semiotic interpretation of them, offer scope for further exploration. So too does the question of colour in cubism – in its relation to the discourse of decora-tion and *la peinture décorative*, to the received notions of a gendered difference between drawing and colour, and the implications, in this context, of the avant-gardist 'recuperation' of colour.[96]

There remain also, however, areas where research needs to be done in clarifying the discursive spaces themselves of the pre-1914 Parisian avant-garde. Following the important work of uncovering the asymmetries of gender within this field, their intersections with the dynamics of class, nationalism and consumerism – in the cre-ation and consolidation of it as a field, in the shaping of the historically possible meanings for cubism within it, and the intra- and extra-European dimensions of the dynamics of these – need to be more thoroughly understood. As my criticisms of the above writings imply, and as I hope the previous chapters have made plain, my own commitment here is to the articulation of a developed conjunctural under-standing of those dynamics; without it, as I have argued, it is not possible to com-prehend either the historically possible range of meanings that artworks such as cubist paintings had for their various makers and viewers, or the ways in which these were constellated. More than this: in the absence of that dimension, the pro-ject of a social history of art risks being limited to the filling-in of (ever richer and more detailed) backgrounds of pictures whose main configurations remain undis-turbed, still outside of history.

Notes

Preface

1 See T. J. Clark, 'Cubism and collectivity', ch. 4 of his *Farewell to an Idea: Episodes from a History of Modernism*, New Haven, CT, and London: Yale University Press, 1999; and Christopher Green, 'Les définitions du cubisme', in *Les Années cubistes*, Paris: Editions du Centre Georges Pompidou, 1999.
2 John Golding, *Cubism: A History and an Analysis 1907–1914*, 2nd edn, London: Faber & Faber, 1968.
3 David Cottington, *Cubism in the Shadow of War: The Avant-Garde and Politics in Paris 1905–1914*, New Haven, CT, and London: Yale University Press, 1998.

Chapter 1

1 *Journal officiel des Débats*, 3 December 1912, 2924.
2 *Ibid.*, 2925–6.
3 See Jeffrey Weiss's indispensable *The Popular Culture of Modern Art: Picasso, Duchamp and Avant-Gardism*, New Haven, CT, and London: Yale University Press, 1994.
4 Roger Allard, 'La vie artistique. Le Salon d'Automne', *Les Ecrits français* (November 1913), 3. At the same time, he also noted that cubism's influence was widespread – indeed it had penetrated 'almost to the heart of the Ecole des Beaux-Arts and of the Salon des Artistes Français, those bastions of the Institut' ('presque au coeur de l'Ecole des Beaux-Arts, du Salon des Artistes Français, ces bastions de l'Institut'.)
5 This was a short-lived (December 1906–March 1908) commune established by the young writers René Arcos, Henri-Martin Barzun, Georges Duhamel, Alexandre Mercereau, Charles Vildrac, and their painter friend Albert Gleizes, plus a printer, Lucien Linard, and based in a large house in Créteil, then a country village south-east of (but now absorbed by) the Parisian conurbation. For two views of its ideals and objectives, see Daniel Robbins, 'From symbolism to cubism: the Abbaye of Créteil', *Art Journal* (winter 1963–64), 111–6; and David Cottington, *Cubism in the Shadow of War: The Avant-Garde and Politics in Paris 1905–1914*, New Haven, CT, and London: Yale University Press, 1998, 73–4.
6 'C'était une merveilleuse journée de printemps parisien, ensoleillée et chaude. Je traversais les premières travées de salles où assez peu de monde se pressait. Mais au fur et à mesure que j'avançais la foule devenait plus dense … On s'écrasait dans notre salle, on criait, on riait, on s'indignait, on protestait, on s'y livrait à toutes sortes de manifestations … Nous n'y comprenions pas. Toute l'après-midi ce fut ainsi. La salle 41 ne se désemplit pas[…]

'Du jour au lendemain nous étions devenus célèbres. Inconnus de la veille, ou à peu près, la renommée aux cents bouches colportait nos noms, non seulement á Paris, mais dans la province et dans les pays étrangers ...': Gleizes, *Souvenirs. Le Cubisme 1908–1914*, Paris: Cahiers Albert Gleizes, 1957, 19–20. These memoirs give a detailed account of the manoeuvre that secured room 41 for the group.

7 With the exception of Robert Delaunay, who had distanced himself from the group earlier in the year, and made this official in an open letter to *Gil Blas* on 25 October 1912. He no longer exhibited at the Salon d'Automne anyway, after its jury rejected his entries in 1908.

8 Roger Allard, 'La vie artistique. Le Salon d'Automne (suite): les ensembles décoratifs', *La Cote*, 14 October 1912, 8. On the Cubist House see, *inter alia*: M.-N. Pradell, 'La *Maison cubiste* en 1912', *Art de France*, 1 (1961), 177–86; Nancy J. Troy, *Modernism and the Decorative Arts in France: Art Nouveau to Le Corbusier*, New Haven, CT, and London: Yale University Press, 1991, 79–102; D. Cottington, 'The *Maison cubiste* and the meaning of modernism in pre-1914 France', in Eve Blau and Nancy J. Troy (eds), *Architecture and Cubism*, Montreal, Cambridge, MA, and London: MIT Press–Canadian Centre for Architecture, 1998, 17–40. As Troy explains, just when the title '*Maison cubiste*' was first applied to the project is uncertain, although the inference has become customary that it was during its planning stages; the 1912 Salon d'Automne catalogue describes exhibit no. 1127 as an ensemble 'composed of a façade, entrance, salon, bedroom': Troy, *Modernism and the Decorative Arts*, 243, n72.

9 See chapter 5.

10 *Du 'Cubisme'*, Paris: Figuière, 1912; English translation in Robert L. Herbert, *Modern Artists on Art*, New York: Prentice-Hall, 1964.

11 Linda Nochlin, 'The invention of the avant-garde: France, 1830–80', in T. Hess and J. Ashbery (eds), *The Avant-Garde, Art News Annual*, 34 (1968), 16.

12 Christophe Charle, *Naissance des 'intellectuels' (1880–1900)*, Paris: Editions de Minuit, 1990, 11–13, 54–5. The number of artists in France rose from around 22,500 in 1872 to around 40,000 by 1914: *ibid.*, 237; see also Christophe Charle, *Les Elites de la République (1880–1900)*, Paris: Fayard, 1987.

13 Martha Ward, *Pissarro, Neo-Impressionism and the Spaces of the Avant-Garde*, Chicago, IL, and London: University of Chicago Press, 1996, 54; See also her article 'Impressionist installations and private exhibitions', *Art Bulletin*, 73 (December 1991), 599–622.

14 Ward, *Pissarro*, 58. A comparable strategy, pursued by Gauguin at the same moment, but with regard to Manet, is discerned by Griselda Pollock; she summarises it as a three-part strategy of 'reference, deference and difference': Griselda Pollock, *Avant-Garde Gambits 1888–1893: Gender and the Colour of Art History*, London: Thames & Hudson, 1992, 14.

15 Ward, *Pissarro*, 51.

16 P. Bourdieu, 'The field of cultural production, or: the economic world reversed' (1983), in P. Bourdieu, *The Field of Cultural Production: Essays on Art and Literature*, ed. Randal Johnson, London: Polity Press, 1993.

17 On the private academies see: André Warnod, *Les Berceaux de la jeune peinture*, Paris: A. Michel, 1925; J. P. Crespelle, *La Vie quotidienne à Montparnasse à la grande epoque 1905–1930*, Paris: Hachette, 1976; Gill Perry, *Women Artists and the Parisian Avant-Garde: Modernism and 'Feminine' Art, 1900 to the Late 1920s*, Manchester and New York: Manchester University Press, 1995.

18 The new appointments were noted by Oliver Hourcade in *L'Action*, 25 February 1912, 3. The replacing of Blanche by Le Fauconnier did not impress Apollinaire, however, who described it at the time in a letter to Soffici as an exchange of like for like ('un preté pour un rendu'): Guillaume Apollinaire, 'Vingt lettres à Ardengo Soffici', *Le Flâneur des Deux Rives*, 4 (December 1954), 3.

19 On the situation of women as art students *c.* 1900 see Perry, *Women Artists and the Parisian Avant-Garde*; Tamar Garb, *Sisters of the Brush: Women's Artistic Culture in Late Nineteenth-Century Paris*, New Haven, CT, and London: Yale University Press, 1994.

20 *Ibid.* Garb in particular discusses in detail the emergence of professional bases for women's art practice in the late nineteenth century.

21 Octave Uzanne, *Parisiennes de ce Temps*, Paris: Mercure de France, 1910; translated as *The Modern Parisienne*, London: Heinemann, 1912, 129; quoted in Perry, Women Artists, 7.

22 See Garb, *Sisters of the Brush*.

23 Uzanne, *Parisiennes de ce Temps*, 271–2 (my translation).

24 'Virility and domination in early twentieth century vanguard painting', *Artforum* (December 1973), 103.

25 Lisa Tickner, 'Men's work? Masculinity and modernism', in N. Bryson, M. Holly and K. Moxey (eds), *Visual Culture: Images and Interpretations*, Hanover and London: Wesleyan University Press, 1994, 42–82; see also Raymond Williams, 'The politics of the avant garde', in *The Politics of Modernism: Against the New Conformists*, ed. Tony Pinckney, London: Verso, 1989, 56–7.

26 On the cités d'artistes see Warnod, *Les Berceaux de la jeune peinture*; Crespelle, *La Vie quotidienne à Montparnasse*; John Milner, *The Studios of Paris*, New Haven, CT, and London: Yale University Press, 1988, 219–31.

27 On Montmartre in this period see Louis Chevalier, *Montmartre du Plaisir et du Crime*, Paris: Robert Laffont, 1980, part 3; also Jean-Paul Crespelle, *La Vie quotidienne à Montmartre au Temps de Picasso 1900–1910*, Paris: Hachette, 1978.

28 On this milieu see Jerrold Seigel, *Bohemian Paris: Culture, Politics and the Boundaries of Bourgeois Life, 1830–1930*, Harmondsworth, England, and New York: Viking Penguin, 1986.

29 Henri Bidou, 'Les salons de 1910', *Gazette des Beaux-Arts* (May 1910), 47.

30 Louis Vauxcelles, 'Les salons de 1911', *Touche à Tout* (1911), 443–4.

31 *Ibid.*, 444.

32 See Roger Benjamin, 'Fauves in the landscape of criticism', in *The Fauve Landscape*, London: Guild, 1990, 252–7.

33 Roméo Arbour, *Les Revues littéraires 1900–1914*, Paris: Corti, 1956; see also Yves Chèvrefils-Desbiolles, *Les Revues d'Art à Paris, 1905–1940*, Paris: Entrevues, 1993.

34 '[L]es "ismes" allaient bientôt se multiplier par les volontés d'artistes cherchant plus à attirer l'attention sur eux qu'à réaliser des oeuvres sérieuses': A. Gleizes, *Souvenirs. Le Cubisme 1908–1914*, Paris: Cahiers Albert Gleizes, 1957, 20.

35 'La constitution pendant une période de 10 ans d'une collection de tableaux, principalement d'oeuvres importantes de peintres jeunes ou commençant à peine à arriver à leur notoriété ... leur revente aux enchères publiques': excerpt from the statutes of the Society, registered in February 1904, cited in Guy Habasque, 'Quand on vendait La Peau de L'Ours', *L'Oeil* (March 1956), 17. On this sector of the market, see Malcolm Gee's indispensable 'Dealers, critics and collectors of modern

painting: aspects of the Parisian art market 1910–30', unpublished PhD thesis, University of London, 1977.

36 On the activities of such collectors see Level's *Souvenirs d'un Collectionneur*, Paris: Club des Librairies de France, 1959.

37 This independence of judgement, which led them to reject the impressionist and decorative conventions that dominated public taste, was however grounded in a profound attachment to tradition. Thus Wilhelm Uhde, one of the keenest of the dénicheurs, later recalling his acquisition of cubist paintings by Picasso and Braque, declared: 'what interested me as a collector was the "grande peinture" by which these painters were perpetuating the tradition of the Louvre' ('Ce qui m'intéressait en tant que collectionneur, c'était la grande peinture par laquelle ces peintres perpetuaient la tradition du Louvre'): Wilhelm Uhde, 'Le collectionneur', *Style en France*, 5, no. 2 (January–March 1947), 61.

38 On the dénicheurs and their influence see Cottington, *Cubism in the Shadow of War*, 45–8. The gender imbalance was maintained also on the supply side: even dealer Berthe Weill, more sympathetic than most to women artists and always supportive of new talent, showed the work of only 10 women, as against 110 men, in the sixty exhibitions held in her gallery prior to the First World War: Perry, *Women Artists*, Appendix 2, 160–3.

39 D. Cottington, 'Cubism and the politics of culture in France 1905–1914', unpublished PhD thesis, University of London, 1985, 180–90 and 203–4; see also D.-H. Kahnweiler with F. Crémieux, *My Galleries and Painters*, trans. H. Weaver, New York: Viking, 1971.

40 '[I]l faut que la peinture roule, change du milieu': André Derain, *Lettres à Vlaminck*, Paris: Flammarion, 1955, 191n. As Werner Spies has noted: 'Exclusivity also signalled that if he was prepared to take risks, he wished in return to be certain of being in sole control of the market. It is because of this attitude that Kahnweiler very quickly became a "powerful" dealer': W. Spies, 'Vendre des tableaux – donner à lire', in *Daniel-Henry Kahnweiler: Marchand, Éditeur, Écrivain*, Paris: Centre Georges Pompidou, 1984, 29–30.

41 On this 'aristocratic' reputation see E. Tériade, 'Nos enquêtes: entretien avec Henry Kahnweiler', *Cahiers d'Art*, 2 (1927), no. 2, Supplément: 'Feuilles volantes', 1.

42 Fry's second post-impressionist exhibition in London and the Blaue Reiter exhibitions in Munich, for example, included significant contributions from Kahnweiler.

43 'A l'aide d'articles de presse, d'expositions savamment organisées, avec conférences contradictoires, polémiques, manifestes, proclamations, prospectus et autre publicité futuriste, on lance un peintre ou un groupe de peintres. A Boston ou à Kiew ou à Copenhague, ce tintamarre fait illusion et l'étranger adresse quelques commandes ...': R. Allard, 'Les arts plastiques', *Les Ecrits français*, 1 (5 December 1913), 64.

44 The self-promotional strategy that this orientation entailed also helped settle the question of gender: such attention-seeking, career-advancing, behaviour was no more appropriate for women artists in the regressively sexist milieux of the avant-garde than was the display of sexual appetite. It is significant that, although Sonia Delaunay was the artistic as well as marital partner of Robert, she found no place in room 41 (indeed, in those years, when he was first making his name, she abandoned painting for decorative art – a move that I explore in a later chapter); significant, too, that while there were female participants in room 41 – Marie Laurencin and Maroussia Rabannikoff – their

inclusion was at the insistence of their then partners, respectively Apollinaire and Le Fauconnier, rather than the result of any perceived resemblance between their paintings and those of the others: see pp. 97–9.

45 Gleizes, *Souvenirs*, 9–15.

46 Pierre Daix and Joan Rosselet, *Picasso: The Cubist Years 1907–1916*, London: Thames & Hudson, 1979, cat. 642; see also chapter 2, this book.

47 See William Rubin's searching analysis of this relationship, 'Picasso and Braque: an introduction', in *Picasso and Braque: Pioneering Cubism*, New York: Museum of Modern Art, 1989.

48 'J'ai crainte que le mystère dont s'enveloppe Picasso ne serve sa légende. Qu'il fasse une exposition,tout bêtement, et nous le jugerons': *Gil Blas*, 21 October 1912, 5.

49 F. T. Marinetti, 'The founding and manifesto of futurism', trans. R. W. Flint, in Umbro Apollonio (ed.), *Futurist Manifestos*, London: Thames & Hudson, 1973, 19–24, first published in *Le Figaro*, 20 February 1909, 1; Henri Le Fauconnier, 'L'oeuvre d'art', published as 'Das kunstwerk' in *Neue Kunstlervereinigung, München E. V., II Ausstellung*, Munich: Moderne Galerie, 1910; Jean Metzinger, 'Note sur la peinture', Pan (November 1910), 649–52.

50 A member of several anti-academic art associations outside of France, including the Neue Kunstlervereinigung (NKV) in Munich and the Moderne Kunst Kring in Amsterdam, Le Fauconnier participated in at least thirty exhibitions across the continent prior to 1914, more than any other cubist except Picasso: see Donald E. Gordon, *Modern Art Exhibitions 1900–1916*, 2 vols, Munich: Prestel, 1974, vol. 1, 342. On his position as cubism's *chef d'école* see André Salmon, 'Courrier des ateliers', *Paris-Journal*, 22 May 1911, 4.

51 Weiss, *The Popular Culture of Modern Art*, 61.

52 Camille Mauclair, 'Le préjugé de la nouveauté dans l'art moderne', *La Revue*, 1 April 1909, 290; Weiss, *The Popular Culture of Modern Art*, 53.

53 Weiss, *The Popular Culture of Modern Art*, 71.

54 Jean des Cars and Pierre Pinon, *Paris-Haussmann*, Paris: Pavillon de l'Arsenal, 1991; Norma Evenson, *Paris: A Century of Change, 1878–1978*, New Haven, CT, and London: Yale University Press, 1979

55 Michael B. Miller, *The Bon Marché: Bourgeois Culture and the Department Store 1869–1920*, Princeton, NJ: Princeton University Press, 1981, 53; see also S. Tize, 'Les grands magasins', in Y. Brunhammer, N. Aakre and D. McFadden (eds), *L'Art de Vivre: Decorative Arts and Design in France 1789–1989*, New York: Vendome Press, 1989, 72–105.

56 Miller, *The Bon Marché*, 2, 185.

57 Rosalind Williams, *Dream Worlds: Mass Consumption in Late Ninreteenth-Century France*, Berkeley, Los Angeles and London: University of California Press, 1982, 64–5.

58 Adam Gopnik and Kirk Varnedoe, *High and Low: Modern Art and Popular Culture*, New York: Museum of Modern Art and Harry N. Abrams, Inc., 1990, 249; see also Weiss, *The Popular Culture of Modern Art*, 62–5.

59 Daniel Pope, 'French advertising men and the American "promised land"', *Historical Reflections*, 5 (summer 1978), 125; see also Gopnik and Varnedoe, *High and Low*, 25–30.

60 Gopnik and Varnedoe, *High and Low*, 30.

61 See chapter 4, this book.

62 'Pour ce qui concerne nos oeuvres, je pense ... que le public est forcé de s'accoutumer. L'effort qu'il doit faire est lent, car il est noyé dans les habitudes. D'un autre côté, l'artiste a beaucoup à faire ... La raideur primitive du système est encore pour le public une pierre peu attirante pour son besoin de plaisir': letter of April 1912, reprinted in R. Delaunay, *Du Cubisme à l'Art abstrait*, ed. Pierre Francastel, Paris: SEVPEN, 1957, 178–80.

63 Weiss, *The Popular Culture of Modern Art*, 36.

64 P. Bourdieu, *Distinction: A Social Critique of the Judgement of Taste*, London: Routledge, 1984, 282–3.

65 Pinard, *La Consommation, le bien-être et le luxe*, 217–18; P. Bonnet, *La Commercialisation de la Vie française du première Empire à nos Jours*, Paris: Plon, 1929, 267.

66 Maurice Talmeyr, 'Café-concerts et music-halls', *La Revue des Deux Mondes*, 1 July 1902, 181–2.

67 Santillane, 'Les music-halls', *Gil Blas*, 12 September 1901, i, cited in Weiss, *The Popular Culture of Modern Art*, 5.

68 Charles Rearick, *Pleasures of the Belle Epoque*, New Haven, CT, and London: Yale University Press, 193.

69 On the audience for the cinema see Christian Jouhaud, 'La "belle époque" et le cinéma', *Le Mouvement social*, 139 (April–June 1987), 107–13; Natasha Staller, 'Méliès' "fantastic" cinema and the origins of cubism', *Art History*, 12, no. 2 (June 1989), 202–32; Réné Doumic, 'L'age du cinéma', *Revue des Deux Mondes*, 15 August 1913, 919–30; Louis Haugmard, 'L'"esthétique" du cinématographe', *Le Correspondant*, 215 (May 1913), 762–71.

70 'M.R.', 'Affaires du jour', *Les Soirées de Paris*, 23 (April 1914), 189–91, and 'Chronique cinématographique', *Les Soirées de Paris*, 26–7 (July–August 1914), 361–4. Gris's painting *Fantomas (Still-Life)* is in the National Gallery of Art, Washington, DC; see E. A. Carmean Jr, 'Juan Gris' "Fantomas"', *Arts*, 51, no. 5 (January 1977). As Staller notes, Raynal's writing on cinema contrasted sharply with the lofty tone of the art criticism that he was writing at the same time: Staller, 'Méliès' "fantastic" cinema', 207.

71 An 1899 survey of living standards among the working class of the outer-city 13th arrondissement found that half of its inhabitants lacked the 1 franc a day minimum to subsist without want or assistance; see Lenard R. Berlanstein, *The Working People of Paris, 1870–1914*, Baltimore, MD, and London: Johns Hopkins University Press, 1984, 40. On the disparity in incomes in this avant-guerre see J. B. Duroselle, *La France de la 'belle epoque'*, 2nd edn, Paris: Presses de la Fondation Nationale des Sciences Politiques, 1992, 50.

72 C. Bouglé, 'Solidarisme et morale scientifique', *La Revue bleue*, 2 September 1905, 310.

73 L. Mercier, *Les Universités populaires: 1899–1914. Education populaire et mouvement ouvrier au début du siècle*, Paris: Ouvrières, 1986; A. de la Chapelle, 'Un art nouveau pour le peuple. De "l'art dans tout" à "l'art pour tous"', *Histoire de l'Art*, 31 (October 1995), 59–68; J. M. Mayeur and M. Rebérioux, *The Third Republic from its Origins to the Great War, 1871–1914*, Cambridge: Cambridge University Press, 1984, ch. 8.

74 On Gleizes and Mercereau in 1905 see *L'Avenir de la Mutualité* (Paris), 23 December 1905. On the cubists and the universités populaires, see L. Dintzer, F. Robin and L. Grelaud, 'Le mouvement des universités populaires', *Le Mouvement social*, 35 (April–June 1961), 3–29.

75 'Quand l'art se mêle intimement à la vie unanime, la désignation "d'art social" seule peut lui convenir; on ne saurait restreindre à une classe le privilège de ses inventions; il

appartient à tous, sans distinction de rang ni de fortune; c'est l'art du foyer et de la cité-jardin, l'art du château et de l'école, l'art du bijou précieux et de la broderie paysanne; c'est aussi l'art du sol, de la race et de la nation': Roger Marx, 'De l'art social, et de la nécessité d'en assurer le progrès par une exposition', *Idées modernes* (January 1909); reprinted in Roger Marx, *L'Art social*, Paris: Fasquelle, 1913, 50–1.

76 See, e.g., *ibid.*, 33.

77 C. Morineau, 'Roger Marx et l'art social', mémoire de maîtrise, Université de Paris IV, 1988, 242–3.

78 J. McMillan, *Housewife or Harlot: The Place of Women in French Society 1870–1940*, Brighton, UK: Harvester, 1981, 51–3; M. Perrot, 'The new Eve and the old Adam: changes in French women's condition at the turn of the century', in M. Higgonet, J. Jenson, S. Michel, and M. Collins Weitz (eds), *Behind the Lines: Gender and the Two World Wars*, New Haven and London: Yale University Press, 1987, 53; S. Hause and A. Kenney, *Women's Suffrage and Social Politics in the French Third Republic*, Princeton, NJ: Princeton University Press, 1984. Such advances should not be exaggerated – 'in the family, factory, schools, hospitals, and on the street, men were still the masters': Perrot, 'The new Eve', 57.

79 The population of France rose by 8 per cent in the forty years from 1871, while that of Germany rose by 42 per cent and that of England and Wales by 59 per cent: Karen Offen, 'Depopulation, nationalism and feminism in fin-de-siècle France', *American Historical Review*, 89 (1984), 652. On male reactions, see Annelise Maugue, *L'Identité masculine en crise au tournant du siècle 1871–1914*, Paris: Rivages, 1987.

80 Debora L. Silverman, *Art Nouveau in Fin-de-Siècle France: Politics, Psychology and Style*, Berkeley, Los Angeles and London: University of California Press, 1989, 193–202; Offen, 'Depopulation, nationalism and feminism', 654.

81 Leora Auslander, *Taste and Power: Furnishing Modern France*, Berkeley, Los Angeles and London: University of California Press, 1996, 306–22.

82 Nancy J. Troy, *Modernism and the Decorative Arts in France*, 63–7; Kenneth Silver, *Esprit de Corps: The Art of the Parisian Avant-Garde and the First World War, 1914–1925*, London: Thames & Hudson, 1989, 171–4.

83 David Thompson, *Democracy in France since 1870*, 4th edn, Oxford University Press, 1964, 72–4.

84 See, e.g., E. Weber, *The Nationalist Revival in France, 1904–1914*, Berkeley: University of California Press, 1959; and R. Girardet, *Le Nationalisme français. Anthologie (1871–1914)*, Paris: Seuil, 1983.

85 The Second Socialist International voted at its Amsterdam congress in late 1904 against participation in bourgeois governments, while in its 1906 Charter of Amiens the syndicalist (trades unionist) Confédération générale du travail (CGT) re-affirmed its neutrality vis-à-vis political parties and its commitment to the principle of the general strike. On these developments see, e.g., F. Ridley, *Revolutionary Syndicalism in France*, Cambridge: Cambridge University Press, 1968.

86 Mayeur and Rebérioux, *The Third Republic*, 249.

87 J. L. Breton, 'Tribune libre. Le scandale du Salon d'Automne', *La Lanterne*, 24 October 1912, 1; G. Lecomte, 'Pour l'art français'; Anon. (Lampué), 'Le Salon d'Automne est un scandale'.

88 'Les cubistes jouent en effet dans l'art actuel un rôle analogue à celui que tiennent avec tant d'éclat, dans l'ordre politique et social, les apôtres de l'antimilitarisme et du sabotage organisé; et, de même qu'il est évident que les prédications d'un Hervé ont aidé

puissamment à la renaissance du sentiment patriotique à laquelle nous assistons, on ne saurait contester que les excès où se sont portés les anarchistes et les saboteurs de la peinture française n'aient contribué à raviver chez les artistes et les amateurs dignes de ce nom le goût de l'art véritable et de la véritable beauté': *Le Journal*, 30 September 1911, 2. Gustave Hervé was editor of the anti-militarist and pro-syndicalist newspaper *La Guerre sociale*.

89 Following a wave of anarchist violence in 1893–94 a series of government measures criminalised anarchist publicists as well as anarchist terrorists, and pro-anarchist intellectuals were caught in their net. The poet Mallarmé was the most celebrated of the intellectuals who were subsequently put on trial in the notorious 'Procès des Trente' in August 1894: see Jean Maitron, *Le Mouvement anarchiste en France*, Paris: Maspéro, 1975, vol. 1, 252; Robert and Eugenia Herbert, 'Artists and anarchism: unpublished letters of Pissarro, Signac and others', *Burlington Magazine*, 102 (November–December 1960), 472–82, 517–22; Richard D. Sonn, *Anarchism and Cultural Politics in Fin de Siècle France*, Lincoln and London: University of Nebraska Press, 1989, 22–4.

90 Nicos Hadjinicolaou, 'Sur l'idéologie de l'avant-gardisme', *Histoire et Critique des Arts*, 6 (second trimester 1978), 49–76.

91 André Billy, *L'Epoque contemporaine*, Paris: Tallandier, 1956, 133. For a survey of neo-symbolism c1905–10 see Michel Décaudin, *La Crise des Valeurs symbolistes: Vingt Ans de Poésie française 1895–1914*, Toulouse: Privat, 1960, part 3.

92 P. Aubéry, *Anarchiste et décadent: Mécislas Golberg, 1868–1907*, Paris: Lettres Modernes, 1978.

Chapter 2

1 Maurice Denis, 'De Gauguin et de van Gogh au classicisme', *L'Occident*, 90 (May 1909), 190, reprinted in Maurice Denis, *Le Ciel et l'Arcadie: Textes réunis*, ed. Jean-Paul Bouillon, Paris: Hermann, 1993, 161. Denis's support for Action française was stated in reply to an enquête in the *Revue du Temps présent* (June 1911), 569.

2 Raoul Girardet, *Le Nationalisme français*, Paris: Seuil, 1983.

3 On the role of Le Play's ideas in the formation of French proto-fascism, see Stanford Elwitt, *The Third Republic Defended: Bourgeois Reform in France, 1880–1914*, Baton Rouge and London: Louisiana State University Press, 1986, 20–7.

4 'La volonté de conserver notre patrie française une fois posée comme postulat, tout s'enchaîne, tout se déduit d'un mouvement inéluctable ... Si vous avez résolu d'être patriote, vous serez obligatoirement royaliste ... La raison le veut': *Enquête sur la Monarchie*, cited in Raoul Girardet, *Le Nationalisme français*, Paris: Seuil, 1983, 197.

5 Action française began in 1899 as a *coterie* centred on a fortnightly periodical, but was launched as a mass movement in 1905; a daily newspaper, *L'Action française*, followed in 1908. Eugen Weber, *The Nationalist Revival in France, 1905–1914*, Berkeley: University of California Press, 1959, 66.

6 'Tant que je demeurerai, ni mes ascendants, ni mes bienfaiteurs ne seront tombés en poussière. Et j'ai confiance que moi-même, quand je ne pourrai plus me protéger, je serai abrité par quelques-uns de ceux que j'éveille ... Ainsi je possède mes points fixes, mes repérages dans le passé et dans la postérité. Si je les relie, j'obtiens une des grandes lignes du classicisme français. Comment ne serai-je point prêt à tous les sacrifices pour la protection de ce classicisme qui fait mon épine dorsale?': *Scènes et Doctrines du Nationalisme*, Paris: Plon, 1902; quoted in Girardet, *Le Nationalisme français*, 189.

7 This is not, however, to claim any simple identity between Barrésian nationalism and fascism. As was stressed by several contributors to the lively debate that followed the publication of Sternhell's *Ni Droite ni Gauche: L'Idéologie fasciste en France* in 1983 (Paris: Seuil), the character of the 'family of national reunification ideologies' of the *avant-guerre* was too complex to be reduced to such a schema. See A. C. Pinto, 'Fascist ideology revisited: Zeev Sternhell and his critics', *European History Quarterly*, 16 (1986), 465–83.

8 Recent historians have characterised Maurras as nationalism's theoretician, and Barrès as its poet. Pascal Ory and Jean-Francois Sirinelli, *Les Intellectuels en France, de l'Affaire Dreyfus à nos Jours*, Paris: Armand Colin, 1986, 49.

9 Quoted by Eugen Weber, *Action française: Royalism and Reaction in Twentieth Century France*, Stanford, CA: Stanford University Press, 1962, 77.

10 M. Barrès, *Scènes et Doctrines du nationalisme*, quoted in Zeev Sternhell, Maurice Barrès et le nationalisme française, Paris: Editions Complexe, 1985, 275.

11 *Ibid.*, 275–6.

12 Barrésian sentiments were widely voiced (not least by J.-L. Breton himself); see, e.g., Georges Lecomte, 'Pour l'art français. contre les défis au bon sens', *Le Matin*, 7 October 1912, 1. For an analysis of Gleizes's articles see chapter 5, this book.

13 Eugen Weber, *My France: Politics, Culture, Myth*, Cambridge, MA, and London: Harvard University Press, 1991, 28–9. On the history of the 'race war' thesis and its opponents, see also Krzysztof Pomian, 'Franks and Gauls', in Pierre Nora (ed.), *Realms of Memory*, New York: Columbia University Press, 1996, vol. 1, 26–76 and 534–45.

14 For an example of such emphases see Jacques Reboul, *L'Impérialisme français. Sous le Chêne celtique*, Paris: E. Sansot, 1913.

15 Weber, *My France*, 32–3.

16 An influential example of such art-historical initiatives was that made at the start of the pre-war decade by Henri Bouchot, curator of paintings at the Louvre: see *Exposition des primitifs français au Palais du Louvre (Pavillon de Marsan) et à la Bibliothèque Nationale*, exhibition catalogue (exh. cat., hereafter), Paris: Bibliothèque Nationale, 1904. The same argument was consistently presented through the following decade by the curator of modern sculpture at the Louvre, André Michel; see, e.g., his 'Hotels et maisons de la renaissance française', *Journal officiel des Débats*, 7 February, 1911, 1.

17 Adrien Mithouard, *Traité de l'Occident*, Paris: Perin, 1904, 76.

18 '[L]e monde moderne est devenu breton et il s'en honore', *ibid.*, 5.

19 Michel Décaudin, *La Crise des valeurs symbolistes: Vingt Ans de Poésie française 1895–1914*, Toulouse: Privat, 1960, 330.

20 Auguste Anglès, *André Gide et le premier groupe de la Nouvelle Revue française 1890–1910*, Paris: Gallimard, 1978, 185; on anti-semitism see e.g. Gide, 'Nationalisme et littérature', *NRF*, 5 (June 1909).

21 Maurice Denis, 'De la gaucherie des primitifs' (1904), reprinted in Maurice Denis, *Théories (1890–1910). Du Symbolisme et de Gauguin Vers un nouvel ordre classique*, 4th edn, Paris: Rouart et Watelin, 1920 (1912), 172–8.

22 'Le Salon d'Automne de 1905', *L'Ermitage*, 15 November 1905.

23 'De Gauguin et de van Gogh au classicisme', in Denis, *Le Ciel et l'Arcadie*, 170.

24 Charles Morice, 'Enquête sur les tendances actuelles des arts plastiques', *Mercure de France*, 195–7 (August–September 1905).

25 'Qu'une tradition naisse à notre époque ... c'est de Cézanne qu'elle naiitra ... il ne s'agit pas d'un art nouveau, mais d'une résurrection de tous les arts solides et purs, classiques': *Mercure de France*, 196 (August 1905), 544.

26 Theodore Reff, 'The reaction Against fauvism: the case of Braque', in William Rubin and Lynn Zelevansky (eds), *Picasso and Braque: A Symposium*, New York: Museum of Modern Art, 1992, 26–8. The catalogue for Braque's solo exhibition at Kahnweiler's gallery in November 1908 listed twenty-seven works, almost all from the previous year, of which around twenty were landscapes: see Donald E. Gordon, *Modern Art Exhibitions 1900–1916*, Munich: Prestel Verlag, 1974, vol. 2, 285.

27 Judith Cousins with Pierre Daix, 'Documentary chronology', in William Rubin (ed.), *Picasso and Braque: Pioneering Cubism*, exh. cat., New York: Museum of Modern Art, 1989, 348.

28 Pierre Daix, *Picasso Créateur*, Paris: Seuil, 1978, 91–2.

29 Anna C. Chave, 'New encounters with *Les Demoiselles d'Avignon*: gender, race and the origins of cubism', *Art Bulletin*, 86, no. 4 (December 1994), 604; see also Christopher Green (ed.), *Picasso's 'Les Demoiselles d'Avignon'*, Cambridge: Cambridge University Press, 2001.

30 Among the first scholars to assess the *Demoiselles* in relation to the history and discourse of colonialism in France was Patricia Leighten: see her 'The white peril and *l'art nègre*: Picasso, primitivism and anticolonialism', *The Art Bulletin*, 72 (December 1990), 609–30, and her update of this in 'Colonialism, *l'art nègre* and *Les Demoiselles d'Avignon*', in Christopher Green (ed.), *Picasso's* Les Demoiselles d'Avignon, Cambridge: Cambridge University Press, 2001, 77–103.

31 For a useful summary of the availability of such African masks in pre-1914 Paris see J. B. Donne, 'African art and Paris studios', in Michael Greenhalgh and Vincent Megan (eds), *Art and Society: Studies in Style, Culture and Aesthetics*, London: St Martin, 1978.

32 Chave, 'New encounters with *Les Demoiselles d'Avignon*', 606.

33 Gelett Burgess, 'The wild men of Paris', *The Architectural Record* (Boston), 27, no. 5 (May 1910), 400–14; Edward Fry, 'Cubism 1907–1908: an early eyewitness account', *Art Bulletin*, 48, no. 1 (March 1966), 70–3; Cousins and Daix, 'Documentary chronology', 349–50.

34 On Picasso's Trocadero visit see William Rubin, 'The genesis of *Les Demoiselles d'Avignon*', in W. Rubin, H. Seckel and J. Cousins (eds), *Studies in Modern Art 3: Les Demoiselles d'Avignon*, New York: Museum of Modern Art, 1994, 103–6, and Hélène Seckel's documentation of the artist's statements about it, in the same volume, 219–22.

35 Leo Steinberg, 'Resisting Cézanne: Picasso's "Three Women"', *Art in America* (November–December 1978), 122.

36 *Ibid.*, 123.

37 See e.g. Apollinaire's catalogue's Preface for this exhibition, reprinted in *Apollinaire on Art: Essays and Reviews 1902–1914*, trans. S. Suleiman, ed. L. C. Breunig, London: Thames & Hudson, 50–2; Louis Vauxcelles's review in *Gil Blas*, 14 November 1908; Matisse's retrospective comments quoted in E. Tériade, 'Matisse speaks', *Art News Annual* (1952), 40–71.

38 On Picasso's familiarity by 1908 with Rousseau's work see William Rubin, 'From narrative to "iconic" in Picasso: the buried allegory in *Bread and Fruitdish on a Table*

and the role of the *Demoiselles d'Avignon*', *Art Bulletin*, 65, no. 4 (December 1983), 620–2.

39 Christian Geelhaar, 'Pablo Picassos stilleben "Pains et compotier aux fruits sur une table"': Metamorphosen einer Bildidee', *Pantheon*, 28 (1970), no. 2, 127–40.

40 Rubin, 'From narrative to "iconic" in Picasso', 622–4, 637–9.

41 See also Theodore Reff, 'Themes of love and death in Picasso's early work', in R. Penrose and J. Golding (eds), *Picasso 1881–1973*, London: Paul Elek, 1973.

42 Beverly Whitney Kean, French Painters, Russian Collectors: The Merchant Patrons of Modern Art in Pre-Revolutionary Russia, London: Hodder & Stoughton, 1983; Michael C. Fitzgerald, *Making Modernism: Picasso and the Creation of the Market for Twentieth Century Art*, New York: FSG, 1995.

43 Daniel-Henry Kahnweiler with Francis Crémieux, *My Galleries and Painters* (1961), trans. Helen Weaver, New York: Viking, 1971, 39.

44 David Cottington, 'Cubism, aestheticism, modernism', in Rubin and Zelevansky (eds), *Picasso and Braque: A Symposium*, 66–7.

45 D.-H. Kahnweiler, *Der Weg zum Kubismus*, Munich: Delphin, 1920, 27; English edition, *The Rise of Cubism*, trans. Henry Aronson, New York: Wittenborn Schultz, 1949, 10.

46 Alfred H. Barr (ed.), *Cubism and Abstract Art*, exh. cat., New York: Museum of Modern Art, 1936; William Rubin (ed.), *Picasso and Braque: Pioneering Cubism*; see chapter 6, this book, for a more detailed consideration of this historiography.

47 Y.-A. Bois, 'Kahnweiler's lesson', *Representations*, 18 (spring 1987), 38, the argument of which was later developed in his 'The semiology of cubism', in Rubin and Zelevansky (eds), *Picasso and Braque: A Symposium*, 169–208; I discuss both more fully in chapter 7. If anything, Bois reinforces this framework, especially the break of 1912.

48 L. Steinberg, 'Resisting Cézanne', and its sequel, 'The polemical part', *Art in America* (March–April 1979), 114–27; see also 'The philosophical brothel, part I', *Art News*, 71, no. 5 (September 1972), 22–9; 'Part II', *Art News*, 71, no. 6 (October 1972), 38–47; see also his *Other Criteria: Confrontations with Twentieth-Century Art*, New York: Oxford University Press, 1972.

49 R. Krauss, 'The motivation of the sign', in Rubin and Zelevansky (eds), *Picasso and Braque*, 270–1, an interpretation first suggested in her review of Douglas Cooper's exhibition 'The Cubist Epoch' in *Artforum*, 9, no. 6 (February 1971), 32–3.

50 Kahnweiler, *The Rise of Cubism*, 10.

51 T. J. Clark, *Farewell to an Idea: Episodes from a History of Modernism*, New Haven, CT, and London: Yale University Press, 1999, ch. 4.

52 Bois, 'The semiology of cubism', 182–3 and 202, n51; Clark, *Farewell to an Idea*, 208.

53 See, e.g., *Woman with a Mandolin* of spring 1909 or that of spring 1910, shortly before Picasso's departure for Spain, in Pierre Daix and Joan Rosselet, *Picasso: The Cubist Years 1907–1916*, London: Thames & Hudson, 1979, cat. 236 and 341.

54 Bois, 'The semiology of cubism', 177.

55 Cousins and Daix, 'Documentary chronology', 368.

56 Rubin, *Picasso and Braque: Pioneering Cubism*, 23.

57 Nicole Worms de Romilly and Jean Laude, *Braque: Cubism, 1907–1914*, Paris: Editions Maeght, cat. 77.

58 An example of Braque's drawing at this moment is the *Figure*, done in L'Estaque or Paris that autumn or winter: see Rubin, *Picasso and Braque: Pioneering Cubism*, 164. An

example of Picasso's Cadaqués landscapes is the *Harbour at Cadaqués*, now in Prague: *ibid.*, 163.

59 Clark, *Farewell to an Idea*, 192; Bois, 'The semiology of cubism', 184.

60 Clark, *Farewell to an Idea*, 427, n36.

61 Adam Gopnik, 'High and low: caricature, primitivism, and the cubist portrait', *Art Journal*, 43, no. 4 (winter 1983), 371–6.

62 *Ibid.*, 372.

63 *Ibid.*, 374.

64 *Ibid.*, 375–6.

65 *Ibid.*, 373.

66 Picasso's own enjoyment of cartoons has been often noted in accounts of his Bateau-Lavoir days (such as Gertrude Stein's *Autobiography of Alice B. Toklas*), as has the fact that numerous artists in the pre-war Parisian avant-garde made some kind of a living by cartooning for the city's satirical or humorous magazines, among them Jacques Villon, Marcel Duchamp, Frank Kupka and Louis Marcoussis (the last of whom parodied the cubist style even as he was making cubist paintings!). These activities are perhaps worth more attention in aesthetic terms, as well as social, than they have yet been given; see chapter 5 on Gris's cartooning.

67 Rubin, *Picasso and Braque: Pioneering Cubism*, 26.

68 Clark, *Farewell to an Idea*, 215.

69 '[P]ar le heurt de leurs inégalités mobilisés; ils s'allument de reflets réciproques comme une virtuelle traînée de feu sur les pierreries': Mallarmé, 'Crise de vers', *Oeuvres complètes*, ed. H. Mondor and G. Jean-Aubry, Paris: Gallimard, 1945, 366.

70 Clark, *Farewell to an Idea*, 174.

71 See chapter 1, note 5.

72 Albert Gleizes, *Souvenirs. Le Cubisme 1908–1914*, Paris: Cahiers Albert Gleizes, 1957, 14.

73 Henri Le Fauconnier, 'L'oeuvre d'art', published as 'Das Kunstwerk' in *Neue Kunstlervereinigung, München E. V., II Ausstellung*, Munich: Moderne Galerie, 1910.

74 'Un beau tableau n'est qu'une juste équilibre, c'est-à-dire un accord de poids et un rapport de nombres ... libre au génie de dilater la tradition dans le sens du classicisme futur!': Roger Allard, 'Au Salon d'Automne de Paris', *L'Art libre* (Lyon), 2, no. 12 (November 1910), 443; 'Est-il une oeuvre, entre les plus actuelles de la peinture et de la sculpture qui, en secret, n'obéisse pas au rythme grec?'; 'Le Fauconnier situe son idéal, inaccessible à ceux-là surtout qui parlent sans mesure d'ordonnance et de style, en un vaste équilibre de nombres': Jean Metzinger, 'Note sur la peinture', *Pan* (November 1910), 649, 651.

75 'Qu'il peigne un visage, un fruit, l'image totale rayonne dans la durée; le tableau n'est plus une portion morte de l'espace': Metzinger, 'Note sur la peinture', 650.

76 'Ainsi naît, aux antipodes de l'impressionnisme, un art qui ... offre dans leur plénitude picturale, à l'intelligence du spectateur, les éléments essentiels d'une synthèse située dans la durée': Allard, 'Au Salon d'Automne de Paris', 442.

77 'Donc aimer l'oeuvre vivante, à cause des forces de vie qui sont en elle, c'est comprendre et posséder la nature, puisque par le fait du génie, une pensée humaine a su la contenir toute entière'; 'Donc aimer l'oeuvre vivante, à cause des forces de vie qui sont en elle, c'est comprendre et posséder la nature, puisque par le fait du génie, une pensée humaine a su la contenir toute entière': Roger Allard, 'Les Beaux-Arts', *La Revue indépendante* (August 1911), 138.

78 Tancrède de Visan, 'La philosophie de M. Bergson et le lyrisme contemporain', *Vers et Prose* (April–June 1910), 125–40; Joseph Billiet, 'Littérature', *L'Art libre* (summer 1911), 618–22; Mark Antliff, *Inventing Bergson: Cultural Politics and the Parisian Avant-Garde*, Princeton, NJ: Princeton University Press, 1993, ch. 1.

79 Gleizes, *Souvenirs*, 14; Christopher Green, *Léger and the Avant-Garde*, New Haven, CT, and London: Yale University Press, 1977, 32–3; David Cottington, *Cubism in the Shadow of War: The Avant-Garde and Politics in Paris, 1905–1914*, New Haven, CT, and London: Yale University Press, 1998, 87–91; Antliff, *Inventing Bergson*, 92–4.

80 For a dissenting recent assessment see Daniel Robbins's view, discussed in chapter 8.

81 Georges Duhamel and Charles Vildrac, *Notes sur la Technique poétique*, Paris, 1910.

82 Gleizes, *Souvenirs*, 9–11.

83 See, e.g., Daniel Robbins, 'The formation and maturity of Albert Gleizes', unpublished PhD thesis, New York University, 1975, 82–3.

84 Daniel Robbins, 'Jean Metzinger: at the center of cubism', in Joann Moser (ed.), *Jean Metzinger in Retrospect*, exh. cat., Iowa City: University of Iowa Museum of Art, 1985, 18–19. This is less than certain, however. Kahnweiler later confirmed that he first met Léger after he had exhibited his *Nudes in the Forest* at the Indépendants – presumably on the occasion of Léger's first visit to his gallery. D.-H. Kahnweiler, *Mes Galeries et Mes Peintres: Entretiens avec Francis Crémieux*, Paris: Gallimard, 1961, 59. The group's visit to the gallery could not have been before March 1911, when Delaunay apparently first met Apollinaire: G. Vriesen and M. Imdahl, *Robert Delaunay: Light and Colour*, New York: Abrams, 1967, 39.

85 Berthe Weill, *Pan! Dans l'oeil! Ou, Trente ans dans les coulisses de la peinture contemporaine 1900–1930*, Paris: Lipschutz, 1933, 87; Gelett Burgess, 'The wild men of Paris', *Architectural Record* (Boston), May 1910, 412–4.

86 Jean Metzinger, *Le Cubisme etait né: Souvenirs*, Paris: Présence, 1972, 20–3.

87 His other entries were a landscape, a portrait head and a still life, none of which have been identified.

88 Gleizes, *Souvenirs*, 11.

89 By the following autumn, he had clearly displaced Le Fauconnier in this role, as Salmon noted in his 'Courrier des ateliers', *Paris-Journal*, 7 September 1911, 5.

90 See chapter 3.

91 Metzinger, 'Note sur la peinture', 649–52: 'confusions savantes du successif et du simultané … l'image totale rayonne dans la durée'; 'il fonde une perspective libre, mobile, telle que la sagace mathématicien Maurice Princet en déduit toute une géométrie', 650. On Princet see E. Fry, *Cubism*, New York and Toronto: McGraw-Hill, 1966, 61; Jean Metzinger, *Le Cubisme Etait né*, 43, 57; Didier Ottinger, 'Le secret de la Section d'or. Maurice Princet au pays de la quatrième dimension', in *La Section d'or 1912–1920–1925*, exh. cat., Musées de Châteauroux–Musée Fabre Montpellier, Paris: Cercle d'Art, 2000, 63–8.

92 E.g. Leo Steinberg, 'The Algerian women and Picasso at large', in *Other Criteria*, 160; for a discussion of Steinberg's revisionist interpretation of cubism and its legacy, see chapter 7. As T. J. Clark notes, it was this text of Metzinger's that was among the first to 'float the ensuing idea of perceptual mobility': *Farewell to an Idea*, 426, n31.

93 'Cézanne nous montra les formes vivre dans la Réalité de la lumière, Picasso nous apporteun compte-rendu matériel de leur vie réelle dans l'esprit': *ibid.*, 650.

94 '[H]autement éclairés, ils ne croient à la stabilité d'aucun système, s'appellerait-il art classique': *ibid.*, 649.

95 Christopher Green, *Juan Gris*, exh. cat., London: Whitechapel Gallery, 1992, 29–30; see also Antliff, *Inventing Bergson*, 44.

96 'Ils se sont permis de tourner autour de l'objet pour en donner, sous le contrôle de l'intelligence, une représentation concrète faite de plusiers aspects successifs. Le tableau possédait l'espace, voilà qu'il règne aussi dans la durée': Jean Metzinger, '"Cubisme" et tradition', *Paris-Journal*, 16 August 1911, 5.

97 E. Bréon, 'Evolution de la ville du XVIII· au XX· siècle', in M. Culot and B. Foucart (eds), *Boulogne–Billancourt. Ville des Temps modernes*, Paris: Mardaga, 1992, 179–94.

98 On which, see his *Souvenirs*, 23–5.

99 *Ibid.*, 25–6.

100 A. Gleizes, 'L'art et ses représentants: Jean Metzinger', *La Revue indépendante*, 4 (September 1911), 164. This was Gleizes's literary debut; see chapter 5.

101 '[La peinture] représente les objets tels qu'ils sont, c'est-à-dire autrement que nous ne les voyons': Jacques Rivière, 'Sur les tendances actuelles de la peinture', *La Revue d'Europe et d'Amérique*, 1 March 1912, 387.

102 'Mon intention est de rendre aux cubistes un peu plus de liberté et d'aplomb, en leur fournissant les raisons profondes de ce qu'ils font': *ibid.*, 385.

103 '[C]ombien les cubistes ont mal compris le cubisme': *ibid.*, 399

104 '[C]ette folle cacophonie qui nous donne à rire': *ibid.*, 402; 'En somme, les cubistes ont l'air de se parodier eux-mêmes ... Ils suppriment le volume de l'objet pour ne vouloir omettre aucun de ses éléments. Ils suppriment l'intégrité respective des objets dans le tableau, à force de vouloir les conserver intacts. Ils suppriment la profondeur, qui sert à les distinguer, à force de vouloir la figurer solidement': *ibid.*, 404.

105 'Il y a dans le *cubisme* une idée extrêmement intéressante et d'une considérable importance. Mais, à coup sûr, personne n'est plus anxieux que les cubistes d'apprendre quelle est cette idée': *ibid.*, 383.

106 'Tout en conservant l'égalité lumineuse des faces de l'objet, le peintre les distinguera les unes des autres par de légères arêtes; il les fera découler de ces arêtes comme les pentes opposées d'un toit; il les articulera avec solidité comme elles s'articulent dans la nature; il leur laissera leur obliquité réciproque et leur agencement angulaire': *ibid.*, 390–1.

107 '[T]el que nous le voyons quand nous le voyons bien': *ibid.*, 393.

108 '[C]omme si elle était chose matérielle. A cet effet, de toutes les arêtes de l'objet il fera partir de légers plans d'ombre qui fuiront vers les objets les plus lointains': *ibid.*, 398.

109 Such is the view of T. J. Clark: see *Farewell to an Idea*, 204–6. This leads him to the conclusion not only that in these proposed formulae 'Rivière's text exceeds or deconstructs its own neo-Kantian frame of reference' (427, n33) but that the critic's understanding of what cubism could be coincides with his own reading of Picasso's 1909 Horta figures: p. 204.

110 '[D]ont les oeuvres récentes me paraissent marquer avec une simplicité admirable l'avènement décisif de la peinture nouvelle': Rivière, 'Sur les tendances actuelles de la peinture', 406.

111 'Lhote is not content with constructing solids. He perceives a whole new world, whose mobility he undertakes to fix ... the air, in becoming palpable, obliges the objects to construct themselves in a new way. It slips across their different sides and lends them its own limpid uniformity ...': Rivière, 'Sur une exposition d'André Lhote (Galerie Druet)' (1910), reprinted in P. Courthion (ed.), *André Lhote*, Paris:, 1926. Although

the *Bacchante* is conventionally dated 1910 (see e.g., Musée de Valence, *Andre Lhote 1885–1962*, Lyon: RMN, 2003, cat. 29) on stylistic grounds I would date it 1912.

112 Clark, *Farewell to an Idea*, 204. Indeed in his closing paragraph Rivière (406) declared himself unable to understand the work of Picasso, 'who has strayed into occult researches where it is impossible to follow him' ('s'est égaré dans des recherches occultes où il est impossible de le suivre'). 'Sur les tendances actuelles de la peinture'. He prefaced this remark with a clarification as to the targets of his criticism: these were 'principally Picasso, Braque, and the group formed by Metzinger, Gleizes, Delaunay, Léger, Herbin, Marcel Duchamp'. Significantly, given his preference for Lhote, 'Le Fauconnier, who has been a member until now, seems to be freeing himself from it. He will perhaps be a fine painter' ('Je me suis attaqué ici principalement à Picasso, à Braque et au groupe formé par Metzinger, Gleizes, Delaunay, Léger, Herbin, Marcel Duchamp. Le Fauconnier qui en a fait parti jusqu'ici, parait être en train de se libérer. Ce sera peut-être un beau peintre'): *ibid*.

113 Picasso's own retrospective description of his cubism, proffered in a conversation of 1933 with Kahnweiler, quoted by Clark, *ibid*., 179 and 424, n110.

114 See Jane Lee, *Derain*, Oxford: Phaidon, 1990, 35, 49; also *André Derain. Le Peintre du 'trouble moderne'*, exh. cat., Paris: Musée d'Art Moderne de la Ville de Paris, 1994, 206.

115 See Kenneth E. Silver, 'The heroism of understatement: the ideological machinery of La Fresnaye's *Conquest of the Air*', in A. D'Souza (ed.), *Self and History: A Tribute to Linda Nochlin*, London: Thames & Hudson, 2001, 116–26 and 215–16.

Chapter 3

1 Roger Allard, 'Sur quelques peintres', *Les Marches du sud-ouest* (June 1911), 62.

2 On the identity of these works see Roger Allard, '*La Tour Eiffel* est un très gros effort et la trouvaille des rideaux évoquant le cadre de la fenêtre sont [*sic*] d'un vrai poète': *La Rue*, 24 (April 1911), 5; also Angelica Rudenstine, cited in Virginia Spate, *Orphism: The Evolution of Non-Figurative Painting in Paris 1910–1914*, Oxford: Oxford University Press, 1979, Appendix C.

3 On his 'chic' parents and his upbringing 'in the luxurious world of the Parisian haute bourgeoisie', see Sonia Delaunay, *Nous irons jusqu'au soleil*, Paris: Laffont, 1978, 26.

4 '[I]l arrive maintenant une équipe qui renverse l'intellectualisme, le goût. Le métier joue maintenant un grand rôle': Robert Delaunay, *Du Cubisme à l'Art abstrait. Documents inédits publiés par Pierre Francastel*, Paris: SEVPEN, 1957, 160–1.

5 '[L]e monde n'est pas notre représentation recrée par la raisonnement (cubisme), le monde est notre métier': 'Representation et métier', *ibid*., 115.

6 '[L]e type de ces peintres que l'on rencontre dans les banlieues, les campagnes, les bourgs, l'expression naive et directe de ces artisans, peinture de foire, de coiffeurs, amateurs, de laitiers, etc. Toute cette peinture de source directement des idées touffues du peuple, Rousseau en a été le génie, la fleur précieuse': R. Delaunay, 'Extrait de H R le douanier: sa vie, son oeuvre, la critique', unpublished MS of 1911, Paris: Bibliothèque Nationale, Fonds Delaunay, dossier 18, 5 bis.

7 'Cet art sorti des profondeurs du peuple, complètement incompris dans les centres artistiques aussi bien des révolutionnaires que des académiques': R. Delaunay, 'Mon ami Henri Rousseau, part I', *Les Lettres françaises*, 7 August 1952, 9.

8 'Rousseau le peuple toujours lui-même avec toute la sûreté de la race une plénitude du 1er moment jusqu'à la fin … Cézanne, le bourgeois, le 1er briseur, le premier saboteur.

Deux formes complètement distinct dans cette époque héroïque de la peinture moderne
– deux primitifs de ce grand mouvement': Delaunay, 'Extrait de H R le douanier', 7.

9 '[R]egagne la tradition par la vision, par le mouvement ce qui est moderne chez lui':
 Delaunay, *Du Cubisme à l'Art abstrait*, 161.

10 *Ibid.*, 72.

11 On this series, and Delaunay's engagement in it with perceptual issues, see Spate,
 Orphism, 166–8

12 Pascal Rousseau, 'Saint-Séverin', in *Robert Delaunay 1906–1914: De l'Impressionnisme
 à l'Abstraction*, exh. cat., Paris: Centre Georges Pompidou, 1999, 105–6; also Kevin D.
 Murphy, 'Cubism and the Gothic Tradition', in Eve Blau and Nancy J. Troy (eds),
 Architecture and Cubism, Montréal, Cambridge, MA, and London: MIT Press and
 Canadian Centre for Architecture, 1998, 59–76.

13 Pascal Rousseau, 'La construction de simultané: Robert Delaunay et l'aéronautique',
 Revue de l'Art, 113, no. 3 (1996), 20–1.

14 *Ibid.*, 20.

15 Sonia Delaunay, *Nous irons jusqu'au soleil*, Paris: Laffont, 1978, 38. As Pascal Rousseau
 has established, Robert visited the aircraft factory of his friend Emile Borel at Chartres
 on more than one occasion: 'La construction de simultané', 24–5.

16 'Je suis comme un morceau de sucre dans ta bouche,/ ville gourmande': Jules Romains,
 La Vie unanime (1908), Paris: Mercure de France, 1913, 133.

17 From 'Futurist painting: technical manifesto', originally published as a leaflet by *Poesia*
 (Milan), 11 April 1910, and in Paris in the arts-orientated daily newspaper *Comoedia* on
 18 May 1910; English translation from the catalogue of the *Exhibition of Works by the
 Italian Futurist Painters*, London: Sackville Gallery, March 1912, reprinted in U.
 Apollonio (ed.), *Futurist Manifestos*, London: Thames & Hudson, 1973, 27–8.

18 André Salmon noted the approaching futurist exhibition in his 'Courrier des ateliers'
 column in *Paris-Journal*, 5 October 1911, 4, commenting that, keenly anticipated, it
 'aura au moins un beau succès de curiosité'.

19 Apollinaire's celebrated remark about Delaunay's paintings in the 1910 Salon
 des Indépendants, that they 'unfortunately look as if they were commemorating an
 earthquake', antedates this Karlsruhe *Tower*, and, as Spate suggests, probably refers to
 his *Saint-Séverin No. 2* (figure 3.2); Spate, *Orphism*, Appendix C, 372.

20 T. J. Clark, *Farewell to an Idea: Episodes from a History of Modernism*, New Haven, CT,
 and London: Yale University Press, 1999, 187.

21 On the dating of the paintings in this series see Spate, *Orphism*, 372–7, and Rousseau in
 Robert Delaunay 1906–1914, 118–21, 130–7.

22 See chapter 4, this book.

23 'Et si Apollinaire et Max Jacob n'étaient pas venus nous voir, on n'aurait même pas su
 ce qui se passait à Montmartre. Ils nous ont dit d'aller chez Kahnweiler, et là nous
 avons vu, avec le gros Delaunay, ce que les cubistes faisaient. Alors Delaunay, surpris
 de voir leurs toiles grises, s'est écrie: 'Mais ils peignent avec des toiles d'araignée, ces
 gars!' C'est ça qui donnait un peu de relief à la chose': quoted in Dora Vallier, 'La Vie
 fait l'oeuvre de Fernand Léger', *Cahiers d'Art*, 2 (1954), 149.

24 The group's visit to the gallery could not have been before March 1911, when Delaunay
 apparently first met Apollinaire: G. Vriesen and M. Imdahl, *Robert Delaunay: Light and
 Colour*, New York: Abrams, 1967, 39; see p. 61 and note 84 to chapter 2.

25 It was at this moment that the salon cubists began to meet on Sundays at the home
 of the Duchamp brothers in the suburb of Puteaux, in the company of friends and

sympathetic critics; this 'Puteaux group' was instrumental in salon cubism's develop-
ment from coterie to movement. The exhibitors in room 8 at the Salon d'Automne
were Duchamp, Duchamp-Villon, Gleizes, de la Fresnaye, Le Fauconnier, Léger,
Lhote, Metzinger, Moreau and de Segonzac – see A. Gleizes, *Souvenirs. Le Cubisme
1908–1914*, Paris: Cahiers Albert Gleizes, 1957, 27–8. The exhibition which followed
(it opened on 20 November, two weeks after the Salon d'Automne closed), was held
at the galerie d'Art ancien et d'Art contemporain, in the rue Tronchet, under the
auspices of the Société Normande de Peinture moderne which had held its first exhi-
bition in Rouen in 1909, and had been founded by painter Pierre Dumont, a friend of
the Duchamps from their time in that city.

26 Severini had lived in Paris since 1906, moved in the same circles (including that of the
Closerie des Lilas) as the salon cubists in 1911 and visited Gleizes's studio several times
in that year. His painting was thus perhaps known to the latter and his friends. See
Gino Severini, *The Life of a Painter*, trans. Jennifer Franchina, Princeton, NJ:
Princeton University Press, 1995, chs 2–4.

27 Exhibition catalogue, galerie Bernheim-Jeune, Paris. This English version is from the
catalogue of the 'Exhibition of Works by the Italian Futurist Painters', Sackville
Gallery, London, March 1912: Apollonio (ed.), *Futurist Manifestos*, 47.

28 In a letter written during his Paris trip Boccioni reports having visited these artists and
seen their work, and indicates his intention to visit 'Picasso, Braque and some others'
(among whom, given his prominence in cubist milieux at that time, was surely Robert
Delaunay); there is, however – tantalisingly – no documentation of this intention
having been fulfilled: letter to Signore Baer and Ruberl, 15 October 1911, in Maria
Drudi Gambillo and Teresa Fiori (eds), *Archivi del Futurismo*, 2 vols, 2nd edn, Rome:
de Luca, 1986, vol. 2, 39.

29 Apollinaire acknowledged their primacy in this, in 'Simultanisme-librettisme', *Les
Soirées de Paris*, 15 June 1914, 324, having two years earlier remarked upon their
original application (if not their introduction) of the term, in his review of their debut
exhibition at Benheim-Jeune. 'La vie artistique: les peintres futuristes italiens',
L'Intransigeant, 7 February 1912, reprinted in G. Apollinaire, *Apollinaire on Art: Essays
and Reviews 1902–1918*, trans. S. Suleiman, ed. L. C. Breunig, London: Thames &
Hudson, 1972, 199. For a survey of these avant-garde discussions, see Pär Bergman's
still-indispensable *Modernolatrià et Simultanéità*, Stockholm: Scandinavian University
Books, 1962, 263–78.

30 Vanessa R. Schwartz, *Spectacular Realities: Early Mass Culture in Fin-de-Siècle France*,
Berkeley and London: University of California Press, 1999, 171.

31 On the ideas circulating in the post-Abbaye milieu, see Christopher Green, *Léger and
the Avant-Garde*, New Haven, CT, and London: Yale University Press, 1976, ch. 1.

32 Among them Henri Guilbeaux's 'dynamisme', Nicolas Beauduin's 'paroxysme' and
Henri-Martin Barzun's 'simultanéisme' (aka 'dramatisme' – of which, more below).
Besides Bergman's *Modernolatrià et Simultanéità*, Michel Décaudin's *La Crise des
Valeurs symbolistes*, Toulouse: Privat, 1960, remains an irreplaceable guide to this field.

33 On Léger's enthusiasm for such visual contrasts, see his 'Les réalisations picturales
actuelles', a lecture given at the Académie Wassilieff, Paris, 9 May 1914; first published
in *Les Soirées de Paris*, 3, no. 25, (June 1914), 349–56, and reprinted in Fernand Léger,
Fonctions de la peinture, ed. Sylvie Forestier, Paris: Gallimard, 1997, 41–3.

34 The title in the Indépendants' catalogue was *Composition avec Personnages*; see Green,
Léger and the Avant-Garde, 320 n1.

35 Marcel Duchamp quoted in M. Le Bot, *Francis Picabia et la Crise des Valeurs figuratifs*, Paris: Klincksieck, 1968, 51; Georges Ribemont-Dessaignes, *Déjà jadis*, Paris: Juillard, 1958, 30. On the affair of Duchamp's painting, see *ibid.*, 38; also Pierre Cabanne, *Entretiens avecv Marcel Duchamp*, Paris: Belfond, 1967, 21–2 and 51.

36 Albert Gleizes and Jean Metzinger, *Du 'Cubisme'*, Paris: Figuière, 1912; in English, *Modern Artists on Art*, ed. and trans. R. Herbert, New York: Prentice-Hall, 1964, 15.

37 'Ils se sont permis de tourner autour de l'objet pour en donner, sous le contrôle de l'intelligence, une représentation concrète faite de plusieurs aspects successifs': '"Cubisme" et tradition', *Paris-Journal*, 16 August 1911, 5.

38 *Du 'Cubisme'* (ed. and trans. Herbert), 8.

39 'C'est le Nombre qui fait la part des sons et des silences, des lumières et des ombres, des formes et des vides. Michel-Ange et Bach m'apparaissaient comme de divins calculateurs': Jean Metzinger, *Le Cubisme Etait Né*, Paris: Présence, 1972, 20.

40 'Cette science me donna le goût des arts … Déjà je sentais que la mathématique seule permet l'oeuvre durable. Qu'elle soit le résultat d'une patiente étude ou d'une fulgurante intuition, elle est seule capable de réduire à la stricte unité d'une messe, d'une fresque ou d'un buste nos diversités pathétiques': *ibid.*

41 On *Du 'Cubisme'* and other statements of aesthetic principle by cubist painters, and the relation of these to the rising tide of nationalism, see chapter 5.

42 On these discursive underpinnings, see Mark Antliff, *Inventing Bergson: Cultural Politics and the Parisian Avant-Garde*, Princeton, NJ: Princeton University Press, 1993, chapter 4; see also chapter 8, this book.

43 See chapter 5.

44 Reviewing the Salon d'Automne in *Les Ecrits français*, 'avant-premier' number, November 1913.

45 On this systematic approach see A. Gleizes, *La Peinture et ses lois*, Paris: Cahiers Albert Gleizes, 1924, and Peter Brooke, *Albert Gleizes: For and Against the Twentieth Century*, New Haven, CT, and London: Yale University Press, 2001, chapter 8.

46 Daniel Robbins, 'Albert Gleizes: reason and faith in modern painting', in *Albert Gleizes 1881–1953*, exh. cat., New York: Solomon R. Guggenheim Museum, 1964, 17.

47 The final version of this painting that was exhibited at the salon is no longer extant, and is known only through black-and-white photographs (see e.g. *ibid.*, figure 4); at 220 x 187 cm it was much larger than the final study shown here, but in all other respects the two works appear very similar.

48 The reference to the newsreel, though no source for it is given, is made in Daniel Robbins, 'Le Fauconnier and cubism', in *Henri Le Fauconnier (1881–1946): A Pioneer Cubist*, exh. cat., New York: Salander–O'Reilly Galleries, 1990, n.p.

49 It is significant that Le Fauconnier took no part in the Salon de la Section d'or exhibition that was held concurrently with the Salon d'Automne of 1912, instead choosing to hold a major solo retrospective at the annual salon of the Moderne Kunst Kring in Amsterdam – the city that he would make his home from August 1914.

50 G. Apollinaire, *L'Intransigeant*, 22 March 1910, reprinted in *Apollinaire on Art: Essays and Reviews 1902–1918*, trans. Susan Suleiman, ed. L. C. Breunig, London: Thames & Hudson, 1972, 73. The notice was doubtless, it must be said, in deference to Le Fauconnier, whose work the critic was beginning to promote; Appolinaire had four, days earlier, written that the artist 'is directing his experiments towards majesty and nobility, going so far even as to sacrifice beauty': *ibid.*, 68.

51 It is significant that after his 1910 appreciation in Maroussia's work of qualities that he was ready to ascribe also to those of a male artist, Apollinaire's review of her room 41 entries spoke only of her 'instinctive canvases ... imbued with gaiety and feeling' – registering what was clearly a gendered decline in achievement: *ibid.*, 152. For biographical information on Maroussia I am indebted to Le Fauconnier's nephew, the late M. J. Sevin.

52 'A dater du jour où nous avons vécu ensemble, je me suis mise au second plan': Sonia Delaunay, *Nous irons jusqu'au soleil*, 67; see also Sherry Buckberrough, 'A biographical sketch: eighty years of creativity', in *Sonia Delaunay: A Retrospective*, Buffalo, NY: Albright–Knox Art Gallery, 1980, 21.

53 'Si je ne suis pas devenue peintre cubiste, c'est que je ne jamais pu. Je n'en étais pas capable, mais leurs recherches me passionnent.' 'Si je me sens si loin des peintres, c'est parce qu'ils sont des hommes ... Leurs discussions, leurs recherches, leur génie, m'ont toujours étonnée ... le génie de l'homme m'intimide –': Marie Laurencin, *Le Carnet des Nuits*, Geneva: Cailler, 1956 (1942), 22 and 16.

54 'On est venu pour une exposition avec vous chez Barbazanges, mais cher Ami quelles pauvretés j'aurai à envoyer – pour vous et pour moi, cela m'ennuie ... Cela me tracasse bien, et pour une seule raison c'est que je doute la qualité de mon envoi': undated letter from Marie Laurencin to Robert Delaunay, Musée National d'Art Moderne, Paris, Fonds Delaunay, boîte 28. I am indebted to Mme Anne-Marie Zucchelli for permission to consult these archives.

55 '[J]e me sens parfaitement à l'aise avec tout ce qui est féminin: petite, j'aimais les fils de soie, je volais les perles, les bobines de couleur; je croyais les bien cacher et, seule, je les regardais. J'aurais voulu avoir beaucoup d'enfants pour les peigner et leur mettre des rubans': Laurencin, *Le Carnet des Nuits*, 16. On the performance of femininity, see Joan Rivière, 'Womanliness as masquerade', in Victor Burgin, James Donald and Cora Kaplan (eds), *Formations of Fantasy*, New York: Methuen, 1986.

56 André Salmon, *La Jeune Peinture française*, Paris: Société des Trente–Albert Messein, 1912, 111, 115–16.

57 R. Felski, *The Gender of Modernity*, Cambridge, MA, and London: Harvard University Press, 24–5; Peter Wollen, '"Out of the past": fashion/orientalism/the body', *New Formations*, 1 (spring 1987), reprinted with revisions in Peter Wollen, *Raiding the Icebox: Reflections on Twentieth-Century Culture*, London and New York: Verso, 1993, 17, 29.

58 Pascal Rousseau, 'Visions simultanées: l'optique de Robert Delaunay', *Robert Delaunay 1906–1914*, 84–5.

59 See chapter 4.

60 Most of Delaunay's writings remained unpublished during his lifetime, however; see Robert Delaunay, *Du Cubisme à l'Art abstrait* (cited in note 4).

61 *Ibid.*, 146–7.

62 '[U]n art des contrastes simultanés, *des formes de la couleur ... La ligne c'est la limite. La couleur donne la profondeur* (non perspective, *non successive*, mais *simultanée*) *et sa forme et son mouvement*. La vision simultanée des futuristes est dans un tout autre sens ... Dynamisme successif, machiniste en peinture, ainsi que cela ressort de leur manifeste. C'est un mouvement machiniste et non vivant': *ibid.*, 110 (italics in original).

63 'Du sujet dans la peinture moderne', reprinted in translation in *Apollinaire on Art*, ed. Breunig, 197–8; on Apollinaire's ideas here expressed, and their development into his

conception of pictorial 'orphism', see Spate, *Orphism*, 71–81, who suggests also the relevance for them of Frank Kupka's recent *Amorpha* paintings.

64 Sherry Buckberrough, 'The simultaneous content of Robert Delaunay's Windows', *Arts Magazine* (September 1979), 106 and 111, n33.

65 Paul Klee, *Journal*, Paris: Grasset, 1959, 256.

66 Gerd Henninger, 'Paul Klee und Robert Delaunay', *Quadrum*, 3 (1957), 137–41, cited in *Robert Delaunay 1906–1914*, 167.

67 On the dating of the works in this series see Spate, *Orphism*, Appendix C, and Pascal Rousseau, 'Fenêtres', in *Robert Delaunay 1906–1914*, 164–71. My brief account of them is indebted to the latter's meticulous and detailed analyses, and to the essay by Georges Rocque, 'Les vibrations colorées de Delaunay: une des voies de l'abstraction', in the same volume.

68 'Si l'Art s'apparente *à l'Objet*, il devient *descriptif, divisionniste, littéraire*': 'La Lumière', in Delaunay, *Du Cubisme à l'Art abstrait*, 146; see also Spate, *Orphism*, 376.

69 For Robert Delaunay's 1912 links with Kandinsky, Marc, Klee and others see his correspondence of that year collected in Robert Delaunay, *Du Cubisme à l'Art abstrait*. On his break with cubism see his letter of April 1912 to Kandinsky, *ibid.*, 178–9, and his open letter to the critic Louis Vauxcelles, 'Des origines du cubisme', *Gil Blas*, 25 October 1912, 4; see also chapter 5, note 87.

70 On these interpretations and their cultural politics, see Antliff, *Inventing Bergson*.

71 'Through the Salon des Indépendants', Supplement to *Montjoie!* 18 March 1913; reprinted in translation in *Apollinaire on Art*, ed. Breunig, 290–1.

72 For a detailed guide and references to this see Bergman, *Modernolatrià et Simultanéità*, 270–1.

73 André Salmon noted the appearance of the prospectus in *Gil Blas*, 11 October 1913; see *Sonia and Robert Delaunay*, exh. cat., Paris: Bibliothèque Nationale, 1977, 35.

74 'Texte peinture simultané' was one term, and 'présentation synchrome' another, given by the authors to this work on the poster designed by Sonia to accompany its publication – it is uncertain whether this was ever printed and used: *ibid.*, 36–7.

75 *Ibid.*, 316; for a detailed description of this work and an English translation of Cendrars's poem, see Monica Strauss, 'The first simultaneous book', *Fine Print*, 13 (July 1987), 139–50.

76 Barzun's protest was a typewritten tract circulated to the press, entitled 'La Poésie simultanée honorée d'un nouveau plagiat métèque', and signed 'Les Antagonistes': see e.g. *Gil Blas*, 16 October 1913, and *Paris-Journal*, 24 October 1913. His manifesto-essay 'Après le symbolisme: L'art poétique d'un idéal nouveau. Voix, rythmes et chants simultanées' appeared in *Poème et Drame*, 1, no. 4 (May 1913).

77 Bergman, *Modernolatrià et Simultanéità*, 302–3.

Chapter 4

1 Salmon, 'Courrier des Ateliers', *Paris-Journal*, 3 October 1911, 4.

2 See chapter 5.

3 Albert Gleizes and Jean Metzinger, *Du 'Cubisme'*, Paris: Figuière, 1912; in English, *Modern Artists on Art*, trans. and ed. R. Herbert, New York: Prentice-Hall, 1964, 16.

4 *Ibid.*, 6.

5 *Ibid.*, 5.

6 Roger Allard, 'Le Salon des Indépendants', *La Revue de France et des Pays français*, 2, March 1912, 68.

7 'Pour la première fois il éclaira de la vertu du sourire une figure cubique': André Salmon, 'Le Salon des Indépendants', *Paris-Journal*, 19 March 1912, 5.

8 Apollinaire, 'The Salon d'Automne', *Poésie* (autumn 1910); reprinted in translation in *Apollinaire on Art: Essays and Reviews 1902–1918*, ed. L. C. Breunig, London: Thames & Hudson, 1972, 114.

9 On fashion in the avant-guerre, see Nancy Troy, *Couture Culture*, Cambridge, MA: MIT Press, 2002; Valerie Steele, *Paris Fashion: A Cultural History*, Oxford and New York: Oxford University Press, 1988; Cristina Nuzzi (intro.), *Fashion in Paris: From the 'Journal des Dames et des Modes', 1912–1913*, London: Thames & Hudson, 1980.

10 See, e.g., Ami Chantre, 'Les reliures d'André Mare', *L'Art décoratif* (December 1913), 251.

11 Troy's *Couture Culture* offers a rich body of evidence in opening up a fresh perspective on the relations between the fashion industry and artistic avant-gardism in the period. See also Peter Wollen, 'Out of the past: fashion/orientalism/the body', *New Formations*, 1 (spring 1987); reprinted with revisions in Wollen, *Raiding the Icebox: Reflections on Twentieth-Century Culture*, London and New York: Verso, 1993; Paul Poiret, *En Habillant l'Epoque* (1930), Paris: Bernard Grasset, 1987.

12 On Poiret's celebrated 'mille et deuxième nuit', his 1911 fancy-dress party tribute to the Ballets Russes' orientalism, see *Poiret le Magnifique*, exh. cat., Paris: Musée Jacquemart-André, 1974.

13 Valerie Steele, *Paris Fashion*, 220, 223.

14 'Metzinger n'a certes perdu ni la finesse ni la distinction de sa palette, mais une certaine minutie qu'on y remarque, donne à ses toiles un air maniéré qui justifierait presque le mot plaisant sur la "peinture spirite"': Roger Allard, 'Le Salon d'Automne (suite)', *La Cote*, 1 (October 1912), 4.

15 'Ce portrait d'une tenue sévère et académique, séduira par sa finesse et surtout par la sûreté de son exècution. Le charme très prenant qu'elle dégage atteste le raffinement de sensibilité de J. Metzinger. Personne ne s'étonnera de ce qu'on puisse le comparer à Renoir don't il a la grâce, l'enjouement et plusieurs des meilleures qualités': Maurice Raynal, 'L'exposition de la Section d'or', *La Section d'or*, 1 (October 1912), 3.

16 See, e.g., Nuzzi (intro.), *Fashion in Paris*, plates 6, 8, 12.

17 Linda Dalrymple Henderson, *The Fourth Dimension and Non-Euclidean Geometry in Modern Art*, Princeton, NJ: Princeton University Press, 1983.

18 On these interests in the Puteaux circle see chapter 5.

19 Andreas Huyssen, 'Mass culture as woman: modernism's other', in *After the Great Divide: Modernism, Mass Culture and Postmodernism*, London: Macmillan, 1988, 47, 50–1.

20 *Ibid.*, 52.

21 Rita Felski, *The Gender of Modernity*, Cambridge, MA, and London: Harvard University Press, 1995, 61–2. See also Mica Nava, 'Modernity's disavowal: women, the city and the department store', in Mica Nava and Alan O'Shea (eds), *Modern Times: Reflections on a Century of English Modernity*, London and New York: Routledge, 1996. Nava's endnotes provide a comprehensive bibliography on this subject.

22 Daniel-Henry Kahnweiler with Francis Cremieux, *Mes Galeries et Mes Peintres: Entretiens avec Francis Cremieux*, Paris: Gallimard, 1961, 57.

23 Stanley Barron in collaboration with Jacques Damase, *Sonia Delaunay: The Life of an Artist*, London: Thames & Hudson, 1995, 32.

24 I owe to Fay Brauer the observation that the hobble skirt which his reputation has credited Poiret with introducing was in fact a creation of Jeanne Paquin.

25 Blaise Cendrars, *Du Monde entier: Poésies complètes: 1912–1924*, Preface by Paul Morand, Paris: Gallimard, 1967.

26 Donald E. Gordon, *Modern Art Exhibitions 1900–1916*, 2 vols, Munich: Prestel Verlag, 1974, vol 2, 293.

27 'A dater du jour où nous avons vécu ensemble, je me suis mise au second plan': Sonia Delaunay, *Nous irons jusqu'au soleil*, Paris: Laffont, 1978, 67. See also p. 98, this book.

28 Susan Suleiman, *Subversive Intent: Gender, Politics and the Avant-Garde*, Cambridge, MA, and London: Harvard University Press, 1990, 27. On the Delaunays' artistic partnership see also W. Chadwick, 'Living simultaneously: Sonia and Robert Delaunay', in W. Chadwick and I. de Courtivron, *Significant Others: Creativity and Intimate Partnership*, London: Thames & Hudson, 1993, 31–48.

29 Sherry Buckberrough, 'A biographical sketch: eighty years of creativity', in *Sonia Delaunay: A Retrospective*, Buffalo, NY: Albright–Knox Art Gallery, 1980, 21. On the Union centrale campaign, see Debora Silverman, *Art Nouveau in Fin-de-Siècle France: Politics, Psychology and Style*, Berkeley: University of California Press, 1989.

30 See chapter 1, note 75.

31 See chapter 1.

32 Recounted in F. Meyer, 'Robert Delaunay, hommage à Blériot', *Jahresberichte der Öffentlichen kunstsammlungen*, Basel, 1962, 67–78.

33 Michel Hoog suggests that this scene was a composite adaptation from two of Rousseau's paintings: 'La Ville de Paris de Robert Delaunay: sources et développement', *Revue du Louvre*, no. 1 (1965), 29–38.

34 'Futurist painting: technical manifesto', published as a leaflet by *Poesia* (Milan), 11 February 1911. English translation in Umbro Apollonio (ed.), *Futurist Manifestos*, London: Thames & Hudson, 1973, 31.

35 Gordon, *Modern Art Exhibitions 1900–1916*, vol 1, 211.

36 'The Salon des Indépendants', *L'Intransigeant*, 20 March 1912; reprinted in *Apollinaire on Art*, 212.

37 The painting was the final, and largest, version of a project that had yielded two earlier versions; see *Robert Delaunay 1906–1914. De l'Impressionnisme à l'abstraction*, exh. cat., Paris: Centre Georges Pompidou, 1999, 191 and 192.

38 On the characteristic formal differences between Robert and Sonia's paintings see V. Spate, *Orphism: The Evolution of Non-Figurative Painting in Paris 1910–1914*, Oxford: Oxford University Press, 1979, 202.

39 These were their sole entries to that year's Indépendants.

40 See p. 103 and note 74 to chapter 3.

41 In this context it is significant that in 1914 Robert submitted a painting of fairground entertainment, *Electric Carousel*, to the Salon des Artistes français – the most conservative of all the salons – where it was refused by the jury: Pascal Rousseau, 'Biographie', in *Robert Delaunay 1906–1914*, 48.

42 Daniel Abadie, 'Sonia Delaunay, à la lettre', in *Art et Publicité 1890–1990*, Paris: Centre Pompidou, 1990, 344–5.

43 On the *Cubist House* see my essay 'The *Maison cubiste* and the meaning of modernism in pre-1914 France', in Eve Blau and Nancy J. Troy (eds), *Architecture and Cubism*,

Montreal, Cambridge, MA, and London: MIT Press–Canadian Centre for Architecture, 1998, 17–40; also, *inter alia*, Nancy J. Troy, *Modernism and the Decorative Arts in France: Art Nouveau to Le Corbusier*, New Haven, CT, and London: Yale University Press, 1991, 79–97; see also chapter 1, n8.

44 Kirk Varnedoe, 'Words', in Kirk Varnedoe and Adam Gopnik, *High & Low: Modern Art/Popular Culture*, New York: Museum of Modern Art, 1991, 39.

45 *Ibid.*, 23.

46 The song was *Dernière chanson*, sung by Harry Fragson; for the details of this source for the phrase, see Jeffrey Weiss, *The Popular Culture of Modern Art: Picasso, Duchamp and Avant-Gardism*, New Haven, CT, and London: Yale University Press, 3.

47 See William Rubin, *Picasso in the Collection of the Museum of Modern Art*, New York: Museum of Modern Art, 1972, 68–70.

48 Pierre Daix, 'Braque et Picasso au temps des papiers collés', in Isabelle Monod-Fontaine (ed.), *Georges Braque: les papiers collés*, exh. cat., Paris: Centre Georges Pompidou, 1982, 17.

49 Robert Rosenblum, 'Still Life with Chair Caning', in *Picasso, from the Musée Picasso, Paris*, exh. cat., Minneapolis: Walker Art Centre, 1980, 43; Christine Poggi, *In Defiance of Painting: Cubism, Futurism and the Invention of Collage*, New Haven, CT, and London: Yale University Press, 1992, 62.

50 *Ibid.*, 67.

51 Yve-Alain Bois, 'The semiology of cubism', in William Rubin and Lynn Zelevansky (eds), *Picasso and Braque: A Symposium*, New York: Museum of Modern Art, 1992, 186–7; see also his discussion of two essays by Walter Benjamin that explore this binarism in relation to painting, drawing and writing, in Y. A. Bois, *Painting as Model*, Cambridge, MA: MIT Press, 1990, 178–80. For an assessment of his argument see chapter 7, this book.

52 Rosalind Krauss, 'The cubist epoch', *Artforum*, 9 no. 6 (February 1971), 33.

53 Varnedoe, 'Words', 36. Not everyone, however, appreciated their qualities, as is revealed by the letter of 17 June 1912 to Kahnweiler in which Picasso wrote from Céret: 'You tell me that Uhde does not like my recent paintings where I use Ripolin and flags. Perhaps we shall succeed in disgusting everyone, and we haven't said everything yet ...': quoted in Judith Cousins with Pierre Daix, 'Documentary chronology', in W. Rubin, *Picasso and Braque: Pioneeering Cubism*, New York: Museum of Modern Art, 1989, 395.

54 See p. 113.

55 Varnedoe, 'Words', 35–6.

56 P. Bourdieu, *Distinction: A Social Critique of the Judgement of Taste*, trans. R. Nice, London: Routledge, 1986, 254.

57 *Ibid.*, 282–3; see chapter 1.

58 P. Bourdieu, 'The field of cultural production, or: the economic world reversed' (1983) in P. Bourdieu, *The Field of Cultural Production: Essays on Art and Literature*, ed. Randal Johnson, London: Polity Press, 1993, 30; see pp. 5–6 and note 16 to chapter 1.

59 Lisa Tickner, 'Men's work? Masculinity and modernism', in Norman Bryson, Michael Ann Holly and Keith Moxey (eds), *Visual Culture: Images and Interpretations*, Hanover, New England, and London: Wesleyan University Press, 1994, 48–82.

60 On this initative and its formal implications see, *inter alia*, Christine Poggi, 'Braque's early papiers collés: the certainties of Faux Bois', in Rubin and Zelevansky (eds), *Picasso and Braque: A Symposium*, 138–9, and Pierre Daix, 'Braque et Picasso', 19.

61 Cousins with Daix, 'Documentary chronology', 403.

62 William Rubin, 'Picasso and Braque: an introduction', in *Picasso and Braque: Pioneering Cubism*, 30–5.

63 *Ibid.*, 33, and 57–8, n63.

64 *Ibid.*, 34–5.

65 Cousins and Daix, 'Documentary chronology', 407.

66 Rubin, 'Picasso and Braque: an introduction', 31–2.

67 Edward F. Fry, 'Picasso, cubism and reflexivity', *Art Journal*, 47, no. 4 (winter 1988), 296–310.

68 Daniel-Henry Kahnweiler, Preface to Brassaï, *The Sculptures of Picasso*, trans. A. D. B. Sylvester, London: Rodney Phillips, 1949, n.p.; Yve-Alain Bois, 'Kahnweiler's lesson', *Representations*, 18 (spring 1987), 33–68; revised version in Bois, *Painting As Model*, 65–97; see also Bois, 'The semiology of cubism', 172–4.

69 Pierre Daix and Joan Rosselet, *Picasso: The Cubist Years 1907–1916*, London: Thames & Hudson, 1979, note to cat. 513; Anne Baldassari, *Picasso: Working on Paper*, trans. George Collins, London and Dublin: Merrell Publishers–Irish Museum of Modern Art, 2000, 71.

70 Bois, 'The semiology of cubism', 188.

71 Robert Rosenblum, 'Picasso and the typography of cubism', in John Golding and Roland Penrose (eds), *Picasso 1881–1973*, London: Elek, 1973, 75. The essay was based on a paper given at the College Art Association conference of 1965. Contributions to the subsequent debate are simply too numerous to list here; for a selection, see the notes to chapter 7.

72 Those who have given extended consideration to Braque's *papiers-collés* are, however, few enough to cite here: principal among them are Isabelle Monod-Fontaine (ed.), *Georges Braque: Les Papiers collés*, exh. cat., Paris: Centre Georges Pompidou; Wendy Holmes, 'Decoding collage: signs and surfaces', in Katherine Hoffman (ed.), *Collage: Critical Views*, Ann Arbor: University of Michigan Research Press, 1989, 193–212; Christine Poggi, *In Defiance of Painting: Cubism, Futurism and the Invention of Collage*, New Haven, CT, and London: Yale University Press, 1992; Mark Roskill, 'Braque's papiers collés and the feminine side to cubism', in Rubin and Zelevansky (eds), *Picasso and Braque: A Symposium*, 222–39; Stephen Scobie, *Earthquakes and Explorations: Language and Painting from Cubism to Concrete Poetry*, Toronto: University of Toronto Press, 1997, ch. 5.

73 Molly Nesbit, *Their Common Sense*, London: Black Dog, 2000, sees Weiss's reading of French avant-guerre popular culture as 'a curious, and decidedly American, bourgeois construction' in its 'scrupulous avoidance' of questions of sex and class: *ibid.*, 330, n1. His argument 'seems unnecessarily narrow' in its exclusive reading of Picasso's collages in relation to the forms of music-hall: *ibid.*, 367, n32.

74 *Ibid.* Nesbit also faults Krauss, Poggi and myself for not having 'tried to see the newpaper page itself as a form in mutation', and argues that the 'hierarchical terms avant-garde and kitsch … belong to a slightly later phase of twentieth-century culture, when a bourgeois mass culture had acquired more definition and more consistency': *ibid.*

75 For a fuller presentation both of the debate that has been conducted over Picasso's *papiers-collés* and of this argument, see my *Cubism in the Shadow of War: The Avant-Garde and Politics in Paris, 1905–1914*, New Haven, CT, and London: Yale University Press, 1998, chapter 5.

76 See chapter 5, this book.

77 F. F. Ridley, *Revolutionary Syndicalism in France*, Cambridge: Cambridge University Press, 1968, 60; see also chapter 1, this book.

78 As late as 27 July 1914 a call for a protest demonstration made at four hours' notice by the proscribed paper *La Bataille syndicaliste* brought between 30,000 (the police estimate) and 100,000 people (*La Bataille syndicaliste*'s estimate) onto the streets of Paris: A. Kriegel and J. J. Becker, *1914: La Guerre et le Mouvement ouvrier français*, Paris: Armand Colin, 1964, 65–8, 188, n30.

79 On Salmon's 'patriotisme esthétique', see L. Werth, 'Le réveil du patriotisme', *Les Cahiers d'Aujourd'hui*, 5 June 1913, 226–7. On Salmon and anarchist milieux, see P. Leighten, *Re-Ordering the Universe*, Princeton, NJ: Princeton University Press, 1989, 69–73 (though Leighten draws different conclusions from the biographical data here presented). On Werth and other pro-syndicalist intellectuals, see Cottington, *Cubism in the Shadow of War*, 80–4.

80 Leighten, *Re-Ordering the Universe*, 126–134; and 'Cubist anachronisms: ahistoricity, cryptoformalism, and business-as-usual in New York', *Oxford Art Journal*, 17, (1994), no. 2, 96–9.

81 Scholars have suggested numerous private referents for the headline 'La Bataille s'est engagé[e]', including Picasso's rivalries with Braque, Matisse, and the cubists then exhibiting at the Salon de la Section d'or; for a reprise of those alternatives see Rubin and Zelevansky (eds), *Picasso and Braque: A Symposium*, 153, 161–3.

Chapter 5

1 Jeffrey Weiss, *The Popular Culture of Modern Art: Picasso, Duchamp and Avant-Gardism*, New Haven, CT, and London: Yale University Press, 1994, 52.

2 Marinetti's manifesto appeared in *Le Figaro*, 20 February, 1909, 1; Mauclair, 'Le préjugé de la nouveauté dans l'art moderne', *La Revue*, 1 April 1909, 289–302. See Weiss, *The Popular Culture of Modern Art*, 52–6.

3 Anon., 'Echos', *Le Figaro*, 24 March 1909, 1, cited in Weiss, *Popular Culture of Modern Art*.

4 The pre-1914 period as yet lacks the equivalent of Martha Ward's invaluable profile of art journalism in 1890s' Paris, but her conclusions are often also relevant for the later decade; see Martha Ward, 'From art criticism to art news: journalistic reviewing in late-nineteenth-century Paris', in Michael R. Orwicz (ed.), *Art Criticism and its Institutions in Nineeenth-Century France*, Manchester and New York: Manchester University Press, 1994, 162–81.

5 'On assure que les cubistes travaillent, non plus dans des ateliers, mais dans les laboratoires'; 'Au lieu de devoir leurs rapports de couleurs à l'interprétation directe de la nature, ils les ont surpris en observant les nuances insoupçonnables qui naissent d'une réaction chimique … les transformations merveilleuses qui s'opèrent au fond des cornues et des "eprouvettes"': Michel Puy, 'Beaux arts: les indépendants', *Les Marges* (July 1911), 27. '[Q]u'ils pourraient … employer plus utilement dans l'industie leur répartition mathématique des couleurs': Régis Gignoux, 'La vie de Paris: les cubistes', *Le Figaro*, 24 September 1911, 1.

6 6 '[C]es bipèdes du parallélépipède … leurs élucubrations, cubes, succubes et incubes!': *Gil Blas*, 30 September 1911, 1.

7 'On ne se souci pas d'autre chose que du décor, de l'ornementation, de l'atmosphère
 colorée, ou plutôt coloriée, de la vie courante, de la vie superficielle, électrique, matéri-
 aliste, tourbillonnante, torrentueuse, trépidante d'impatience, avide de secousses, inca-
 pable de recueillement, impropre à la contemplation, hostile à la pensée, qui est ce que
 nous croyons être notre vie': Arsène Alexandre, 'L'age décoratif', *Comoedia*, 14
 October 1911, 3.

8 'Et dire que peut-être, l'an prochain, quand un nouveau chef d'école âgé de huit ans
 aura découvert un nouveau système plus abracadabrant encore, les cubistes seront
 traités de pompiers! C'est le sort de toutes les surenchères. Les cubistes méprisent
 les fauves. Qui méprisera les cubistes?': Louis Vauxcelles, *Gil Blas*, 30 September
 1911, 1.

9 See chapter 2.

10 '[P]ersonne n'aurait pu penser qu'il y eût là objet à scandale. Et nous les premiers qui
 n'en aurions jamais voulu. A cette époque on avait encore la pudeur de ses actes et le
 fait d'exposer des peintures, conçues dans un esprit quelque peu différent de celui de
 l'entourage, n'entraînait nullement l'intention d'ameuter les foules. Aussi, notre
 surprise fut grande quand, le jour du vernissage, l'explosion se produisit': Gleizes,
 Souvenirs. Le Cubisme 1908–1914, Paris: Cahiers Albert Gleizes, 1957, 19.

11 Régis Gignoux's article cited in note 5 was based on one such interview.

12 Albert Gleizes, 'L'art et ses représentants: Jean Metzinger', *La Revue indépendante*, 4
 (September 1911), 161–72; 'Les beaux-arts: à propos du Salon d'Automne', *Les
 Bandeaux d'or* (November 1911), 42–51; A. Arnyvelde, 'Contribution à l'histoire du
 cubisme', *Gil Blas*, 2 January 1912, 3.

13 'Ceux qui l'on nomme les cubistes tâchent à imiter les maîtres, s'efforçant à façonner
 des types nouveaux'. Jean Meztinger, '"Cubisme" et tradition', *Paris-Journal*, 16
 August 1911, 5.

14 '[L]eur conception aussi respectable, somme toute, que celle des *impressionnistes* et des
 pointillistes': Gleizes, 'Les beaux-arts', 46. In his newspaper gossip column André
 Salmon wryly registered this concern for legitimacy in a reference to 'the cubists,
 whom we would call today's revolutionaries, if they hadn't called themselves
 tomorrow's classics' ('les *Cubistes*, que nous nommerions les révolutionnaires d'au-
 jord'hui, s'ils ne se proclamaient les classiques de demain'): 'Courrier des arts', *Paris-
 Journal*, 13 November 1911, 4.

15 As André Salmon testified in his *Paris-Journal* gossip column: the pile of angry
 letters he received in response to a recent piece on a cubist painter included 'some
 [that] begged me not to favourise an art that was a peril to the nation' ('quelques uns
 m'adjurent de ne pas favoriser un art considéré comme un péril national'). 'Les
 expositions: l'art contemporain (galerie d'Art Contemporain)', *Paris-Journal*, 21
 November 1911, 4.

16 On Allard, see Mark Antliff, *Inventing Bergson: Cultural Politics and the Parisian
 Avant-Garde*, Princeton, NJ: Princeton University Press, 1993, ch. 1; on Apollinaire,
 see *Apollinaire on Art: Essays and Reviews 1902–1918*, trans. S. Suleiman, ed. L. C.
 Breunig, London: Thames & Hudson, 1972; Harry E. Buckley, *Guillaume Apollinaire
 as an Art Critic*, Ann Arbor: University of Michigan Research Press, 1981; Walter L.
 Adamson, 'Apollinaire's politics: modernism, nationalism, and the public sphere in
 avant-garde Paris', *Modernism/Modernity*, 6 (1999), no. 3, 33–56; on both, see my
 Cubism in the Shadow of War: The Avant-Garde and Politics in Paris 1905–1914, New
 Haven, CT, and London: Yale University Press, 1998.

17 See 'Young artists: Picasso the painter', *La Plume*, 15 May 1905, reprinted in English translation in *Apollinaire on Art*, 14–16.

18 *Le Pyrée* was published in *Gil Blas*, 4 May 1908; it was included, as *Le Brasier*, in Apollinaire's volume of poems *Alcools*, Paris: Mercure de France, 1913. *Les Fiançailles* was published in *Pan* (November 1908), and also included in *Alcools*. See V. Spate, *Orphism: The Evolution of Non-Figurative Painting in Paris, 1910–1914*, Oxford: Oxford University Press, 1979, 56.

19 'La Phalange nouvelle', in *La Poésie symboliste*, Paris: Salon des Indépendants, 1908.

20 'The three plastic virtues', *Catalogue de la III Exposition du Cercle de l'Art moderne*, City Hall, Le Havre, June 1908; reprinted in *Apollinaire on Art*, 47–9.

21 *Apollinaire on Art*, 51–2.

22 Apollinaire, 'The Georges Desvalliéres exhibition', *L'Intransigeant*, 7 June 1910; *Apollinaire on Art*, 98.

23 See, e.g., *Apollinaire on Art*, 114, 117, 122, 125.

24 'The Salon des Indépendants: today's young artists and the new disciplines', *L'Intransigeant*, 21 April 1911, reprinted *ibid.*, 151; Preface to the *Catalogue du 8 Salon Annuel du Cercle d'Art 'Les Indépendants' au Musée Moderne de Bruxelles*, Musée Moderne de Bruxelles, June 1911, reprinted *ibid.*, 172.

25 *L'Intransigeant*, 10 October 1911, reprinted in translation in *Apollinaire on Art*, 182.

26 As well as Allard, André Salmon's gossip column in *Paris-Journal* was regularly supportive, as was Alexandre Mercereau in his writing for many little reviews both in Paris and elsewhere (notably Russia). Other support came from Joseph Granié, Jacques Nayral, Léon Rosenthal, Michel Puy and André Warnod.

27 Olivier Hourcade, 'La Tendance de la peinture contemporaine', *La Revue de France et des Pays français*, 1 (February 1912), 35–41. Hourcade had founded *Les Marches du Sud-Ouest* in 1911, in which Allard's keynote essay championing the salon cubists, 'Sur Quelques peintres', had appeared that June; the change of name in early 1912 accompanied a move to a more overt cultural politics.

28 For accounts of the exhibition and of Apollinaire's lecture, see Salmon, 'Les expositions', *Paris-Journal*, 21 November, 4; Roger Allard in *La Cote*, 20 and 25 November; Louis Vauxcelles in *Gil Blas*, 26 November.

29 On both levels of this widespread interest, see Linda Dalrymple Henderson's encyclopaedic volumes *The Fourth Dimension and Non-Euclidean Geometry in Modern Art*, Princeton, NJ: Princeton University Press, 1983, and *Duchamp in Context: Science and Technology in the Large Glass and Related Works*, Princeton, NJ: Princeton University Press, 1998.

30 On Princet, see E. Fry, *Cubism*, New York and Toronto: McGraw-Hill, 1966, 61; Jean Metzinger, *Le Cubisme etait né*, Paris: Présence, 1972, 43, 57; Didier Ottinger, 'Le secret de la Section d'or. Maurice Princet au pays de la quatrième dimension', in *La Section d'or 1912–1920–1925*, exh. cat., Musées de Châteauroux–Musée Fabre Montpellier, Paris: Cercle d'Art, 2000, 63–8.

31 See chapter 2.

32 Spate notes that Kupka, who was close to the Puteaux milieu if not a participant in its meetings (and who lived nearby), had been a medium: *Orphism*, 27. Mercereau, a founder-member of the Abbaye, was secretary and co-founder also of the Société internationale des Recherches psychiques, and a contributor in 1911 to a spiritualist magazine, *La Vie mystérieuse*.

33 The likeliest source for their ideas about the golden section is the treatise by the monk Desiderius of Lenz which, translated by former *nabi* Serusier in 1905 as the *Esthétique de Beuron*, had some currency in the neo-symbolist milieux overlapped by Puteaux; see M. Neveux and H. Huntley, *Le Nombre d'or, Radiographie d'un Mythe, suivi de la divine proportion*, Paris: Seuil, 1995; also R. Herz-Fischler, 'Le Nombre d'or en France de 1896 à 1927', *Revue de l'Art*, 118 (1997), no. 4, 9–16.

34 '[D]es discussion passionés don't il semblait que dût dépendre le sort de l'esprit humain': Georges Ribemont-Dessaignes, *Déjà Jadis*, Paris: Juillard, 1958, 3.

35 '[P]etit, mince, précieux, maniant le paradoxe, d'un esprit rapide, souvent cinglant et prompt aux réparties spirituelles, cependant enclin à se lancer deans des discussions abstraites'; 'tirer sinon les marrons du feu, du moins les lois, et construire le monument du cubisme': *ibid.*, 34.

36 Announcement of its imminent publication appeared as early as March 1912, and again in October; it was eventually published, it seems, in November – although a recent claim that it was reprinted twelve times before the end of 1912 further confuses the issue. See Cécile Debray, 'La Section d'or 1912–1920–1925', *La Section d'or 1912–1920–1925*, 19–41.

37 A. Gleizes and J. Metzinger, *Du 'Cubisme'*, Paris: Figuière, 1912; English translation, *Modern Artists on Art*, trans. and ed. R. Herbert New York: Prentice-Hall, 1964, 18.

38 John Nash, 'The nature of cubism: a study of conflicting explanations', *Art History*, 3, no. 4 (December 1980), 441.

39 Gleizes and Metzinger, *Modern Artists on Art*, 7.

40 Christopher Green, *Juan Gris*, exh. cat., London: Whitechapel Art Gallery, 1992, 118, 302.

41 *Ibid.*, 303.

42 *Ibid.*, 17–18.

43 John Golding, *Cubism: A History and an Analysis, 1907–1914*, 2nd edn, London: Faber & Faber, 1968, 29.

44 See, *inter alia*, John E. Bowlt and Matthew Drutt (eds), *Amazons of the Avant-Garde*, London: Royal Academy of Arts, 1999.

45 See D. Cottington, 'Cubism and the politics of culture in France, 1905–1914', unpublished PhD thesis, London University, 1985, chs 4 and 7.

46 Bruce Altshuler, *The Avant-Garde in Exhibition*, New York: Abrams, 1994; Donald E. Gordon, *Modern Art Exhibitions, 1900–1916*, Munich: Prestel-Verlag, 1974.

47 '[L]'art gothique, qui est l'art le plus essentiellement français, l'art de notre race, né spontanément sur notre sol': quoted by André Tudesq, 'Du Cubisme et de ses détracteurs: une querelle autour de quelque toiles', *Paris-Midi*, 4 October 1912, 1.

48 '[Le] véritable sens de la tradition française … qui s'oppose violémment à la détestable influence italienne, triste héritage de la Renaissance du seizième siècle, cet attentat à notre génie national': quoted by Henriquez-Phillipe, 'Le cubisme devant les artistes', *Les Annales politiques et littéraires*, 1536 (1 December 1912), 475.

49 Albert Gleizes, 'Le cubisme et la tradition', *Montjoie!*, 1 (10 February 1913), 4; 2 (25 February 1913), 2–3.

50 Mark Antliff, 'Cubism, celtism and the body politic', *Art Bulletin*, 74, no. 4 (December 1992), 655–68; see also his *Inventing Bergson*, chapter 4.

51 Antliff, 'Cubism, celtism and the body politic', 656–7.

52 Herman Lebovics, *True France: The Wars over Cultural Identity, 1900–1945*, Ithaca, NY, and London: Cornell University Press, 1992, 3–8, 142–8; see also Pierre Nora

(ed.), *Lieux de mémoire: La République*, Paris: Gallimard, 1984; Raoul Girardet, *Mythes et Mythologies politiques*, Paris: Seuil, 1989.

53 'Le monde moderne est devenu breton et il s'en honore': Adrien Mithouard, *Traité de l'Occident*, 5. See chapter 2, this book.

54 Reprinted in Marie-Noëll Pradel, 'La *Maison cubiste* en 1912', *Art de France*, 1 (1961), 179.

55 Raymond Duchamp-Villon, 'L'architecture et le fer', *Poème et Drame*, 7 (January–March 1914), 22–9, reprinted in translation in George Heard Hamilton and William C. Agee, *Raymond Duchamp-Villon*, New York: Walker, 1967, 114–17; see p. 77 and note 12 to chapter 3.

56 'L'art d'aujourd'hui se rattache à l'art gothique à travers tout ce que les écoles inter-médiaires ont eu de véritablement français de Poussin à Ingres, de Delacroix à Manet, de Cézanne à Seurat, de Renoir au Douanier Rousseau, cette humble, mais si expres-sive expression de l'art français. La vitalité de cet art énergique et infini qui est issu du sol de la France nous offre un merveilleux spectacle': Guillaume Apollinaire, 'La pein-ture nouvelle', *Les Soirées de Paris*, 4 (May 1912), 113–15.

57 *Les Soirées de Paris* was founded in February 1912 by Apollinaire and his friends André Billy (who acted as editor), René Dalize, André Salmon and André Tudesq, originally – apparantly – as a way of raising Apollinaire's spirits after the trauma of his imprison-ment in the Santé prison on suspicion of stealing the *Mona Lisa* from the Louvre: see Francis Steegmuller, *Apollinaire: Poet Among the Painters*, Harmondsworth: Penguin, 1973, 198–201; also André Billy, *Le Pont des Saints-Pères*, Paris: Fayard, 1947, 93–6. Lack of funds interrupted publication in June 1913, but a second series began that November, with Apollinaire as editor. On the character and aesthetic position of the magazine, see Alexandra Parigoris, 'Les constructions cubistes dans "Les Soirées de Paris": Apollinaire, Picasso et les clichés Kahnweiler', *Revue de l'Art*, 82 (1988), 61–74.

58 Henri-Martin Barzun, 'D'un art poétique moderne: du lyrique au dramatique', *Poème et Drame*, 1, no. 1 (November 1912), 74–83.

59 'Il nous faut, en cet an 1912, lever des cohortes d'athlètes et des légions des pionniers pour défricher et ensemencer ce siècle neuf, pour révéler l'Ere nouvelle…': *ibid.*, 83.

60 See *Poème et Drame*, 1, no. 2 (January 1913), 64, and 2, no. 7 (January–March 1914), 84.

61 On Picabia's role in the planning of the exhibition see Gabrielle Buffet-Picabia, *Rencontres*, Paris: Belfond, 1977, 67; Nicolas Beauduin, 'Les temps héroïques: à propos du Salon de la Section d'or', *Masques et Visages*, 39 (June 1956), 6–7; and Marc Le Bot, *Francis Picabia et la Crise des Valeurs figuratives*, Paris: Klincksieck, 1968, 52.

62 The many accounts of the Salon de la Section d'or that have been offered differ widely in their details: see Beauduin, 'Les temps héroïques', 6; William A. Camfield, 'La Section d'or', unpublished MA thesis, Yale University, 1961; Golding, *Cubism*, 32–3; Green, *Juan Gris*, 47, n116; Spate, *Orphism*, Appendix A, 367–9; and M. Raynal, *Modern Painting*, Geneva: Skira, 1956, 145. For the most recent assessments of the project and its likely participants see the essays in *La Section d'or 1912–1920–1925*.

63 Kahnweiler's commercial strategy combined a rigorous withholding of the work of his artists from all exhibitions in Paris, with maximum exposure of those artists in other cities across Europe and elsewhere; see chapter 1.

64 On cubism and caricature see Adam Gopnik, 'High and low: caricature, primitivism, and the cubist portrait', *Art Journal* (winter 1983), 371–6; Kirk Varnedoe and Adam Gopnik, 'Caricature', in *High and Low: Modern Art and Popular Culture*, New York:

Museum of Modern Art, 1990, 123–34 and 418–19; Christopher Green, 'Figures of artifice and substance', in *Juan Gris*, 113–25.

65 See chapter 2, this book.

66 Green, *Juan Gris*, 38.

67 William A. Camfield, 'Juan Gris and the golden section', *Art Bulletin*, 47 (March 1965), 128–34.

68 'You want to know why I had to stick on a piece of mirror?' Gris asked Michel Leiris, ten years later. 'Well, surfaces can be re-created and volumes interpreted in a picture, but what is one to do about a mirror whose surface is always changing and which should reflect even the spectator? There is nothing else to do but stick on a real piece': quoted in Daniel-Henry Kahnweiler, *Juan Gris: His Life and Work*, trans. Douglas Cooper, London: Lund Humphries, 1947, 87–8.

69 *Letters of Juan Gris, 1913–1927*, collected by Daniel-Henry Kahnweiler, trans. Douglas Cooper, London: the author (self-published), 1956, letter 3, n2.

70 John Richardson, *A Life of Picasso*, vol. 2: *1907–1917*, London: Pimlico, 1997, 67; Pierre Daix, *Dictionnaire Picasso*, Paris: Laffont, 1995, 779; Edward F. Fry, *Cubism*, New York and Toronto: McGraw-Hill, 1966, 93.

71 *Salon de Juin: troisième exposition de la Société Normande de Peinture moderne*, exh. cat., Rouen, 15 June–15 July 1912, 9–11; reprinted in English translation in Fry, *Cubism*, 91, 92.

72 'Conception et vision', *Gil Blas*, 29 August 1912; Fry, *Cubism*, 96. The terms 'realist' and 'autonomist' are Paul Crowther's: see his 'Cubism, Kant and ideology', *Word and Image*, 3, no. 2 (April–June 1987), 196.

73 'Quelle plus belle idée que cette conception d'une peinture *pure* et qui ne soit par conséquent ni descriptive, ni anecdotique, ni psychologique, ni morale, ni sentimentale, ni pédagogique, ni enfin décorative? Je ne dis pas que ces dernières façons de comprendre la peinture soient à négliger mais on ne peut contester, en effet, qu'elles soient irrémédiablement inférieures. La peinture, en effet, ne doit être qu'un art dérivé de l'étude des formes dans un but désintéressé, c'est-à-dire sans aucun des buts que je viens de citer': Raynal, 'L'exposition de "La Section d'or"', *La Section d'or*, 1 (October 1912), 3.

74 The two paragraphs on Metzinger are indeed a masterpiece of ambivalence masquerading as fulsome praise, from which it must have been clear to the informed reader that Raynal, at least, would go far in his profession.

75 Gris's gesture 'has led to many discussions' ('Ce fait a amené bien des discussions'), he reported somewhat obscurely: Raynal, 'L'exposition de "La Section d'or"', 3.

76 *Ibid.*

77 'Jeunes peintres ne vous frappez pas!', *La Section d'or*, 1 (October 1912), 1.

78 Apollinaire stayed with Robert and Sonia Delaunay during November and December 1912 after leaving his apartment in Auteuil and before settling into his new one in Saint-Germain des Prés, and gained a first-hand acquaintance with their recent work and ideas on colour, cubism and abstraction. On his lecture at the exhibition, see Beauduin, 'Les temps héroïques', 6, and Cabanne, *L'Epopée du Cubisme*, Paris: Table Ronde, 1963, 210–11, 227. Delaunay later recalled that Apollinaire had 'wanted the experiments and questionings of artists to join in a common front in the face of the incomprehension of the public and art lovers' ('il voulait que les inquiétudes et les recherches des artistes fassent une masse, un front unique devant l'incompréhension du public et des amateurs de l'époque'): Robert Delaunay, *Du Cubisme à l'Art abstrait*, ed. Pierre Francastel, Paris: SEVPEN, 1957, 172.

79 Cabanne, *L'Epopée du Cubisme*, 230–1, who reads the lukewarm review that Apollinaire gave Salmon's booklet in *L'Intransigeant* as cooled by this irritation, since *Les Peintres cubistes* was not published until April the following year. Cabanne also suggests that Apollinaire's pamphlet originated in a suggestion by the publisher Eugène Figuière, who was impressed by his gallery lecture, that it and other writings on art by the poet be published as the first volume in a new series that he would produce, entitled 'Tous les arts', under Apollinaire's general editorship; this series never materialised: *ibid.*, 217.

80 Apollinaire to Soffici, letter of 4 July 1913, published in 'Vingt lettres de Guillaume Apollinaire à Ardengo Soffici', *Le Flâneur des Deux Rives*, 4 (December 1954), 4.

81 Guillaume Apollinaire, *The Cubist Painters: Aesthetic Meditations*, trans. Lionel Abel, New York: Wittenborn 1970 (1949), 17–18.

82 Spate, *Orphism*, 72–3. 'Zone', probably written in the second half of 1912, was first published in *Les Soirées de Paris*, 11 (December 1912); the same issue also carried Apollinaire's transcription of notes by Robert Delaunay on painting entitled 'Réalité, peinture pure'.

83 Spate, *Orphism*, 38.

84 '[A] vrai dire cette précision eut été omise si certaines tentatives, dont nous parlons plus loin, ne commandaient à chacun de prendre nettement ses responsabilités': *La Cote*, 30 September 1912, 4.

85 'Art et curiosité. Les commencements du cubisme', *Le Temps*, 14 October 1912; reprinted in Guillaume Apollinaire, *Chroniques d'Art 1902–1918*, ed. L. C. Breunig, Paris: Gallimard, 1960, 340–3.

86 '[Q]ue certains … des mes amis tendent à confondre cubisme et cubisme'; 'Que tel bon critique dise donc que la peinture de son favori est de la peinture "pure", je n'y vois pas d'inconvénient. Que, pour cela, l'art de Metzinger, celui de Gleizes, celui de Le Fauconnier, celui de Léger, soient exclusivement de la peinture pure, voilà qu'il n'est pas absolument juste. Et ce sont pourtant ces quatre peintres-là qui, avec Delaunay, ont, en 1910 et surtout aux Indépendants de 1911, *crée*, et sont véritablement le cubisme …': Olivier Hourcade, 'Discussions. A. M. Vauxcelles', *Paris-Journal*, 23 October 1912, 4.

87 Delaunay wrote a letter to Louis Vauxcelles that was published in *Gil Blas*, under the headline 'Des Origines du cubisme', on 25 October 1912, 4: 'I do not share the ill-founded opinion of M. Hourcade, who proclaims me a creator of cubism, with four of my colleagues and friends', he declared in it. 'It was without my knowledge that some young painters made use of my earlier studies. They have recently exhibited some canvases that they call cubist. I am not exhibiting. Only some friends, some artists and critics know the direction that my art has followed.' ('Je ne me rallie pas à l'opinion, qui est injustement basée, de M. Hourcade, qui me proclame créateur du cubisme, avec quatre de mes confrères et amis. C'est à mon insu que quelques jeunes peintres se sont servis de mes anciennes études. Ils ont exposé dernièrement des toiles qu'ils appellent toiles cubistes. Je n'expose pas. Seuls des amis, des artistes et critiques savent la direction qu'a prise mon art.')

88 Letter of 5 April 1912; see chapter 3 note 69.

89 Organised by the Folkwang Museum of Hagen, this briefly secured his international reputation.

90 See p. 92. Although he felt obliged to comply with the request, Duchamp later admitted that it had shocked him, and contributed to his decision to leave the Puteaux milieu entirely; he spent the summer of 1912 in Munich. 'It was a real turning-point in my life',

he recalled; 'I saw that I would never be much interested in groups after that': Pierre Cabanne, *Entretiens avec Marcel Duchamp*, Paris: Belfond, 1967, 21–2, 51; see also Calvin Tomkins, *Duchamp: A Biography*, London: Pimlico, 1998, 83; and Jerrold Seigel, *The Private Worlds of Marcel Duchamp: Desire, Liberation and the Self in Modern Culture*, Berkeley and London: University of California Press, 1995, 61.

91 Cabanne, *L'Epopée du Cubisme*, 203.

92 Paul Matisse, 'Some more nonsense about Duchamp', *Art in America* (April 1980), 79.

93 Tomkins, *Duchamp*, 32–6.

94 *Ibid.*, and see also Pierre Cabanne, *Dialogues with Marcel Duchamp*, trans. Ron Padgett, London: Thames & Hudson, 1971, 16.

95 Cabanne, *Dialogues*, 37–8.

96 '[B]asically I've never worked for a living. I consider working for a living slightly imbecilic from an economic point of view. I hope that some day we'll be able to live without being obliged to work': *ibid.*, 15.

97 On such stylistic appropriations by Duchamp see Dalia Judovitz, *Unpacking Duchamp: Art in Transit*, Berkeley, Los Angeles and London: University of California Press, 1995, 21.

98 *The Complete Works of Marcel Duchamp*, ed. Arturo Schwarz, New York: Abrams, 1969, cited in Tomkins, *Duchamp*, 53; see also Seigel, *The Private Worlds*, 34–5.

99 Seigel, *The Private Worlds*, 41.

100 Cabanne, *Dialogues with Marcel Duchamp*, 30. As Duchamp there recalled, *The Chess Game*, painted in August 1910, had been exhibited in that year's Salon d'Automne. It was followed in October 1911 by *The Chess Players*, and by the *Portrait of Chess Players* in December. The series on movement of winter 1911–12 included *Sad Young Man on a Train*, also completed in December 1911, and *Nude Descending a Staircase No. 1*, of December 1911–January 1912: Cabanne, *ibid.*, 26–30. The last of the series was *The King and Queen Surrounded by Swift Nudes* of May 1912

101 David Joselit, *Infinite Regress: Marcel Duchamp 1910–1941*, Cambridge, MA, and London: MIT Press, 1998, 27. Joselit follows Rosalind Krauss and Yve-Alain Bois in his interpretation of gallery cubism; see chapter 7, this book, for discussion of its implications.

102 *Ibid.*, 23.

103 E.-J. Marey, La Méthode graphique dans les Sciences expérimentales et principalement en Physiologie et Médecine, Paris: G. Masson, 1878, i, trans. and quoted in ibid., 54.

104 Seigel, *The Private Worlds*, 77, and on Roussel generally, 75–85.

105 Duchamp readily agreed to Pierre Cabanne's suggestion of this correspondence, in their discussion of this period of work: Cabanne, *Dialogues with Marcel Duchamp*, 33–4. On Duchamp's developing commitment in his work of between 1910 and 1912 to exploring the limits of painting's communicability and the consequences of exceeding them, see Seigel, *The Private Worlds*, 52, 60, 74–5.

106 On Laforgue's importance for Duchamp see, e.g., Tomkins, *Duchamp*, 88–9; on symbolist poetry, see Cabanne, *Dialogues with Marcel Duchamp*, 34, and Ades, Cox and Hopkins, *Marcel Duchamp*, 38–41.

107 Thierry de Duve, 'The readymade and the tube of paint', *Artforum* (May 1986), 111.

108 Seigel, *The Private Worlds*, 75.

109 Joselit, Infinite Regress, 55.

110 *Ibid.*, 56.

111 *Ibid.*, 204, n44; see also chapter 8, this book.

Chapter 6

1 Christopher Green, *Cubism and its Enemies: Modern Movements and Reaction in French Art, 1916–1928*, New Haven, CT, and London: Yale University Press, 1987, 13.

2 Roger Allard, 'La vie artistique. Le Salon d'Automne', *Les Ecrits français*, avant-premier no. (launch issue) (November 1913), 3

3 Apollinaire, Braque, Duchamp-Villon, Gleizes (initially), Hourcade, Léger and Mare were among those who went to fight, while Le Fauconnier, the Delaunays, Duchamp and Picabia, Kahnweiler and Uhde, and (later) Gleizes went into exile.

4 Green, *Cubism and its Enemies*, 14.

5 Daniel-Henry Kahnweiler, *Der Weg zum Kubismus*, Munich: Delphin, 1920. The first four chapters (which comprised the bulk of the essay) were published in the periodical *Die weissen Blätter* (Zurich and Leipzig) in September 1916; see also notes 20 and 31.

6 Daniel-Henry Kahnweiler, *The Rise of Cubism*, trans. Henry Aronson, New York: Wittenborn, Schultz, 1949, 1.

7 Daniel Robbins, 'Abbreviated historiography of cubism', *Art Journal*, 47, no. 4 (winter 1988), 277–83.

8 Kahnweiler, The Rise of Cubism, 7.

9 *Ibid.*, 10.

10 *Ibid.*, 12.

11 *Ibid.*

12 Immanuel Kant, *The Critique of Pure Reason*, trans. Norman Kemp-Smith, London: Macmillan, 1973, 48; quoted in Paul Crowther, 'Cubism, Kant and ideology', *Word and Image*, 3, no. 2 (April–June 1987), 196.

13 *Ibid.*, 198.

14 'MM Matisse et Picasso auront occasionné des ravages dans les cervelles naïves de leur petits successeurs. Je pourrais citer dix, quinze de ces enfantelets qui commencent tous par avoir 'du génie'. Un peu de talent ne messiérait point. Je livre à leur cognition cette parole féconde d'un grand écrivain français, Fustel de Coulanges: "il faut donner dix ans à l'analyse avant de consacrer une heure à la synthèse"': Louis Vauxcelles in *Gil Blas*, 20 March 1908; quoted in Lynn Gamwell, *Cubist Criticism*, Ann Arbor: University of Michigan Research Press, 1980, 152, n41.

15 'On finira bien par comprendre qu'un tableau n'est pas un tapis, que la déformation n'est pas une esthétique, que la synthèse ne se tente qu'après de longues analyses … et qu'on ne se refait pas en 1910 l'état d'âme de Giotto, moins encore celui de l'homme des cavernes' ('One will end by understanding that a painting is not a tapestry, that deformation is not an aesthetic, that synthesis can happen only after long analyses … and that one cannot recreate in 1910 the state of mind of Giotto, far less that of cavemen'): Camille Mauclair, responding to J. C. Holl's 'Enquête sur l'orientation actuelle de la peinture moderne', *Revue du Temps présent*, 2 April 1911, 317.

16 '[U]n art qui … offre dans leur plénitude picturale, à l'intelligence du spectateur, les éléments essentiels d'une synthèse située dans la durée. Les parentés analytiques des objets et leurs subordinations mutuelles importent peu désormais, puisque supprimées dans la réalisation peinte': Roger Allard, 'Au Salon d'Automne de Paris', *L'Art libre*, 2, no. 12 (November 1910), 442.

17 'Il veut développer le champ visuel en le multipliant, pour l'inscrire dans l'espace de la toile même: c'est alors que le cube jouera un rôle et c'est là que Metzinger utilisera ce

moyen pour rétablir un équilibre que ces audacieuses inscriptions auront momentané-
ment rompu': Albert Gleizes, 'L'Art et ses représentants: Jean Metzinger', *La Revue
indépendante*, 4 (September 1911), 166. Metzinger's explanation had come in his essay
'"Cubisme" et tradition', *Paris-Journal*, 4 August 1911, 5.

18 'Il éprouve, comprend, organise: le tableau ne sera transposition ni schéma, nous y
contemplerons l'équivalent sensible et vivant d'une idée, l'image totale. Thèse,
antithèse, synthèse, la vieille formule subit une énergique interversion dans la substance
des deux premiers termes: Picasso s'avoue réaliste': Jean Metzinger, 'Note sur la pein-
ture', *Pan* (November 1911), 650.

19 Maurice Raynal, Preface, *Salon de Juin: Troisième Exposition de la Société Normande de
Peinture moderne*, exh. cat., Rouen, 15 June–15 July 1912; reprinted in translation in
Edward F. Fry, *Cubism*, New York and Toronto: McGraw-Hill, 1966, 92.

20 When he wrote the manuscript, that distance was geographical in that he was in neutral
Switzerland for the duration of the war; the booklet's publication in 1920 gave it a
temporal distance from its subject matter (the larger part of which concerned Picasso's
and Braque's paintings and *papiers-collés* through 1913, although the section on Léger
was added in 1919).

21 Crowther, 'Cubism, Kant and ideology', 196–7; in his article Crowther offers an exten-
sive and very helpful critique of the range of Kantian concepts deployed by the
contemporary critics of cubism.

22 For an analysis of the relation between these two senses of the term and its role in the
art market, see Pierre Bourdieu, 'The production of belief: contribution to an economy
of symbolic goods' (trans. Richard Nice), *Media, Culture & Society*, 2–3 (July 1980),
261–93; reprinted in Pierre Bourdieu, *The Field of Cultural Production*, ed. Randal
Johnson, Cambridge: Polity, 1993, 74–111.

23 Kahnweiler, *The Rise of Cubism*, 6–7.

24 *Ibid.*, 7, 12, 15.

25 T. J. Clark, *Farewell to an Idea: Episodes from a History of Modernism*, New Haven, CT,
and London: Yale University Press, 1999, 175.

26 *Ibid.*, 192; see chapter 8, this book.

27 Joseph Low (Pepe) Karmel, 'Picasso's laboratory: the role of his drawings in the devel-
opment of cubism, 1910–1914', unpublished PhD thesis, New York University, 1993,
321. Since this book was written, Karmel has published a developed version of his
thesis as *Picasso and the Invention of Cubism* (New Haven and London: Yale University
Press, 2003).

28 *Ibid.*, 325.

29 *Ibid.*, 53.

30 *Ibid.*, 326. A potential which Picasso found the means to explore and express, as Adam
Gopnik was among the first to note, through his love of cartoons; see p. 51.

31 'What did [Picasso and Braque] want? On the one hand, to recover the unity of art, but
on the other, to give the maximum of information about the object represented. This
period of cubism – the end of which came in around 1914 – one can legitimately call its
analytic period' ('Que voulait-ils? D'une part, retrouver l'unité de l'oeuvre d'art, mais,
de l'autre, donner le maximum de renseignements sur l'objet représenté. Cette période
du cubisme – dont la fin peut se situer vers 1914 – on peut l'appeler à juste titre sa
période analytique'): 'Accomplissement classique du cubisme. Juan Gris', chapter 5 of
'La Montée du cubisme', in D. H. Kahnweiler, *Confessions esthétiques*, Paris: Gallimard,
43. Two pages later, writing of Gris's use of collaged materials, he added: 'Here his

spirit of research met an obstacle. True, the assimilation [of such materials] succeeded, but the assimilated object was "distorted", suffered to a degree. This might seem adventitious; but cubism was too realistic an art, in the profoundest sense of the term, not to be disturbed by this. Each of the cubists then sought a solution in keeping with his own nature. The directions taken by Picasso and Braque might well be labelled synthetic cubism …' ('Mais c'est ici que son esprit de recherche rencontre un obstacle. Certes, l'assimilation réussit, mais l'objet assimilé se trouvait "déformé", il souffrait en quelque sorte . Cela peut paraître accessoire; mais le cubisme était un art trop réaliste au sens le plus profond du terme pour ne pas s'en formaliser. Chacun des cubistes chercha donc une solution conforme à sa nature propre. Les voies de Picasso et de Braque peuvent bien être taxées de cubisme synthétique …'): *ibid.*, 45.

32 Christopher Green, *Juan Gris*, exh. cat., London: Whitechapel Art Gallery, 1992, 33.

33 For details of this contestation see Green's *Cubism and its Enemies*; also Kenneth E. Silver, *Esprit de Corps: The Art of the Parisian Avant-Garde and the First World War, 1914–1925*, London: Thames & Hudson, 1989.

34 The phrase is that of Gustave Kahn, once a supporter of cubism; quoted in Green, *Cubism and its Enemies*, 9.

35 '[M[es toiles commencent à avoir une unité dont avant elles manquaient. Ce ne sont plus ces inventaires d'objets qui tant me décourageaient autrefois': letter of 26 March 1915 to Kahnweiler, reprinted in Douglas Cooper, *Letters of Juan Gris, 1913–1927*, London: the author, 1956, letter 31.

36 Christopher Green, 'Synthesis and the "synthetic process" in the paintings of Juan Gris 1915–19', *Art History*, 5, no. 1 (March 1982), 89.

37 Green, *Cubism and its Enemies*, 25.

38 Green, 'Synthesis and the "synthetic process"', 101.

39 Daniel-Henry Kahnweiler, *Juan Gris: His Life and Work*, trans. Douglas Cooper, London: Lund Humphries, 1947, 104.

40 'Je travaille avec les éléments de l'esprit … j'essaie de concrétiser ce qui est abstrait … Mon art est un art de synthèse, un art déductif …': Juan Gris, from a statement made under the pseudonym Vauvrecy (used by Amedée Ozenfant), *L'Esprit nouveau*, 5 (February 1921), 534.

41 Juan Gris, 'Reply to the questionnaire: "Chez les cubistes"', *Bulletin de la Vie artistique*, 6th year, no. 1 (January 1925), 15–17; reprinted in Kahnweiler, *Juan Gris*, 145.

42 Kahnweiler, 'Accomplissement classique du cubisme. Juan Gris', 45.

43 *Ibid.*, 51.

44 The suggestion is William Rubin's: see 'Picasso and Braque: an introduction', in William Rubin, *Picasso and Braque: Pioneering Cubism*, New York: Museum of Modern Art, 1989, 55–6.

45 '1910–1914: Période qui peut être dite celle du CUBISME ANALYTIQUE. C'est la phase 'héroïque' du cubisme…1914–1918. Vers 1914, commence ce qu'on appelle fréquemment [*sic*] le CUBISME SYNTHÉTIQUE. A la description des objets par détails séparés dont la somme restituait les objets primitifs, se substitue une manière moins énumérative d'en rendre compte': Anon., 'Notice documentaire', *Documents* (Paris), 2nd year (1930), no. 3, 180–1.

46 Kahnweiler, The Rise of Cubism, 12.

47 'Les objets sont précieux, comme signes stables de nos actions. On apprécie la ressemblance comme une assurance sur la vie. Le monde comme tautologie': Carl Einstein, 'Notes sur le cubisme', *Documents* (Paris) 1st year (1929), no. 3, 153–4.

48 'La possibilité de répéter les choses tranquilliait ceux qui craignaient la mort. Le monde des doubles picturaux répondait à un besoin d'éternité … Un culte d'ancêtres était pratiqué à l'égard des objets; dans les natures mortes, symboles des joies de la propriété, on éternisait les dindons tués, les raisins et les asperges … Quel truquage d'éternité!': *ibid.*, 147.

49 'Étonnement des miracles, sentiment des lacunes, multiplicité de sens des objets, tout cela s'évanouit au profit d'une répétition rassurante … Mais cette tendance à la réproduction se paie par la diminution de la création.

'Ce furent les cubistes qui ébranlèrent l'objet toujours identique à lui-même, c'est-à-dire la mémoire dans laquelle les notions sont adaptées les unes aux autres. Leur mérite principal est d'avoir détruit les images mnémoniques. La tautologie donne l'illusion de l'immortalité des choses, et c'est au moyen des images descriptives qu'on cherche à éviter l'anéantissement du monde par l'oubli.

'Ils séparèrent l'image de l'objet, éliminèrent la mémoire, et firent du motif une figuration simultanée et plane des représentations de volume:' *ibid.*, 154.

50 'On ne peut pas rendre les sensations d'une table elle-même, mais seulement nos sensations propres, et une table représentée dans un tableau n'a de sens que si la somme de sensations très mêlées qu'on appelle *table* est soumise aux conditions techniques du tableau. Il fallut détruire l'héritage mnémonique des objets, c'est-à-dire oublier, et le tableau devint non la fiction d'une autre réalité, mais une réalité avec ses propres conditions […]

'La condition première est la surface. On ne travaille plus entre deux couches imaginaires qui dépassent la toile. Maintenant, la totalisation du tableau s'opère par son invérifiabilité, et le fait que le spectateur ne sort pas de la réalité du tableau et que la vision de l'artiste n'est pas interrompue par l'observation. On s'isole et on oublie': *ibid.*

51 'Cette manière que nous décrivons est celle du cubisme analytique des environs de 1911': *ibid.*, 155.

52 'Il s'agit d'un processus mortel, et c'est le voyant qui commande, non le motif': *ibid.*, 154.

53 Clark, *Farewell to an Idea*, 186 and 424–5, n19. This and other essays by Einstein have recently been published in English in *October*, 107, Winter 2004, 'Carl Einstein: A Special Issue'.

54 For much of the material in this paragraph I am indebted to the essays and biographical information in V. Lahoda and O. Uhrova (eds), *Vincenc Kramár: From Old Masters to Picasso*, exh. cat., Prague: National Gallery, 2000.

55 Although he occasionally also bought paintings by Braque, including (in May 1913) the *Violin and Clarinet* of 1912 (plate XVII).

56 See p. 244, n37; also Vojtech Lahoda, 'In the mirror of cubism. Vincenc Kramár: the poetics of collecting and the collection of *Visual Poetry* – the half-open window to Europe', in Lahoda and Uhrova (eds), *Vincenc Kramár*, 21.

57 V. Kramár, *Kubismus*, Brno, 1921. This 88-page study, with 24 illustrations (23 Picassos and one Braque), was published initially in the Czech revue *Moravsko-slezská*, 15 (1921–22). Still untranslated from the Czech, it has in consequence suffered undue neglect, although the growing number of studies of Czech cubism in recent years has made fragments of it available in English: see especially Lahoda, 'In the mirror of cubism', 18–33. It has recently been published in French: see Vincent Kramár, *Le Cubisme*, ed. H. Klein and E. Abrams, Paris: Ecole Nationale Supérieure des Beaux-Arts, 2002.

This was not Kramár's first published account of cubism, however. An article of 1913 offers an instance of Kahnweiler's efforts to disseminate his understanding of cubism via his Czech client by other means. In a letter of December 1912 he wrote to the latter: 'Today I am sending you 13 photographs, Salmon's book [*La Jeune peinture française*, 1912] and "Le Cubisme" [*Du 'Cubisme'*, 1912] by Metzinger and Gleizes ... If anything else comes out at any time, I will inform you of it immediately or I will send it to you ... You will surely be writing the article in Czech. I hope there will be a translation of it in French, German or Italian magazines because I would very much like to read it. It will be the first article on Picasso written by an art specialist and someone who knows his subject.' Apparently not entirely confident of this last judgement, however, the dealer added by way of explanation: 'Salmon's book is pure journalism and nonsense. Metzinger and Gleizes base their ideas for the most part on banality, but they are still better than Salmon': Archives of the National Gallery, Prague, Kahnweiler Fund, AA 2945/280/1–93, quoted in translation in 'Elective affinities', in Lahoda and Uhrova (eds), *Vincenc Kramár*, 43. Kramár's article to which Kahnweiler refers appeared as 'Kapitola o -ismech ['Chapter on -isms']. K výstave Le Fauconnierove v Mnichove', in *Umelecky mesicnik*, 2 (1913), 115–30. It seems not to have been translated, however.

58 Kramár, *Kubismus*, quoted in 'Elective affinities', 27–8.

59 *Ibid.*, 24.

60 *Ibid.*, 25.

61 *Ibid.*, 27, n67.

62 In an article of 1925 comparing Picasso to Caravaggio, quoted *ibid.*, 26.

63 John Richardson with Marilyn McCully, *A Life of Picasso*, vol. 2: *1907–1917*, London: Pimlico, 1997, 308 and 467, n19.

64 Beverly Whitney Kean, *French Painters, Russian Collectors: The Merchant Patrons of Modern Art in Pre-Revolutionary Russia*, London: Hodder & Stoughton, 1994, ch. 8; see also p. 145 and chapter 7, this book.

65 On the Moscow milieux and social backgrounds of such artists and writers, and their publics, see Jane A. Sharp, 'The Russian avant-garde and its audience: Moscow, 1913', *MODERNISM/Modernity*, 6 (1999), no. 3, 91–116.

66 On the state of which, see V. Erlich, *Russian Formalism: History – Doctrine*, 3rd edn, New Haven, CT, and London: Yale University Press, 1981, 53.

67 *Ibid.*, 49; on the relations between futurism and formalism in Russia, see *ibid.*, ch. 3: 'The emergence of the formalist school'; also V. Markov, *Russian Futurism: A History*, London: MacGibbon & Kee, 1969.

68 Ivan Aksenov, *Pikasso i okresnosti*, Moscow: Centrifuge, 1917. Like Kramár's volume, this has yet to be translated although excerpts have appeared in English translation in recent years: see *A Picasso Anthology: Documents, Criticism, Reminiscences*, ed. Marilyn McCully, London: Arts Council of Great Britain–Thames & Hudson, 1981, 113–18, and T. J. Clark, *Farewell to an Idea*, 181–3.

69 Markov, *Russian Futurism*, 272–3; *A Picasso Anthology*, 118.

70 *A Picasso Anthology*, 114.

71 *Ibid.*, 115, and Clark, *Farewell to an Idea*, 181.

72 *A Picasso Anthology*, 117.

73 *Ibid.*, 115–17.

74 *Ibid.*, 118. The critical responses here dismissed by Aksenov are identifiable as, among others, those of Nikolay Berdyaev (for 'mysticism'), Georgy Chulkov (for 'demonism') and Yakov Tugenhold (for the 'fourth dimension'); see *ibid.*, 104–12 for examples of

their writing. Aksenov's countering of their interpretations of Picasso's art with an emphasis on 'craft' suggests an awareness also of Robert Delaunay's writings of that time (see this book pp. 75–6). Aksenov, who had visited Paris and probably met him, did plan a book on Delaunay, and published two poems entitled *La Tour Eifel* [*sic*] *I and II* in 1916: Markov, *Russian Futurism*, 272. In this awareness he was all but alone among Russian critics.

75 Sybil Gordon Kantor, *Alfred H. Barr, Jr., and the Intellectual Origins of the Museum of Modern Art*, Cambridge, MA: MIT Press, 2002.

76 Susan Noyes Platt, 'Modernism, formalism and politics: the "Cubism and Abstract Art" exhibition of 1936 at the Museum of Modern Art', *Art Journal*, 47, no. 4 (winter 1988), 286.

77 On these changes in the art market, see M. Gee, 'Dealers, critics and collectors of modern painting: aspects of the Parisian art market, 1910–1930', unpublished PhD thesis, University of London, 1977. Their common orientation to this market should not mask the differences between Barr's and Kramár's art historical methodologies; for the latter, see Pavla Sadílkova, 'The beginnings of Kramár's art history studies: between gothic architecture and the theory of art', in Lahoda and Uhrova (eds), *Vincenc Kramár*, 124–9.

78 A(lfred) H. B(arr), Jr, 'Foreword', in *Painting in Paris from Amercan Collections*, exh. cat., New York: Museum of Modern Art, 1930, 11, quoted in Platt, 'Modernism, formalism and politics', 288.

79 *Ibid.*

80 *Ibid.*, 287.

81 *Ibid.*, 288–9.

82 Barr's exhibition catalogue – *Cubism and Abstract Art*, New York: Museum of Modern Art, 1936 – has since been reprinted three times: in 1966, 1974 and 1986.

83 *Ibid.*, 18.

84 *Ibid.*, 17.

85 Daniel Robbins, 'Abbreviated historiography of cubism', *Art Journal*, 47, no. 4 (winter 1988), 282. See also Christopher Green, *Art in France 1900–1940*, New Haven and London: Yale University Press, 2000. Green's comparison of Barr's 1936 exhibition with two equally ambitious Parisian surveys of modern art mounted the following year (pp. 12–14) and his brief discussion of 'analytic' and 'synthetic' cubism (pp. 94–9) which parallels in many respects that presented here, are especially valuable.

86 Barr, *Cubism and Abstract Art*, 78.

87 *Ibid.*, 15; Barr did, however, add a footnote to this observation, acknowledging and discussing a possibility which Meyer Schapiro had suggested in 'an interesting theory', namely that 'consciously or unconsciously the Cubists through their subject matter reveal significant preoccupation with the bohemian and artistic life'; hedging his bets, Barr concluded that 'the iconography of Cubism should not be ignored'.

88 *Ibid.*, 78.

89 Pierre Daix and Joan Rosselet, *Picasso: The Cubist Years, 1907–1916*, London: Thames & Hudson, 1979, cat. 291.

90 *Ibid.*, cat. 330.

91 All but the first quotation in this paragraph: *Barr, Cubism and Abstract Art*, 31.

92 *Ibid.*, 29 and 77.

93 Kahnweiler, *The Rise of Cubism*, 15.

94 Barr, *Cubism and Abstract Art*, 78.

95 *Ibid.*

96 *Ibid.*, 19. The second current, Barr wrote, 'has its principal source in the art and theo-
ries of Gauguin and his circle, flows through the Fauvisme of Matisse to the ... pre-war
paintings of Kandinsky': *ibid.*

97 Robbins, 'Abbreviated historiography of cubism', 280. Barr, as I have said, had been
preceded in the first two qualities of this formalism by Aksenov in Moscow, though in
terms the discursive specificity of which was to obstruct for sixty years the realisation
of their significance: see this book, p. 211.

98 Robbins, 'Abbreviated historiography of cubism', 278.

99 On this dynamic, and its consequences for art in New York, see Clement Greenberg,
'The late thirties in New York', in *Art and Culture: Critical Essays*, Boston, MA:
Beacon Press, 1961; Serge Guilbaut, *How New York Stole the Idea of Modern Art*,
Chicago, IL: University of Chicago Press, 1983; Dickran Tashjian, *A Boatload of
Madmen: Surrealism and the American Avant-Garde, 1920–1950*, London and New
York: Thames & Hudson, 2002.

100 Clement Greenberg, 'Avant-garde and kitsch', *Partisan Review* (fall 1939); reprinted in
Clement Greenberg, *The Collected Essays and Criticism*, vol. 1: *Perceptions and
Judgements, 1939–1944*, ed. John O'Brian, Chicago, IL, and London: University of
Chicago Press, 1986; on this article see the essays by T. J. Clark, Thomas Crow and
Michael Fried in Francis Frascina (ed.), *Pollock and After: The Critical Debate*,
London: Paul Chapman, 1985.

101 Greenberg, *Perceptions and Judgements*, 9.

102 *Ibid.*, 22.

103 *Ibid.*, 10–11.

104 *Partisan Review*, 7, no. 4 (July–August 1940), reprinted in Frascina (ed.), *Pollock and
After*, 35–46.

105 Obituary of Mondrian, *The Nation*, 4 March 1944; Greenberg, Perceptions and
Judgements, 187.

106 'The decline of cubism', *Partisan Review* (March 1948), reprinted in Clement
Greenberg, *The Collected Essays and Criticism*, vol. 2: *Arrogant Purpose, 1945–1949*,
ed. John O'Brian, Chicago, IL, and London: University of Chicago Press, 1986,
212.

107 *Ibid.*, 213–14.

108 'Reply to George L. K. Morris', *Partisan Review* (June 1948); reprinted in Greenberg,
Arrogant Purpose, 244–5.

109 *The Nation*, 27 November 1948; reprinted in Greenberg, *Arrogant Purpose*, 260, 259.

110 Barr, *Cubism and Abstract Art*, 78. Of course, Kahnweiler's understanding of this
realism as conceptual needs to be distinguished, within this convention, from Barr's
understanding of it as material.

111 'The pasted paper revolution', *Art News* (September 1958); reprinted in Clement
Greenberg, *The Collected Essays and Criticism*, vol. 4: *Modernism with a Vengeance,
1957–1969*, ed. John O'Brian, Chicago, IL, and London: University of Chicago Press,
1993, 64, 61. For a recent assessment of this essay and its relation to Greenberg's other
writings on collage see Lisa Florman, 'The flattening of "collage"', *October*, 102
(autumn 2002), 59–86.

112 John O'Brian, 'Introduction', in Clement Greenberg, *The Collected Essays and
Criticism*, vol. 3: *Affirmations and Refusals, 1950–1956*, ed. John O'Brian, Chicago, IL,
and London: University of Chicago Press, 1993, xxvii.

113 'The present prospects of American painting and sculpture', *Horizon* (October 1947); reprinted in Greenberg, *Arrogant Purpose*, 165.

114 *Ibid.*, 162.

115 *Ibid.*, 163.

116 'The plight of our culture', *Commentary* (June–July 1953); reprinted in Greenberg, *Affirmations and Refusals*, 140.

117 O'Brian, 'Introduction', *ibid.*, xxx.

118 'Collage', in *Art and Culture*, Boston: Beacon Press, 1961, 70–83.

119 The book's text was an enlargement of the catalogue of a 1939 retrospective that MoMA mounted, entitled 'Picasso: Forty Years of His Art'.

120 Alfred H. Barr, *Picasso: Fifty Years of His Art*, New York: Museum of Modern Art, 1946, 82.

121 *Juan Gris: Sa Vie, Son Oeuvre, Ses Ecrits*, Paris: Gallimard, 1946

122 *Ibid.*, 71, 78.

123 Dorothy M. Kosinski, 'Douglas Cooper', in *Douglas Cooper and the Masters of Cubism*, exh. cat., London: Tate Gallery, 1988, 19–25. Kosinski notes (13) that the funds that Cooper set aside for these purchases in 1932, amounted to one-third of the inheritance of the £100,000 into which he came in that year; this figure has since been corroborated by John Richardson in *The Sorcerer's Apprentice: Picasso, Provence and Douglas Cooper*, London: Jonathan Cape, 1999, 23, who also states (25) that this inheritance enabled Cooper to amass a collection of 137 cubist works by 1939.

124 *Braque. Paintings, 1909–1947*, London and Paris: Lindsay Drummond and Editions du Chêne, 1948; Daniel-Henry Kahnweiler, *Juan Gris: His Life and Work*; Douglas Cooper, *Fernand Léger et le nouvel espace*, London and Paris: Lund Humphries and Trois Collines, 1949.

125 Kosinski, 'Douglas Cooper', 19–25; Douglas Cooper, 'Early purchasers of true cubist art', in Douglas Cooper and Gary Tinterow, *The Essential Cubism: Braque, Picasso and Their Friends, 1907–1920*, exh. cat., London: Tate Gallery, 1983, 26–31.

126 Cooper, 'Early purchasers', 28.

127 *Ibid.*, 26–7; see also Gee, 'Dealers, critics and collectors of modern painting, 175–83; Green, *Cubism and its Enemies*, 136–8.

128 Cooper, 'Early purchasers', 25.

129 *Ibid.*, 31. Among the collectors of cubism who had bought paintings cheaply in the early 1920s was G. F. Reber, a German textile magnate, who put together, over the next few years, 'by far the largest collection of cubist and post-cubist art in private hands': Richardson, *The Sorcerer's Apprentice*, 26. It was from Reber's heavy losses on the Paris Bourse in the crash of 1929 that Cooper profited, in his turn, by buying the bulk of this collection from him through the 1930s at knock-down prices, acquiring in the process some of the finest cubist paintings he was to own: *ibid.*, 26–30.

130 Writing of the salon cubist painters in 1983, he declared: 'Generally speaking, the results, in terms of cubism, were pathetic': Douglas Cooper, 'Introduction', *The Essential Cubism*, 14.

131 These accounts were his catalogue for the exhibition 'The Cubist Epoch' that he organised for the Los Angeles County Museum and the Metropolitan Museum of Art, New York, in 1970–71 (D. Cooper, *The Cubist Epoch*, London: Phaidon, 1971) and that for 'The Essential Cubism' at the Tate in 1983. On Cooper's understanding of cubism see also Kosinski, 'Douglas Cooper', 32–3.

132 Cooper, 'Introduction', *The Essential Cubism*, 14.

133 Cooper, 'Introduction', *The Cubist Epoch*, 13–15
134 Review of J. Golding, *Cubism: A History and an Analysis, 1907–1914*, revised edn, London: Faber & Faber, 1968 (paperback edn 1971), *Burlington Magazine* (March 1974), 162.
135 This characterisation is offered most clearly and fully in Kahnweiler, *Juan Gris*, 92–3.
136 Golding, *Cubism*, 117.
137 *Ibid.*, 7, 118. Golding's Preface to the revised edition of *Cubism* succinctly indicates on the one hand the generosity of its scope and on the other the unexamined (at least in his text) acceptance of a qualitative hierarchy, as a historically adequate analytical frame-work, on which it rested. 'Were I to approach the subject over again today', he acknowl-edged, 'I would try to place the movement in a broader historical setting, try to make the distinctions between it and movements surrounding and succeeding it more fluid …'. 'Finally, I feel that I was perhaps unfair to some of the minor and peripheral figures associated with the movement. In my excitement at discovering for myself true Cubism—the Cubism of Picasso, Braque and Gris – I rejected too brusquely the art of those whose work didn't reach the same high level of invention and distinction': Golding, *Cubism*, 7, 8.
138 Barr, *Picasso: Fifty Years of His Art*, 54–7; reprinted in Wiliam S. Rubin, *Picasso in the Collection of the Museum of Modern Art*, New York: Museum of Modern Art, 1972, 40–2.
139 Rubin, *Picasso*, 56.
140 *Ibid.*, 64, 68.
141 Robert Rosenblum, 'Picasso and the typography of cubism', in John Golding and Roland Penrose (eds), *Picasso 1881–1973*, London: Paul Elek, 1973, 49–75.
142 Rubin, *Picasso*, 79; on his distinction of 'analytic' from 'synthetic' cubism, see 76, 84, 86.
143 William S. Rubin, 'Cézannisme and the beginnings of cubism', in *Cézanne: The Late Work*, New York: Museum of Modern Art, 1977, 151–202.
144 Barr, *Picasso: Fifty Years of His Art*; reprinted in Rubin, Picasso, 42.
145 Rubin, 'Cézannisme and the beginnings of cubism', 152–4. Rubin noted Golding's assessment that *Les Demoiselles* was 'not strictly speaking a Cubist painting' and Cooper's, that it was 'not yet Cubist', but drew his support from Rosenblum and Steinberg from their recent emphases on non-cubist aspects of this picture, specifically those of its sexual iconography and the antecedents of this in Goya, Ingres and Manet. For these articles and their significance, see chapter 7, this book.
146 Rubin, 'Cézannisme and the beginnings of cubism', 194; the teleological assumptions of this argument were underwritten by the sanctification of the term 'high' with a capital letter for the first time.
147 *Ibid.*
148 He quoted Kahnweiler's *Der Weg zum Kubismus* as a precedent for this reading: *ibid.*, 178 and 199, n111.
149 Leo Steinberg, 'Resisting Cézanne: Picasso's *Three Women*', *Art in America* (November–December 1978), 115–33, and 'The polemical art', *Art in America* (March–April 1979), 115–47.
150 Rubin, 'Pablo and Georges and Leo and Bill', *Art in America* (March–April 1979), 137.
151 William Rubin, 'From narrative to "iconic" in Picasso: the buried allegory in *Bread and Fruitdish on a Table* and the role of the *Demoiselles d'Avignon*', *Art Bulletin*, 65, no. 4 (December 1983), 618–19; see chapter 4, this book.

152 William Rubin, 'The genesis of *Les Demoiselles d'Avignon*', *Studies in Modern Art*, 3 (December 1994) (New York: Museum of Modern Art).

153 William Rubin, *Picasso and Braque: Pioneering Cubism*, New York: Museum of Modern Art, 1989; William Rubin and Lynn Zelevansky (eds), *Picasso and Braque: A Symposium*, New York: Museum of Modern Art, 1989.

Chapter 7

1 On this scholarship see Patricia Leighten, 'Editor's statement: revising cubism', *Art Journal*, 47, no. 4 (winter 1988), 272.

2 Robert Rosenblum, *Cubism and Twentieth-Century Art*, London: Thames & Hudson, 1960, 40, 57.

3 See, e.g., *ibid.*, 67, for his discussion of Picasso's *Dead Birds* of 1912, of Braque's *The Portuguese* and of Picasso's *Ma Jolie*.

4 *Ibid.*, 12. Rosenblum read the stylistic discontinuities that for Kahnweiler had been evidence of the picture's incompleteness – indeed its failure – as 'an integral part of *Les Demoiselles*. The irrepressible energy behind its creation demanded a vocabulary of change and impulse rather than of measured statement in a style already articulated'.

5 *Ibid.*, 66. Rosenblum not only introduced a semiotic approach but appears, moreover, to have anticipated one of the key applications of it twenty years later: his analysis of Picasso's 1913 painting *Violin* suggests the different sizes of the two sound holes as a device to introduce the idea of depth on a flat surface – a point that Rosalind Krauss was to make about a similar pairing in Picasso's late-1912 *papier-collé* of the same subject; see note 45 below.

6 *Ibid.*, 71.

7 *Ibid.*, 70.

8 *Ibid.*, 72.

9 *Ibid.*, 69.

10 *Ibid.*, 174, 149; see also 174–6. Though Rosenblum's less doctrinaire and more sympathetic approach enabled him to respond appreciatively to particular works, such as Metzinger's *Dancer in a Café* of 1912.

11 *Ibid.*, 150.

12 Rosenblum still felt obliged to defer to the primacy of a formalist interpretation, however, prefacing his exploration of the subject matter of cubist *papiers-collés* with the acknowledgement that this was a 'secondary aspect' of them: 'Picasso and the typography of cubism', in John Golding and Roland Penrose (eds), *Picasso 1881–1973*, London: Paul Elek, 1973, 49.

13 Wendy Holmes, 'Decoding collage: signs and surfaces', in Katherine Hoffman (ed.), *Collage: Critical Views*, Ann Arbor: University of Michigan Research Press, 1989, 209.

14 Rosenblum's 'Picasso and the typography of cubism' originated in the lecture 'The typography of cubism' given by Rosenblum to a meeting of the College Art Association of America in Los Angeles in January 1965; see also the same author's 'Picasso and the coronation of Alexander III: a note on the dating of *Some Papiers Collés*', *Burlington Magazine*, 113 (October 1971), 604–6.

15 A case in point, around which this question has been raised, is the (*papier-collé*) *Still Life 'Au Bon Marché'* that Picasso made in early 1913 (figure 7.1), in which Rosenblum saw a dirty joke on Picasso's part in the positioning of the words 'trou ici' ('hole here') in the space beneath the word 'lingerie': 'Picasso and the typography of cubism', 53.

For a useful exchange of views on this, see the discussion in William Rubin and Lynn Zelevansky (eds), *Picasso and Braque: A Symposium*, New York: Museum of Modern Art, 1992, 79–86.

16 Leo Steinberg, *Other Criteria: Confrontations with Twentieth-Century Art*, New York: Oxford University Press, 1972.

17 '[T]o be workmanlike is an absolute good. Efficiency is self-justifying ... it is the active man's formalism – a value independent of content': Steinberg, 'Other criteria', *ibid.*, 60.

18 *Ibid.*, 64.

19 L. Steinberg, 'The Algerian women and Picasso at large', *ibid.*, 159.

20 Daniel-Henry Kahnweiler, *The Rise of Cubism*, trans. Henry Aronson, New York: Wittenborn, Schultz, 1949, 7; see this book, p. 167.

21 *Ibid.*, 12.

22 Steinberg, 'The Algerian women and Picasso at large', 160.

23 *Ibid.*, 170.

24 *Ibid.*, 172.

25 *Ibid.*, 173.

26 L. Steinberg, 'The philosophical brothel, part I', *Art News*, 71, no. 5 (September 1972), 22–9; 'Part II', *Art News*, 71, no. 6 (October 1972), 38–47. Krauss's remarks came in an 'Editorial note' to a revised version of 'The philosophical brothel' published in *October*, 44 (spring 1988), 4. Steinberg's essay was quickly followed by an iconographic interpretation of Picasso's picture by Robert Rosenblum, 'The *Demoiselles d'Avignon* revisited', *Art News*, 72, no. 4 (April 1973), 45–8.

27 'The philosophical brothel, part I', 23.

28 Krauss, 'Editorial note', 5.

29 'The philosophical brothel, part II', 40.

30 Steinberg, 'The Algerian women and Picasso at large', 166–7.

31 Leo Steinberg, 'Resisting Cézanne: Picasso's *Three Women*', *Art in America* (November–December 1978), 115–33; see this book chapter 6, 2, p. 37.

32 Steinberg, 'The polemical part', 121.

33 Carol Duncan, 'Virility and domination in early twentieth century vanguard painting", *Artforum* (December 1973), 103.

34 Steinberg, 'The Algerian women and Picasso at large', 410, n21; 'The polemical part', *passim*; 'Retrospect: sixteen years after', *October*, 44 (spring 1988), 65–74.

35 Steinberg, 'The philosophical brothel', *October*, 44 (spring 1988), 63, quoted in Rosalind Krauss, 'The motivation of the sign', in Rubin and Zelevansky (eds), *Picasso and Braque: A Symposium*, 284, n28.

36 Rosalind E. Krauss, 'The Cubist Epoch', *Artforum*, 9, no. 6 (February 1971), 32; the quotations of this article that follow are from pp. 32–3.

37 '[M]odernist theory has never been able to come up with a satisfactory history of sculpture ... The conception of modernism in sculpture depends exclusively on describing the developments within constructed sculpture ... What this has meant is that modernist critics find themselves tactically cut off from acknowledging the work of Arp, as well as most of Brancusi ... and clearly, on the grounds of sheer quality, such a distinction is untenable': Rosalind E. Krauss, 'A view of modernism', *Artforum*, 11 (September 1972), 50.

38 'The strategy that is employed in Serra's work is to create a point from which the viewer can sense the logic of the work's structure – can feel it fanning outward from him, like the extended perimeters of his own body ... Again and again, Serra's sculp-

ture makes a viewer realize that the hidden meanings he reads into the corporate body of the world are his own projections and that interiority he had thought belonged to the sculpture is in fact his *own* interiority – the manifestation, from the still point, of his own point of view': *ibid.*, 51.

39 Rosalind E. Krauss, 'Re-presenting Picasso', *Art in America*, 68 (December 1980), 90–6; 'In the name of Picasso', *October*, 16 (spring 1981), reprinted in Rosalind E. Krauss, *The Originality of the Avant-Garde and Other Modernist Myths*, Cambridge, MA: MIT Press, 1985, 23–40. I discuss only the second of those essays here, as being the more extended and developed in its deployment of semiotics.

40 Dangerous because reductive and trivialising, an 'art history turned militantly away from all that is transpersonal in history – style, social and economic context, archive, structure': Krauss, 'In the name of Picasso', 25.

41 *Ibid.*, 32.

42 Thus, as Rosenblum suggests: 'Often, the word BEAUJOLAIS is fragmented to a simple BEAU ... in another example ... he permits only the letters EAU to show on the label (originally B*eau*jolais, B*eau*ne, or Bord*eau*x), and thereby performs his own cubist version of The Miracle at Cana': 'Picasso and the typography of cubism', 56–7, cited in Krauss, 'In the name of Picasso', 31.

43 *Ibid.*, 40.

44 *Ibid.*, 33.

45 *Ibid.*; ironically it was, as I noted earlier, precisely this device which Rosenblum himself had cited as an example of Picasso's semiotic interests; see note 5, above.

46 *Ibid.*, 34.

47 Rosalind E. Krauss, 'A view of modernism', 49.

48 Minimally revised, 'The motivation of the sign' was published (as were other presentations at the MoMA 'symposium') in Rubin and Zelevansky (eds), *Picasso and Braque: A Symposium*, 261–86.

49 *Ibid.*, 271.

50 *Ibid.*, 262.

51 *Ibid.*, 264.

52 'Kahnweiler was the only critic, until the appearance of Clement Greenberg's text dedicated to the *papiers-collés* in 1958, to understand what was crucial in the evolution of cubism', Bois declared in 'Kahnweiler's lesson', *Representations*, 18 (spring 1987), 38; see also chapter 6, this book.

53 Bois, 'Kahnweiler's lesson', 43.

54 D. H. Kahnweiler, Preface to Brassaï, *The Sculptures of Picasso*, trans. A. D. B. Sylvester, London: R. Phillips, 1949; cited *ibid.*, 40–1.

55 D. H. Kahnweiler, 'Negro art and cubism', *Horizon*, 18, no. 108 (December 1948), 419, cited by Kahnweiler, *ibid.*, 40.

56 *Ibid.*, 44.

57 Delivered in Geneva between 1907 and 1911, Ferdinand de Saussure's lectures were published posthumously in 1916 as the *Course in General Linguistics*; English edn trans. Wade Baskin, New York, 1966.

58 Bois, 'Kahnweiler's lesson', 52.

59 *Ibid.*, 53, 54.

60 *Ibid.*, 55.

61 Bois, 'The semiology of cubism', in Rubin and Zelevansky (eds), *Picasso and Braque: A Symposium*, 169–208.

62 All quotations in this paragraph: *ibid.*, 186.

63 *Ibid.*, 175, 188.

64 *Ibid.*, 190–1.

65 See, e.g., Margaret Iversen, 'Saussure versus Peirce', in A. Rees and F. Borzello (eds), *The New Art History*, London: Camden Press, 1986; Stephen Scobie, *Earthquakes and Explorations: Language and Painting from Cubism to Concrete Poetry*, Toronto: University of Toronto Press, 1997, ch. 5; also Mieke Bal and Norman Bryson, 'Semiotics and art history', *Art Bulletin*, 73, no. 2 (June 1991), 174–208.

66 Mieke Bal, *Reading 'Rembrandt': Beyond the Word–Image Opposition*, Cambridge: Cambridge University Press, 1991, 400–1, n16. As Bal emphasises in a more recent essay, however, this in her usage of the term does not mean that a mark or a brushstroke is non-semiotic, but 'that it is *potentially* semiotic, on the condition that it is being processed as such': 'Semiotic elements in academic practices', *Critical Inquiry*, 22 (spring 1996), 576.

67 James Elkins, *On Pictures and the Words that Fail Them*, Cambridge: Cambridge University Press, 1998, ch. 1.

68 Scobie, *Earthquakes and Explorations*, 89; Umberto Eco, *A Theory of Semiotics*, Bloomington: Indiana University Press, 1976, 191–217. Eco's demonstration of the untenability of 'iconicity' leads him to a useful general emphasis on the mutable and circumstantially sensitive nature of signs, and a preference for thinking in terms of 'sign-functions' rather than of fixed categories of sign. See also Malcolm Gee's brief but telling objections to the Bois–Krauss account in 'Cubisms', *Oxford Art Journal*, 17 (1994), no. 2, 129.

69 Bois, 'The semiology of cubism', 177.

70 Thus Krauss: 'In the great, complex cubist collages, each element is fully diacritical, instantiating both line and colour, closure and openness, plane and recession. Each signifier thus yields a matched pair of formal signifieds': 'In the name of Picasso', 37.

71 See Adam Gopnik, 'High and low: caricature, primitivism, and the cubist portrait', *Art Journal*, 43 no. 4 (winter 1983), 371–6, and the discussion in chapter 2, this book. Gopnik notes Picasso's enjoyment of the 'fonny papers' (the comics from the American papers) that Gertrude Stein used to supply him with, as she recalled in *The Autobiography of Alice B. Toklas*. In this context, the Grebo mask's eyes (and the *Guitar*'s sound-hole) might be compared to the convention, in comics (the effectiveness of whose graphic languages is dependent on *their* play with the elasticity of iconicity), whereby a character's viewing of something extraordinary is denoted by drawing their eyes as projecting cylinders ('sticking out like organ-stops').

72 Gee, 'Cubisms', 129.

73 See the 'Discussion' following Bois's 'The semiology of cubism', 213–14; for Bois on Jakobson, see 178 and 200, n38.

74 Krauss, 'In the name of Picasso', 34, 39.

75 *Ibid.*

76 *Ibid.*, 40.

77 Bois argues that Braque's art 'failed to maintain a high level of quality after the cubist adventure': 'The semiology of cubism', 194. Krauss is never as disparaging as Bois in her assessment of Braque, however, and acknowledges a degree of similarity between his and Picasso's use of news clippings 'to punning and ironic effect': see Rosalind Krauss, *The Picasso Papers*, London: Thames & Hudson, 1998, 247, n14.

78 Bois, 'The semiology of cubism', 194.

79 The observations that follow in this paragraph are indebted to Stephen Scobie's indig-
nant response, on Braque's behalf, to Bois's claims, some of which are, he suggests,
'utterly ludicrous': Scobie, *Earthquakes and Explorations*, 93–5.

80 Perhaps more frequently than Picasso Braque made use of the sign-function of 'exem-
plification', in which pasted materials stand as 'samples'. Goodman, discussing this
category of sign, gives the example of 'a tailor's booklet of small swatches of cloth ...
[which] function as samples, as symbols exemplifying certain properties'; in Braque's
work the woodgrain wallpapers, and in Picasso's the cane-patterned oilcloth, are
further examples: Nelson Goodman, *Languages of Art: An Approach to a Theory of
Symbols*, London: Oxford University Press, 1969, 52. Krauss, criticising Rosenblum's
reading of labels in their *papiers-collés*, denies that these *could* be signs, as *absence* is, she
argues, a structural condition essential to the operation of signs: 'In the name of
Picasso', 31–3. Yet ironically, as Wendy Holmes notes, Goodman's theory of exempli-
fication, in its recuperation of the most 'pure', 'literal' or 'abstract' of artistic signs
(such as 'certain patterns of shape, colour, texture') is entirely congruent with
Greenbergian modernism – indeed by means of this theory, 'the modernist shift that
collage plays a part in effecting is described anew as the change from representational
to exemplifying signs': Holmes, 'Decoding collage', 199–200, quoting Goodman,
Languages of Art, 53.

81 Bois has, however, replied to the associated charges of theoretical opportunism and,
more recently, 'crypto-formalism'; see, for the first, 'Introduction : resisting black-
mail', in his *Painting as Model*, Cambridge, MA, and London: MIT Press, 1990,
xi–xxx; for the second, 'Art history and its theories: whose formalism?', *Art Bulletin*,
78, no. 1 (March 1996), 9–12.

82 See, e.g., Scobie, *Earthquakes and Explorations*, 79; Holmes, 'Decoding collage', 210.

83 Krauss, 'The motivation of the sign', 275.

84 *Ibid.*, 278. Contrasting the perceived qualities of symmetry, clarity and balance of his
pasted papers with the futurist cacophony of the 'words in freedom' technique that
Apollinaire had recently adopted, Krauss suggests that Picasso's project was the
recuperation of newspaper for an aesthetic that he shared, ultimately, with
Mallarmé.

85 Rosalind E. Krauss, 'The circulation of the sign' in *The Picasso Papers*, 25–85. See
Patricia Leighten, *Re-Ordering the Universe: Picasso and Anarchism, 1897–1914*,
Princeton, NJ: Princeton University Press, 1989, ch. 5, and her updating of this argu-
ment in 'Cubist anachronisms: ahistoricity, cryptoformalism, and business-as-usual in
New York', *Oxford Art Journal*, 17 (1994), no. 2, 91–102.

86 *Ibid.*, 78–81; see also Jacques Derrida, 'The double session', in *Dissemination*, trans.
Barbara Johnson, London: Athlone Press, 1981, 251–64.

87 *The Picasso Papers*, 43.

88 *Ibid.*, 47–8.

89 Leighten, 'Cubist anachronisms'. 96.

90 Mikhail Bakhtin, *Discourse in the Novel* (1934–35), reprinted in English translation in
The Dialogic Imagination: Four Essays by M. M. Bakhtin, ed. M. Holquist, Austin:
University of Texas Press, 1981, 259.

91 *Ibid.*, 272.

92 See p. 53 and note 69 to chapter 2.

93 Bahktin, *Discourse in the Novel*, 277; cf. also Mallarmé's image of a theatrical chan-
delier, the interreflections of which allow no exterior reality to penetrate it, and

Derrida's discussion of this as emblematic of the text as 'mimicry imitating nothing' in 'The double session', 179–207. Krauss makes reference to both in *The Picasso Papers*, 35.

94 Bahktin, *Discourse in the Novel*, 311–12. Bakhtin discussed this 'principled criticism' and its subversive implications at much greater length in his major study of *Rabelais and His World*, written in the 1940s but not published until 1965 (and in English translation in 1968). Compare Derrida on the play of meaning in a text: 'If there is thus no thematic unity or overall meaning to reappropriate beyond the textual instances, no total message located in some imaginary order, intentionality, or lived experience, then the text is no longer the expression or representation (felicitous or otherwise) of any *truth* that would come to diffract or assemble itself in the polysemy of literature. It is this hermeneutic concept of *polysemy* that must be replaced by *dissemination*': 'The double session', 262; see also chapter 6, this book.

95 *Ibid.*, 312–13.

Chapter 8

1 On Robbins's initial approach to the subject, see the Preface and Acknowledgements to D. Robbins, 'The formation and maturity of Albert Gleizes: a biographical and critical study, 1881 through 1920', unpublished PhD thesis, New York University, 1975. The fragment of Gleizes's memoirs was published as *Souvenirs. Le Cubisme 1908–1914*, Paris: Cahiers Albert Gleizes, 1957.

2 D. Robbins, 'Albert Gleizes: reason and faith in modern painting', in *Albert Gleizes 1881–1953*, exh. cat., New York: Solomon R. Guggenheim Museum, 1964, 12–25.

3 *Ibid.*, 19.

4 *Ibid.*, 16.

5 *Ibid.*

6 *Ibid.*, 17.

7 D. Robbins, 'From symbolism to cubism: the Abbaye of Créteil', *Art Journal* (winter 1963–64), 116.

8 Robbins, 'Albert Gleizes', 14.

9 *Ibid.*, 19.

10 Robbins writes (*ibid.*, 17), for example: 'Gleizes' *Harvest Threshing*, the masterpiece of the *Section d'Or* ... is not merely an anecdote in a scene. Rather, it is a multiple panorama celebrating the worker, his material life and his collective activity in securing that life on a permanently changing land. Gleizes confronts us not with one action or place, but with many; not with one time, but with past and future as well as present'. Yet the formal means to this, the pictorial bases for this interpretation, are not offered, far less analysed.

11 Occupied by his responsibilities as director, first, of the Museum of Art at the Rhode Island School of Design and, subsequently, of the Fogg Art Museum at Harvard, Robbins published, through the late 1960s and 1970s, chiefly small pieces on individual members of the salon cubist milieu such as Villon and Duchamp-Villon; only the article 'Sources of cubism and futurism', *Art Journal*, 41, no. 4 (winter 1981), 324–7, approached his earlier writing in scope.

12 Daniel Robbins, 'Jean Metzinger: at the center of cubism', in Joann Moser (ed.), *Jean Metzinger in Retrospect*, exh. cat., Iowa City: University of Iowa Museum of Art, 1985, 9–23.

13 *Ibid.*, 19.

14 *Ibid.*, 21, quoting Metzinger, 'Note sur la peinture', *Pan* (October–November 1910), 649, reprinted (trans. Jonathan Griffin) in Edward Fry, *Cubism*, London: Thames & Hudson, 1966, 59–61.

15 On his early interest in and attempts to find *Mountaineers*, see Robbins's article 'Henri Le Fauconnier's *Mountaineers Attacked by Bears*', *Rhode Island School of Design: Museum Notes*, 83, no. 4 (June 1996), 24–53. Published posthumously, this was an edited version of an unfinished manuscript begun by Robbins in 1978 with the provisional title 'Le Fauconnier and the bears: a study in epic cubism'. He had envisaged the essay, as the accompanying notes indicate, 'as a chapter in a projected study entitled "The Unknown Cubism", a concentration on the neglected masters of the movement': *ibid.*, 24.

16 D. Robbins, *Henri Le Fauconnier (1881–1946): A Pioneer Cubist*, exh. cat., New York: Salander–O'Reilly Galleries, 1990, n.p.

17 *Ibid.*; the (possibly unintentional) ambiguity of Robbins's syntax here strikes an appropriately grisly note for any viewer of the painting.

18 *Ibid.*

19 Robbins, 'Henri Le Fauconnier's *Mountaineers Attacked by Bears*', 41.

20 *Ibid.*, 38–40.

21 *Ibid.*, 52.

22 Panofsky's account both of this methodology and his refugee experience are in E. Panofsky, *Meaning in the Visual Arts: Papers in and on Art History*, New York: Doubleday Anchor, 1955, 26–54 and 321–46.

23 Constraints of space limit the illustration of this to two examples. First: interpreting the Cézannesque facetting of rocks and fields in Le Fauconnier's Ploumanach landscapes of 1909–10 as representing the facetted forms of the igneous extrusions that characterise that region of Brittany, Robbins suggests on the artist's part a 'nascent concept of crystal' that, shared also by 'the Gris/Lipchitz circle of cubists during the latter half of the First World War … owes something to a newly intensified awareness of the dramatic history of the earth's surface': Robbins, 'Henri Le Fauconnier's *Mountaineers Attacked by Bears*', 31. Thus, he argues, Le Fauconnier was abreast of 'the astonishing developments of nineteenth-century geology' in which French contributions, in particular by Nicholas Desmarest and H.B. de Saussure, had been significant, and his familiarity with this 'geology that relied on volcanic theory and on stratigraphical investigation' had a bearing on the artist's treatment of form (*ibid.*). Layered on top of this erudition, Robbins suggests, was Le Fauconnier's response also to the menhirs that punctuate this landscape: thoughts of the 'primitive rituals centering around a hewn menhir … sacred earth and sky spirits entwined in the primordial act of creation' led him, 'it seems clear', to treat these megaliths as phalluses. Finally, the 'biographical aspects' of this symbolism (the artist was living with the young Russian painter Maroussia Rabanikoff at the time) adds 'yet a third layer of meaning to the landscapes: life-power, the energy of primal creation, celebration of sex, and its identification with the most primordial events, the creation and continuing formation of the earth' (*ibid.*). Imaginative though these inferences are, there is little to support them other than Robbins's own lively responses to the forms in the paintings – no evidence at all that would confirm them as Le Fauconnier's interests too.

 Second: Le Fauconnier painted *Abundance* in 1910–11, prior to a trip to Italy and a return stop in Savoie, the following summer; there is no indication in any of the

biographical writing on the artist that he had made a prior visit to that region. During the 1911 stay he painted a study of the castle that Robbins identifies as that in *Abundance*. There is little similarity between them – the Savoie castle as painted has neither the battlements nor the tall turreted tower that feature in the earlier picture – yet 'the evidence is incontrovertible' that the artist visited the region in 1910, and that this castle, which he saw and must have committed to memory, if not to canvas, at that time furnished the motif for *Abundance*: *ibid*., 37. The insistence is unhelpful: at the most, the suggestion is a possibility, but not so firm as to bear the weight of assertion that is first placed on it here, and then deployed in its turn (as I have noted) to support the larger interpretation that the symbolism inferred by Robbins was intended by the artist: *ibid*., 40.

Both Panofsky himself and, following him, Ernst Gombrich warned of the dangers of the excesses of interpretive zeal, the latter quoting, as a motto for his own essay on the subject, the former's witty observation: 'There is admittedly some danger that iconology will behave, not like ethnology as opposed to ethnography, but like astrology as opposed to astrography': Panofsky, *Meaning in the Visual Arts*, 32, quoted in E. H. Gombrich, 'Aims and limits of iconology', in his *Symbolic Images: Studies in the Art of the Renaissance*, 2nd edn, London: Phaidon Press, 1978, 1.

24 *Ibid*., 38.

25 'Materials seem to constrain this fine artist considerably; he thinks better than he paints' ('La matière semble considérablement gêner ce bel artiste: il pense plus qu'il ne peint'), wrote Gleizes, reviewing Le Fauconnier's entries in the 1911 Salon d'Automne: 'Les beaux-arts: à propos du Salon d'Automne', *Les Bandeaux d'or* (November 1911), 48.

26 Robbins, 'Henri Le Fauconnier's *Mountaineers Attacked by Bears*', 45–6.

27 C. Green, *Léger and the Avant-Garde*, New Haven, CT, and London: Yale University Press, 1976.

28 C. Green, *Cubism and its Enemies: Modern Movements and Reaction in French Art, 1916–1928*, New Haven, CT, and London: Yale University Press, 1987.

29 *Ibid*., 160.

30 On combatant cubists' use of the style, in sketches made in the trenches, as a means of representing the brutalities and anonymity of mechanised warfare, see Elizabeth Louise Kahn, 'Art from the front, death imagined and the neglected majority', *Art History* (June 1985), 192–208, and André Mare, *Carnets de Guerre 1914–1918*, ed. Laurence Graffin, Paris: Herscher, 1996.

31 Green, *Cubism and its Enemies*, 13.

32 *Ibid*., 1.

33 *Ibid*.

34 This inference is supported by a note confirming Green's adoption of a convention whereby 'Modernism' refers to the critical and theoretical doctrine (to the consolidation of which the writings of Clement Greenberg were central), and 'modernism' the range of cultural practices to which it might be applied: *ibid*., 301, n6. For reviews of *Cubism and its Enemies* that share this inference (and offer critiques similar to the present one), see Daniel Robbins, 'Formal considerations', *Times Literary Supplement*, 8–14 April 1988, 395–6, and Paul Wood, 'A mountain of words', *Oxford Art Journal*, 11 (1988), no. 2, 94–6.

35 See, e.g., Peter Bürger, 'On the problem of the autonomy of art in bourgeois society', in *Theory of the Avant-Garde* (1974), trans. Michael Shaw, Manchester and Minneapolis:

Manchester University Press and University of Minnesota Press, 1984, 35–54 and 112–14.

36 Green, *Léger and the Avant-Garde*, 5.

37 Virginia Spate, *Orphism: The Evolution of Non-Figurative Painting in Paris 1910–1914*, Oxford: Clarendon Press, 1979.

38 Kenneth E. Silver, *Esprit de Corps: The Art of the Parisian Avant-Garde and the First World War, 1914–1925*, London: Thames & Hudson, 1989.

39 Malcolm Gee, 'Dealers, critics and collectors of modern painting: aspects of the Parisian art market between 1910 and 1930', unpublished PhD thesis, University of London, 1977; published in New York by Garland Press in 1981; Raymonde Moulin, *Le Marché de la Peinture en France*, Paris: Minuit, 1967; see also Malcolm Gee, 'The avant-garde, order and the art market, 1916–1923', *Art History*, 2, no. 1 (March 1979), 95–106.

40 *Art Journal*, 47, no. 4, special issue: 'Revising cubism' (winter 1988).

41 'Editor's statement: revising cubism', *ibid.*, 269, 273.

42 A. L. Rees and Frances Borzello (eds), *The New Art History*, London: Camden Press, 1986.

43 The obvious omission was of feminism – of which, however, there was at the time no representative within this field (and little has changed since; see pp. 239–40).

44 P. Leighten, 'Picasso's collages and the threat of war, 1912–13', *Art Bulletin*, 67, no. 4 (December 1985), 653–72; '"La propagande par le rire": satire and subversion in Apollinaire, Jarry and Picasso's collages', *Gazette des Beaux-Arts* (6th series), 112 (October 1988), 163–70; 'The white peril and *l'art nègre*: Picasso, primitivism and anti-colonialism', *Art Bulletin*, 72, no. 4 (December 1990), 610–30; *Re-Ordering the Universe: Picasso and Anarchism, 1897–1914*, Princeton, NJ: Princeton University Press, 1989. More recently, with Mark Antliff, Leighten has further developed these themes in *Cubism and Culture*, London and New York: Thames & Hudson, 2001.

45 Leighten, 'Picasso's collages and the threat of war', 654.

46 Leighten, *Re-Ordering the Universe*, 11.

47 'Editor's statement', 272.

48 Leighten, *Re-Ordering the Universe*, 9.

49 On the Barcelona milieux and Leighten's account of these, see Robert S. Lubar's fine-grained and sharp critique in his review of *Re-Ordering the Universe* in *Art Bulletin*, 72, no. 3 (September 1990), 505–10.

50 Leighten, *Re-Ordering the Universe*, 49.

51 Leighten, 'Picasso's collages and the threat of war', 654.

52 Leighten, *Re-Ordering the Universe*, 9–10.

53 P. Leighten, 'Cubist anachronisms: ahistoricity, cryptoformalism, and business-as-usual in New York', *Oxford Art Journal*, 17 (1994), no. 2, 91–102.

54 Rees and Borzello, *The New Art History* (to which the brief summary of this paragraph is indebted), 6–7.

55 T. J. Clark, *The Absolute Bourgeois: Artists and Politics in France 1848–1851* and *Image of the People: Gustave Courbet and the 1848 Revolution*, both London: Thames & Hudson, 1973.

56 Clark, *Image of the People*, ch. 1: 'On the social history of art', 12.

57 Nicos Hadjinicolaou, *Art History and Class Struggle*, trans. Louise Asmal, London: Pluto Press, 1978.

58 Raymond Williams, *Marxism and Literature*, Oxford: Oxford University Press, 1977.

59 Terry Eagleton, *Criticism and Ideology: A Study in Marxist Literary Theory*, London: New Left Books, 1976.

60 On Clark's role at Leeds, where his close colleagues included Griselda Pollock, Fred Orton and John Tagg, see Tagg's essay 'Art history and difference', in Rees and Borzello (eds), *The New Art History*, 164–71. At UCLA Clark supervised the PhD dissertations of Thomas Crow and Serge Guilbaut, among others.

61 London: Thames & Hudson.

62 For a critique of Clark's lack of attention to the former, see Griselda Pollock, 'Vision, voice and power: feminist art history and Marxism' (1981), reprinted in Pollock, *Vision and Difference: Femininity, Feminism and Histories of Art*, London: Routledge, 1986; on the latter, see Adrian Rifkin, '"Marx" Clarkism', *Art History*, 8, no. 4 (December 1985), 488–95.

63 Rifkin, '"Marx" Clarkism', 488.

64 T. J. Clark, 'Cubism and collectivity', in *Farewell to an Idea: Episodes from a History of Modernism*, New Haven, CT, and London: Yale University Press, 175.

65 *Ibid.*

66 *Ibid.*, 174.

67 *Ibid.*, 184, 180.

68 *Ibid.*

69 *Ibid.*, 187, 192.

70 *Ibid.*

71 *Ibid.*, 223.

72 *Ibid.*

73 Hal Foster, 'Who's afraid of the neo-avant-garde?' in his *The Return of the Real: The Avant-Garde at the End of the Century*, Cambridge, MA, and London: MIT Press, 1996, 8, 10.

74 Most recently, with Patricia Leighten, he has extended this reconstruction, on an introductory level, in *Cubism and Culture*.

75 Mark Antliff, 'Cubism, celtism and the body politic', *Art Bulletin*, 74, no. 4 (December 1992), 655–68, revised and reprinted in Antliff, *Inventing Bergson: Cultural Politics and the Parisian Avant-Garde*, Princeton, NJ: Princeton University Press, 1993, ch. 4, 'The body of the nation: cubism's celtic nationalism'.

76 Antliff, 'Cubism, celtism and the body politic', 657.

77 For a detailed presentation of this argument see my *Cubism in the Shadow of War: The Avant-Garde and Politics in Paris 1905–1914*, New Haven, CT, and London: Yale University Press, 1998.

78 Antliff, 'Cubism, celtism and the body politic', 667, n59.

79 Antliff, *Inventing Bergson*, 132, 134.

80 Krzysztof Pomian notes over 100 different postcards available between 1906 and 1914 on the subject of Alésia (the site of Vercingetorix's climactic struggle against the Romans) alone; 'Franks and Gauls', in Pierre Nora (ed.), *Realms of Memory*, New York: Columbia University Press, 1996, vol. 1, 32–3, 68–9.

81 Herman Lebovics, *True France: The Wars Over Cultural Identity 1900–1945*, Ithaca, NY, and London: Cornell University Press, 1992.

82 Eugen Weber, *My France: Politics, Culture, Myth*, Cambridge, MA, and London: Harvard University Press, 1991, 28–33; see also chapter 1, this book.

83 On Gleizes's involvement with popular education initiatives *c.*1905, see chapter 1, this book.

84 Anne-Marie Thiesse, *Ecrire la France: Le Mouvement littéraire régionaliste de la Langue française entre la Belle Epoque et la Libération*, Paris: Presses Universitaires de France, 1991, 44–5. The leader of the Ligue celtique française, Robert Pelletier, nodded towards political decentralisation in an article of 1913 discussed by Antliff (*Inventing Bergson*, 121–2), but this sat uneasily with his nationalism (and was also a component of Action française's political platform).

85 Gleizes's cultural populism was, moreover, congruent with the vernacular classicism embraced by André Mare as the guiding aesthetic principle of his *Cubist House*, which it is hard to see as a militantly political project.

86 Among the many writings that address these premisses, see David Carroll (ed.), *The States of 'Theory': History, Art and Critical Discourse*, Stanford, CA: Stanford University Press, 1990; Mieke Bal and Norman Bryson, 'Semiotics and art history', *Art Bulletin*, 73, no. 2 (March 1991), 174–208; Andrew Hemingway, 'Introduction: Marxism and art history after the fall of communism', in A. Hemingway and W. Vaughan (eds), *Art in Bourgeois Society, 1790–1850*, Cambridge: Cambridge University Press, 1998; Peter Osborne, *The Politics of Time: Modernity and Avant-Garde*, London: Verso, 1995, 1–29.

87 David Joselit, *Infinite Regress: Marcel Duchamp 1910–1941*, Cambridge, MA, and London: MIT Press, 1998, 9–70. See chapter 7.

88 *Ibid.*, 37.

89 *Ibid.*, 204, n44.

90 *Ibid.*, 45.

91 See note 73.

92 Reviewing no fewer than ten new books on Duchamp at the same time, Sheldon Nodelman noted that a survey of such studies from 1995 on 'would multiply this number severalfold': 'The once and future Duchamp', *Art in America*, 88, no. 1 (January 2000), 37.

93 Linda Dalrymple Henderson, *The Fourth Dimension and Non-Euclidean Geometry in Modern Art*, Princeton, NJ: Princeton University Press, 1983; *Duchamp in Context: Science and Technology in the Large Glass and Related Works*, Princeton, NJ: Princeton University Press, 1998.

94 Molly Nesbit, *Their Common Sense*, London: Black Dog, 2000; see also Pascal Rousseau's ongoing work on Robert Delaunay, which follows Henderson's in many respects. Nesbit's 'cultural mapping' is comparable to both, but brings to this methodology a theoretical sophistication of which the Gramscian reference in her title is but one register.

95 Anna C. Chave, 'New encounters with *Les Demoiselles d'Avignon*: gender, race and the origins of cubism', *Art Bulletin*, 76, no. 4 (December 1994), 596–611; thus Chave introduces a brief discussion of 'cubist space' with the hope that it 'may facilitate a much-needed feminist analysis of cubism more generally', and noting only in passing the masculinism of prevailing accounts of this space: *ibid.*, 602–3. See also Tamar Garb, '"To kill the nineteenth century": sex and spectatorship with Gertrude and Picasso', in Christopher Green (ed.), *Picasso's* Les Demoiselles d'Avignon, Cambridge University Press, 2001, 55–76.

96 There has been little substantive engagement with this issue since Linda Nochlin's rich yet wide-ranging article of over twenty years ago: 'Picasso's color: schemes and gambits', *Art in America*, 68 (December 1980), 105–23, 177–83; on gender and colour, see also David Batchelor, *Chromophobia*, London: Reaktion, 2000.

Select bibliography

Allard, R. (1910), 'Au Salon d'Automne de Paris', *L'Art libre* (Lyon), 2, no. 12, November, 441–3.

—— (1911), 'Sur Quelques Peintres', *Les Marches du sud-ouest*, June, 57–64.

—— (1911), 'Les Beaux-Arts', *La Revue indépendante*, August, 127–40.

Aksenov, I (1917), *Pikasso i okresnosti*, Moscow: Centrifuge.

Albright–Knox Art Gallery (1982), *Sonia Delaunay: A Retrospective*, Buffalo, NY: Albright–Knox Art Gallery.

Antliff, M. (1992), 'Cubism, celtism and the body politic', *Art Bulletin*, 74, no. 4, December, 655–68.

—— (1993), *Inventing Bergson: Cultural Politics and the Parisian Avant-Garde*, Princeton, NJ: Princeton University Press.

—— and P. Leighten (2001), *Cubism and Culture*, London and New York: Thames & Hudson.

Apollinaire, G. (1949), *The Cubist Painters: Aesthetic Meditations* (1913), trans. Lionel Abel, New York: Wittenborn.

—— (1972), *Apollinaire on Art: Essays and Reviews 1902–1918*, trans. S. Suleiman, ed. L. C. Breunig, London: Thames & Hudson.

Arbour, R. (1956), *Les Revues littéraires 1900–1914*, Paris: Corti.

Arnyvelde, A. (1912), 'Contribution à l'histoire du cubisme', *Gil Blas*, 2 January, 3.

Auslander, L. (1996), *Taste and Power: Furnishing Modern France*, Berkeley, Los Angeles and London: University of California Press.

Bakhtin, M. M. (1981), *The Dialogic Imagination: Four Essays by M. M. Bakhtin*, ed. M. Holquist, Austin: University of Texas Press.

Baldassari, A. (2000), *Picasso: Working on Paper*, trans. George Collins, London and Dublin: Merrell Publishers–Irish Museum of Modern Art.

Barr, A. (ed.) (1936), *Cubism and Abstract Art*, exh. cat., New York: Museum of Modern Art.

Barron, S. with J. Damase (1995), *Sonia Delaunay: The Life of an Artist*, London: Thames & Hudson.

Barzun, H.-M. (1912), 'D'un art poétique moderne: du lyrique au dramatique', *Poème et Drame*, 1, no. 1, November, 74–83.

—— (1913), 'Après le symbolisme: L'art poétique d'un idéal nouveau. Voix, rythmes et chants simultanées', *Poème et Drame*, 1, no. 4, May.

Beauduin, N. (1956), 'Les temps héroïques: à propos du Salon de la Section d'or', *Masques et Visages*, 39, June, 6–7.

Bergman, P. (1962), *Modernolatrià et Simultanéità*, Stockholm: Scandinavian University Books.

Bibliothèque Nationale (1977), *Sonia and Robert Delaunay*, exh. cat., Paris: Bibliothèque Nationale.

Bois, Y.-A. (1992), 'The semiology of cubism', in W. Rubin and L. Zelevansky (eds), *Picasso and Braque: A Symposium*, New York: Museum of Modern Art, 169–208.

Bourdieu, P. (1984), *Distinction: A Social Critique of the Judgement of Taste*, London: Routledge.

—— (1993), *The Field of Cultural Production: Essays on Art and Literature*, ed. and trans. Randal Johnson, London: Polity Press.

Brooke, P. (2001), *Albert Gleizes: For and Against the Twentieth Century*, New Haven, CT, and London: Yale University Press.

Buckberrough, S. (1979), 'The simultaneous content of Robert Delaunay's Windows', *Arts Magazine*, September.

Burgess, G. (1910), 'The wild men of Paris', *Architectural Record* (Boston, MA), 27, no. 5, May, 400–14.

Cabanne, P. (1963), *L'Epopée du Cubisme*, Paris: La Table Ronde.

—— (1967), *Entretiens avec Marcel Duchamp*, Paris: Belfond.

Centre Georges Pompidou (1984), *Daniel-Henry Kahnweiler: Marchand, Editeur, Ecrivain*, exh. cat., Paris: Editions du Centre Georges Pompidou.

—— (1999), *Les Années cubistes*, Paris: Editions du Centre Georges Pompidou.

Cercle d'Art (2000), *La Section d'or 1912–1920–1925*, exh. cat., Musées de Châteauroux–Musée Fabre, Montpellier; Paris: Cercle d'Art.

Chave, Anna C. (1994), 'New encounters with *Les Demoiselles d'Avignon*: gender, race and the origins of cubism', *Art Bulletin*, 86, no. 4, December, 596–611.

Clark, T. J. (1973), *Image of the People: Gustave Courbet and the 1848 Revolution*, London: Thames & Hudson.

—— (1985), *The Painting of Modern Life: Paris in the Art of Manet and His Followers*, London: Thames & Hudson.

—— (1999), *Farewell to an Idea: Episodes from a History of Modernism*, New Haven, CT, and London: Yale University Press.

Cooper, D. (1971), *The Cubist Epoch*, London: Phaidon.

—— and G. Tinterow (1983), *The Essential Cubism: Braque, Picasso and Their Friends, 1907–1920*, exh. cat., London: Tate Gallery.

Cottington, D. (1992), 'Cubism, aestheticism, modernism', in William Rubin and Lynn Zelevansky (eds), *Picasso and Braque: A Symposium*, New York: Museum of Modern Art, 58–72.

—— (1998), *Cubism in the Shadow of War: The Avant-Garde and Politics in Paris 1905–1914*, New Haven, CT, and London: Yale University Press.

—— (1998), 'The *Maison cubiste* and the meaning of modernism in pre-1914 France', in Eve Blau and Nancy J. Troy (eds), *Architecture and Cubism*, Montreal, Cambridge, MA, and London: MIT Press–Canadian Centre for Architecture, 17–40.

Cox, N. (2000), *Cubism*, London: Phaidon.

Crespelle, J. P. (1976), *La Vie quotidienne à Montparnasse à la grande epoque 1905–1930*, Paris: Hachette.

Daix, P. and J. Rosselet (1979), *Picasso: The Cubist Years 1907–1916*, London: Thames & Hudson.

Décaudin, M. (1960), *La Crise des Valeurs symbolistes: Vingt Ans de Poésie française 1895–1914*, Toulouse: Privat.

Delaunay, R. (1957), *Du Cubisme à l'Art abstrait*, ed. Pierre Francastel, Paris: SEVPEN.

Delaunay, S. (1978), *Nous irons jusqu'au soleil*, Paris: Laffont.

Denis, M. (1920 [1912]), *Théories (1890–1910). Du Symbolisme et de Gauguin Vers un nouvel ordre classique*, 4th edn, Paris: Rouart et Watelin.

—— (1993), *Le Ciel et l'Arcadie: Textes réunis*, ed. Jean-Paul Bouillon, Paris: Hermann.

Derrida, J. (1981), 'The double session', in *Dissemination*, trans. Barbara Johnson, London: Athlone Press, 251–64.

Duroselle, J. B. (1992), *La France de la 'belle epoque'*, 2nd edn, Paris: Presses de la Fondation Nationale des Sciences Politiques.

ECGP (1999), *Robert Delaunay 1906–1914: De l'Impressionnisme à l'Abstraction*, exh. cat., Paris: Editions du Centre Georges Pompidou.

Einstein, C. (1929), 'Notes sur le cubisme', *Documents* (Paris; 1st series), no. 3, 146–55.

Felski, R. (1995), *The Gender of Modernity*, Cambridge, MA, and London: Harvard University Press.

Fitzgerald, M. (1995), *Making Modernism: Picasso and the Creation of the Market for Twentieth Century Art*, New York: FSG.

Foster, H. (1996), *The Return of the Real: The Avant-Garde at the End of the Century*, Cambridge, MA. and London: MIT Press.

Fry, E. (1966), *Cubism*, New York and Toronto: McGraw-Hill.,

—— (1978), 'Picasso, cubism and reflexivity', *Art Journal*, 47, no. 4, winter, 296–310.

Garb, T. (1994), *Sisters of the Brush: Women's Artistic Culture in Late Nineteenth-Century Paris*, New Haven, CT, and London: Yale University Press.

Gee, M. (1977), 'Dealers, critics and collectors of modern painting: aspects of the Parisian art market 1910–30', unpublished PhD thesis, University of London.

—— (1979), 'The avant-garde, order and the art market, 1916–1923', *Art History*, 2, no. 1, March, 95–106.

—— (1994), 'Cubisms', *Oxford Art Journal*, 17, no. 2, 129.

Gleizes, A. (1911) 'L'art et ses représentants: Jean Metzinger', *La Revue indépendante*, 4, September, 161–72.

—— (1911), 'Les beaux-arts: à propos du Salon d'Automne', *Les Bandeaux d'or*, November, 42–51.

—— (1913), 'Le cubisme et la tradition', *Montjoie!*, no. 1, 10 February, 4; and no. 2, 25 February, 2–3.

—— (1957), *Souvenirs. Le Cubisme 1908–1914*, Paris: Cahiers Albert Gleizes.

—— and J. Metzinger (1912), *Du 'Cubisme'*, Paris: Figuière.

Gopnik, A. (1983), 'High and low: caricature, primitivism and the cubist portrait', *Art Journal*, 43, no. 4, winter, 371–6.

Golding, J. (1968), *Cubism: A History and an Analysis 1907–1914*, 2nd edn, London: Faber & Faber.

Green, C. (1977), *Léger and the Avant-Garde*, New Haven, CT, and London: Yale University Press.

—— (1987), *Cubism and its Enemies: Modern Movements and Reaction in French Art, 1916–1928*, New Haven, CT, and London: Yale University Press.

—— (1992), *Juan Gris*, exh. cat., London: Whitechapel Gallery.

—— (2000), *Art in France 1900–1940*, New Haven, CT, and London: Yale University Press.

—— (ed.) (2001), *Picasso's 'Les Demoiselles d'Avignon'*, Cambridge: Cambridge University Press.

Greenberg, C. (1986 and 1993)), *The Collected Essays and Criticism*, ed. John O'Brian, Chicago and London: University of Chicago Press; vol. 1: *Perceptions and Judgments, 1939–1944* (1986); vol. 2: *Arrogant Purpose, 1945–1949* (1986); vol. 3: *Affirmations and Refusals, 1950–1956* (1993); vol. 4: *Modernism with a Vengeance, 1957–1969* (1993).

Henderson, L. D. (1983), *The Fourth Dimension and Non-Euclidean Geometry in Modern Art*, Princeton, NJ: Princeton University Press.

—— (1998), *Duchamp in Context: Science and Technology in the Large Glass and Related Works*, Princeton, NJ: Princeton University Press.

Henriquez-Phillipe (1912), 'Le cubisme devant les artistes', *Les Annales politiques et littéraires*, no. 1536, 1 December, 473–5.

Hicken, A. (2002), *Apollinaire, Cubism and Orphism*, London: Ashgate.

Holmes, W. (1989), 'Decoding collage: signs and surfaces', in Katherine Hoffman (ed.), *Collage: Critical Views*, Ann Arbor: University of Michigan Research Press, 193–212.

Hourcade, O. (1912), 'La tendance de la peinture contemporaine', *La Revue de France et des Pays français*, 1, February, 35–41.

Joselit, D. (1998), *Infinite Regress: Marcel Duchamp 1910–1941*, Cambridge, MA, and London: MIT Press.

Kahnweiler, D.-H. (1947), *Juan Gris: His Life and Work*, trans. Douglas Cooper, London: Lund Humphries, 87–8.

—— (1949 [1920]), *The Rise of Cubism*, trans. Henry Aronson, New York: Wittenborn Schultz.

—— with F. Crémieux (1961), *Mes Galeries et Mes Peintres: Entretiens avec Francis Crémieux*, Paris: Gallimard; English edn, *My Galleries and Painters*, trans. H. Weaver, New York: Viking (1971).

Kantor, S. (2000), *Alfred H. Barr, Jr., and the Intellectual Origins of the Museum of Modern Art*, Cambridge, MA: MIT Press.

Karmel, P. (1993), 'Picasso's laboratory: the role of his drawings in the development of cubism, 1910–1914', unpublished PhD thesis, New York University.

—— (2003), *Picasso and the Invention of Cubism*, New Haven and London: Yale University Press.

Kramár, V. (2002[1921]), *Le Cubisme*, trans. Erika Abrams, ed. H. Klein and E. Abrams, Paris: Ecole Nationale Supérieure des Beaux-Arts.

Krauss, R. (1971), 'The cubist epoch', *Artforum*, 9, no. 6, February, 33.

—— (1985), 'In the name of Picasso' (1981), in *The Originality of the Avant-Garde and Other Modernist Myths*, Cambridge, MA: MIT Press, 23–40.

—— (1992), 'The motivation of the sign', in W. Rubin and L. Zelevansky (eds), *Picasso and Braque: A Symposium*, New York: Museum of Modern Art, 261–86.

—— (1998), *The Picasso Papers*, London: Thames & Hudson.

Lahoda, V. and O. Uhrova (2000), *Vincenc Kramár: From Old Masters to Picasso*, exh. cat., Prague: National Gallery.

Laurencin, M. (1956), *Le Carnet des Nuits* (1942), Geneva: Cailler.

Le Bot, M. (1968), *Francis Picabia et la Crise des Valeurs figuratifs*, Paris: Klincksieck.

Lebovics, H. (1992), *True France: The Wars Over Cultural Identity 1900–1945*, Ithaca and London: Cornell University Press.

Lee, J. (1990), *Derain*, Oxford: Phaidon.

Le Fauconnier, H. (1910), 'Das kunstwerk', in *Neue Kunstlervereinigung, München E. V., II Ausstellung*, Munich: Moderne Galerie.

Leighten, P. (1985), 'Picasso's collages and the threat of war, 1912–13', *Art Bulletin*, 67, no. 4, December, 653–72.

—— (1988), '"La propagande par le rire": satire and subversion in Apollinaire, Jarry and Picasso's collages', *Gazette des Beaux-Arts* (6th series), 112, October, 163–70.

—— (1988), 'Editor's statement: revising cubism', *Art Journal*, 47, no. 4, winter, 269–76.

—— (1989), *Re-Ordering the Universe*, Princeton, NJ: Princeton University Press.

—— (1990), 'The white peril and *l'art nègre*: Picasso, primitivism and anticolonialism', *Art Bulletin*, 72, no. 4, December, 609–30.

—— (1994), 'Cubist anachronisms: ahistoricity, cryptoformalism, and business-as-usual in New York', *Oxford Art Journal*, 17, no. 2, 91–102.

—— (2001), 'Colonialism, *l'art nègre* and *Les Demoiselles d'Avignon*', in C. Green (ed.), *Picasso's* Les Demoiselles d'Avignon, Cambridge University Press, 77–103.

Level, A. (1959), *Souvenirs d'un Collectionneur*, Paris: Club des Librairies de France.

Marx, R. (1913), *L'Art social*, Paris: Fasquelle.

Mayeur, J. M. and M. Rebérioux (1984), *The Third Republic from its Origins to the Great War, 1871–1914*, trans. J. R. Foster, Cambridge: Cambridge University Press.

Metzinger, J. (1910), 'Note sur la peinture', *Pan* (Paris), November, 649–52.

—— (1911) '"Cubisme" et tradition', *Paris-Journal*, 16 August, 5.

—— (1972), *Le Cubisme Etait Né: Souvenirs*, Paris: Présence.

Meyer, F. (1962), 'Robert Delaunay, *Hommage à Blériot*', *Jahresberichte der Öffentlichen kunststsammlungen* (Basel), 67–78.

Monod-Fontaine, I. (ed.) (1982), *Georges Braque: Les Papiers Collés*, exh. cat., Paris: Centre Georges Pompidou.

Murphy, Kevin D. (1998), 'Cubism and the gothic tradition', in Eve Blau and Nancy J. Troy (eds), *Architecture and Cubism*, Montreal, Cambridge, MA, and London: MIT Press–Canadian Centre for Architecture, 59–76.

Musée d'Art Moderne (1994), *André Derain. Le Peintre du 'trouble moderne'*, exh. cat., Paris: Musée d'Art Moderne de la Ville de Paris.

Nesbit, M. (2000), *Their Common Sense*, London: Black Dog.

Perry, G. (1995), *Women Artists and the Parisian Avant-Garde: Modernism and 'Feminine' Art, 1900 to the Late 1920s*, Manchester and New York: Manchester University Press.

Poggi, C. (1992), *In Defiance of Painting: Cubism, Futurism and the Invention of Collage*, New Haven, CT, and London: Yale University Press.

Raynal, M. (1912), 'L'exposition de la Section d'or', *La Section d'or*, 1, October, 3.

Rearick, C. (1985), *Pleasures of the Belle Epoque*, New Haven, CT, and London: Yale University Press.

Rees, A. L. and F. Borzello (eds) (1986), *The New Art History*, London: Camden Press.

Ribemont-Dessaignes, G. (1958), *Déjà jadis*, Paris: Juillard.

Richardson, J. (1999), *The Sorcerer's Apprentice: Picasso, Provence and Douglas Cooper*, London: Jonathan Cape.

——, with M. McCully (1998), *A Life of Picasso*, vol. 2: *1907–1917: The Painter of Modern Life*, London: Jonathan Cape.

Rifkin, A. (1985), '"Marx" Clarkism', *Art History*, 8, no. 4, December, 488–95.

Rivière, J. (1912), 'Sur les tendances actuelles de la peinture', *La Revue d'Europe et d'Amérique*, 1, March, 384–406.

Robbins, D. (1963–64), 'From symbolism to cubism: the Abbaye of Créteil', *Art Journal*, winter, 111–6.

—— (1964), 'Albert Gleizes: reason and faith in modern painting', in Robbins, *Albert Gleizes 1881–1953*, exh. cat., New York: Solomon R. Guggenheim Museum.

—— (1975) , 'The formation and maturity of Albert Gleizes', unpublished PhD thesis, New York University.

—— (1985), 'Jean Metzinger: at the center of cubism', in Joann Moser (ed.), *Jean Metzinger in Retrospect*, exh. cat., Iowa City: University of Iowa Museum of Art, 9–23.

—— (1990), 'Le Fauconnier and cubism', in Salander–O'Reilly Galleries, *Henri Le Fauconnier (1881–1946): A Pioneer Cubist*, exh. cat., New York: Salander–O'Reilly Galleries.

—— (1996), 'Henri Le Fauconnier's *Mountaineers Attacked by Bears*', *Rhode Island School of Design: Museum Notes*, 83, no. 4, June, 24–53.

Romilly, N. Worms de, and J. Laude (1982), *Braque: Cubism, 1907–1914*, Paris: Editions Maeght.

Rosenblum, R. (1960), *Cubism and Twentieth-Century Art*, London: Thames & Hudson.

—— (1973), 'Picasso and the typography of cubism', in John Golding and Roland Penrose (eds), *Picasso 1881–1973*, London: Elek.

Rousseau, P. (1996), 'La construction de simultané: Robert Delaunay et l'aéronautique', *Revue de l'Art*, 113, no. 3, 20–1.

—— (1997), 'Les couleurs "suggestives" de l'affiche, *L'Equipe de Cardiff* de Robert Delaunay et la querelle des "panneaux-réclame"', *Histoire de l'Art*, 39, October, 77–89.

—— (1997), '"Cherchons à voir": Robert Delaunay, l'oeil primitif et l'esthétique de la lumière', *Les Cahiers du Musée National d'Art Moderne*, 61, autumn, 21–47.

Rubin, W. (1972), *Picasso in the Collection of the Museum of Modern Art*, New York: Museum of Modern Art.

—— (1983), 'From narrative to "iconic" in Picasso: the buried allegory in *Bread and Fruitdish on a Table* and the role of the *Demoiselles d'Avignon*', *Art Bulletin*, 65, no. 4, December, 620–2.

—— (ed.) (1989), *Picasso and Braque: Pioneering Cubism*, New York: Museum of Modern Art.

—— and L. Zelevansky (eds) (1992), *Picasso and Braque: A Symposium*, New York: Museum of Modern Art.

Salmon, A. (1912), *La Jeune Peinture française*, Paris: Société des Trente–Albert Messein.

Schwartz, Vanessa R. (1999), *Spectacular Realities: Early Mass Culture in Fin-de-Siècle France*, Berkeley and London: University of California Press.

Scobie, S. (1997), *Earthquakes and Explorations: Language and Painting from Cubism to Concrete Poetry*, Toronto: University of Toronto Press.

Severini, G. (1995 [1946]), *The Life of a Painter*, trans. Jennifer Franchina, Princeton, NJ: Princeton University Press.

Seigel, J. (1995), *The Private Worlds of Marcel Duchamp: Desire, Liberation and the Self in Modern Culture*, Berkeley and London: University of California Press.

Silver, K. (1989), *Esprit de Corps: The Art of the Parisian Avant-Garde and the First World War, 1914–1925*, London: Thames & Hudson.

—— (2001), 'The heroism of understatement: the ideological machinery of La Fresnaye's *Conquest of the Air*', in A. D'Souza (ed.), *Self and History: A Tribute to Linda Nochlin*, London: Thames & Hudson, 116–26 and 215–16.

Silverman, D. (1989), *Art Nouveau in Fin-de-Siècle France: Politics, Psychology and Style*, Berkeley: University of California Press.

Spate, V. (1979), *Orphism: The Evolution of Non-Figurative Painting in Paris 1910–1914*, Oxford University Press.

Staller, N. (1989), 'Méliès' "fantastic" cinema and the origins of cubism', *Art History*, 12, no. 2, June, 202–32.

—— (2001), *A Sum of Destructions: Picasso's Cultures and the Creation of Cubism*, New Haven, CT, and London: Yale University Press.

Steele, V. (1988), *Paris Fashion: A Cultural History*, Oxford and New York: Oxford University Press.

Steinberg, L. (1972), *Other Criteria: Confrontations with Twentieth-Century Art*, New York: Oxford University Press.

—— (1972), 'The philosophical brothel, part I', *Art News*, 71, no. 5, September, 22–9; 'Part II', *Art News*, 71, no. 6, October, 38–47.

—— (1978), 'Resisting Cézanne: Picasso's *Three Women*', *Art in America*, 66, no. 6, November–December, 114–33.

—— (1979) 'The polemical part', *Art in America*, 67, no. 2, March–April, 114–27.

Strauss, M. (1987), 'The first simultaneous book', *Fine Print*, 13, July, 139–50.

Tickner, L. (1994), 'Men's work? Masculinity and modernism', in N. Bryson, M. Holly and K. Moxey (eds), *Visual Culture: Images and Interpretations*, Hanover and London: Wesleyan University Press, 42–82.

Tomkins, C. (1998), *Duchamp: A Biography*, London: Pimlico.

Troy, Nancy J. (1991), *Modernism and the Decorative Arts in France: Art Nouveau to Le Corbusier*, New Haven, CT, and London: Yale University Press.

—— (2003), *Couture Culture: A Study in Modern Art and Fashion*, Cambridge, MA: MIT Press.

Tudesq, A. (1912), 'Du cubisme et de ses détracteurs: une querelle autour de quelque toiles', *Paris-Midi*, 4 October, 1.

Uzanne, O. (1910), *Parisiennes de ce Temps*, Paris: Mercure de France.

Varnedoe, K. and A. Gopnik (1991), *High and Low: Modern Art/Popular Culture*, New York: Museum of Modern Art.

Vriesen, G. and M. Imdahl (1967), *Robert Delaunay: Light and Colour*, New York: Abrams.

Warnod, A. (1925), *Les Berceaux de la jeune peinture*, Paris: A. Michel.

Weill, B. (1933), *Pan! Dans l'Oeil! Ou, Trente Ans dans les Coulisses de la Peinture contemporaine 1900–1930*, Paris: Lipschutz.

Weiss, J. (1994), *The Popular Culture of Modern Art: Picasso, Duchamp and Avant-Gardism*, New Haven, CT, and London: Yale University Press.

Wollen, P. (1993), *Raiding the Icebox: Reflections on Twentieth-Century Culture*, London and New York: Verso.David Cottington

Index

Note 'n' after a page reference indicates a note number on that page.